Ultimate Hotel Design

teNeues

Ultimate Hotel Design

Editor in chief:	Paco Asensio
Project coordination and texts:	Aurora Cuito, Ana Cristina G. Cañizares
Art director:	Mireia Casanovas Soley
Layout:	Diego González
Research:	Eva Raventós
Copy editing:	Raquel Vicente Durán
German translation:	Susanne Engler, Anette Hilgendag (introduction)
French translation:	Marion Westerhoff, Michel Ficerai/Lingo Sense (introduction)
Italian translation:	Maurizio Siliato, Sara Tonelli (introduction)

Published by teNeues Publishing Group

teNeues Publishing Company
16 West 22nd Street
New York, NY 10010, USA
Tel.: 001-212-627-9090, Fax: 001-212-627-9511

teNeues Book Division
Kaistraße 18
40221 Düsseldorf, Germany
Tel.: 0049-(0)211-99 45 97-0, Fax: 0049-(0)211-99 45 97-40

teNeues Publishing UK Ltd.
P.O. Box 402
West Byfleet
KT14 7ZF, Great Britain
Tel.: 0044-1932-403509, Fax: 0044-1932-403514

teNeues France S.A.R.L.
4, rue de Valence
75005 Paris, France
Tel.: 0033-1-55 76-62 05, Fax: 0033-1-55 76-64 19

www.teneues.com

© 2004 teNeues Verlag GmbH + Co. KG, Kempen

ISBN:	3-8238-4594-2
Editorial project:	2004 **LOFT** Publications
	Via Laietana 32, 4º Of. 92
	08003 Barcelona, Spain
	Tel.: 0034 932 688 088
	Fax: 0034 932 687 073
	e-mail: loft@loftpublications.com
	www.loftpublications.com
Printed by:	Anman Gràfiques del Vallès, Spain
	www.anman.com
	anman@anman.com
	2004

Bibliographic information published by Die Deutsche Bibliothek.
Die Deutsche Bibliothek lists this publication in the Deutsche Nationalbibliografie; detailed bibliographic data is available in the Internet at http://dnb.ddb.de

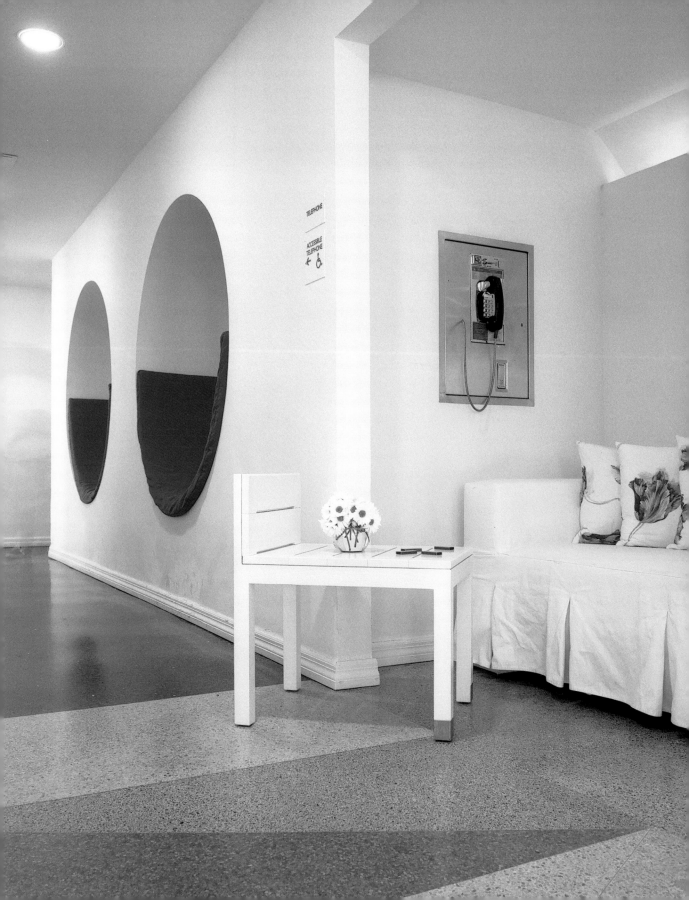

America

Australia
Asia

Europe

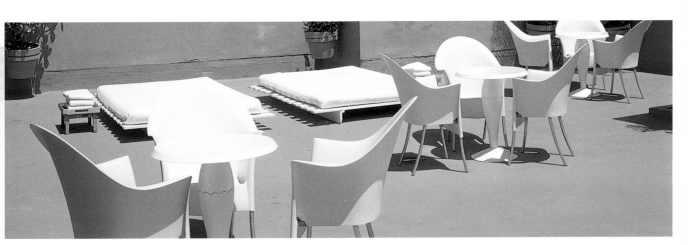

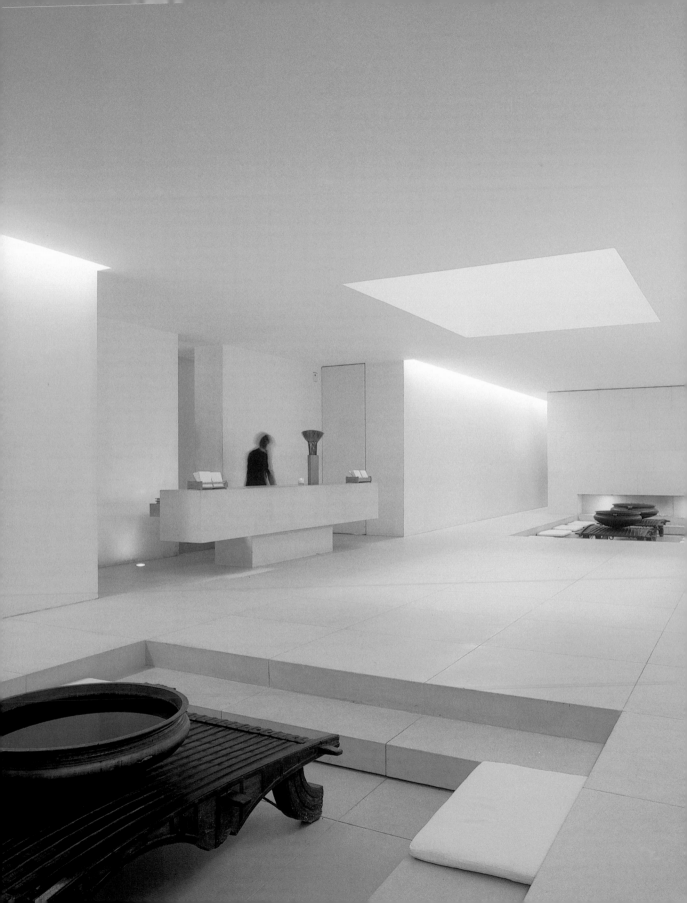

Over the past two decades, the growing demand for hotels with an especially personalized and individual character has posed an interesting challenge for both architects and designers alike. Aesthetically speaking, if the luxury hotel was once represented by the presence of expensive materials, ostentatious decoration and formality, now they are signaled by customized comfort and individual personality. Spacious rooms (intimate spaces alike), atmospheres that explore new sensations, the incorporation of the latest technology, and above all, a stylish sense of character are showcased in these spaces by some of the world's most prestigious architects and designers.

This new generation of designer hotels—fueled by the exponential growth of the travel industry—is notable for its attention to detail and unique character. Globalization, in this case, has produced an effect contrary to standardization. With more leisure time and more money available to spend on travel, the more popular this hobby has become, and the more crucial vitality and variety have become in competing for the affections and pocketbooks of today's travelers. The interiors of these new designer hotels can afford to be more detailed as they can extravagant in their varying motifs. This attention to personality coupled with an organic integration of the building with its history and surroundings, are the hallmarks of this new generation, reflected in each project presented in this collection of design hotels.

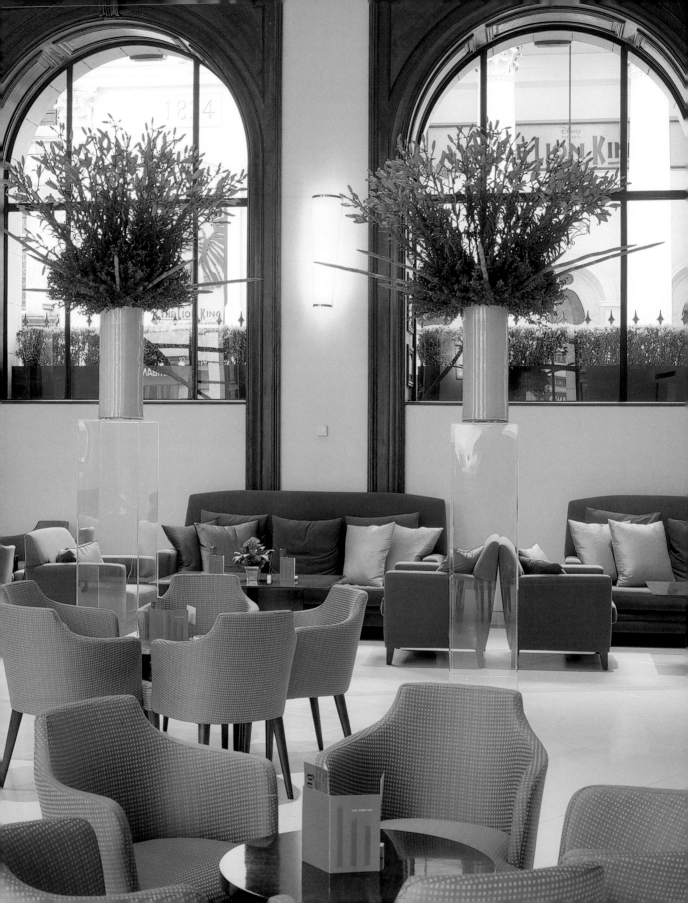

Das Bestreben vieler Hotels nach einer immer individuelleren Note hat dazu geführt, dass dieser Bereich für Architekten und Designer seit zwei Jahrzehnten zu den interessanten Tätigkeitsbereichen gehört. Vom ästhetischen Gesichtspunkt aus gesehen hat ein Wandel stattgefunden von der Idee, die man früher mit einem Luxushotel verband, hin zu den heutigen Konzepten. Von kostspieligen Materialien, überladener Dekoration und einer steifen, formellen Umgebung hin zu einem Konzept, bei dem Luxus Synonym für bequeme Räumlichkeiten mit persönlicher Note ist. Großzügige Räume auch in den persönlichsten Bereichen, Umgebungen mit besonderem Ambiente, modernste Technologien im Dienste des Designs und Gestaltungen von sehr eigenem Charakter herrschen in diesen Häusern vor, die von einigen der renommiertesten Architekten und Designer entworfen worden sind.

Eine neue Generation von Designerhotels, gekennzeichnet von dem steten Wachstum der Tourismusindustrie, zeigt sich im Inneren von besonderen Gebäuden mit großer Individualität. Unsere globalisierte Welt hat in diesem Fall das genaue Gegenteil der sonst vorherrschende Uniformierung bewirkt. Die Tatsache, dass immer mehr Personen über mehr Freizeit und mehr Geld verfügen, hat die Zahl der Urlaubsreisenden erhöht und das Angebot der Hotelbranche ins Unendliche wachsen lassen. Die neuen Designerhotels können sich den Luxus leisten, ihre Inneneinrichtung gleichermaßen speziellen wie extravaganten Themen zu widmen. Dies und die Verpflichtung zur Anpassung des Gebäudes an seine städtische oder ländliche Umgebung sind die Hauptmerkmale dieser neuen Generation von Hotels, die in jedem einzelnen der in dieser Kollektion vorgestellten Projekte zum Ausdruck kommen.

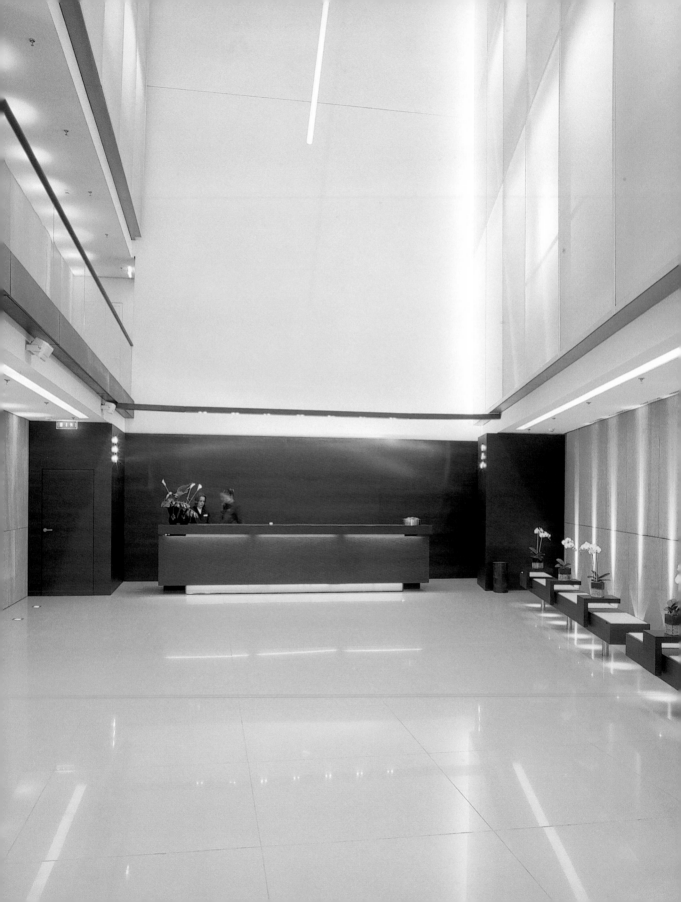

La nécessité impérative d'accentuer toujours davantage la personnalisation a fait du design hôtelier, depuis déjà deux décennies, l'un des exercices les plus intéressant pour tout architecte ou designer. Quant à l'esthétique, l'idée que l'on se faisait d'un endroit luxueux, synonyme de matériaux coûteux, de décoration étudiée et d'atmosphères très formelles, a cédé la place à un nouveau concept faisant rimer luxe avec espace confortable et personnalité nettement affirmée. Les volumes importants, notamment dans les endroits les plus intimes, les ambiances explorant de nouvelles sensations, les technologies de pointe appliquées au design et les atmosphères au caractère prononcé sont les dominantes de ces espaces popularisés par les architectes et designers les plus prestigieux.

Aujourd'hui, une nouvelle génération d'hôtels design, déterminée par la croissante ininterrompue de l'industrie du tourisme, se reflète à l'intérieur d'espaces très particuliers affichant une forte personnalité. Le monde globalisé s'accompagne, en l'occurrence, d'un effet complètement contraire à la normalisation de l'espace. La croissance du temps consacré aux loisirs et l'amélioration des conditions économiques facilitant l'accès du plus grand nombre au tourisme ont généré un éventail infini de possibilités dans l'univers de l'hôtellerie. Les nouveaux hôtels design peuvent se permettre le luxe d'orienter la personnalité de leurs intérieurs sur des thèmes aussi spécifiques qu'extravagants. Ces approches, conjointement à une relation engagée avec l'environnement urbain ou naturel, sont les caractéristiques de cette nouvelle génération et se reflètent dans chaque projet présenté dans cette collection d'hôtels design.

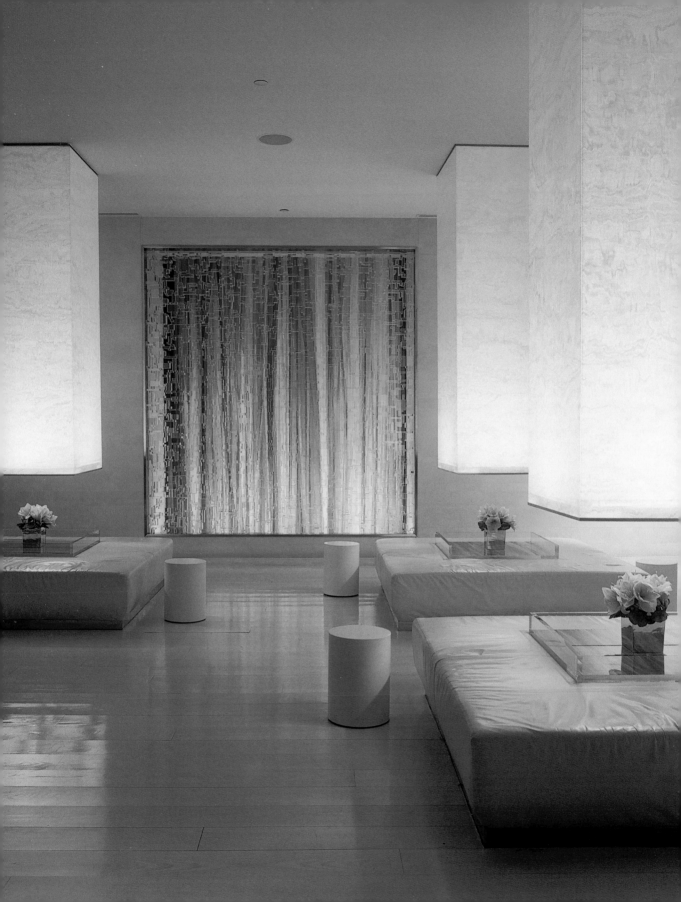

La necesidad de lograr un carácter cada vez más personalizado ha determinado que el diseño de hoteles, desde hace ya dos décadas, sea uno de los ejercicios más interesantes para cualquier arquitecto o diseñador. Desde un punto de vista estético la idea que se concebía de un lujoso lugar, que aludía a materiales costosos, a una recargada decoración y a un ambiente de gran formalidad, ha dado paso a un nuevo concepto en el que lujo es sinónimo de espacio confortable con un acentuado carácter propio. Los amplios espacios, incluso en las zonas más íntimas, los ambientes que exploran nuevas sensaciones, las últimas tecnologías aplicadas al diseño y las estancias con gran personalidad son las características predominantes de estos espacios que se han popularizado gracias a los más prestigiosos arquitectos y diseñadores del mundo.

La nueva generación actual de hoteles de diseño, determinada por el incesante crecimiento de la industria del turismo, se ve reflejada en el interior de espacios muy particulares e impregnados de una fuerte carácter. El mundo globalizado trae consigo, en este caso, un efecto completamente contrario a la estandarización del espacio. El aumento del tiempo destinado al ocio y las mejoras en las condiciones económicas han generado un infinito abanico de posibilidades en el mundo de la hostelería para que un mayor número de personas tengan acceso al turismo. Los nuevos hoteles de diseño se pueden permitir enfocar el carácter de su interior hacia temas tan específicos como extravagantes. Estas aproximaciones, junto a una comprometida relación con el entorno urbano o natural, son las características de esta nueva generación y se reflejan en cada proyecto presentado en esta colección de hoteles de diseño.

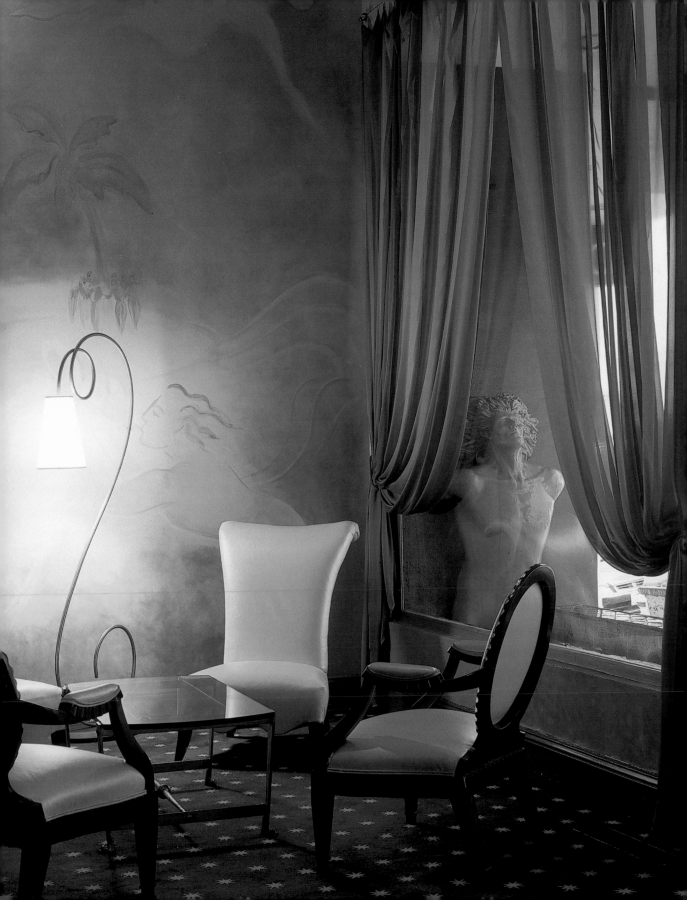

Una richiesta crescente di hotel con un carattere personalizzato ha fatto sì che, negli ultimi venti anni, gli architetti e i designer abbiano manifestato un interesse sempre maggiore per questo settore. Se una volta gli hotel di lusso significavano materiali costosi, esagerazione e grande formalità, oggi sono sinonimo di comfort su misura e personalità. Gli ampi spazi, le atmosfere sensuali, le tecnologie più moderne e, soprattutto, un carattere proprio con uno stile ben definito sono racchiusi in nuovi ambienti progettati dagli architetti e dai designer più famosi del mondo.

La nuova generazione degli hotel di design, sostenuta da una crescita incessante nell'industria del turismo, si riflette negli interni particolari, dotati di un forte carattere proprio. La tendenza alla globalizzazione nell'industria del turismo non significa necessariamente standardizzazione. L'aumento della quantità di tempo libero e una maggiore disponibilità di spesa hanno offerto a più persone la possibilità di affrontare un viaggio e hanno amplificato l'importanza della varietà nell'offerta degli hotel. I nuovi hotel di design possono permettersi di dedicare maggiore cura ai dettagli e di essere più inclini all'eccentricità. L'attenzione per la personalità e l'integrazione organica dell'edificio nella sua storia e nell'ambiente circostante si riflettono in ogni progetto presentato in questa collezione.

 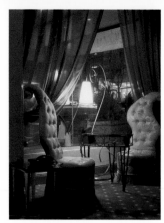 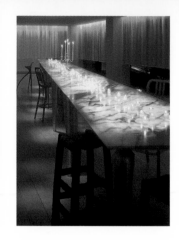 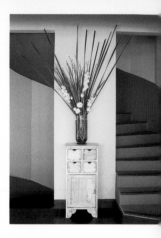

America

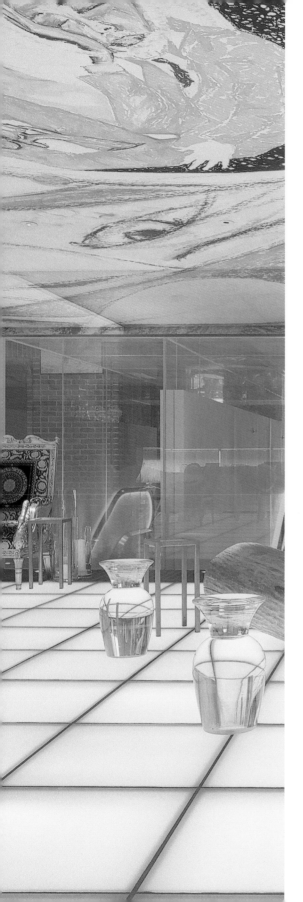

Argentina

Buenos Aires Design Suites & Towers
NH City Hotel

Brazil

São Paulo Emiliano

Canada

Montreal St. Paul Hotel

Mexico

Mexico D.F. Hotel Habita
Hotel Sheraton Centro Histórico
Quintana Roo Deseo

United States

Los Angeles Mondrian
Sunset Marquis
The Standard
W Los Angeles Westwood
Miami Aqua
Chesterfield
Delano
Mandarin Oriental Miami
The Hotel Chelsea
The Marlin
The Royal Hotel
The Sagamore Hotel
The Shore Club
Townhouse
Whitelaw
New York 60 Thompson
Ameritania Hotel
Dylan Hotel
Hudson Hotel
The Muse
W Union Square
San Francisco Clift
Hotel Triton
Seattle Ace Hotel
Washington Hotel Rouge

Uruguay

Punta del Este Le Club

Galería de Arte

Marcelo T. de Alvear 1683, C1060AAE Buenos Aires, Argentina Tel. + Fax: +54 11 4814 8700
www.designsuites.com

Design Suites & Towers

Architect: Ernesto Goransky Photographer: © Virginia Del Guidice Opening date: 1999
Rooms: 40 rooms (including 20 suites)

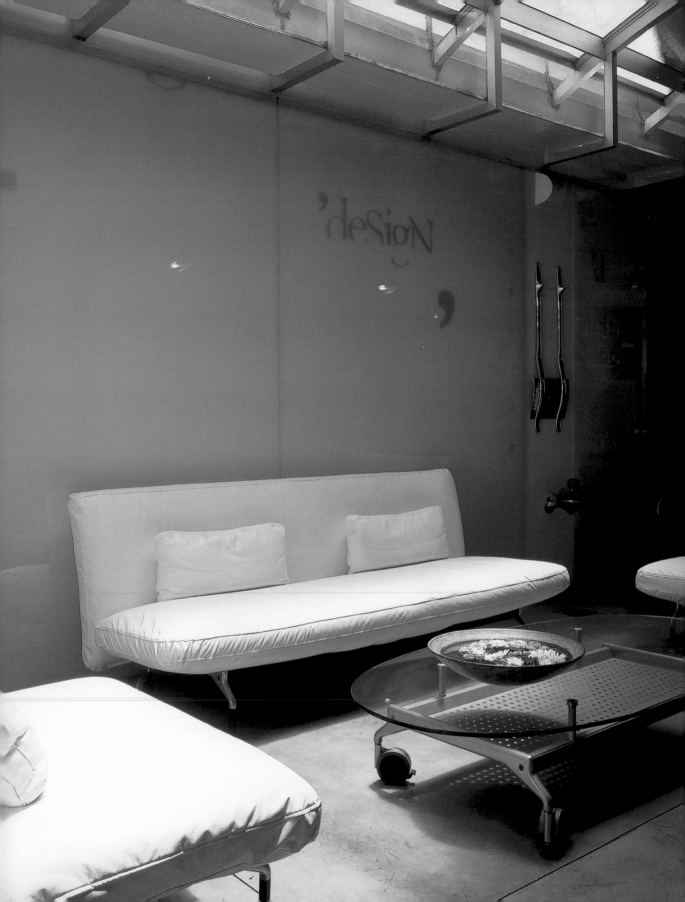

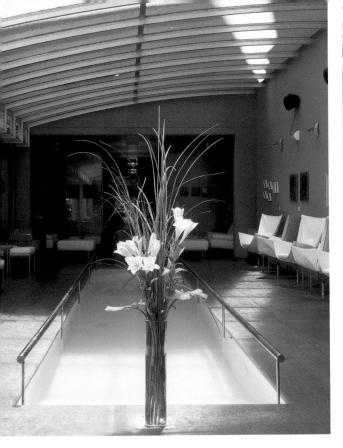 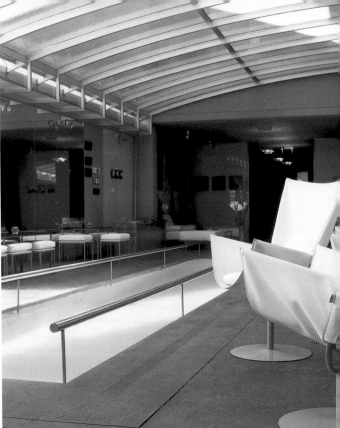

The designers of the hotel paid special attention to the integration of natural light into all the areas. In the indoor pool an ambience similar to that of a living room is achieved due to the color of the walls and the furnishings.

Die Gestalter legten besonderen Wert darauf, dass das Tageslicht alle Ecken und Winkel erreicht. Die Atmosphäre im Hallenbad erinnert aufgrund der Farbe der Wände und der verwendeten Möbel an ein Wohnzimmer.

Les concepteurs prêtèrent une attention particulière à l'intégration de la lumière naturelle dans tous les espaces. L'ambiance de la piscine couverte ressemble à celle d'un salon, par la couleur des murs et du mobilier choisi.

Los diseñadores prestaron especial atención a la integración de la luz natural en todas las zonas. El ambiente de la piscina cubierta se asemeja a la de una sala de estar, dado el color de las paredes y el mobiliario utilizado.

I progettisti hanno prestato particolare attenzione all'inserimento della luce naturale in tutte le zone. L'ambiente della piscina coperta somiglia a quello di un soggiorno, visto il colore delle pareti e l'arredamento utilizzato.

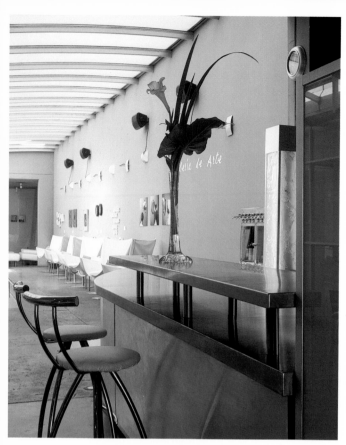
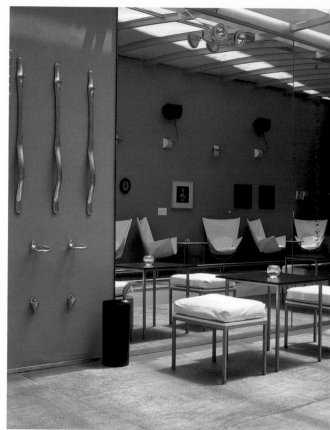
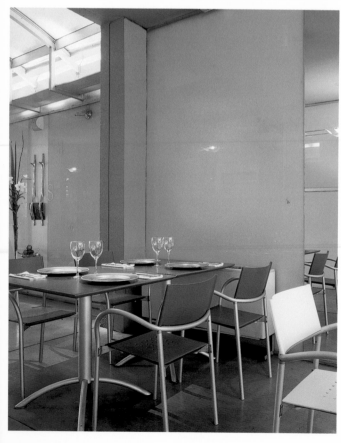
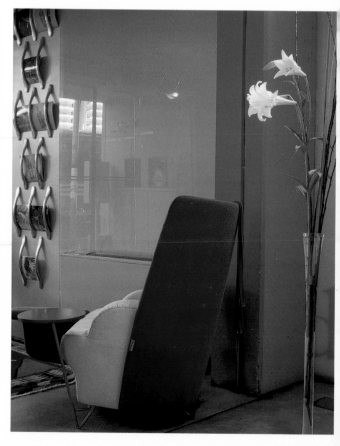

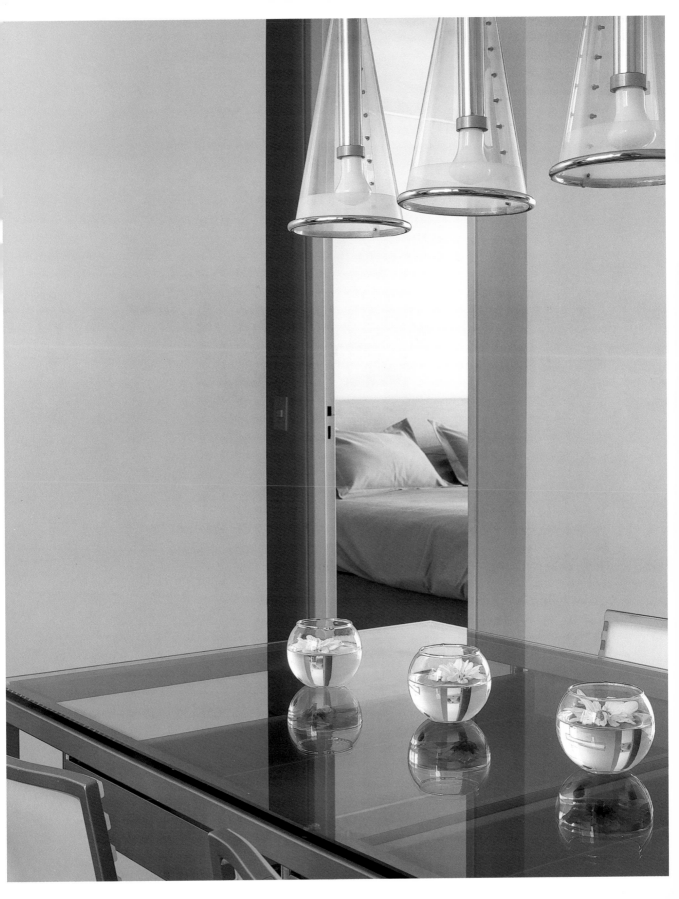

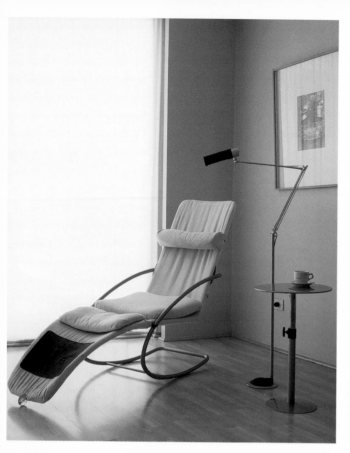
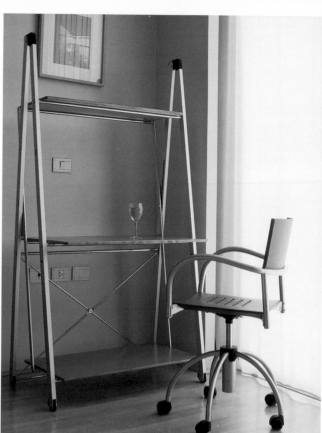
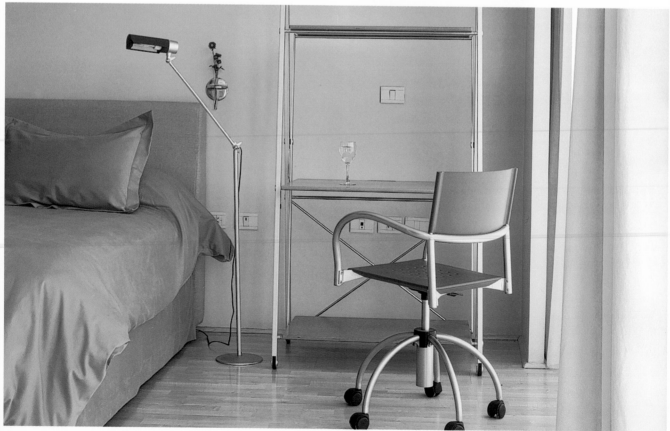

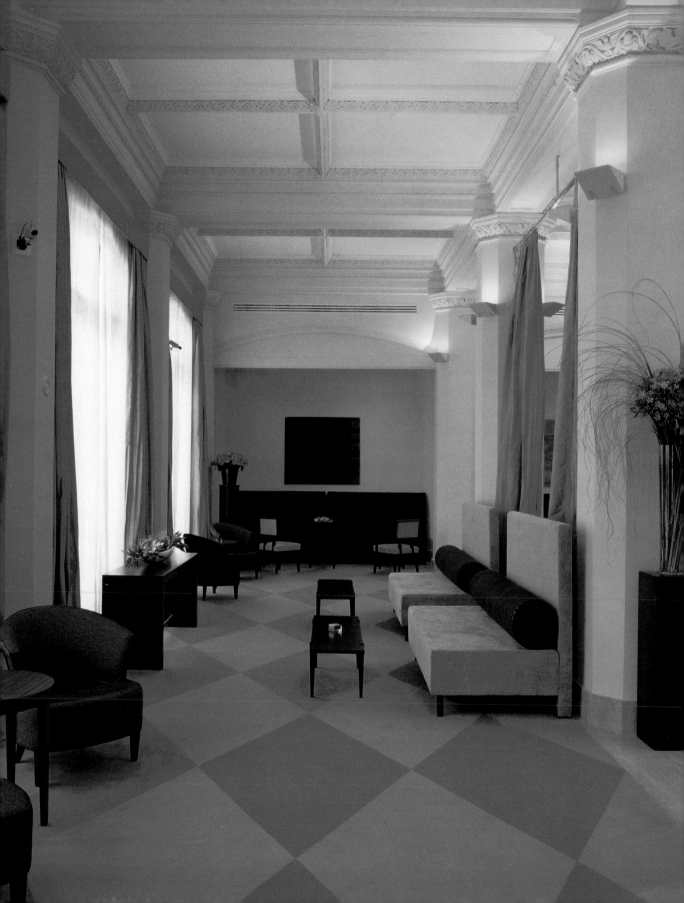

Bolivar 160, C1066AAD, Buenos Aires, Argentina Tel.: +54 11 4121 6464 Fax: +54 11 4121 6450
nhcity@nh-hotels.com www.nh-hoteles.com

NH City Hotel

Architects: Cora Entelman and Roberto Caparra / Caparra Entelman & Associates

Collaborators: Lucila Pérez Elizalde and Lucas Gashu **Photographers:** © C&E, NH and Sur-Press-Hitters

Opening date: 2000 **Rooms:** 303 (including 34 superior rooms, 6 executive suites and 46 junior suites)

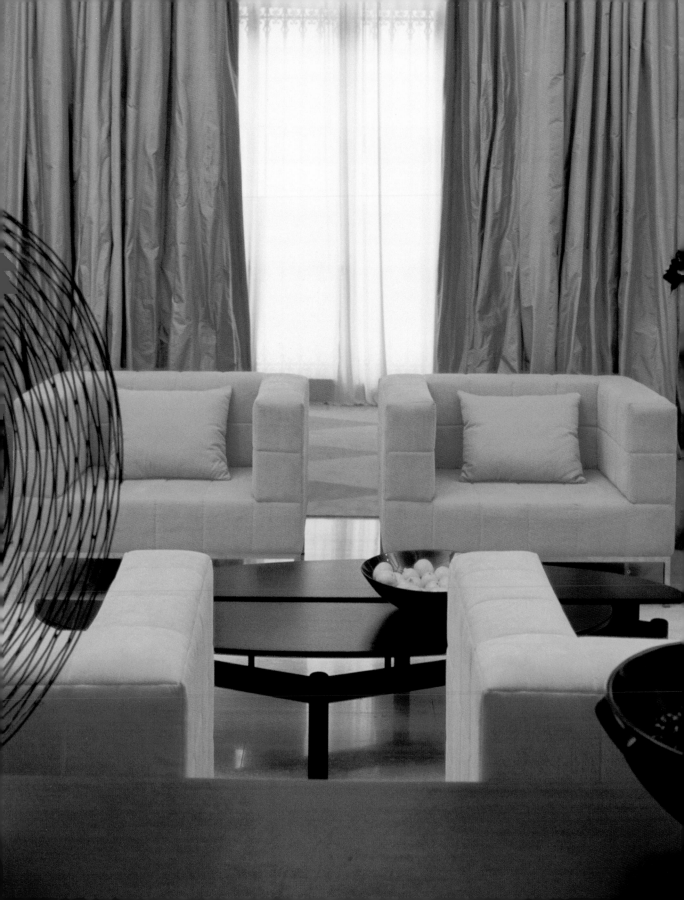

The furnishings, designed especially for the hotel, recreate various interpretations of classic furniture in a contemporary language, resulting in completely timeless space.

Das exklusiv für dieses Hotel entworfene Mobiliar interpretiert klassische Möbel in einer zeitgenössischen Sprache, wodurch absolut zeitlose Räumlichkeiten entstanden.

Le mobilier, conçu spécialement pour l'hôtel, est l'interprétation contemporaine de meubles classiques, crée ainsi un espace totalement intemporel.

El mobiliario, diseñado especialmente para el hotel, recrea varias interpretaciones de muebles clásicos con un lenguaje contemporáneo y logra un espacio completamente intemporal.

L'arredamento, concepito appositamente per l'hotel, ricrea varie interpretazioni di mobili classici mediante un linguaggio contemporaneo, ottenendo uno spazio completamente atemporale.

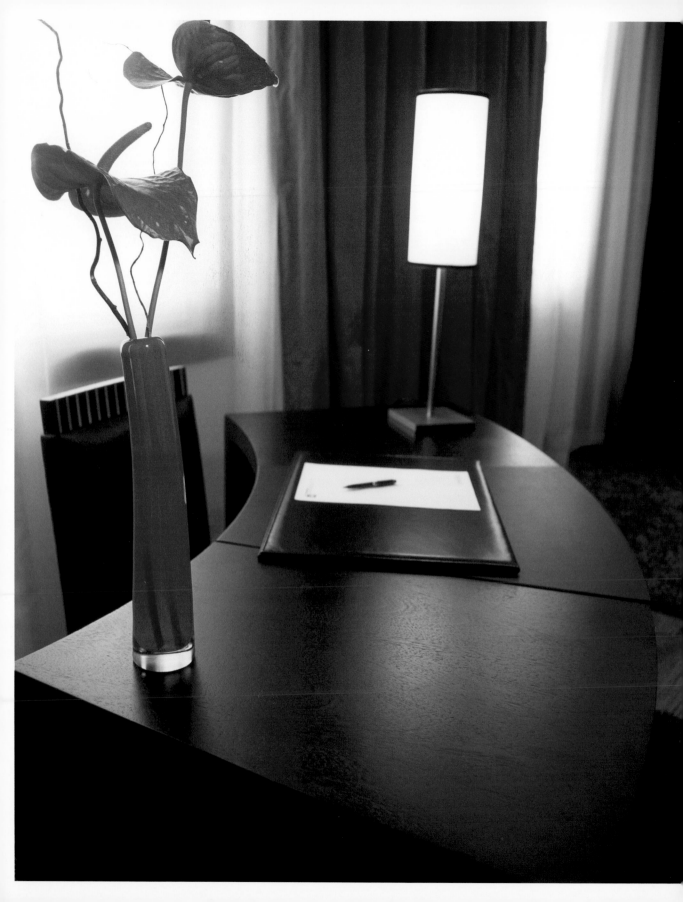

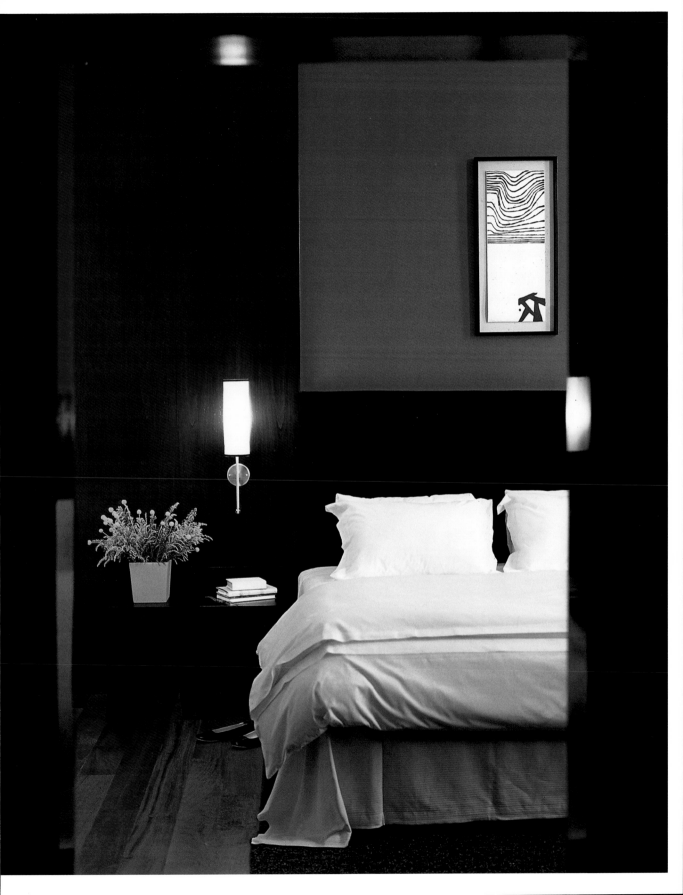

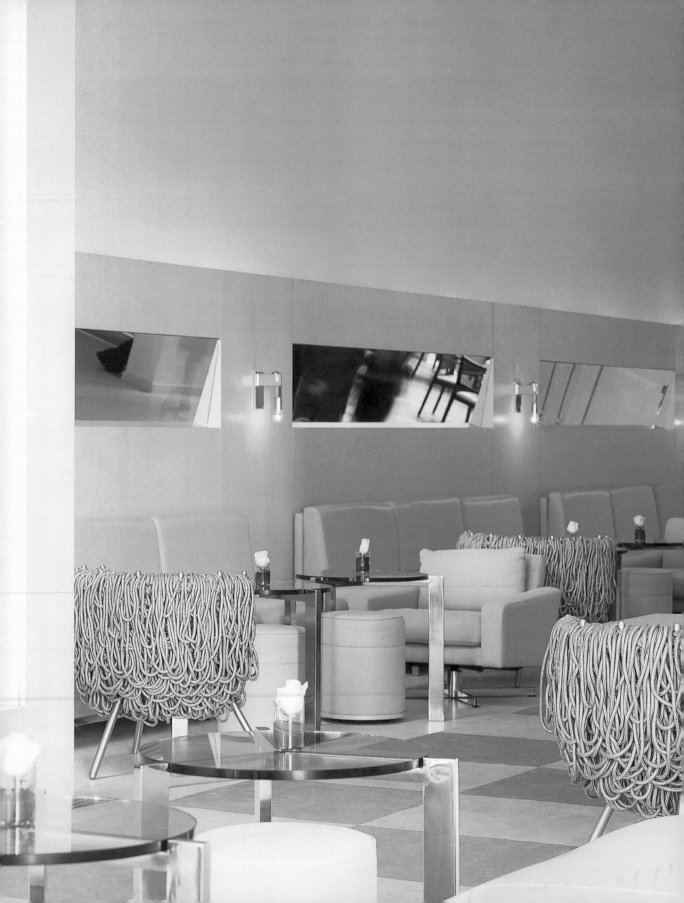

R. Oscar Freire 384, Jardim America, 01426-000 São Paulo, Brazil Tel.: +55 11 3068 4393
reservas@emiliano.com.br www.emiliano.com.br

Emiliano

Architect: Arthur de Mattos Casas **Photographer:** © Tuca Reinés **Opening date:** 2001 **Rooms:** 57

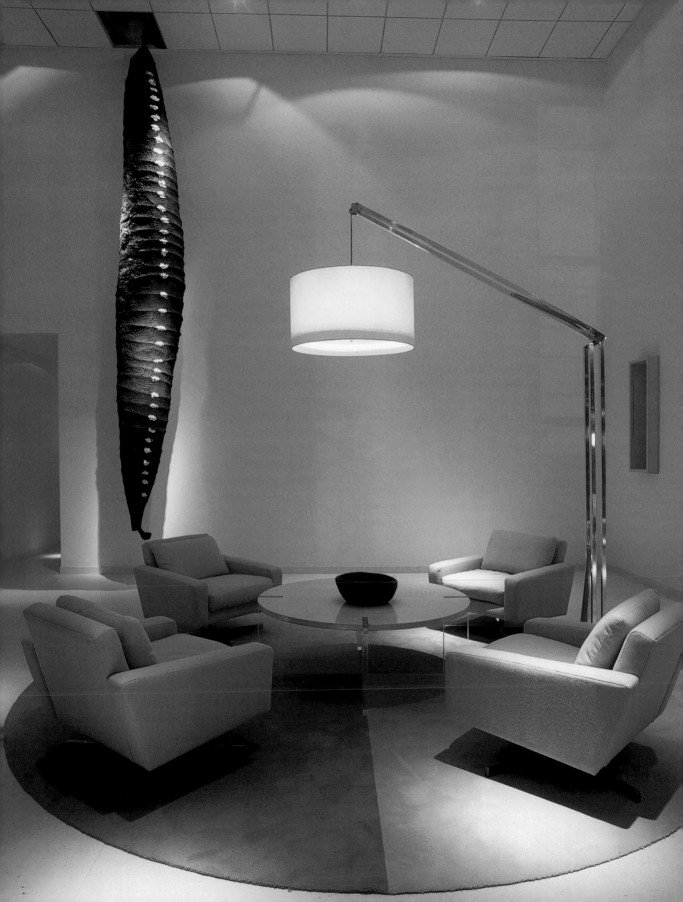

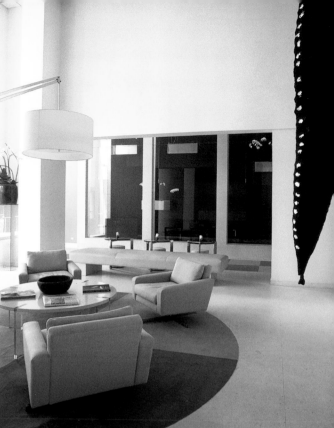

To counterbalance the narrow proportions of the lot, light colors were used for the furnishings and decorative objects in the public areas. The repetition of elements and the use of mirrors accentuate the widening effect.

Um die engen Proportionen des Grundstücks auszugleichen, wurden in den öffentlichen Bereichen Möbel und Dekorationsobjekte in hellen Farben verwendet. Durch die Wiederholung von Elementen und die Verwendung von Spiegeln entsteht ein Gefühl der Weite.

Pour contrecarrer les proportions étroites du terrain, les concepteurs ont utilisé, dans les espaces publics, des meubles et objets de décoration aux couleurs claires. La répétition des éléments et l'emploi de miroirs accentuent l'impression de largesse.

Para contrarrestar las proporciones estrechas del solar, se emplearon colores claros para los muebles y objetos decorativos en los espacios públicos. La repetición de elementos y la utilización de espejos acentúan la sensación de amplitud.

Per contrastare le strette dimensioni del terreno, sono stati utilizzati dei colori chiari per i mobili e oggetti decorativi negli spazi pubblici. La ripetizione di alcuni elementi e l'uso degli specchi accentuano la sensazione di spaziosità.

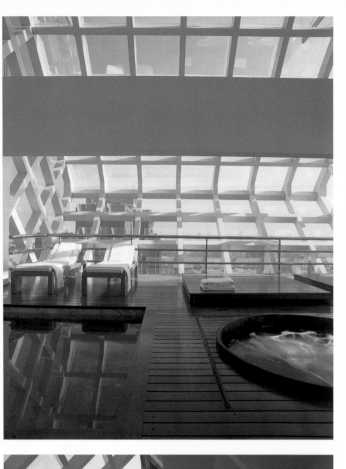
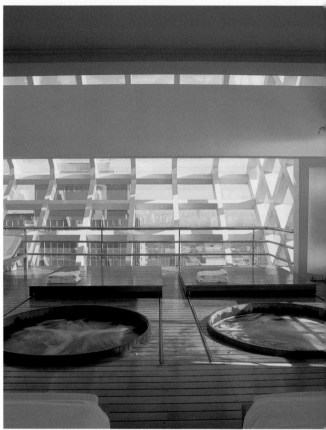
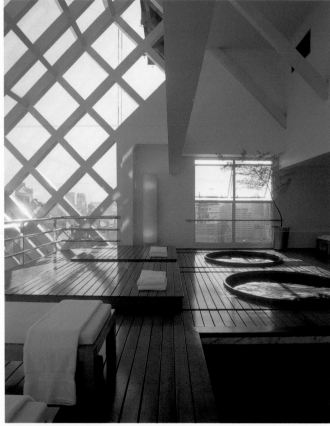
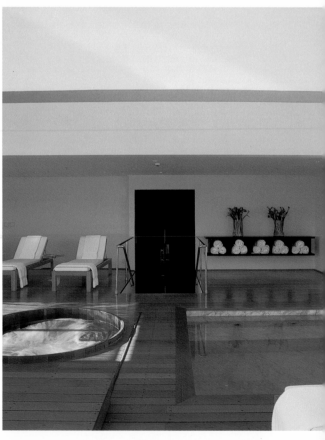

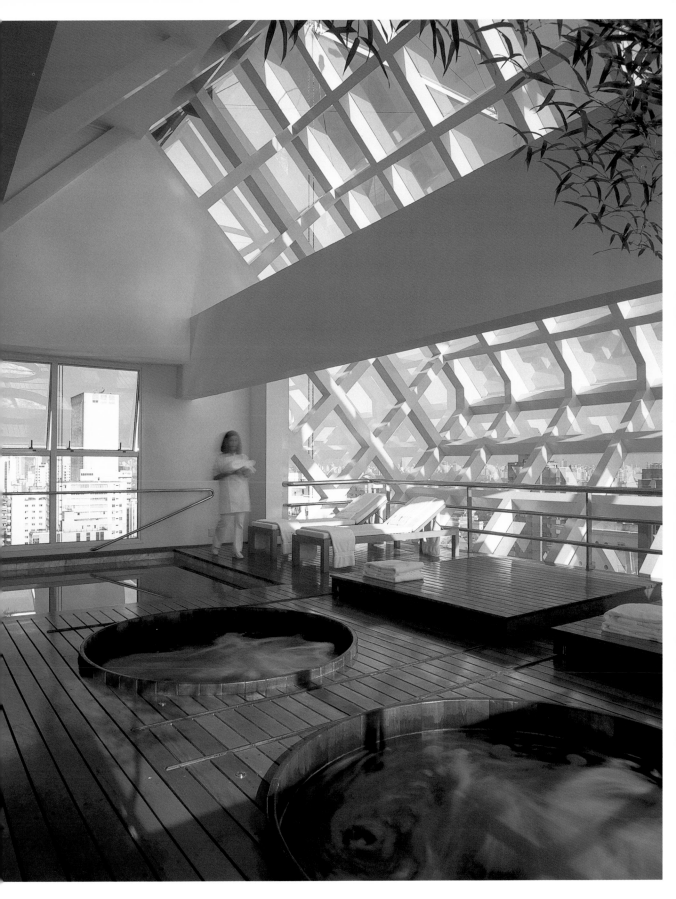

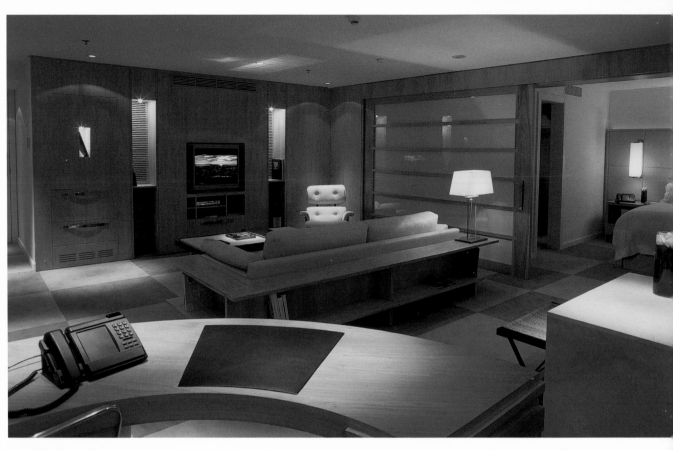
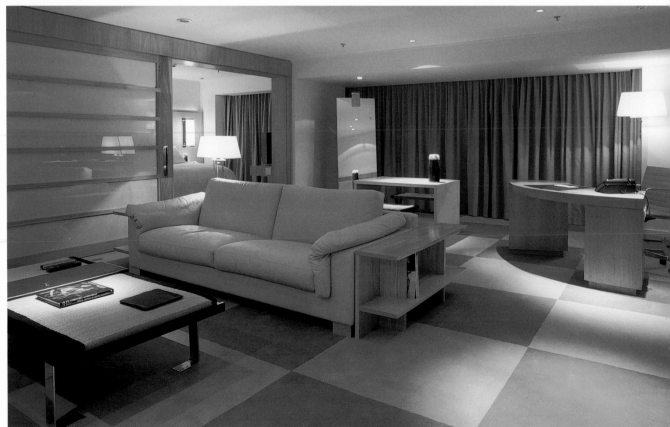

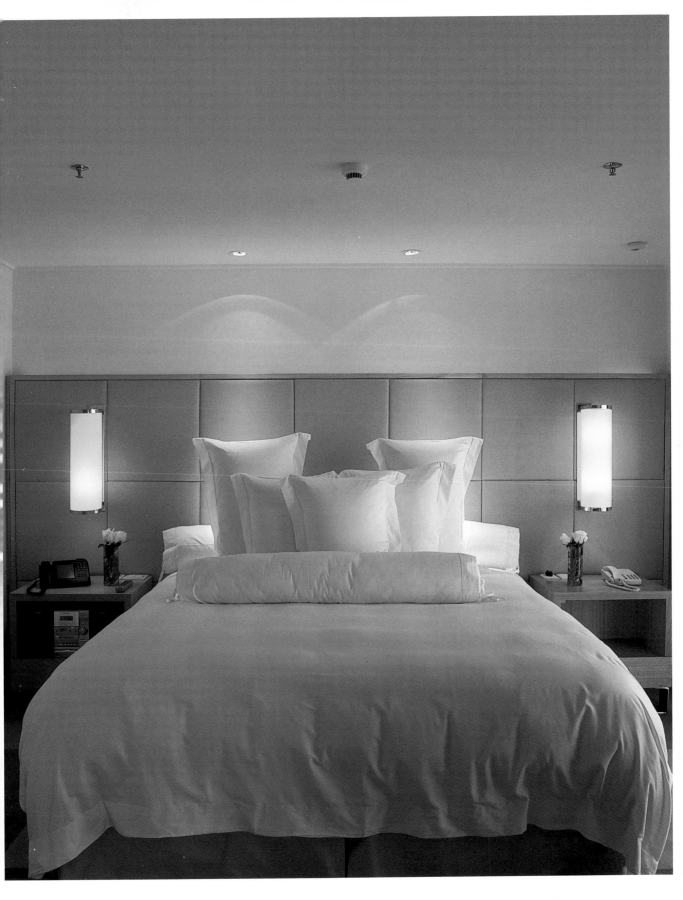

355 rue McGill, Montreal, QC, H2Y 2E8, Canada Tel.: +1 514 380 2222 Fax: +1 514 380 2200
concierge@hotelstpaul.com www.hotelstpaul.com

St. Paul Hotel

Interior Designer: Ana Borrallo Photographer: © Jean Blais Opening date: 2001
Rooms: 120 (including 24 suites)

Contrast is a recurring theme in this hotel. It is reflected in the difference in style between the classic exterior and the contemporary interior as well as in the design of each space, where light and dark create dramatic effects.

Zentralthema der Raumgestaltung in diesem Hotel sind die Kontraste. Das spiegelt sich in der Verschiedenheit der Stile wider, des klassischen Stils außen und des zeitgenössischen Stils innen. Auch die einzelnen Räume sind kontrastreich dekoriert, durch Helldunkel-Kombinationen entstehen dramatische Effekte.

Le thème central du projet de l'hôtel est axé sur les contrastes. Ils se reflètent dans la différence de styles entre la structure classique de l'extérieur et l'intérieur contemporain, ainsi que dans la conception de l'espace où les clairs-obscurs engendrent des effets dramatiques.

El diseño del hotel recurre a los contrastes como tema central. Esto se refleja en la diferencia de estilos entre la estructura clásica del exterior y el interior contemporáneo, como también en el diseño de cada espacio en donde los claroscuros crean efectos dramáticos.

Lo stile dell'hotel ricorre ai contrasti come tema centrale. Ciò si rispecchia nella differenza di stili tra la struttura classica dell'esterno e quella contemporanea dell'interno, così come nella concezione di ogni spazio dove i chiaroscuri creano effetti e contrasti molto intensi.

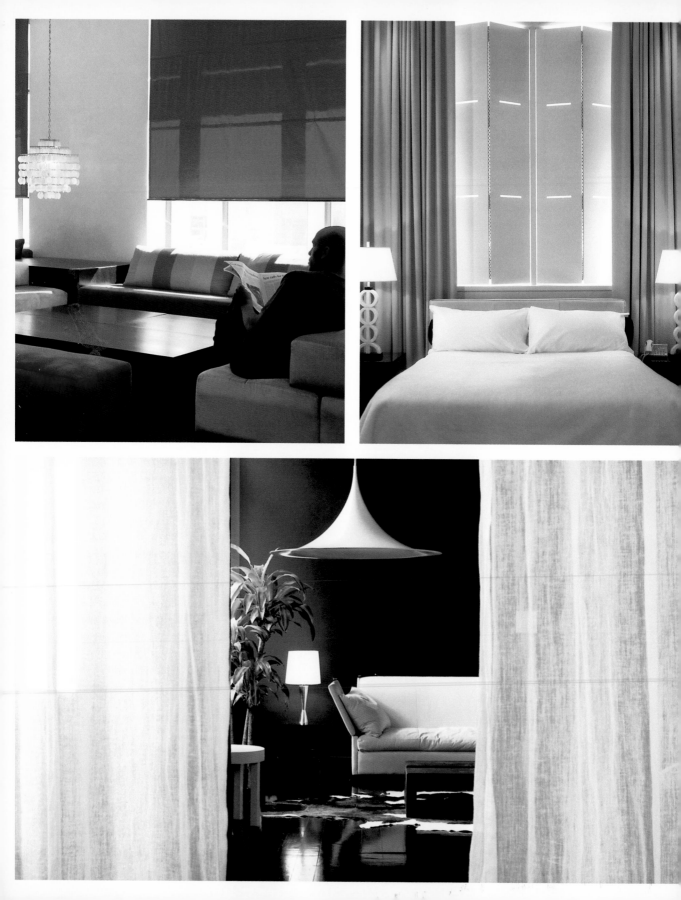

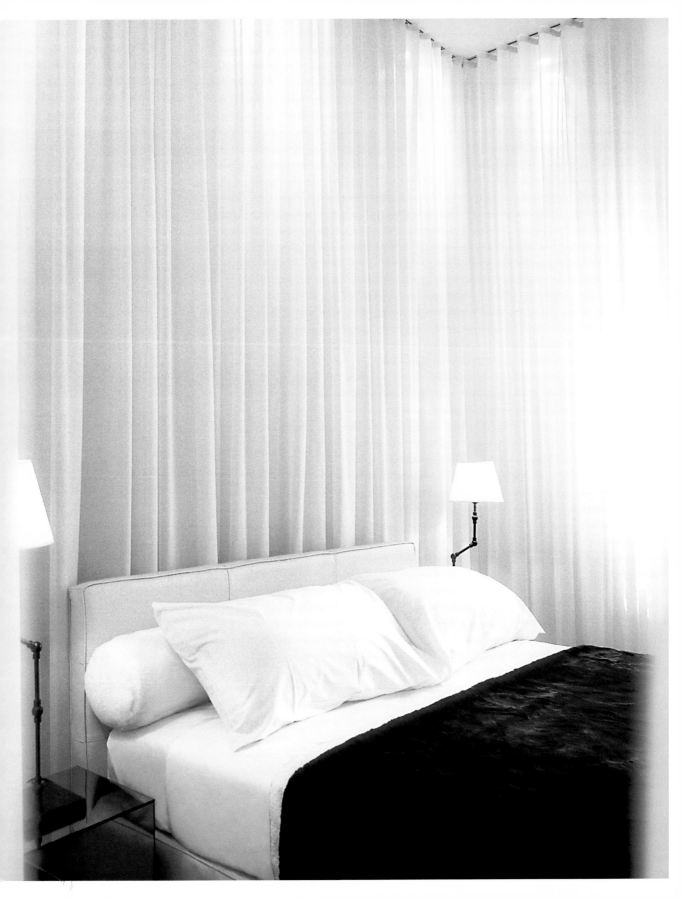

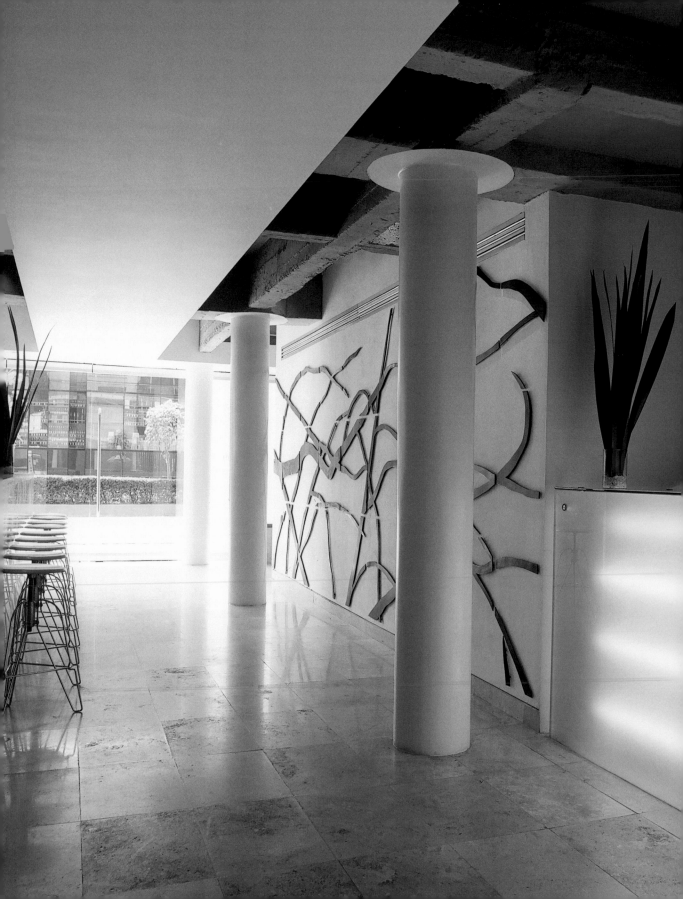

Avenida Presidente Masaryk 201, Col. Polanco 11560, Mexico D.F., Mexico Tel.: +52 55 5282 3100
Fax: +52 55 5282 3101 info@hotelhabita.com www.hotelhabita.com

Hotel Habita

Architects: TEN Arquitectos **Photographer:** © Undine Pröhl **Opening date:** 2001 **Rooms:** 36

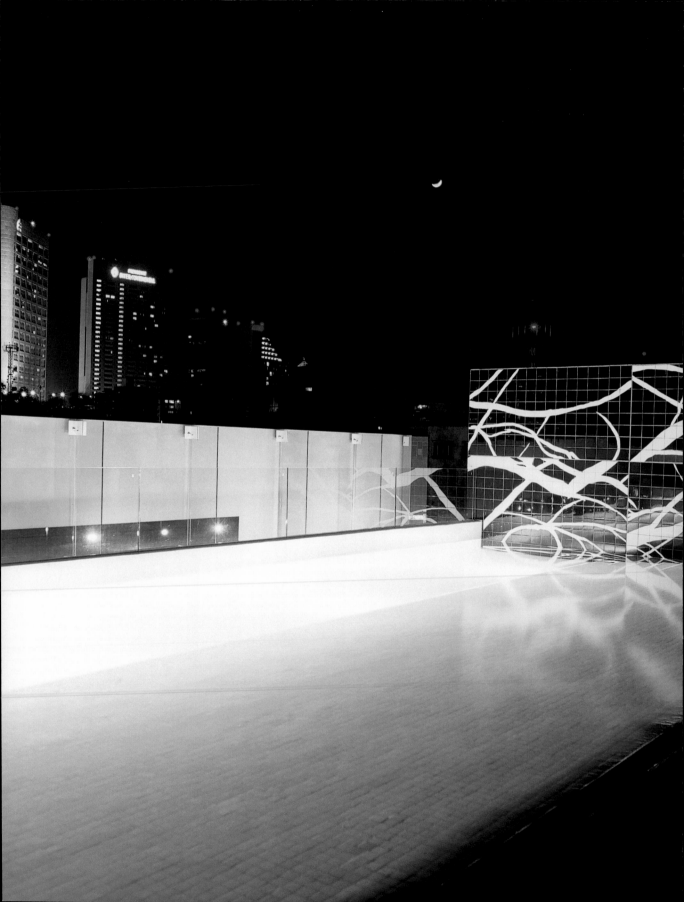

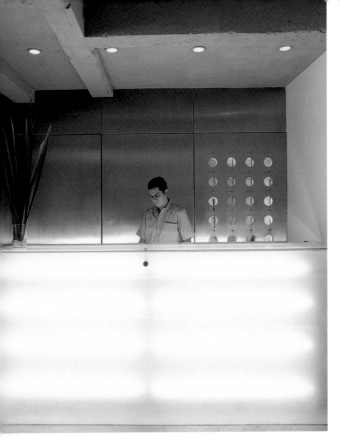

On the second-to-last floor a pool deck enjoys splendid panoramic views of the city. A black and white mural designed by Jan Hendrix adds a dramatic touch.

Im vorletzten Stockwerk befindet sich eine Terrasse mit Pool, von der aus man einen wundervollen Blick auf die Stadt hat. Das Wandbild in Schwarz und Weiß von Jan Hendrix hat eine leicht dramatische Wirkung.

Une terrasse avec piscine, située à l'avant dernier étage, offre des vues splendides sur la ville. Une peinture murale en noir et blanc, dessinée par Jan Hendrix ajoute une touche dramatique.

En la penúltima planta, una terraza con piscina goza de unas vistas espléndidas de la ciudad. Un mural de colores blanco y negro diseñado por Jan Hendrix aporta un toque dramático al paisaje.

Al penultimo piano, dalla terrazza con piscina si gode un panorama splendido della città. Un murale in bianco e nero, opera di Jan Hendrix aggiunge un tocco altamente emotivo.

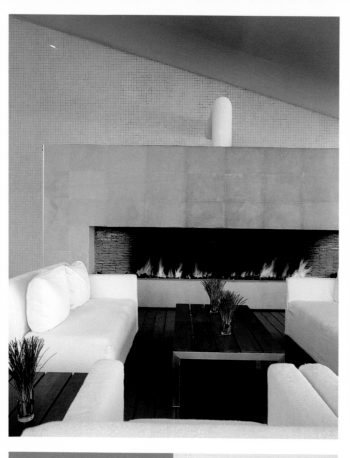
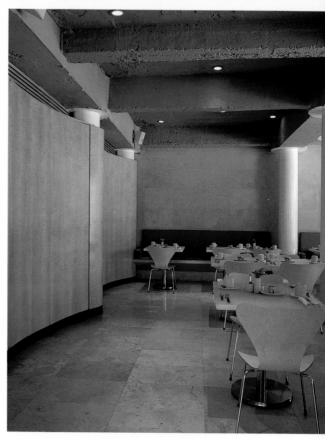
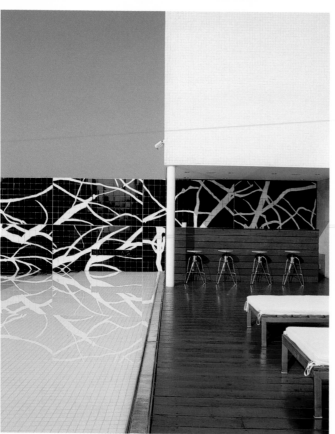
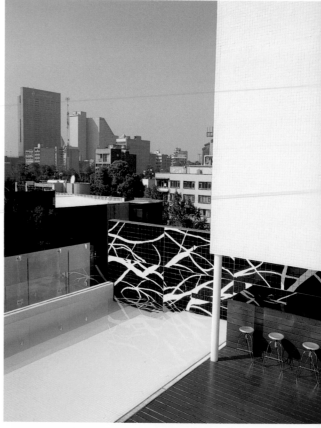

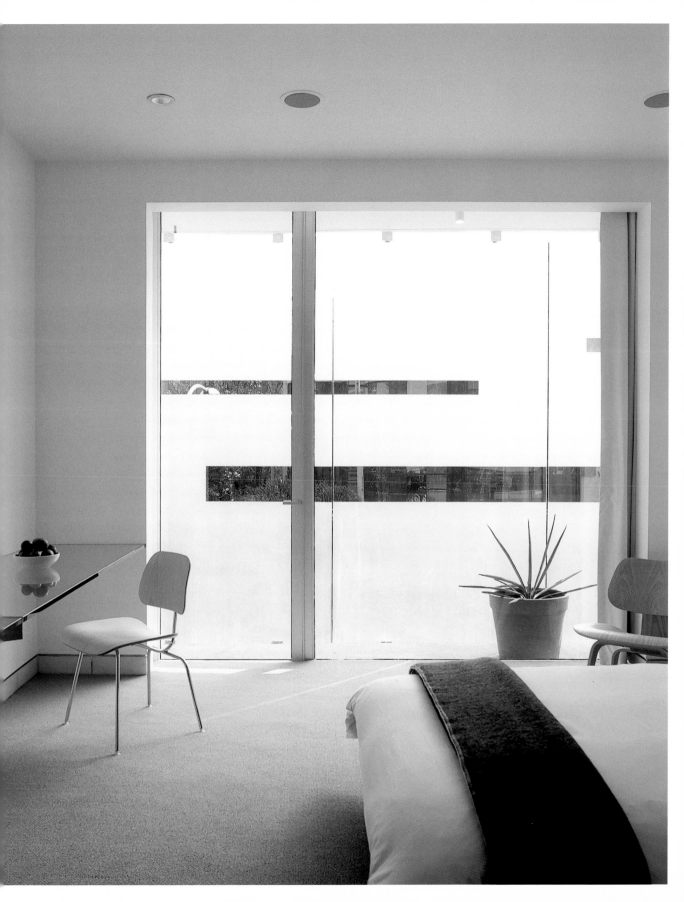

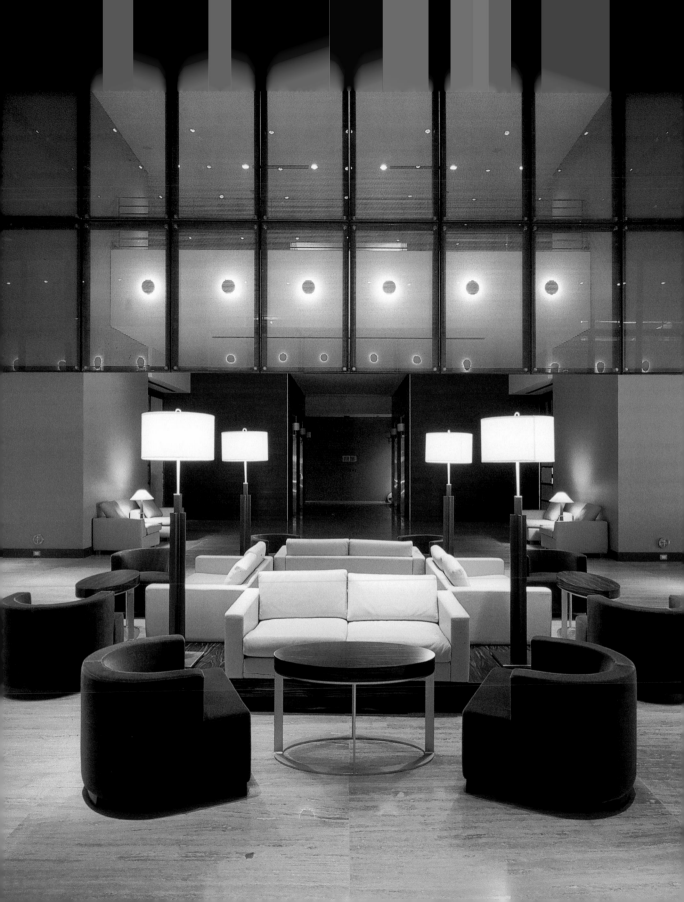

Avenida Juárez 70, Colonia Centro, 06010 Mexico D.F., Mexico Tel.: +52 55 5130 5300
Fax: +52 55 5130 5255 reservaciones@sheraton.com.mx www.starwood.com/sheraton

Hotel Sheraton
Centro Histórico

Architects: Pascal Arquitectos **Photographer:** © Fernando Cordero **Opening date:** 2003 **Rooms:** 457

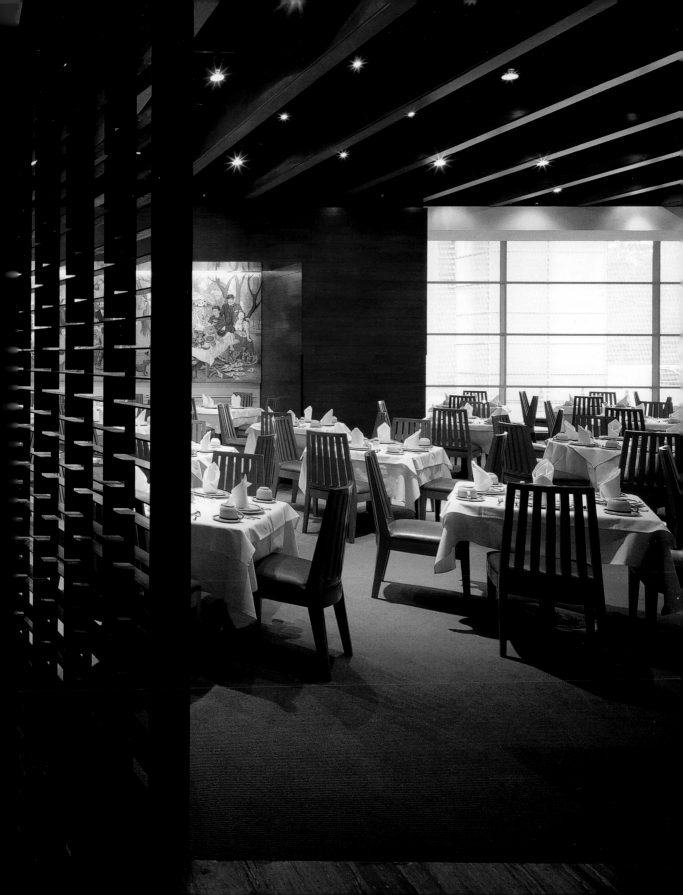

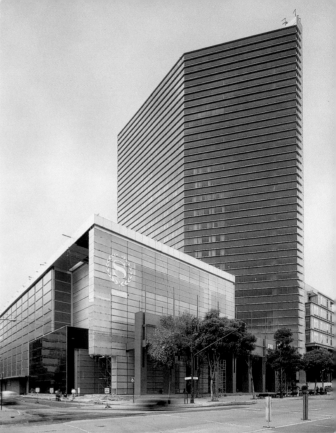

The approach to the décor is that of modernity combined with controlled luxury. Thus, the furniture, tapestries and bedspreads assume a certain uniformity with the background of a red, blue, beige and gray chromatic range of colors.

Die Raumgestaltung ist eine Kombination aus Modernität mit kontrolliertem Luxus. So sind zum Beispiel die in den Zimmern eingesetzten Farben Rot, Blau, Beige und Grau das Mittel, durch das die Möbel, Teppiche und Tagesdecken einheitlich gestaltet wurden.

Le concept de décoration est d'offrir modernité alliée au luxe contrôlé : à titre d'exemple, dans les chambres, la gamme chromatique - rouge, bleu, beige et gris - décline meubles, tapis et couvre-lits en un design uniforme.

El espíritu de la decoración es combinar modernidad y lujo moderado; así, por ejemplo, en las habitaciones la gama cromática –rojo, azul, beige y gris– es la herramienta con la que muebles, tapices y colchas adquieren un diseño uniforme.

L'essenza dell'arredamento consiste nell'offrire modernità abbinata a un lusso controllato; così, per esempio, nelle camere la gamma cromatica –rosso, blu, beige e grigio– è lo strumento mediante cui mobili, arazzi e copriletto acquisiscono un disegno uniforme.

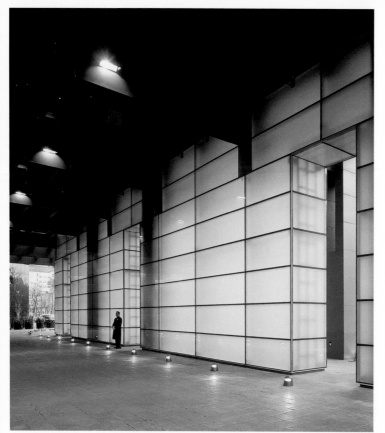

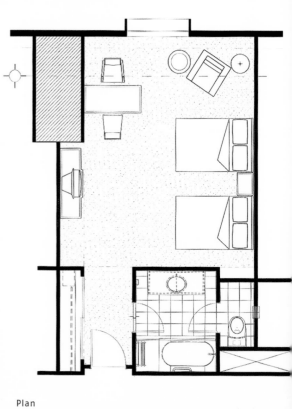

Plan

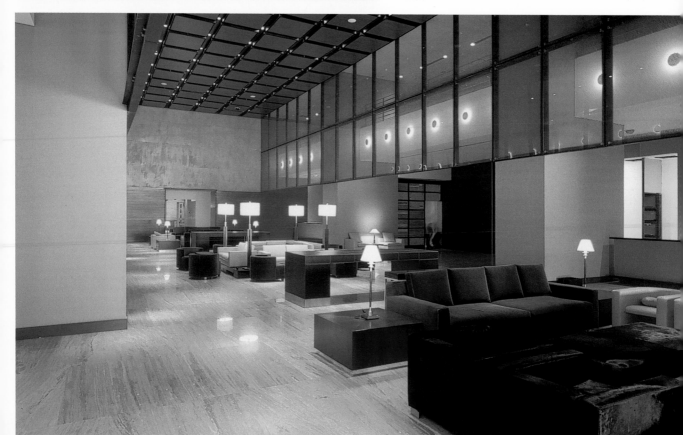

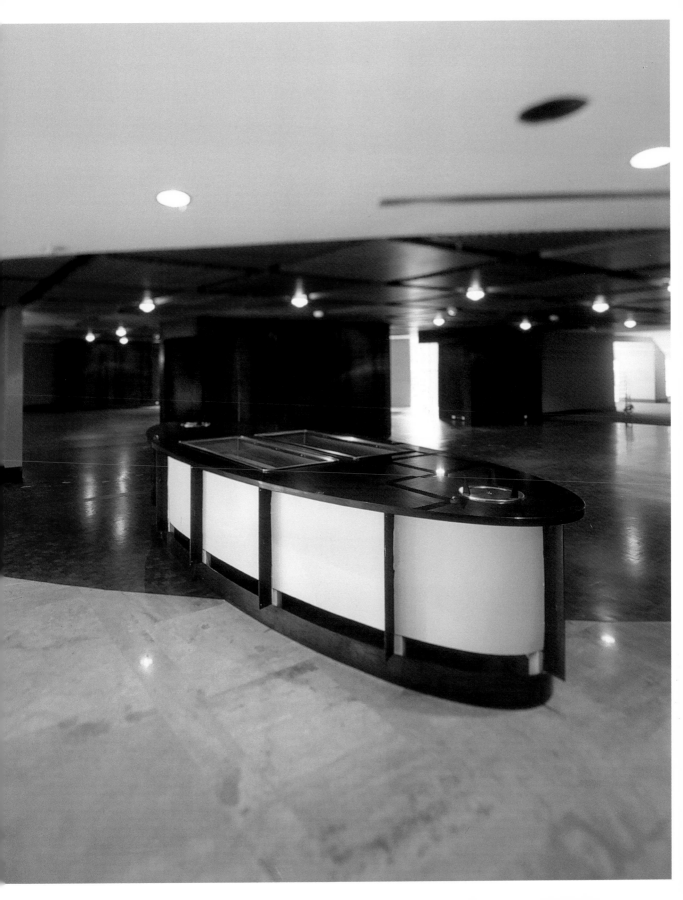

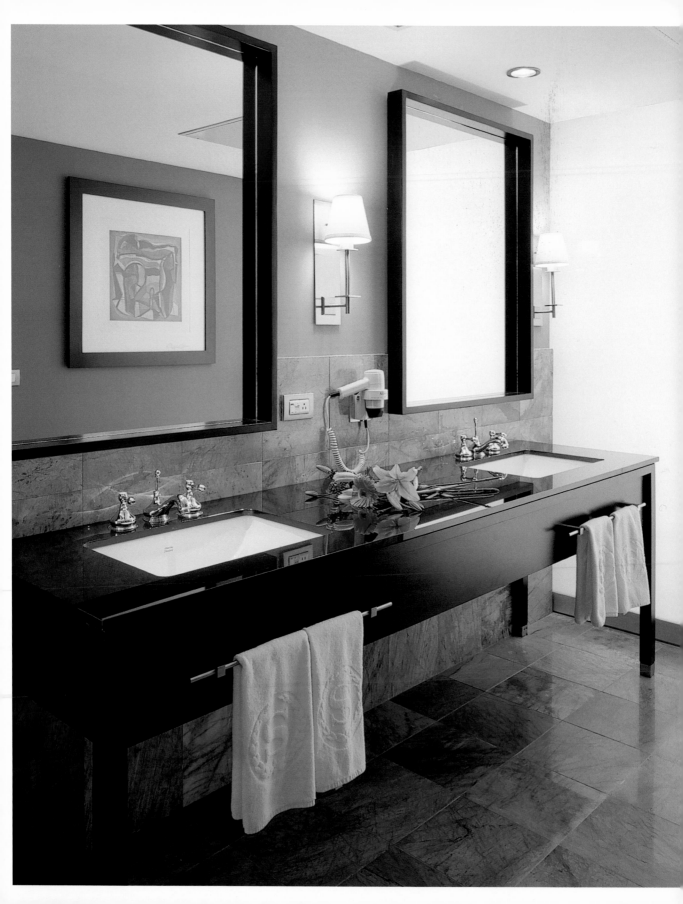

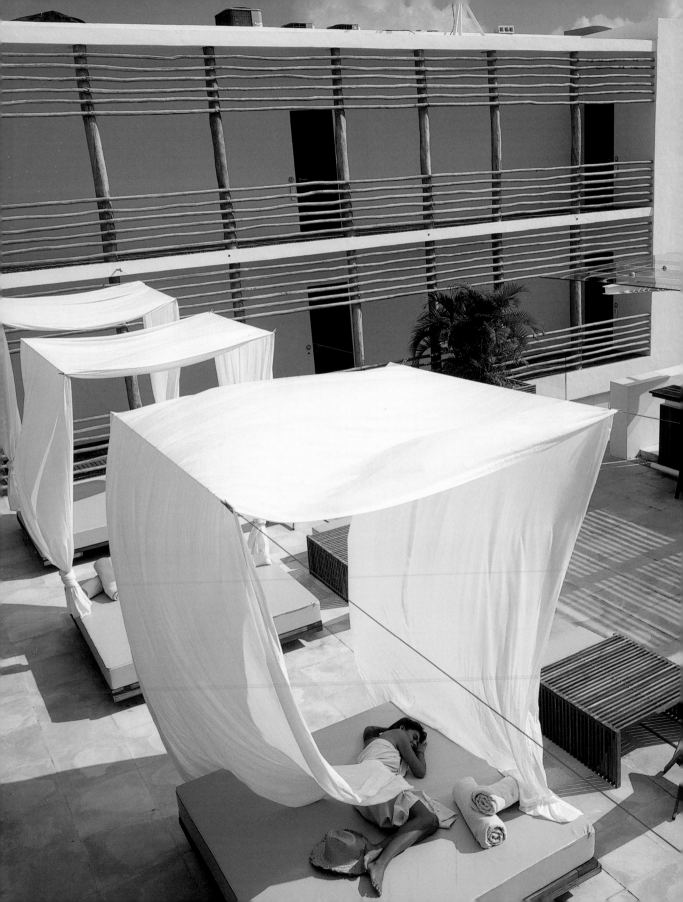

5ª Avenida and Calle 12, Playa del Carmen, 77710 Quintana Roo, Mexico Tel.: +52 984 879 3620
Fax: +52 984 879 3621 info@hoteldeseo.com www.hoteldeseo.com

Deseo

Architects: Central de Arquitectura **Photographer:** © Undine Pröhl **Opening date:** 2001 **Rooms:** 15

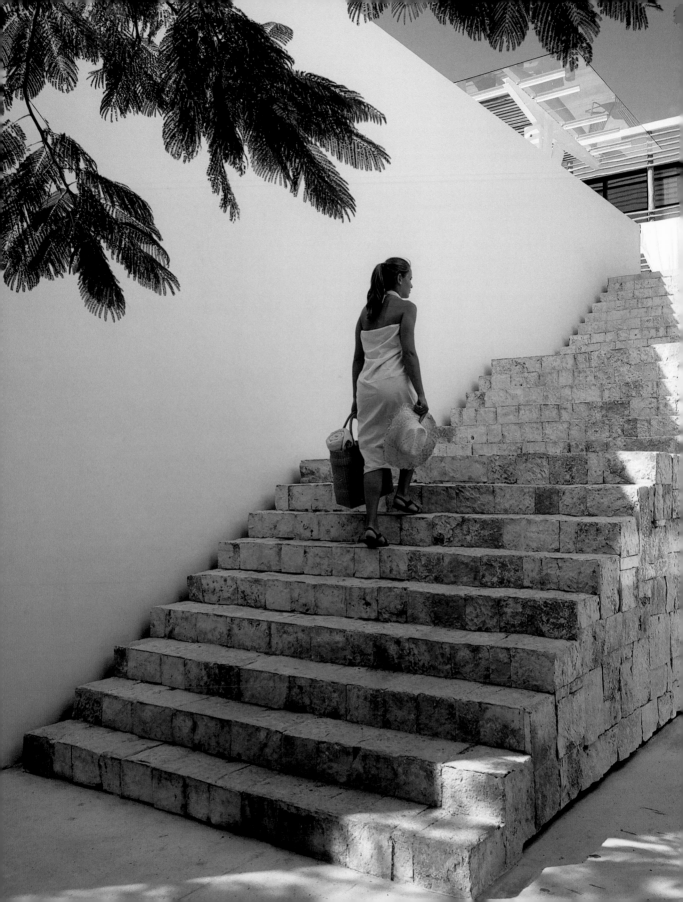

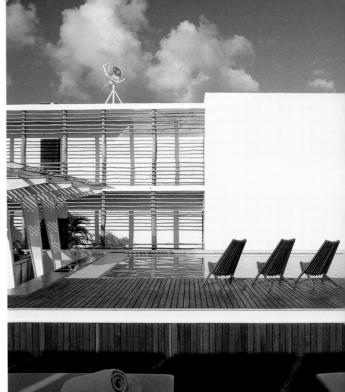

All the areas of the hotel face the central space, a large deck with a pool. The lounge area is a place to meet or rest where guests can enjoy the enormous beds, Jacuzzi and pool, as well as ongoing music spinned by the resident disc jockey.

Alle Räume des Hotels liegen zur Terrasse mit Swimmingpool. Die Lounge ist Treffpunkt und Ruhezone, in der die Gäste sich auf den riesigen Liegen, im Jacuzzi und im Pool entspannen und die Musik des jeweiligen Diskjockeys genießen können.

Toutes les pièces de l'hôtel sont tournées vers la terrasse dotée d'une piscine. Le « lounge » est un lieu de rencontre et de repos où les hôtes peuvent profiter d'énormes lits, du jacuzzi et de la piscine, dans l'ambiance musicale animée par le disc jockey de l'hôtel.

Todas las estancias del hotel miran hacia la terraza con piscina. El "lounge" es un lugar de encuentro y descanso en donde los huéspedes pueden disfrutar de las enormes camas, del jacuzzi y de la piscina, como también de la música seleccionada por el disc-jockey del hotel.

Tutte le camere dell'hotel danno sulla terrazza con piscina. La lounge è un luogo di incontro e relax dove poter rilassarsi sui divani enormi, nel jacuzzi e in piscina, oppure ascoltando la musica proposta dal dj residente.

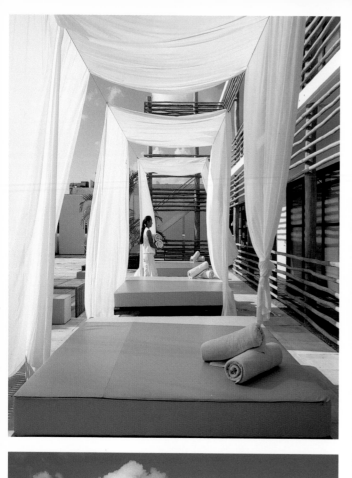
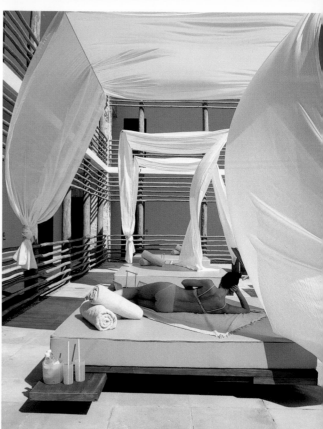
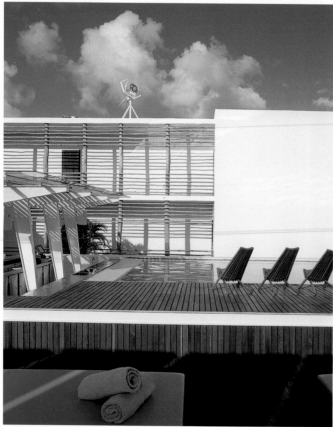

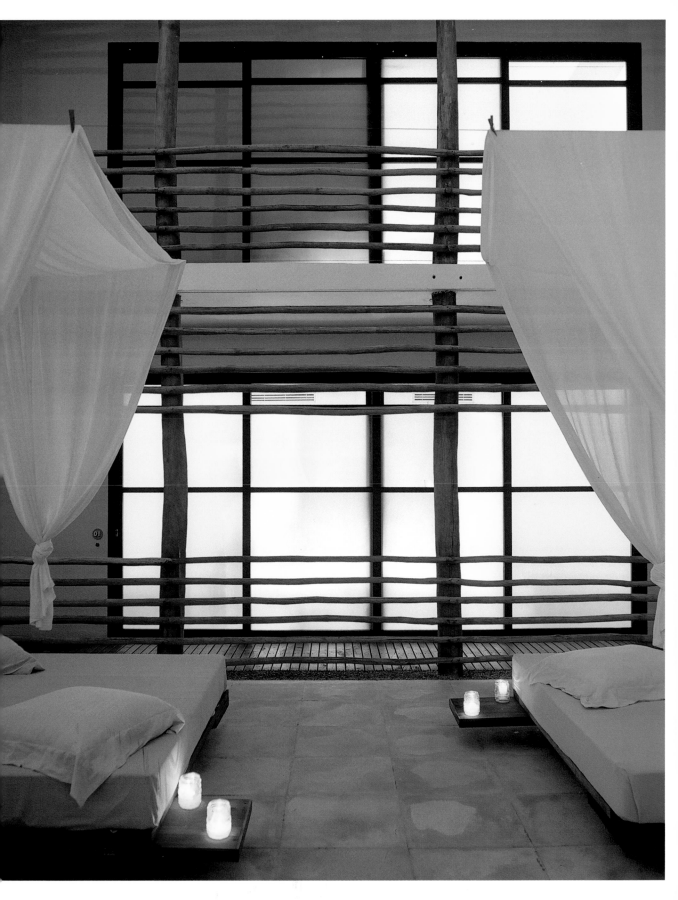

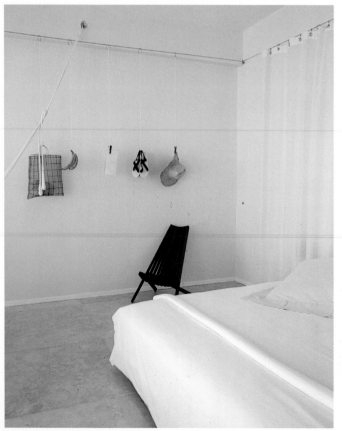

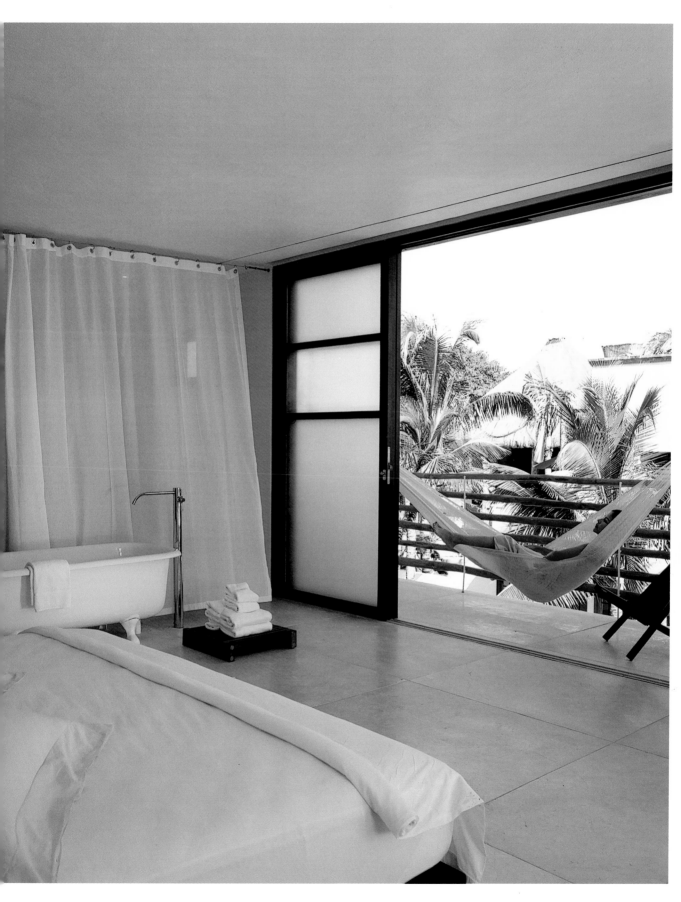

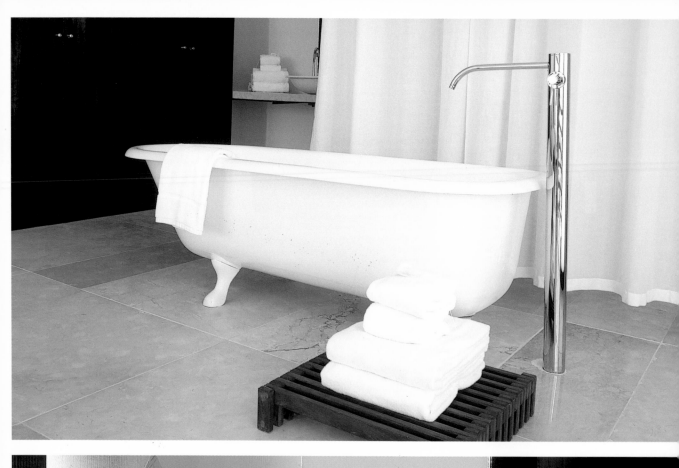
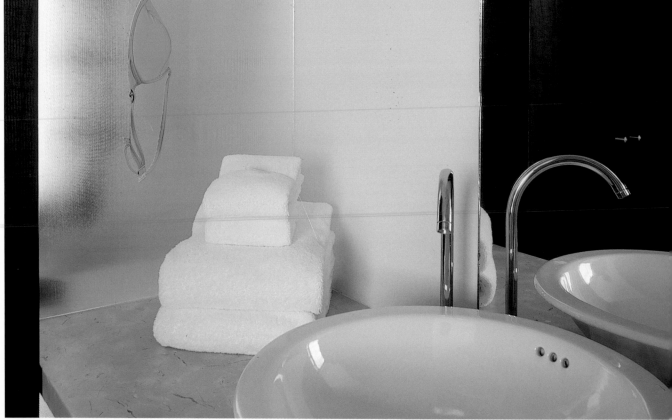

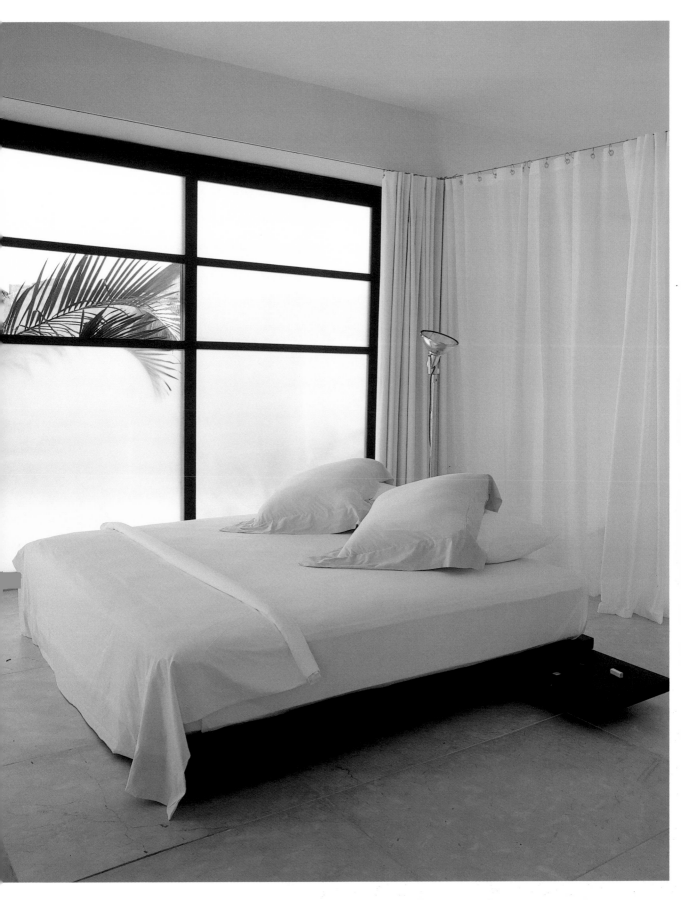

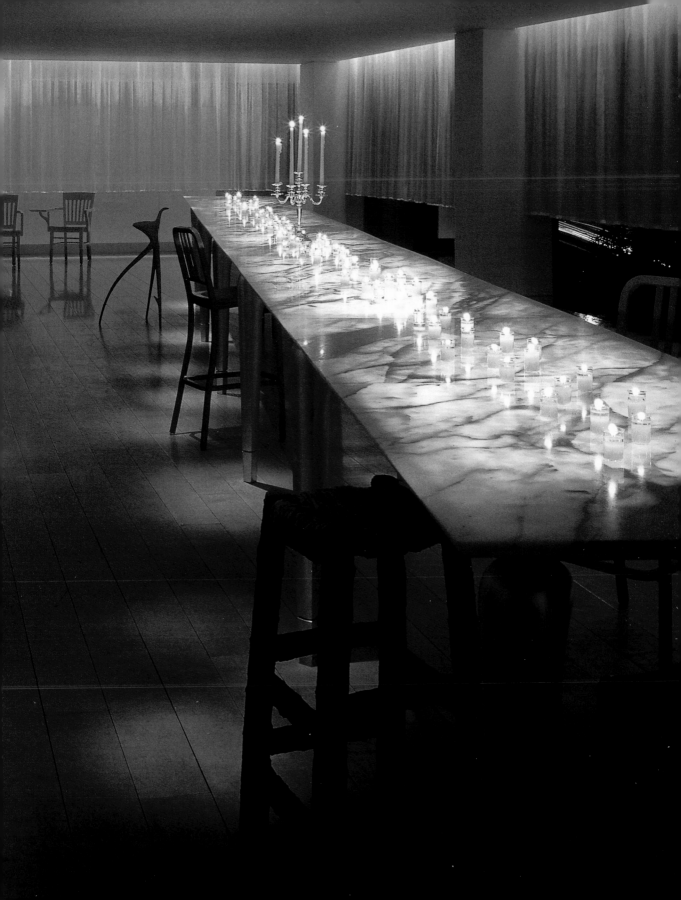

8440 Sunset Boulevard, Los Angeles, CA 90069, US Tel.: +1 323 650 8999 Fax: +1 323 650 5215
mondrian@morganshotelgroup.com www.morganshotelgroup.com

Mondrian

Designer: Philippe Starck Photographer: © Todd Eberle Opening date: 1997 Rooms: 245

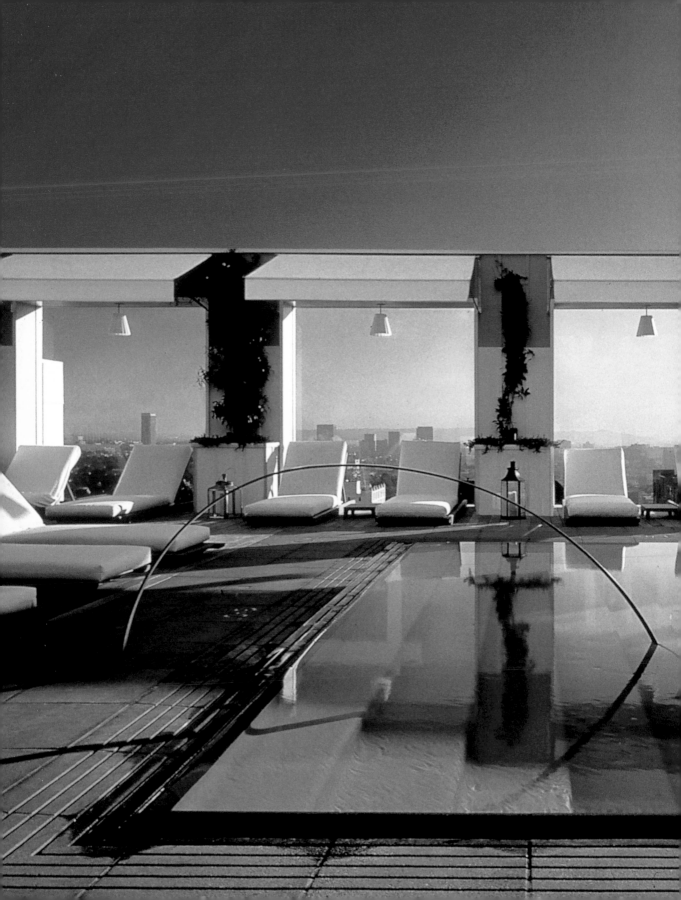

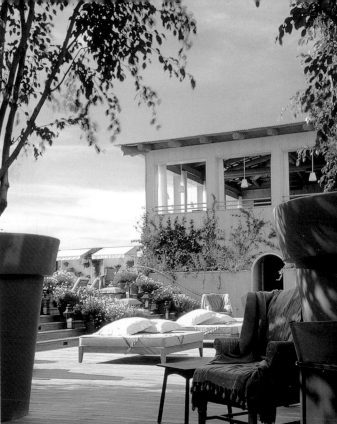

Guests can enjoy the stunning views of the surrounding skyline from the rooftop terrace and pool, or relax in the lounge area whose plants, beds, cushions and textures make one feel as if at home.

Die Gäste können den überwältigenden Blick auf die Stadt von der Terrasse und dem Swimmingpool aus genießen oder sie können sich in den Ruhezonen entspannen. Hier fühlt man sich zwischen Pflanzen, Liegen, Kissen und angenehmen Texturen wie zuhause.

Depuis la terrasse et la piscine, les hôtes peuvent jouir des vues fantastiques sur la ville ou se reposer dans l'espace détente où l'agencement de plantes, lits, coussins et tissages leur offre un cadre familial.

Los huéspedes pueden disfrutar de las impresionantes vistas de la ciudad desde la terraza y la piscina, o descansar en la zona de relajación donde la presencia de las plantas, las camas, los cojines y las texturas genera la sensación de estar como en casa.

Gli ospiti possono godersi la magnifica vista della città dalla terrazza e dalla piscina, o riposare nella zona relax dove la presenza di piante, letti, cuscini e accessori diversi fa sì che si sentano come a casa loro.

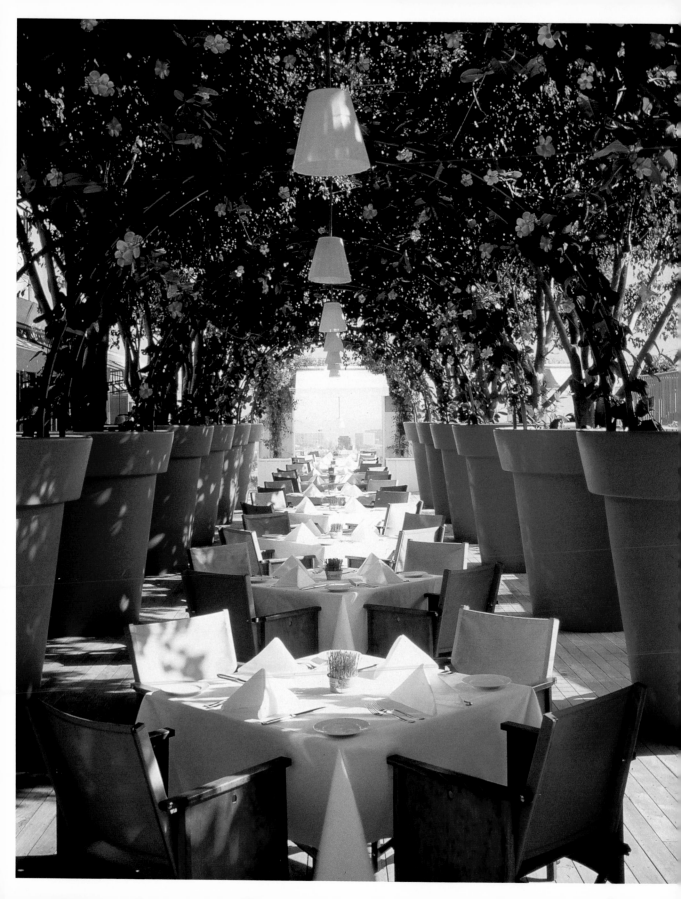

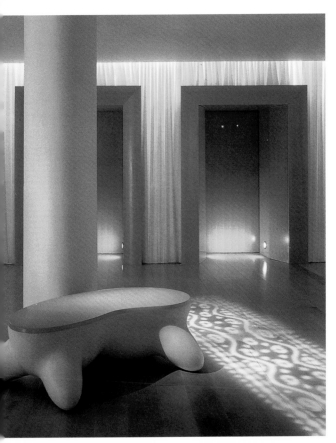

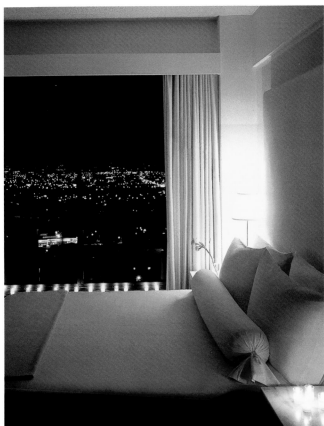

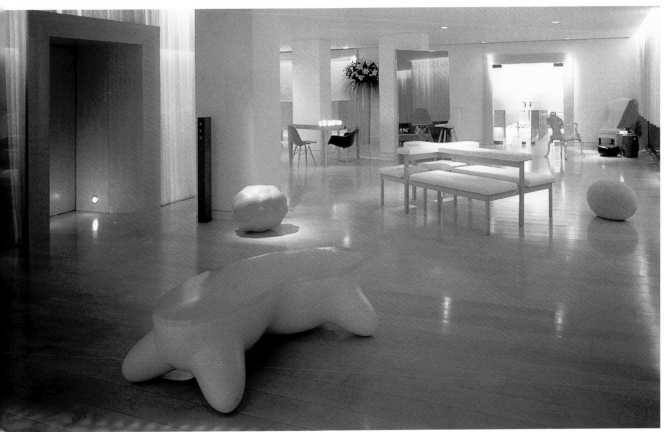

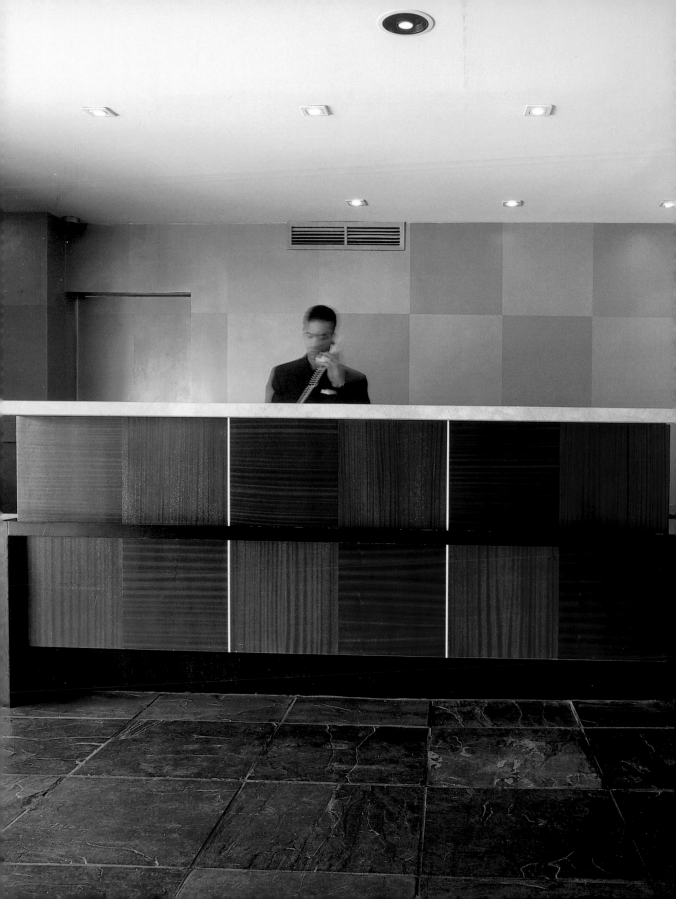

1200 North Alta Loma Road, Los Angeles, CA 90069, US Tel.: +1 310 657 1333 Fax: +1 310 652 5300
information@sunsetmarquishotel.com www.sunsetmarquishotel.com

Sunset Marquis

Architects: Olivia Villaluz and Barry Salehian **Photographer:** © Undine Pröhl
Opening date: 1963 **Rooms:** 108 suites and 12 villas

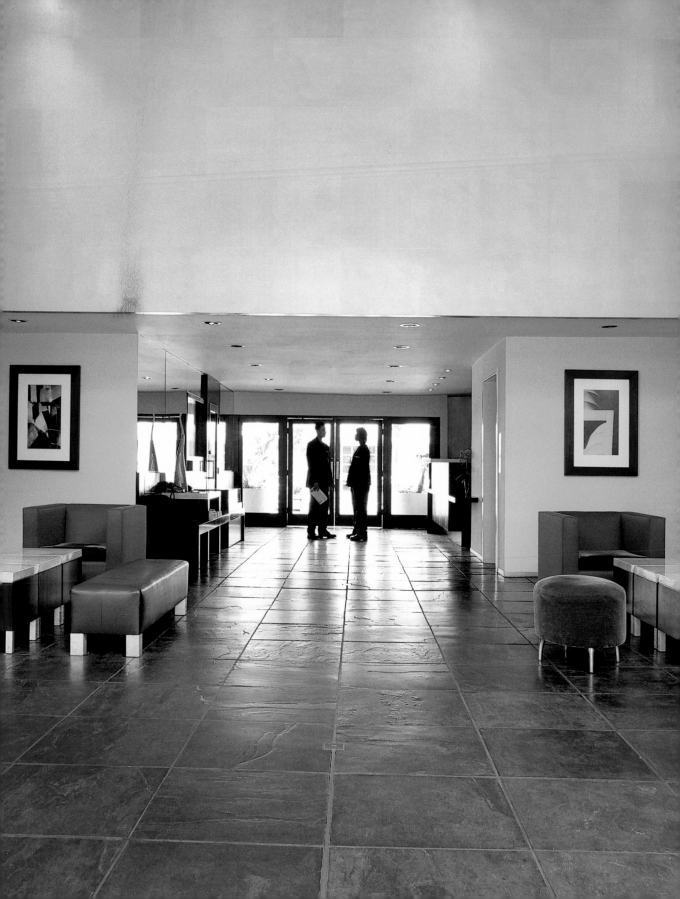

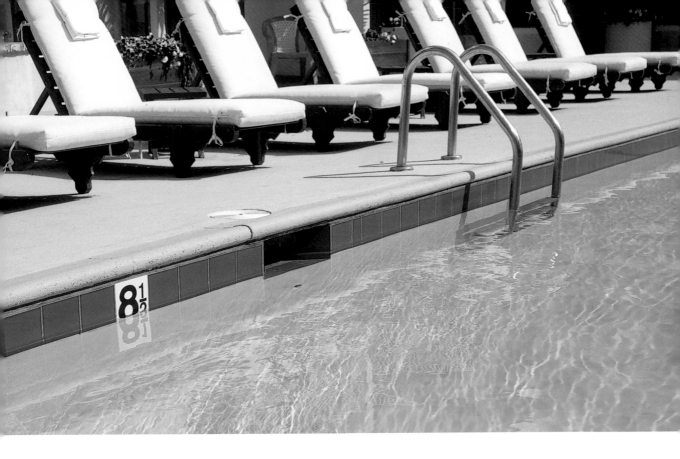

The design of the furniture is based on linear shapes and elemental volumes, complemented by a monochromatic palette that is camouflaged so as to not deter from the timelessness of the interior design.

Die Gestaltung der Möbel beruht auf einfachen Grundlinien und Volumen und wird durch eine Einfarbigkeit ergänzt, die sich an die Umgebung anpasst. So wird vermieden, dass der Stil der Einrichtung mit irgendeiner vorübergehenden Modeerscheinung gleichgesetzt werden kann.

Le design du mobilier aux lignes et volumes simples est complété par une monochromie qui se love dans l'atmosphère, évitant au style intérieur de n'être que l'expression des tendances du moment.

El diseño del mobiliario se basa en líneas y volúmenes elementales y se complementa con una monocromía que se camufla en el ambiente y evita comprometer el estilo del interior con la moda del momento.

Lo stile dei mobili, basato su linee e volumi essenziali, viene completato da una monocromia che si mimetizza nell'ambiente, e fa sì che l'arredamento degli spazi interni non venga catalogato riduttivamente come una semplice tendenza del momento.

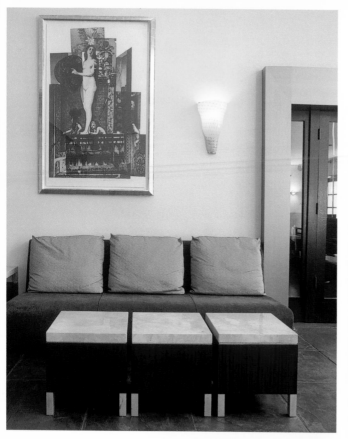

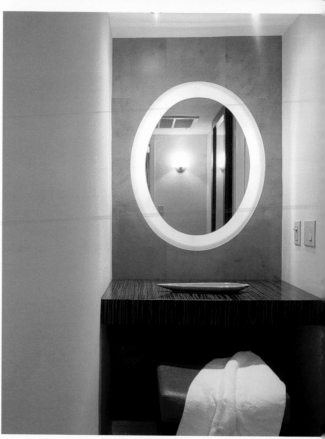

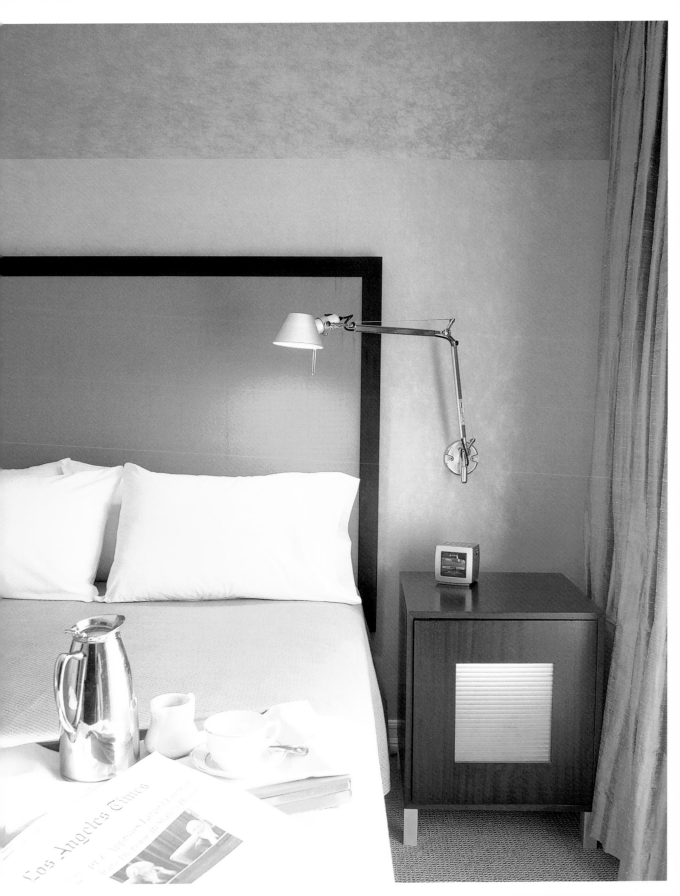

550 South Flower Street, Los Angeles, CA 90071, US Tel.: +1 213 892 8080 Fax: +1 213 892 8686
downtownla@standardhotel.com www.standardhotel.com

The Standard

Architects: Koning-Eizenberg Architects **Interior Designer:** Shawn Hausman **Photographer:** © Undine Pröhl
Opening date: 2002 **Rooms:** 207

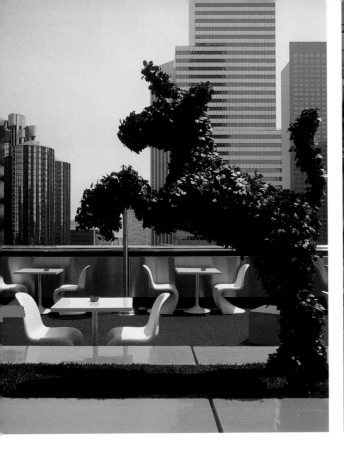
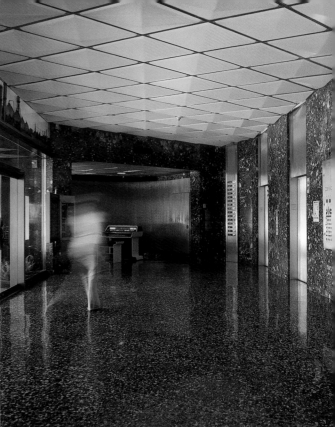

On the hotel deck, where guests can enjoy spectacular panoramic vistas of downtown Los Angeles, the ambience becomes somewhat seductive. The idea was to create a party space and meeting space for the city's urbanites.

Auf der Hotelterrasse können die Gäste den überwältigenden Panoramablick auf das Zentrum von Los Angeles in einer verführerischen Umgebung genießen. Die Idee, die hier verwirklicht wurde, war die Schaffung eines Veranstaltungsortes für Feste und eines Treffpunktes für die Städter.

Sur la terrasse de l'hôtel, les hôtes peuvent profiter de vues panoramiques spectaculaires sur le centre de Los Angeles, baignés d'une ambiance séduisante. L'idée initiale était de créer un espace pour organiser des fêtes et un lieu de rencontre pour les urbanistes de la ville.

En la terraza del hotel, los huéspedes pueden disfrutar de las espectaculares vistas panorámicas del centro de Los Ángeles envueltos en un seductor ambiente. La idea fue crear un espacio para fiestas y un punto de encuentro en la ciudad.

Nella terrazza dell'hotel, gli ospiti possono godersi la spettacolare vista panoramica del centro di Los Angeles, circondati da un ambiente seducente. L'idea è stata quella di creare uno spazio dove organizzare feste e un punto di incontro per coloro che amano restare in città.

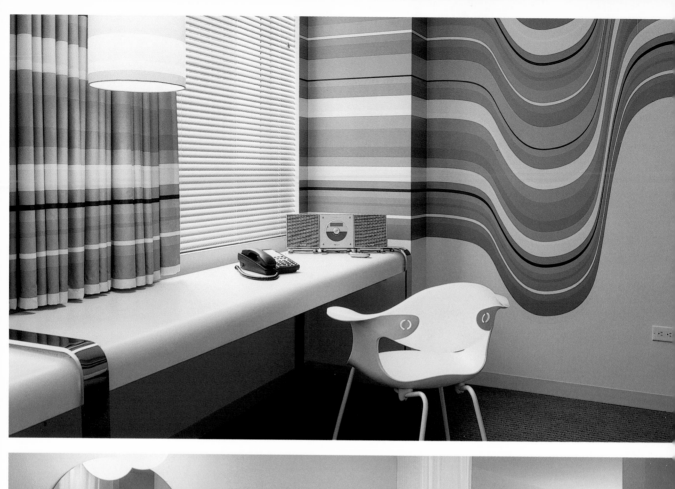
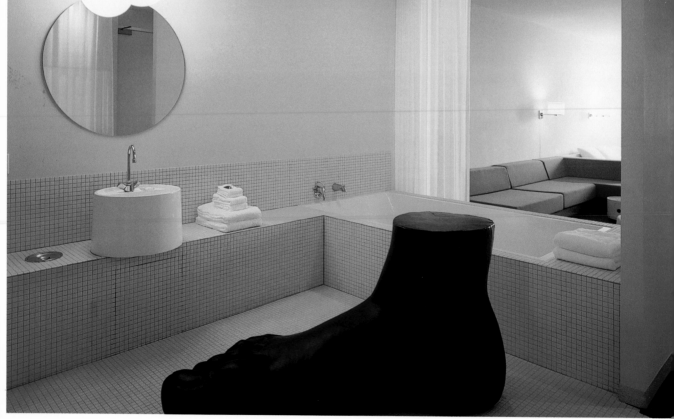

930 Hilgard Avenue, Los Angeles, CA 90024, US Tel.: +1 310 208 8765 Fax: +1 310 824 0355
www.whotels.com

W Los Angeles Westwood

Architects: Jon Brouse, AIA **Interior Designers:** Dayna Lee, Power Strip in collaboration with Starwood Design Group **Photographer:** © Undine Pröhl **Opening date:** 2000 **Rooms:** 258

 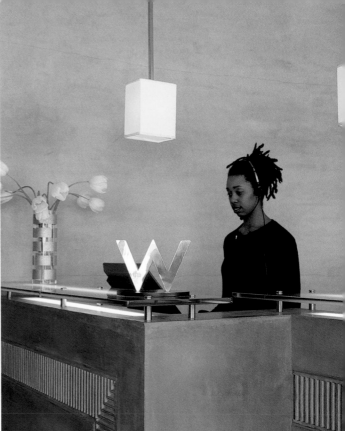

Dayna Lee's skill in combining materials, textures, colors, and elements from almost every latitude is renowned. Combined with a careful management of the lighting, the result becomes personal, sophisticated ambiences for relaxation.

Dayna Lee hat für die Meisterhaftigkeit in der Kombination von Materialien, Texturen, Farben und Elementen aus fast der ganzen Welt bereits große Anerkennung erlangt. In Kombination mit der gut durchdachten Beleuchtung entstehen eine Reihe von sehr persönlichen, stilvollen und entspannenden Räumlichkeiten.

Dayna Lee est connue pour son talent dans le mélange de matières, textures, couleurs et objets du monde entier. Grâce à un éclairage judicieux, elle parvient à créer une suite d'ambiances personnalisées, sophistiquées et relaxantes.

La destreza empleada por Dayna Lee al combinar materiales, texturas, colores y elementos de casi todo el mundo es ya reconocido. Junto a una cuidada iluminación, el resultado es una serie de ambientes personales, sofisticados y relajantes.

È già nota l'abilità con cui Dayna Lee riesce ad abbinare vari materiali, texture, colori ed elementi provenienti da quasi tutto il mondo. Oltre ad un'impeccabile illuminazione, il risultato consiste in una serie di ambienti personali, sofisticati e rilassanti.

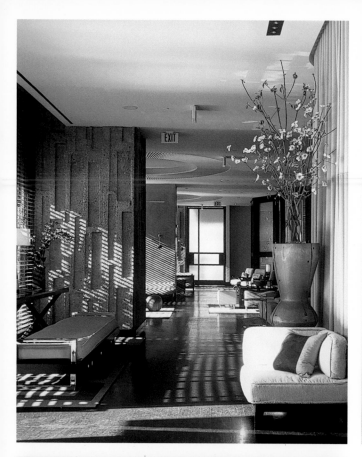

Elevation

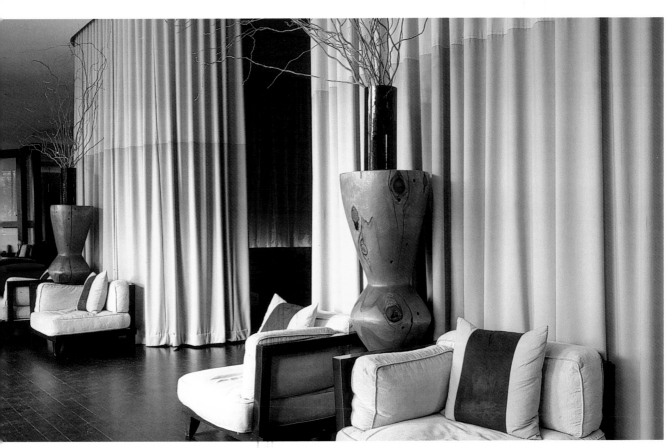
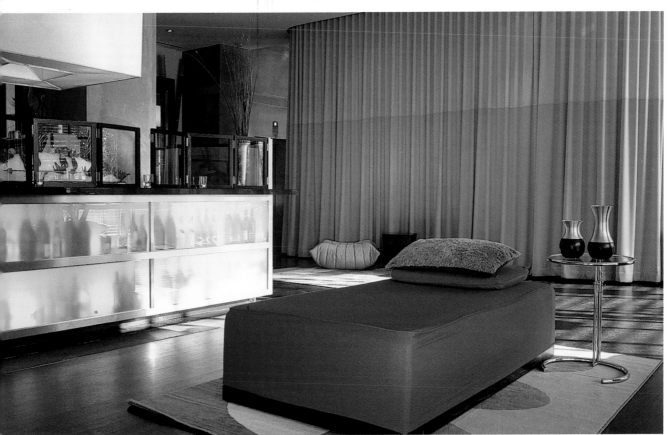

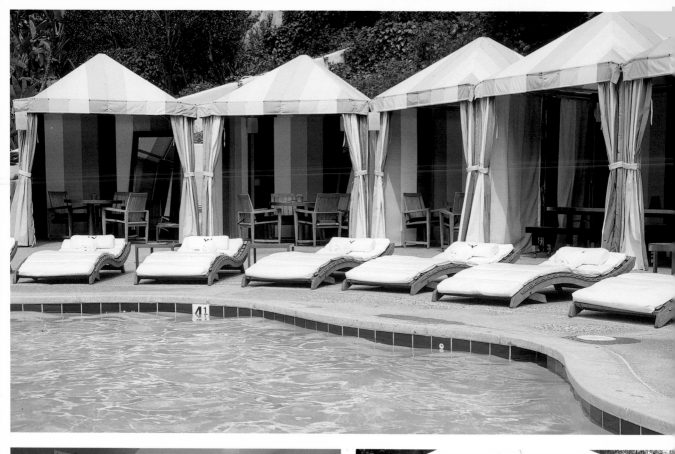

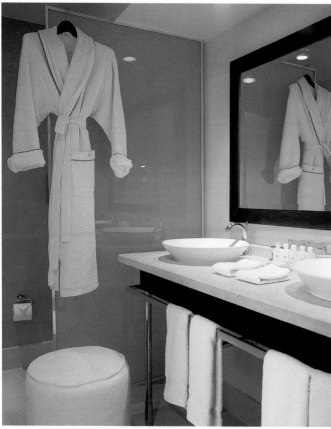

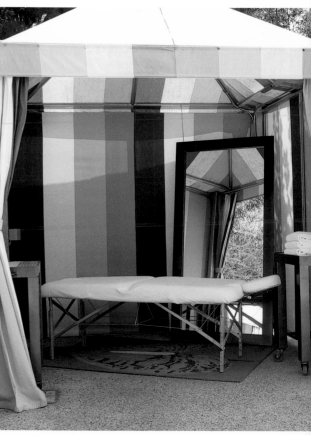

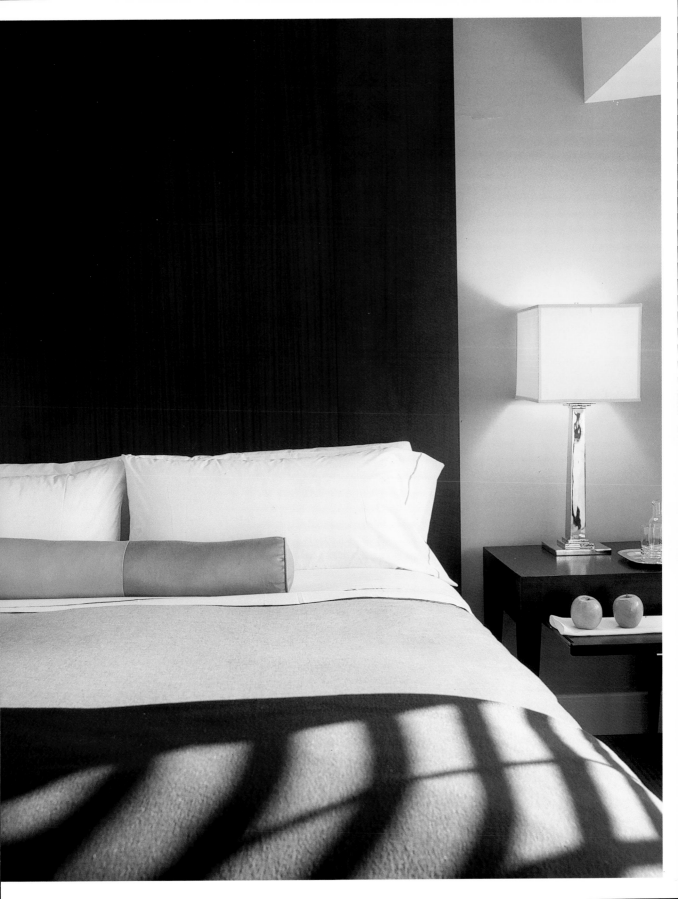

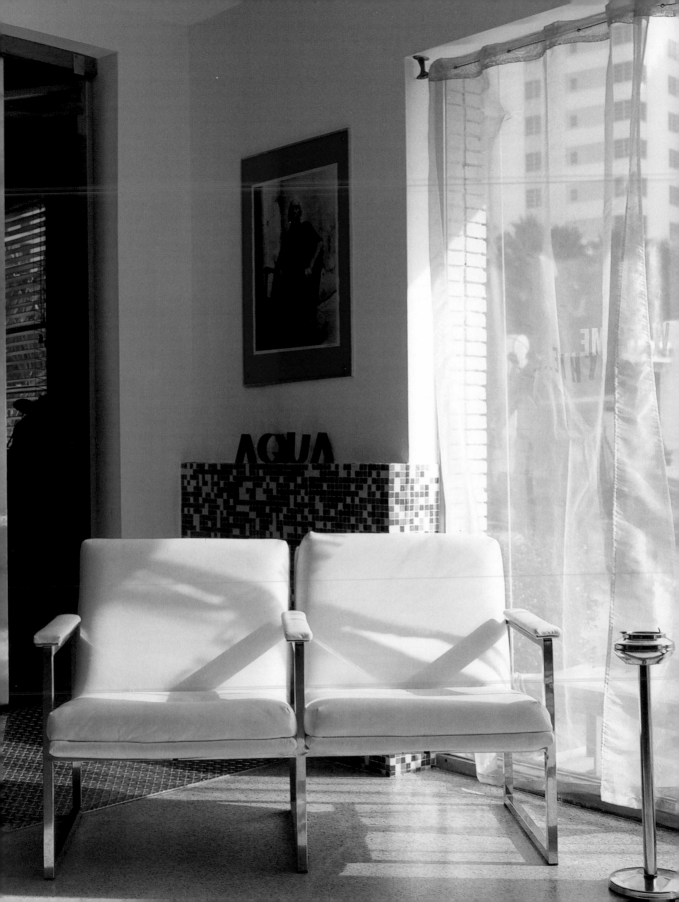

1530 Collins Avenue, Miami Beach, FL 33139, US Tel.: +1 305 538 4361 Fax: +1 305 673 8109
www.aquamiami.com

Aqua

Designer: Eric Gabriel Photographer: © Pep Escoda Opening date: 2001 Rooms: 45

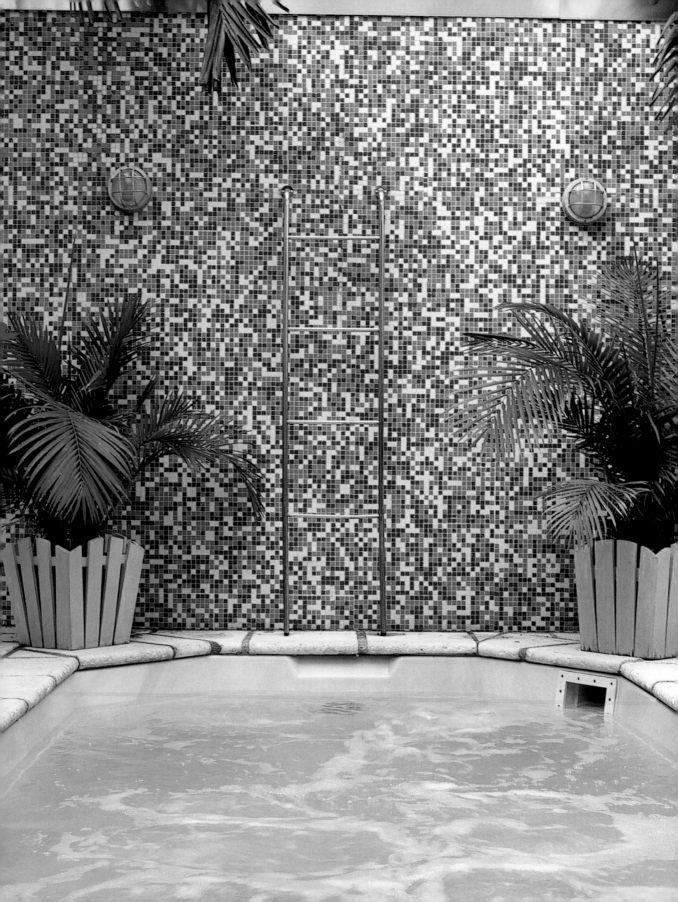

The new design places special emphasis on the maritime theme taking pre-renovation details as a point of departure. The atmosphere, fun and relaxed, is reached through a careful balance of materials, furnishings and accessories.

Die neue Gestaltung wurde von Meeresmotiven und Einzelheiten des Originalgebäudes inspiriert. Die fröhliche und entspannte Atmosphäre ist dem gelungenen Gleichgewicht zwischen Materialien, Möbeln und Dekorationselementen zu verdanken.

Le nouveau concept initial s'inspire d'éléments marins et de détails de construction originaux. L'atmosphère, agréable et relaxante, est issue d'un équilibre parfaitement étudié entre matériaux, mobilier et accessoires.

El nuevo diseño se inspira en motivos marítimos y en detalles de la construcción original como punto de partida. El ambiente, divertido y relajado, se logra gracias al cuidado equilibrio de los materiales, del mobiliario y de los accesorios.

Come punto di partenza, il nuovo stile si ispira a motivi marittimi e ai particolari dell'edificio originale. L'ambiente divertente e rilassato, si ottiene grazie ad un accurato equilibrio tra i materiali, la mobilia e gli accessori.

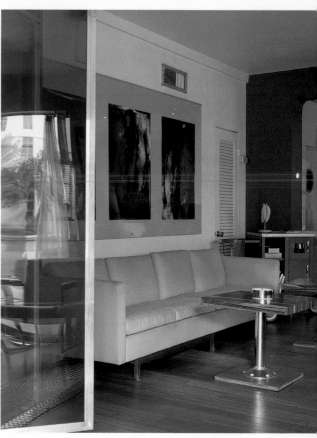
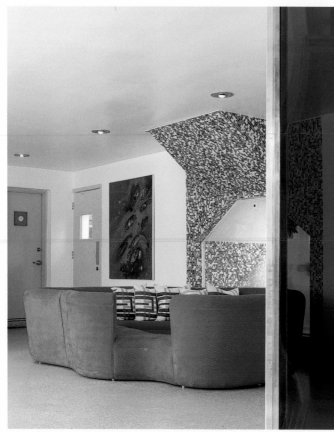

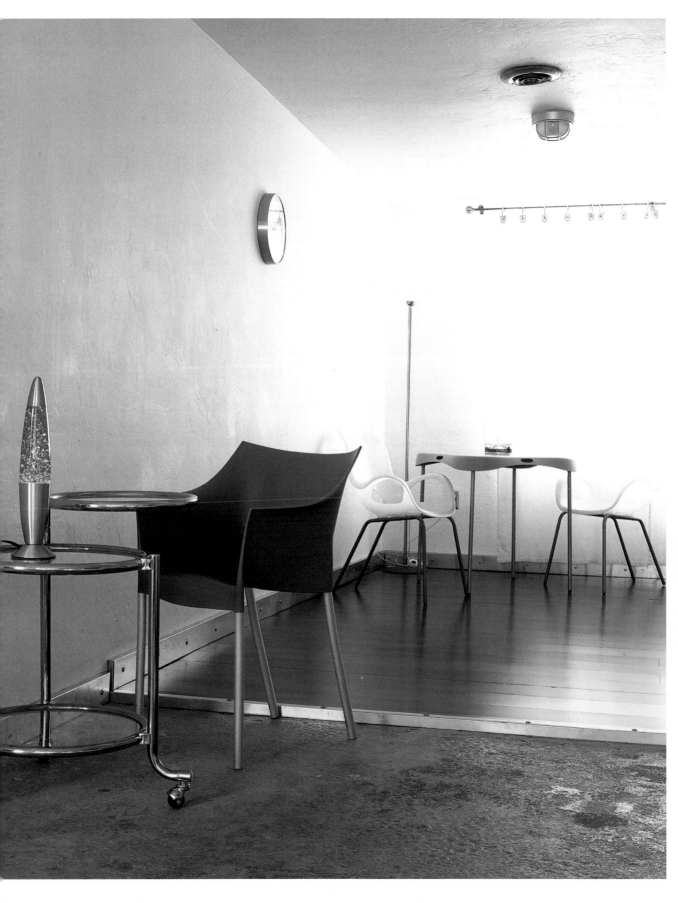

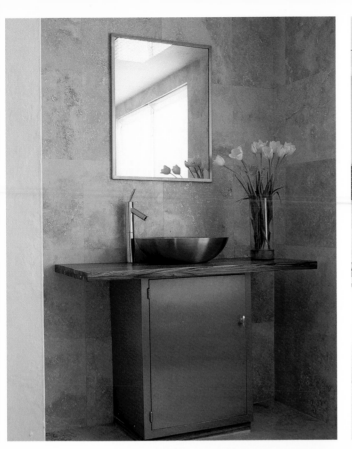
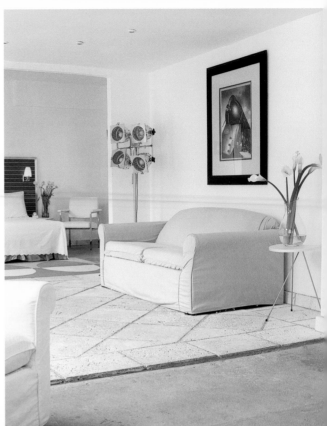
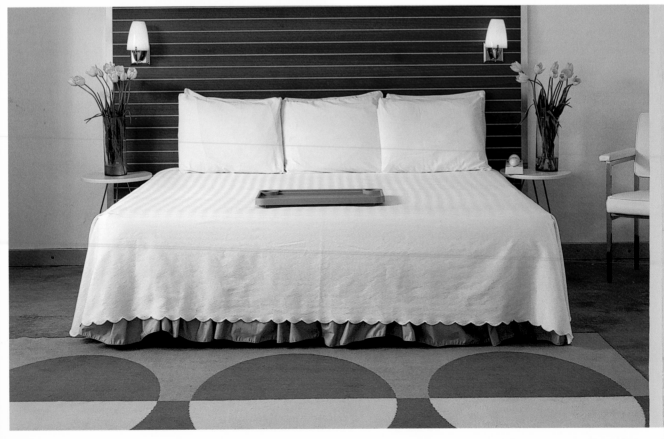

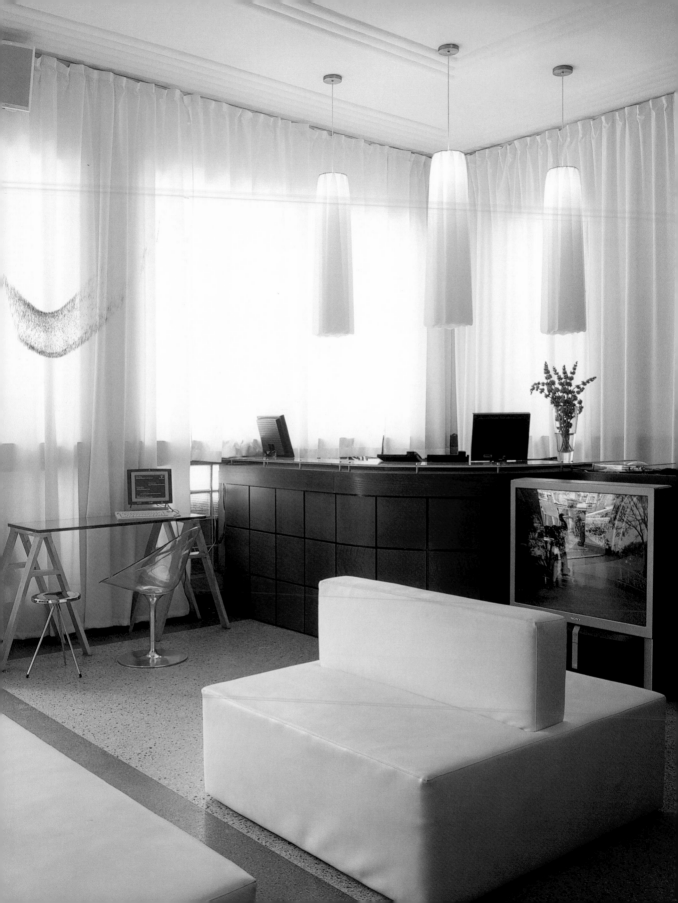

855 Collins Avenue, Miami Beach, FL 33139, US Tel.: +1 305 531 5831

www.thechesterfieldhotel.com

Chesterfield

Architect: Alan Liberman Photographer: © Pep Escoda Opening date: 2002 Rooms: 50

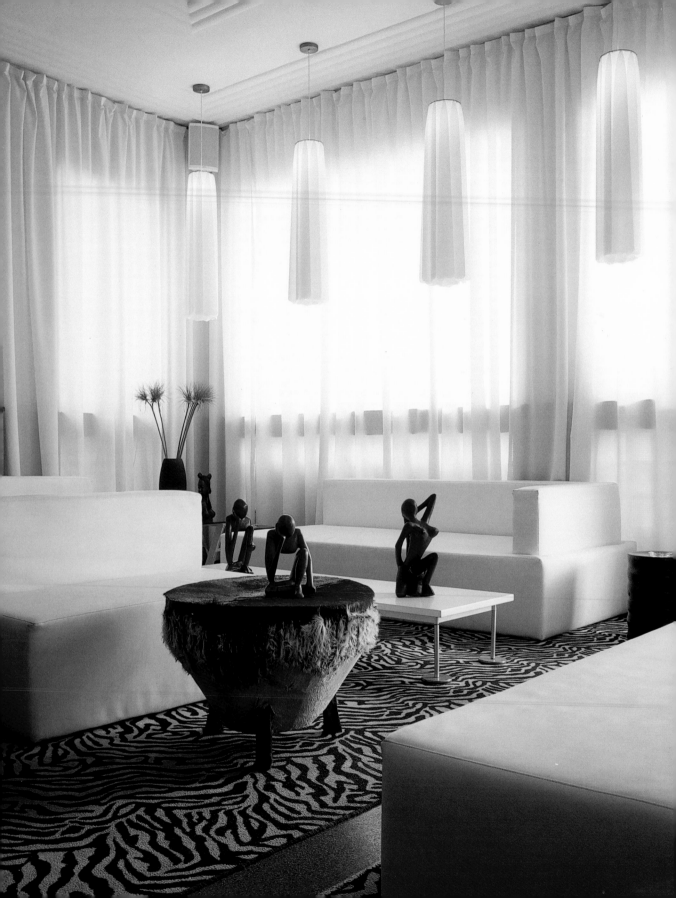

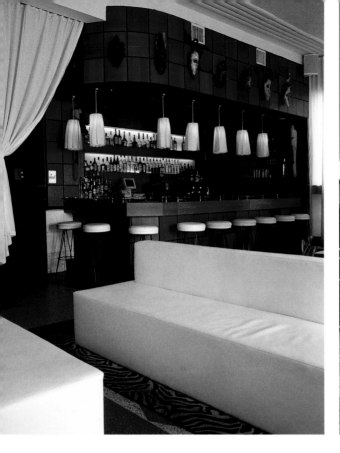
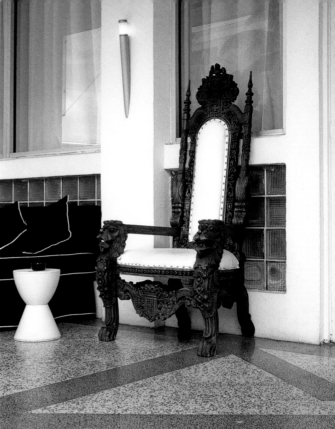

African sculptures and decorative objects of ethnic influence complement the contemporary architectural design. The result is a space full of contrasts where modernity and tradition are combined with sobriety and comfort.

Afrikanische Skulpturen und ethnische Objekte ergänzen die architektonische Gestaltung mit zeitgenössischem Charakter. Das Ergebnis sind Räumlichkeiten voller Kontraste, in denen moderne und traditionelle Elemente schlicht und bequem miteinander kombiniert wurden.

Sculptures africaines et objets ethniques parachèvent le concept architectural contemporain. Il en résulte un espace rempli de contrastes où le moderne et le classique se mêle avec sobriété et fonctionnalité.

Esculturas africanas y objetos étnicos complementan el diseño arquitectónico de carácter contemporáneo. El resultado es un espacio lleno de contrastes en el que lo moderno y lo tradicional se combina con sobriedad y comodidad.

Sculture africane ed oggetti etnici completano lo stile architettonico di natura contemporanea. Il risultato è uno spazio pieno di contrasti dove il moderno e il tradizionale si abbinano con sobrietà e comodità.

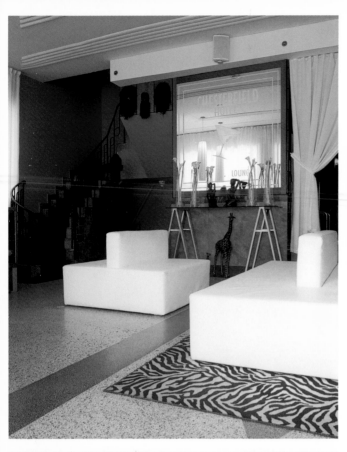
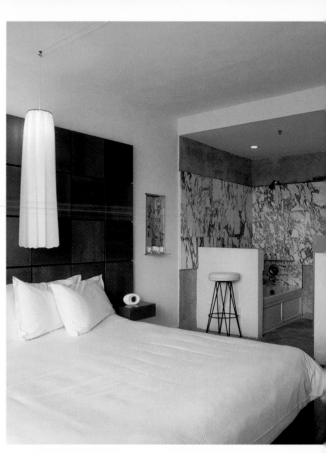
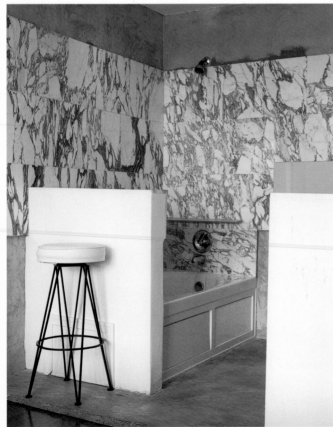

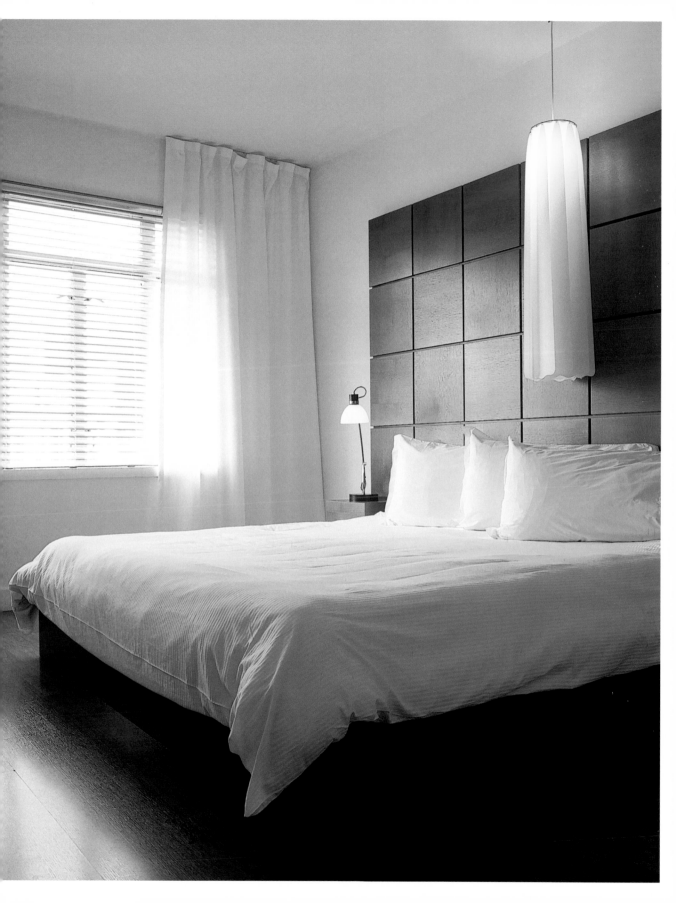

1685 Collins Avenue, Miami Beach, FL 33139, US Tel.: +1 305 672 2000 Fax: +1 305 532 0099
delano@morganshotelgroup.com www.morganshotelgroup.com

Delano

Designer: Philippe Starck **Photographer:** © Pep Escoda **Opening date:** 1995 **Rooms:** 208

Bold colors, sensual textures and a combination of styles characterize the common areas of this hotel, contrasted by the serene, white guestrooms and the pool terrace.

Vibrierende Farben, sinnliche Texturen und eine Kombination verschiedener Stile charakterisieren die Gemeinschaftszonen dieses Hotels. Dadurch entsteht ein Kontrast zu der Weiße und Neutralität der Zimmer und der Terrasse mit Swimmingpool.

Couleurs vibrantes, textures sensuelles et mélange de styles caractérisent les zones communes de cet hôtel, en contraste profond avec la neutralité des chambres et de la terrasse avec piscine.

Colores vibrantes, texturas sensuales y una combinación de estilos caracterizan las zonas comunes de este hotel, que contrastan con la blancura y la neutralidad de las habitaciones y de la terraza con piscina.

Colori vibranti, texture sensuali e un abbinamento di stili diversi caratterizzano le zone comuni di questo hotel, in netto contrasto con il bianco, la neutralità delle camere e della terrazza con piscina.

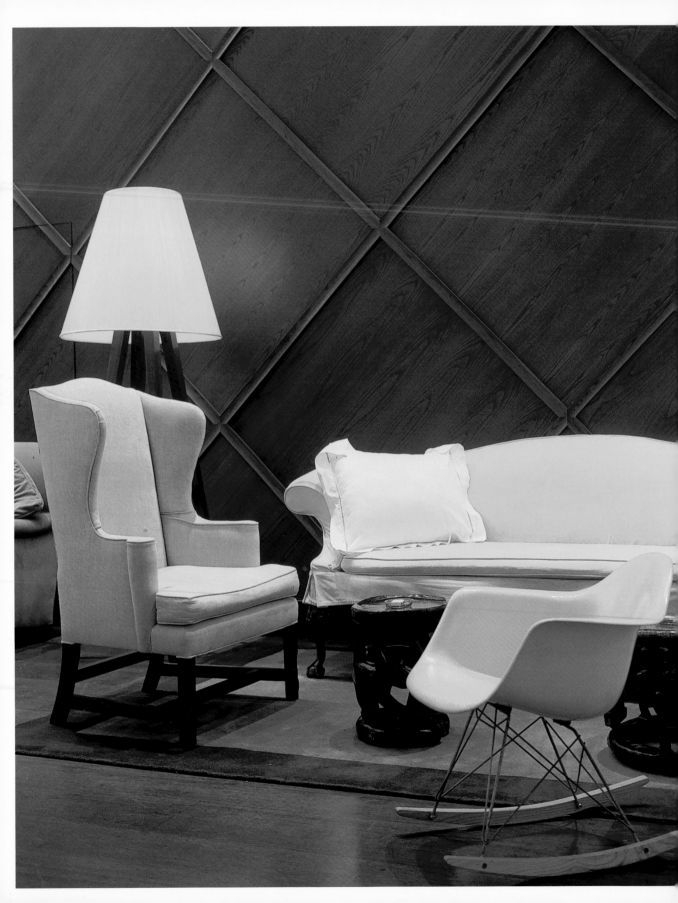

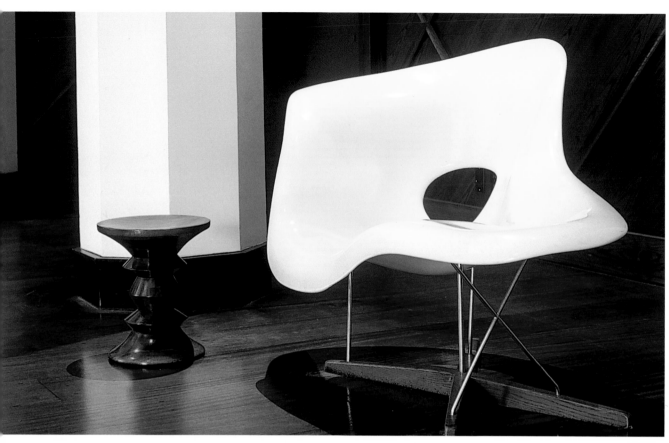

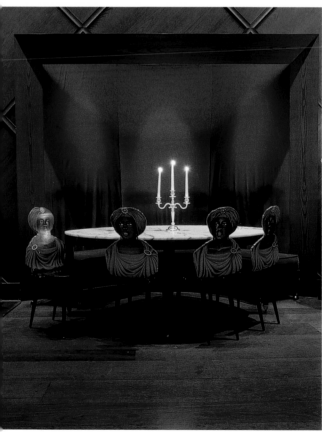

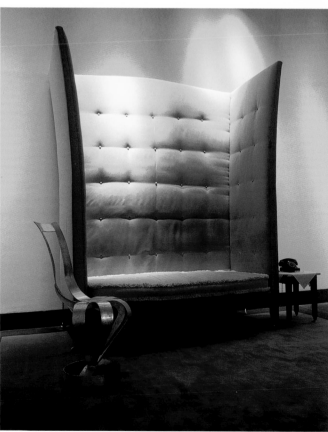

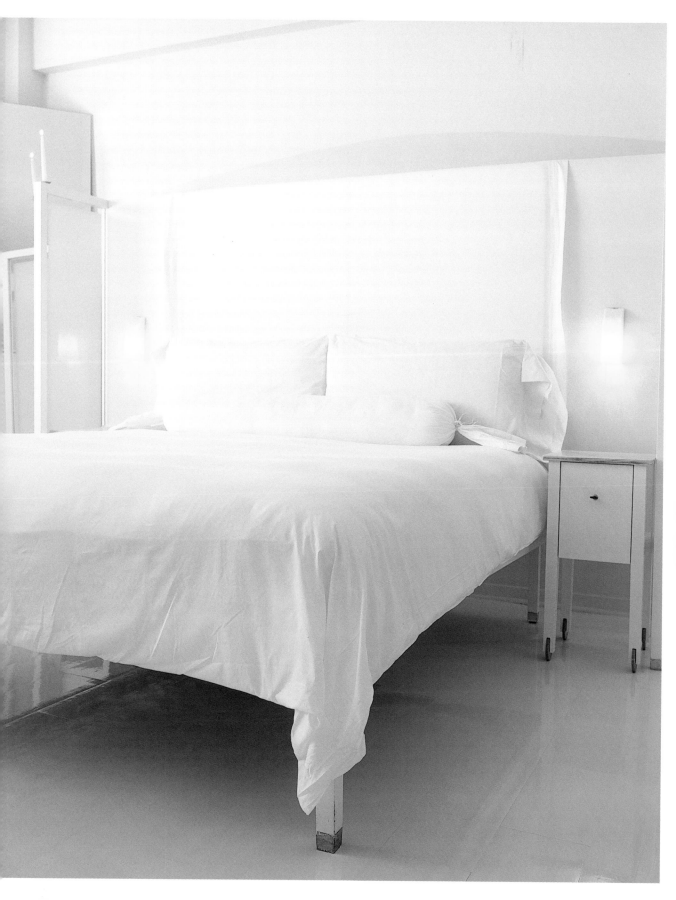

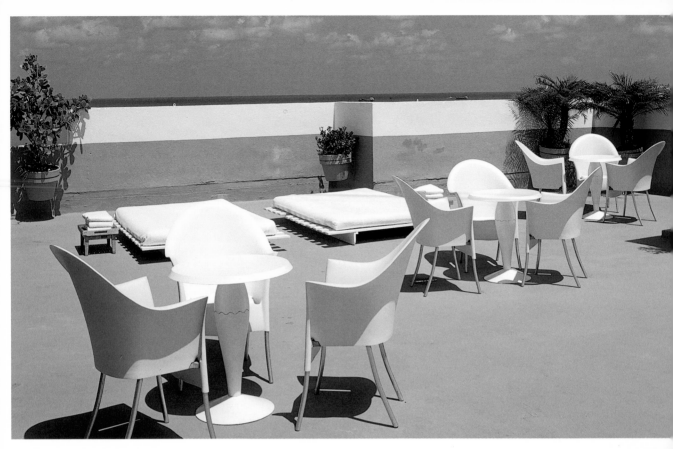

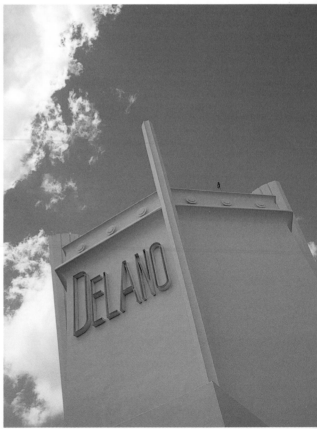

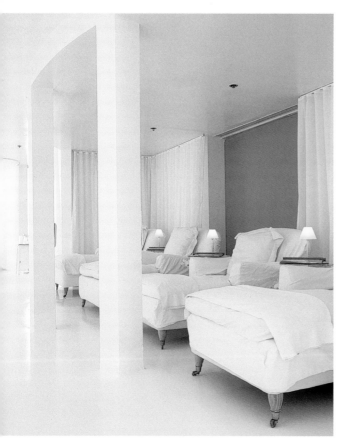
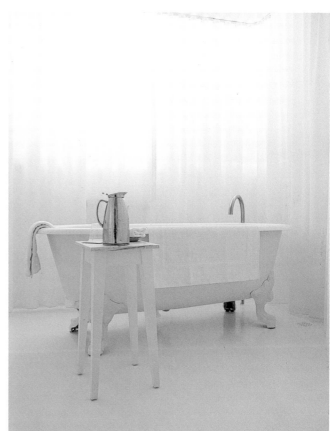
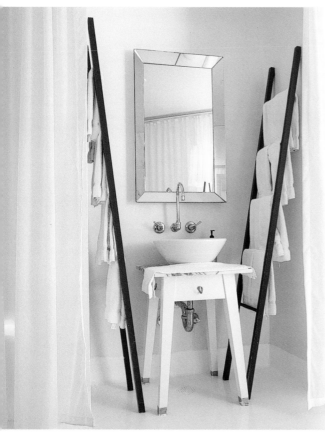
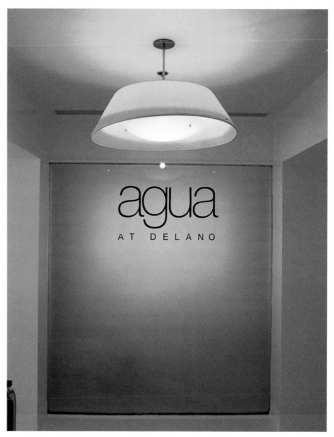

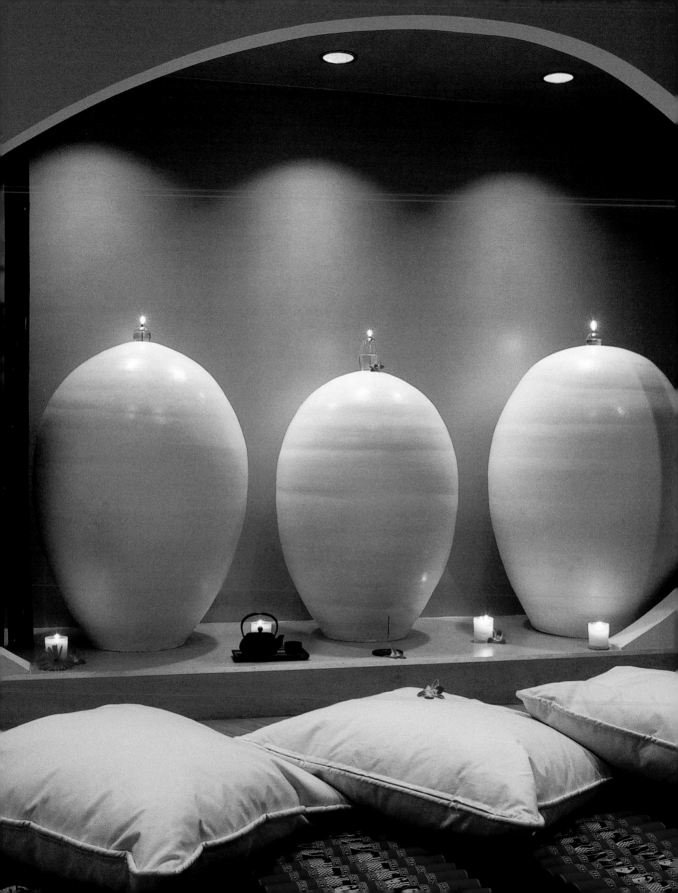

500 Brickell Key Drive, Miami, FL 33131, US Tel.: +1 305 913 8288 Fax: +1 305 913 8300
momia-reservations@mohg.com www.mandarinoriental.com

Mandarin Oriental Miami

Architects: RTKL Associates **Designers:** Hirsch Bedner & Associates **Photographer:** © Pep Escoda
Opening date: 2001 **Rooms:** 329 (including superior, deluxe and executive rooms)

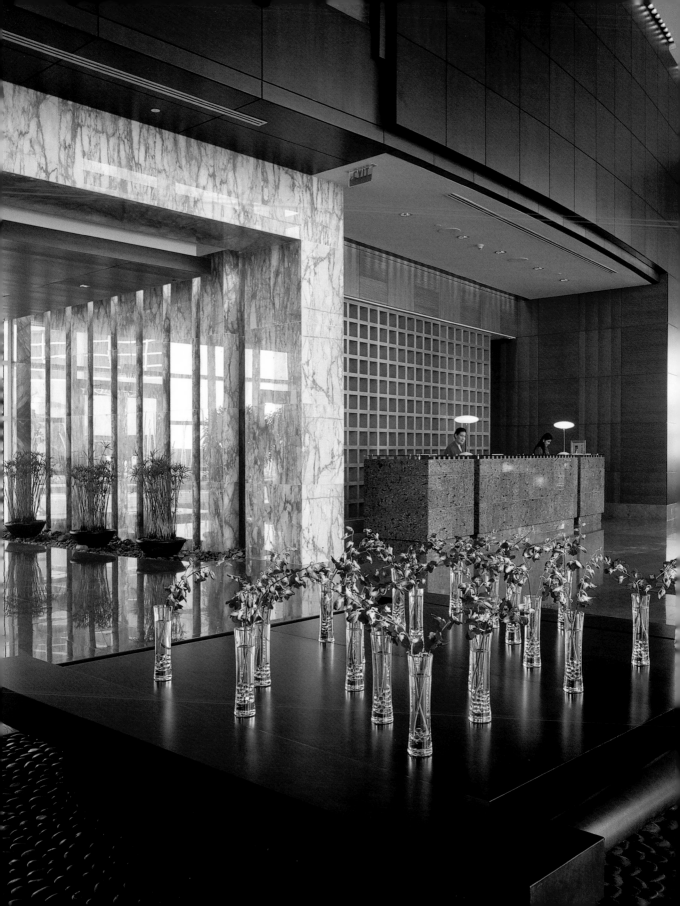

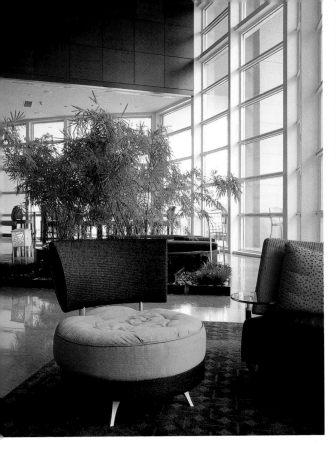
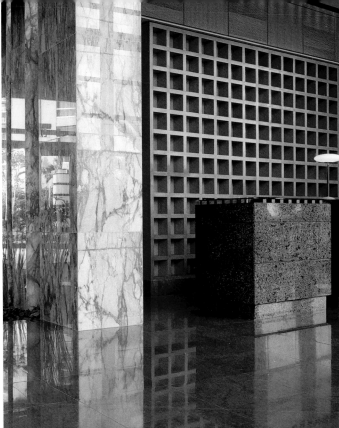

Due to the shape of the building, the vestibule area has large, wide windows that flood the interior with natural light. The exuberant vegetation and colorful furnishings enhance the tropical feeling of the hotel.

Aufgrund der Form des Gebäudes dringt viel Tageslicht durch die großen Fenster der Empfangshalle ein. Die üppige Vegetation und die bunten Möbel unterstreichen die tropische Atmosphäre dieses Hotels.

La forme de l'édifice permet à la lumière d'entrer à flots grâce aux baies vitrées du vestibule. L'exubérance de la végétation et les meubles hauts en couleur rehaussent l'atmosphère tropicale de l'hôtel.

La forma del edificio permite la entrada de abundante luz natural a través de los amplios ventanales del vestíbulo. La exuberante vegetación y los coloridos muebles acentúan el ambiente tropical del hotel.

La forma dell'edificio fa sì che entri luce naturale in abbondanza attraverso i finestroni della hall. L'esuberante vegetazione e i mobili colorati risaltano l'ambiente tropicale dell'hotel.

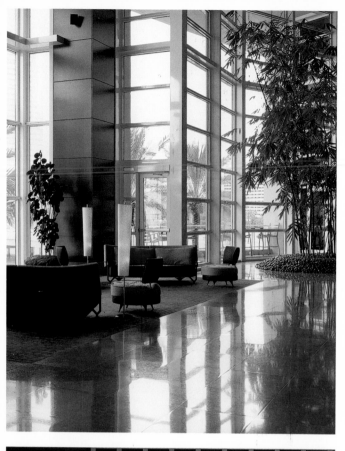
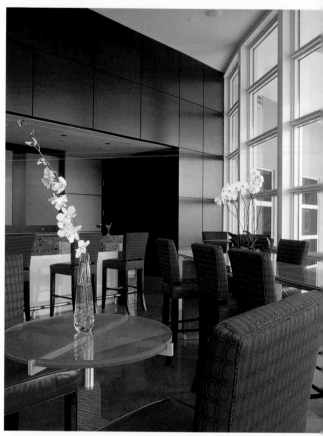
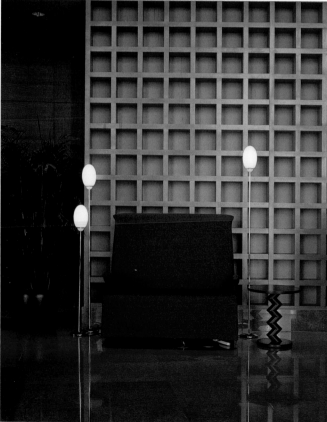
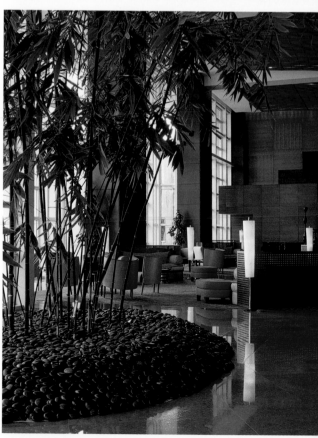

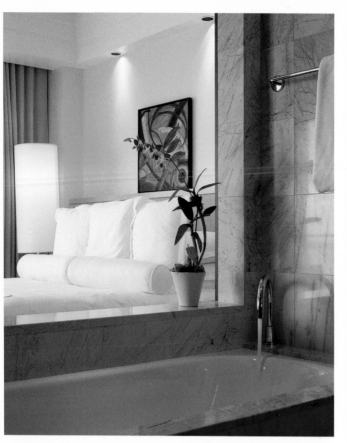
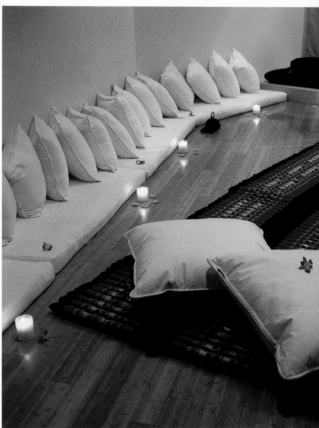
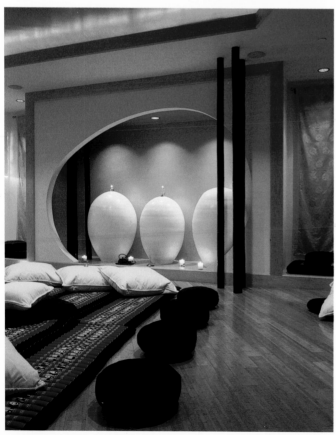
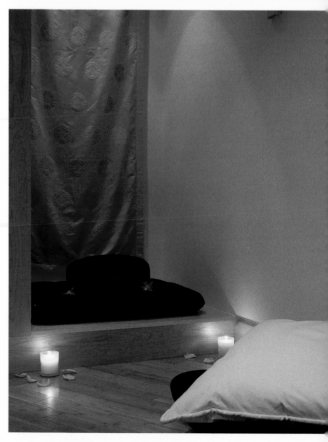

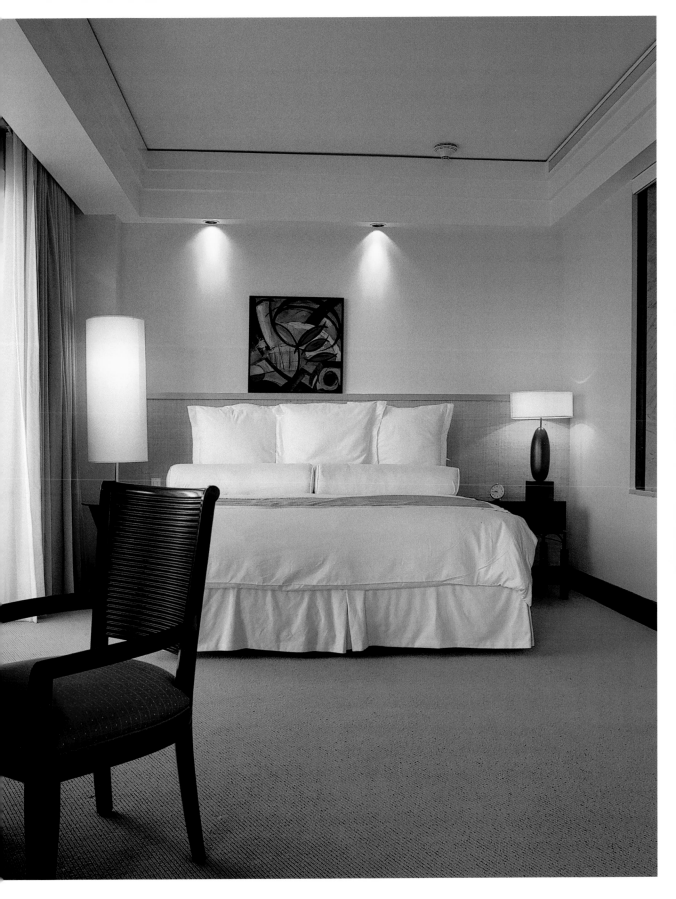

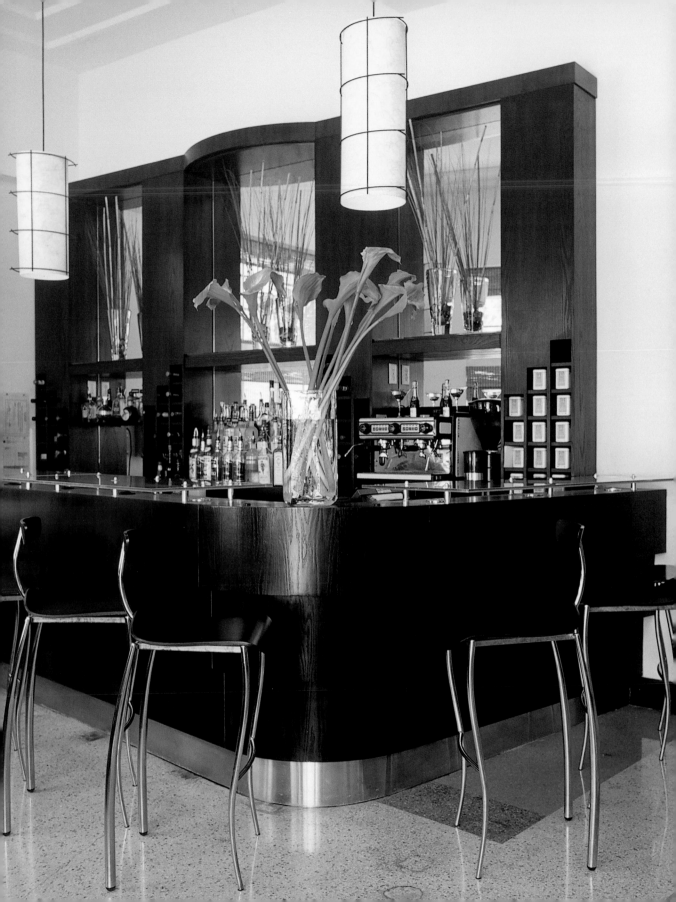

944 Washington Avenue, Miami Beach, FL 33139, US Tel.: +1 305 534 4069 Fax: +1 305 672 6712
www.thehotelchelsea.com

The Hotel Chelsea

Architect: Alan Lieberman Photographer: © Pep Escoda Opening date: 2001 Rooms: 42

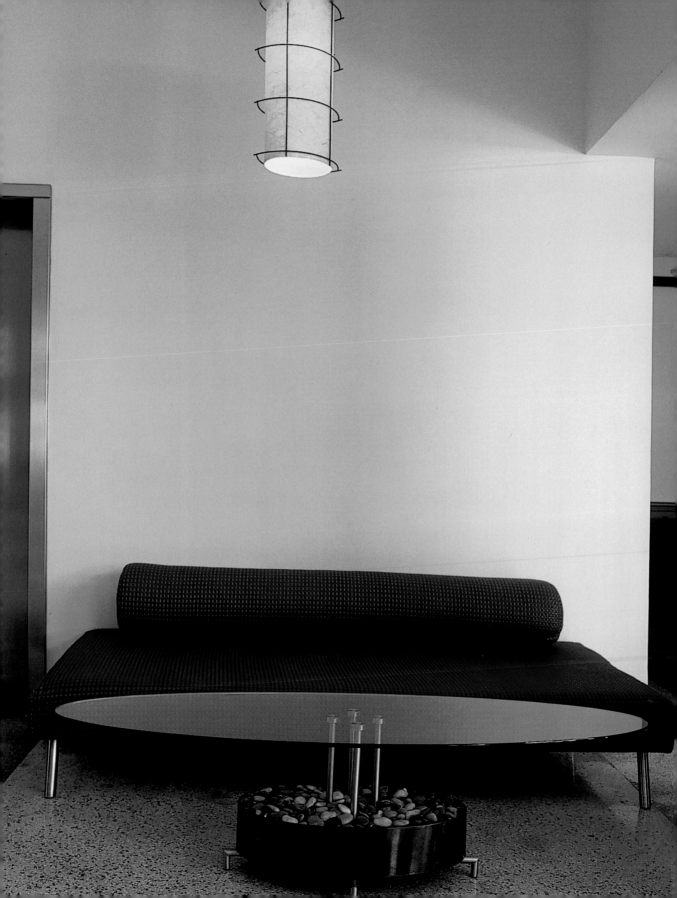

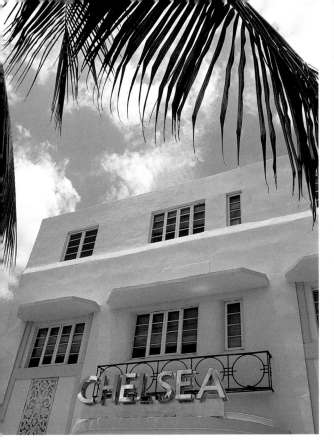
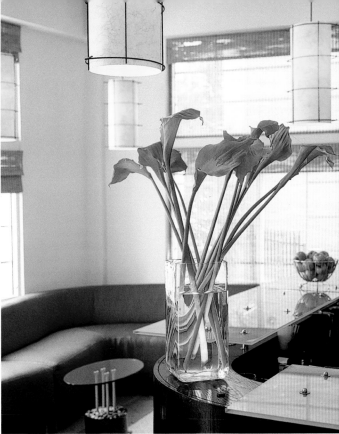

The accessories have been chosen for their discreet appearance: the transparency and lightness of the glass and steel define the oval forms of the coffee tables which complement the sofas.

Die Dekorationselemente wirken sehr schlicht und die Transparenz und Leichtigkeit der Materialien Glas und Stahl definieren die ovalen Formen der Tische, die bei den Sofas stehen.

Les accessoires ont été choisis pour leur apparence discrète. La transparence et la légèreté du cristal e de l'acier définissent les formes ovales des tables assorties aux canapés.

Los accesorios se escogieron por su apariencia discreta. La transparencia y ligereza del cristal y el acero definen las formas ovaladas de las mesas que complementan los sofás.

Gli accessori sono stati scelti per il loro aspetto discreto. La trasparenza e leggerezza del vetro e dell'acciaio delineano le forme alquanto ovali dei tavoli abbinati ai divani.

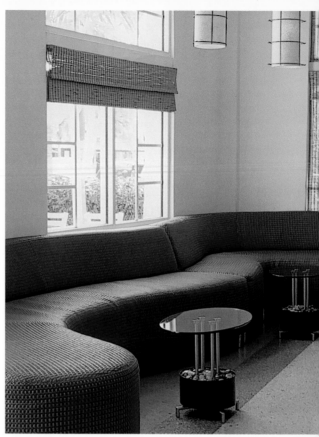
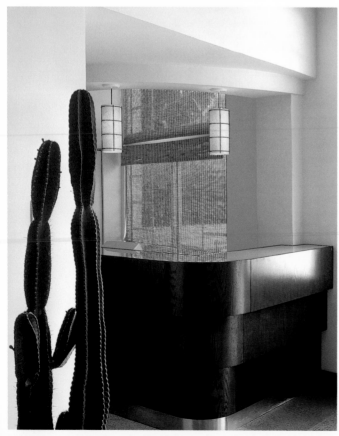
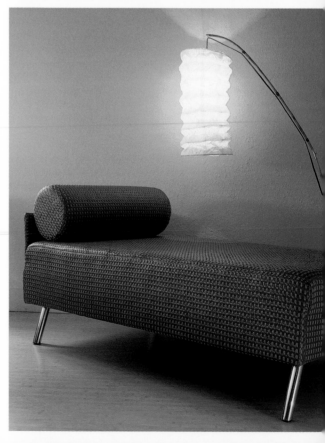

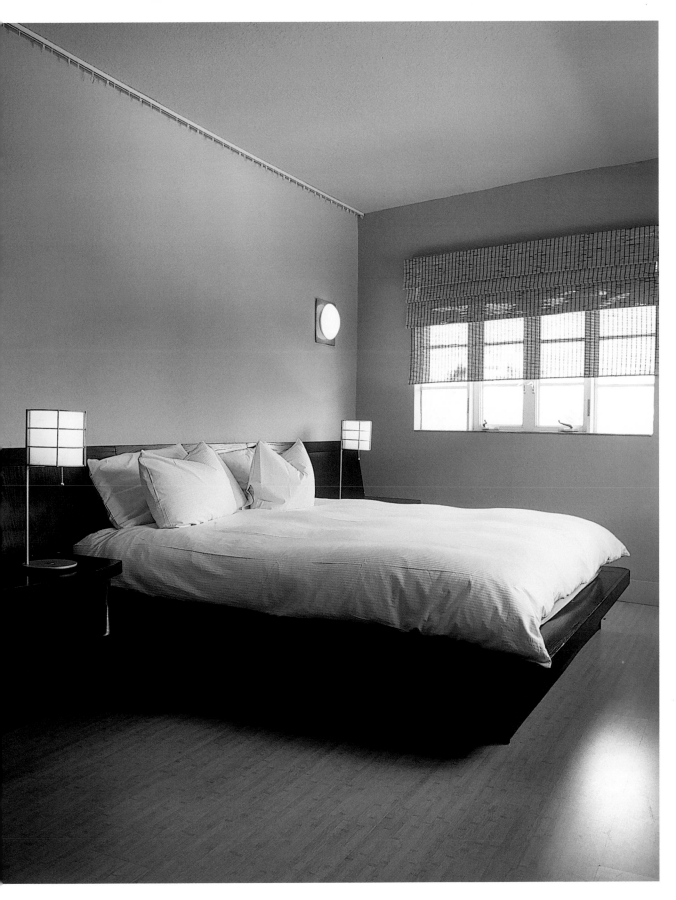

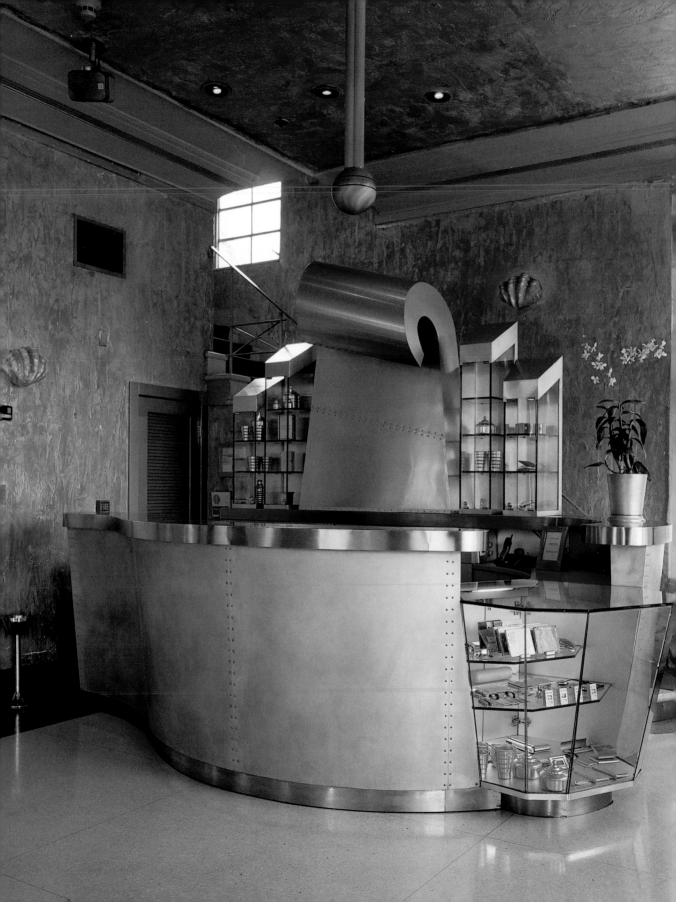

1200 Collins Avenue, Miami Beach, FL 33139, US Tel.: +1 305 604 5063 Fax: +1 305 673 9609
www.islandoutpost.com

The Marlin

Architect: L. Murray Dixon Interior Designer: Barbara Hulamicki Photographer: © Pep Escoda
Opening date: 2000 Rooms: 12

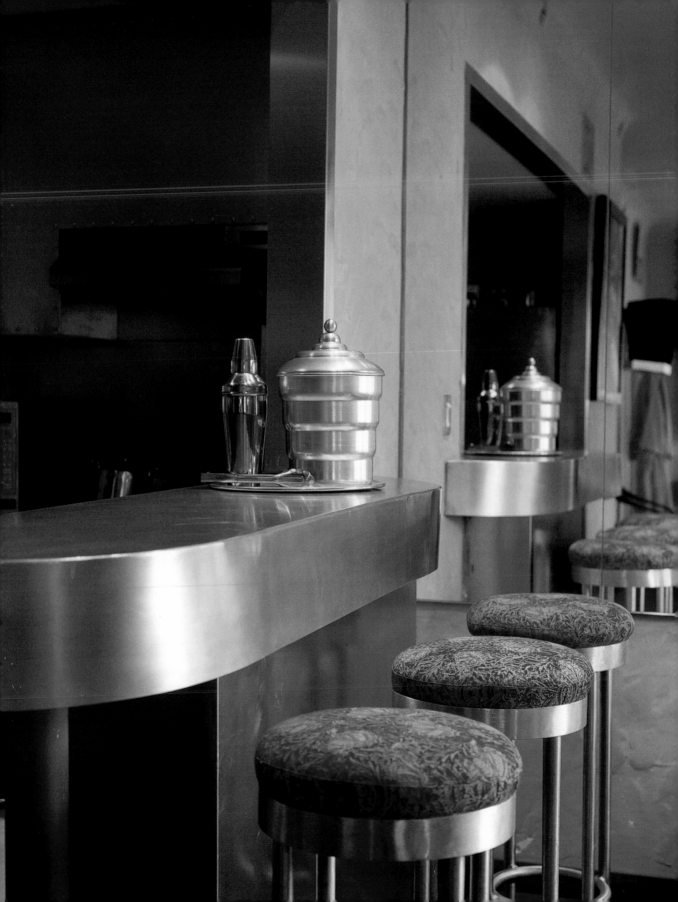

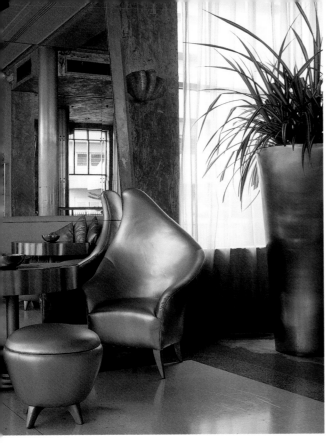
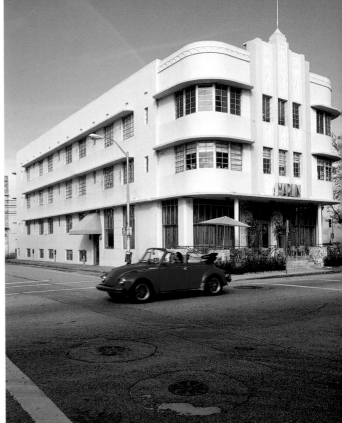

The designers opted for a metalized gray in the bar and lobby that imitates the effect of stainless steel. The metalized tone grants luminosity which, combined with upholstered furniture, generates a curious effect of appearance versus reality.

Der Bereich der Bar und die Empfangshalle sind in metallicgrau gehalten, das rostfreien Stahl imitiert. Diese Metallicfarbe besitzt eine Leuchtkraft, der die gepolsterten Möbel entgegenwirken, so dass eine merkwürdige Wechselbeziehung zwischen Schein und Wirklichkeit entsteht.

La couleur choisie pour les espaces du bar et du vestibule est un gris métallisé qui imite l'acier inoxydable. L'aspect métallisé apporte une luminosité qui, au contact de meubles recouverts de tissu, crée un contraste générateur d'un effet spécial entre réalité et apparence.

El color elegido para el área del bar y del vestíbulo es un gris metalizado que imita el acero inoxidable. Este tono aporta gran luminosidad y al combinarse con muebles tapizados genera un curioso efecto de realidad y apariencia.

Il colore scelto per le zone del bar e della hall è un grigio metallizzato che imita l'acciaio inossidabile. I toni metallizzati donano una luminosità che trattandosi di mobili tappezzati viene contrastata fino a creare uno strano effetto tra la realtà e l'apparenza.

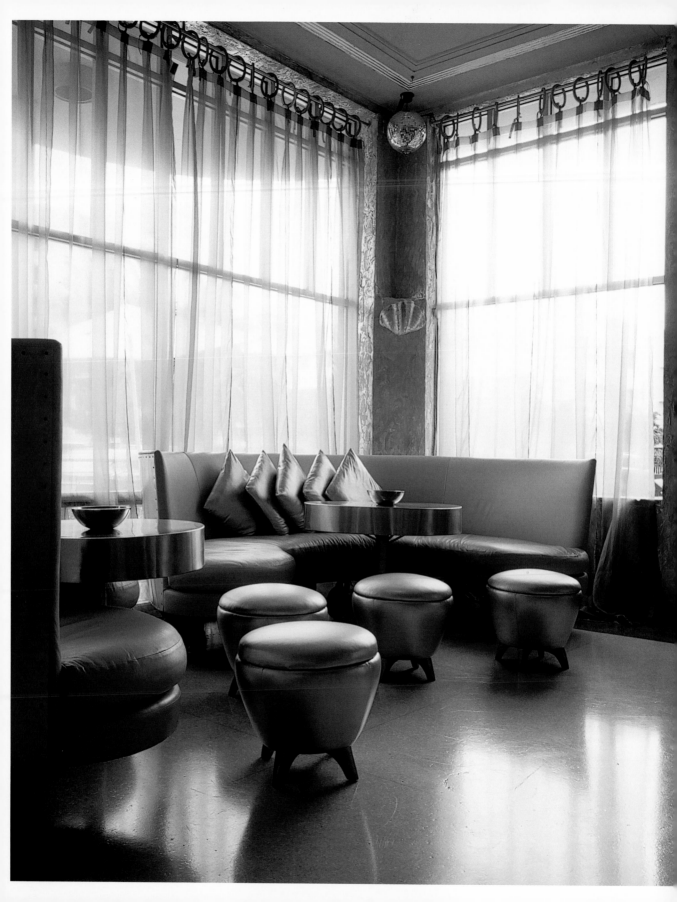

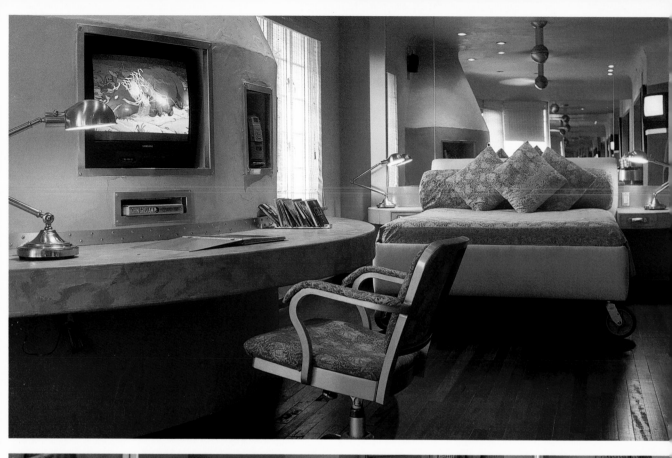

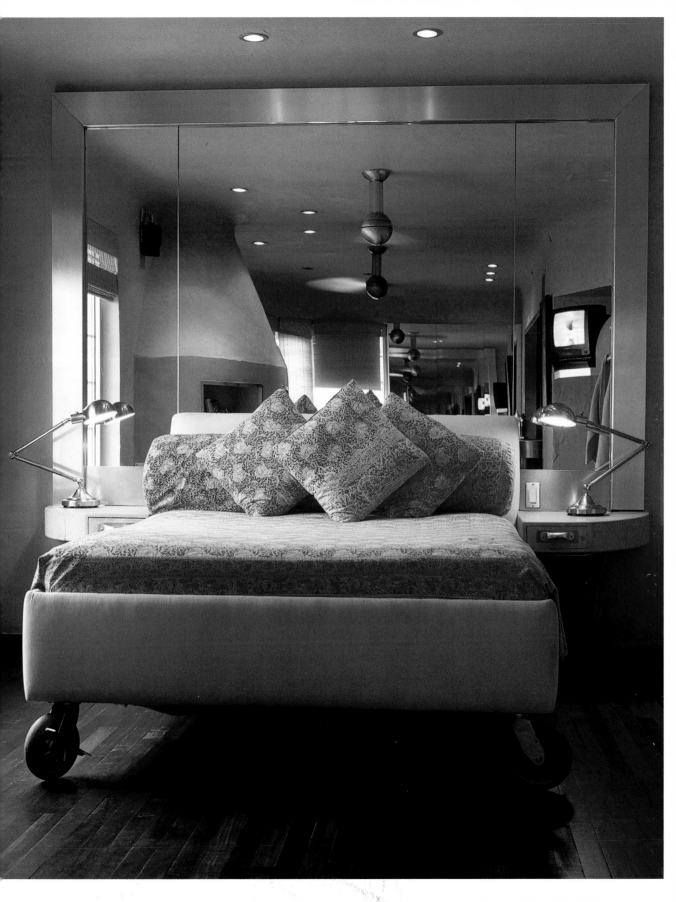

758 Washington Avenue, Miami Beach, FL 33139, US Tel.: +1 305 673 9009 Fax: +1 305 673 9244
info@royalsouthbeach.com www.royalhotelsouthbeach.com

The Royal Hotel

Architect: Jordan Mozer Photographer: © Pep Escoda Opening date: 2001 Rooms: 42

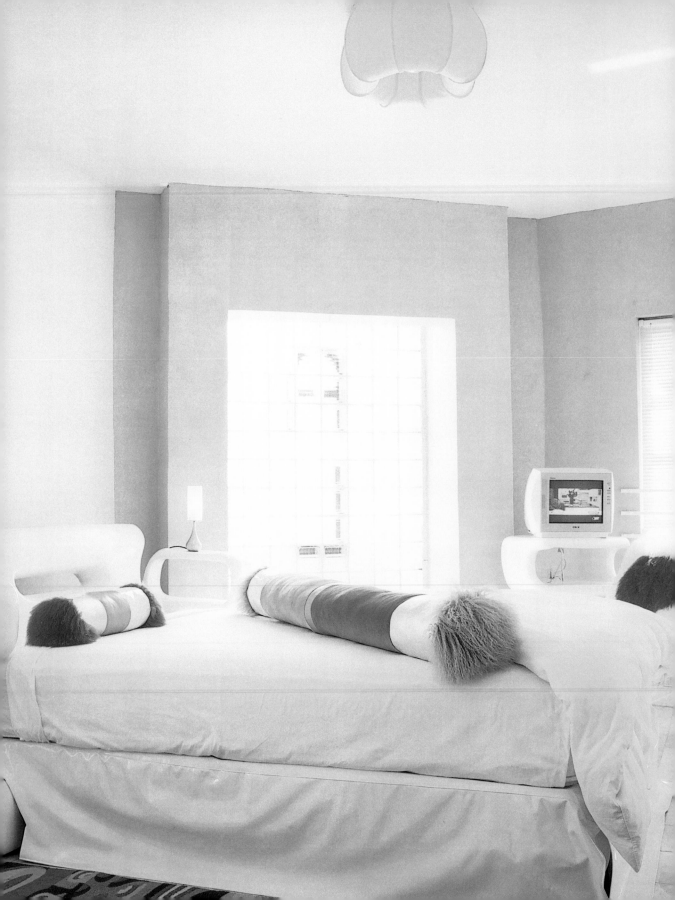

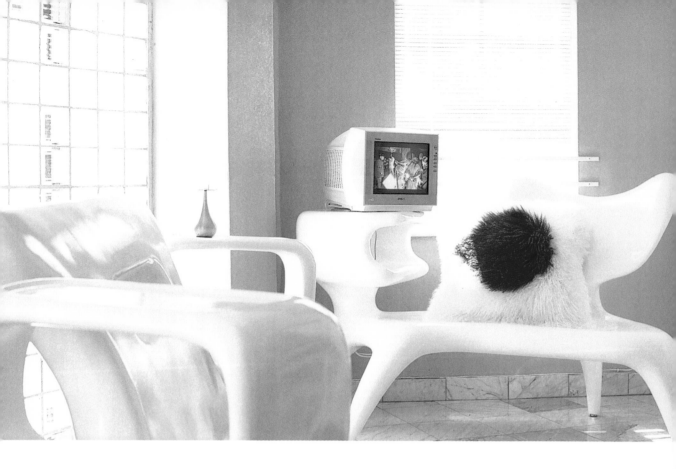

The furniture, specially designed for the hotel, is made of plastic resin that accentuates the sparkle and luminosity of the space. The rugs found along the corridors were designed by the architect and contribute strong elements of color to the design.

Die Möbel wurden speziell für dieses Hotel entworfen. Das Kunststoffharz, aus dem sie hergestellt wurden, unterstreicht den Glanz und das Licht der Räumlichkeiten. Einige der Teppiche in den Fluren wurden von dem Architekten selbst entworfen, ihre ansprechenden Farben prägen die Atmosphäre.

Le mobilier, dessiné tout spécialement pour l'hôtel, est fabriqué en résine plastique qui accentue l'éclat et la lumière de l'espace. Le même architecte à dessiner certains des tapis des corridors, suggérant des images de couleurs.

El mobiliario, especialmente creado para el hotel, está fabricado con una resina plástica que acentúa el brillo y la luz del espacio. Algunas alfombras colocadas en los pasillos han sido diseñadas por el mismo arquitecto y aportan un sugerente toque de color al lugar.

La mobilia, ideata appositamente per l'hotel, è realizzata in una resina plastica che accentua lo splendore e la luminosità dello spazio. Alcuni tappeti nei corridoi sono stati ideati dallo stesso architetto e contribuiscono ad evocare suggestive e colorate immagini.

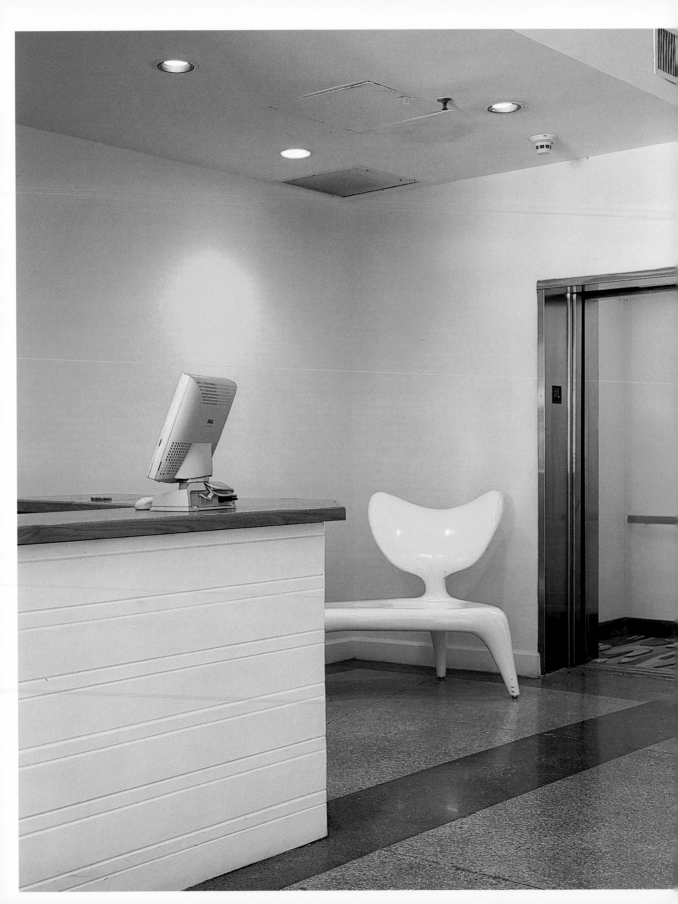

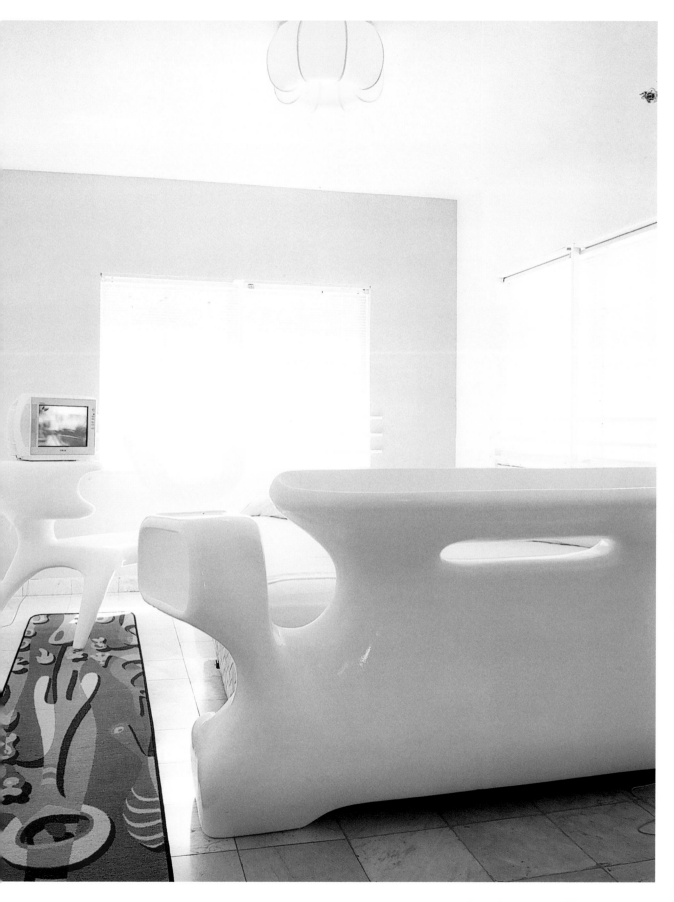

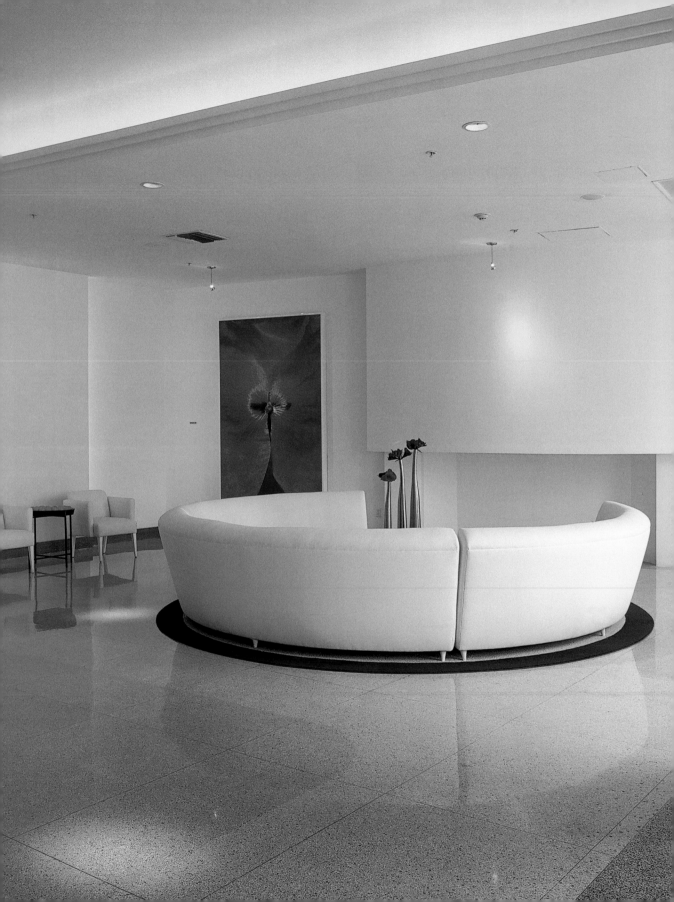

1671 Collins Avenue, Miami Beach, FL 33139, US Tel.: +1 305 535 8088 Fax: +1 305 535 8185
info@sagamorehotel.com www.sagamorehotel.com

The Sagamore Hotel

Architect: Albert Anis Remodelation: Allan Shulman Interior Designers: Henri Almanzar and Patrick Kennedy
Photographer: © Pep Escoda Opening date: 2002 Rooms: 93

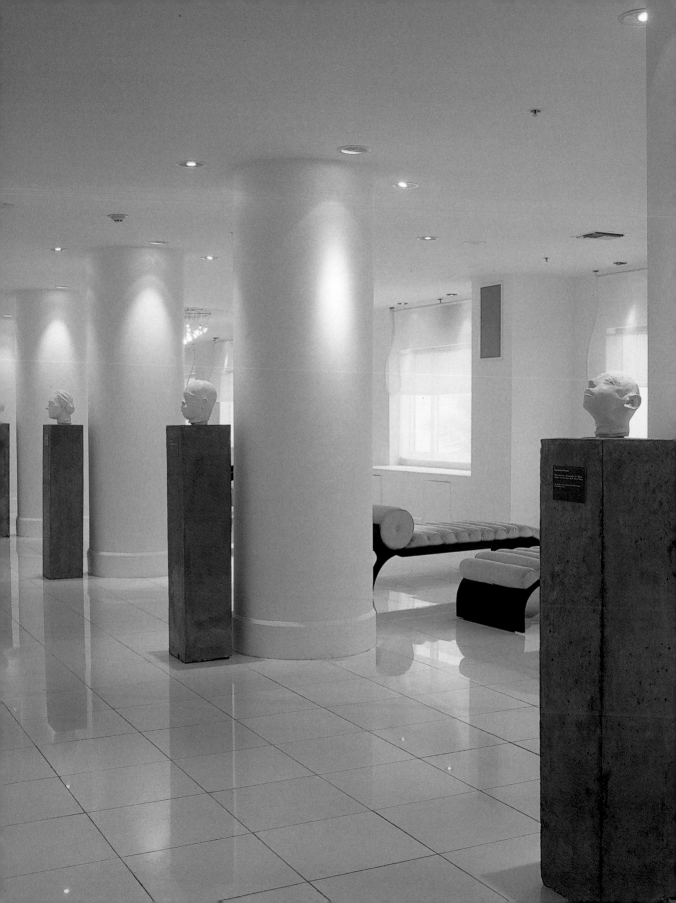

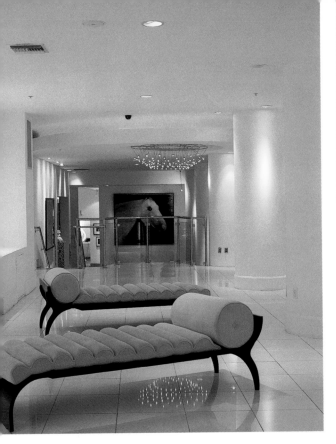

The art gallery occupies practically all of the common spaces and the upper lobby, which is also privileged with direct views of the sea and where columns, reminiscent of classical architecture, are incorporated.

Die Kunstgalerie nimmt fast alle Gemeinschaftsräume und die obere Empfangshalle ein. Man hat von dort oben einen direkten Blick aufs Meer und es wurden klassisch wirkende Säulen aufgestellt.

La galerie d'art occupe presque tous les espaces communs et le vestibule supérieur avec vues directes sur la mer entre des colonnes d'inspiration classique.

La galería de arte ocupa casi todos los espacios comunes y el vestíbulo superior, desde donde poder disfrutar de vistas privilegiadas al mar y en la que se hallan instaladas unas columnas de reminiscencias clásicas.

La galleria d'arte occupa quasi tutti gli spazi comuni e la hall superiore, con vista diretta sul mare e dove sono state collocate colonne dalle reminiscenze classiche.

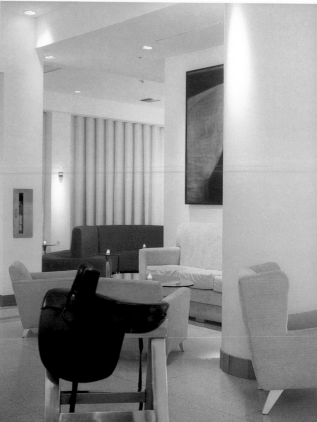

First floor

Ground floor

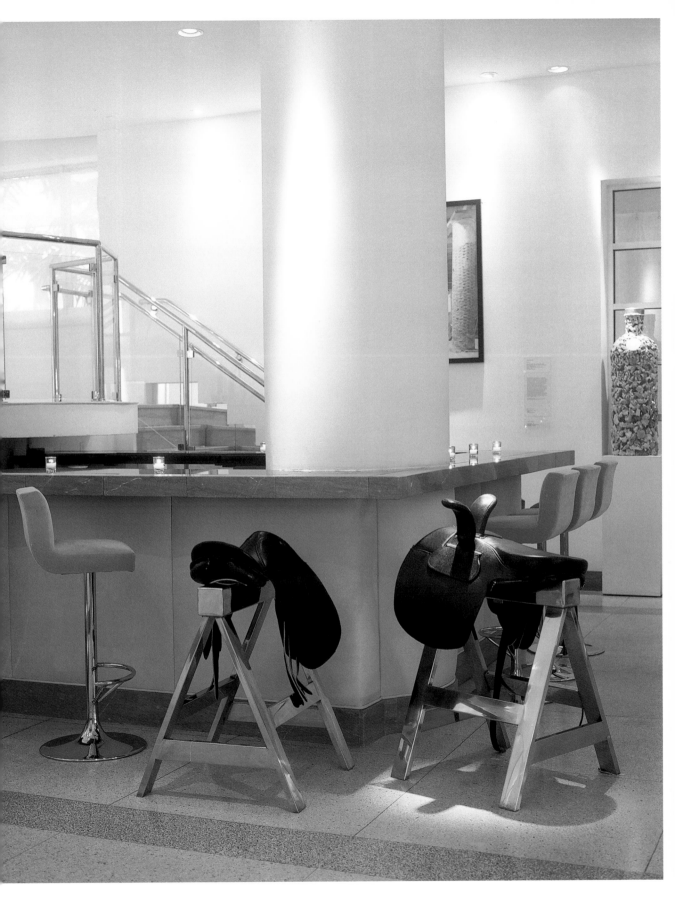

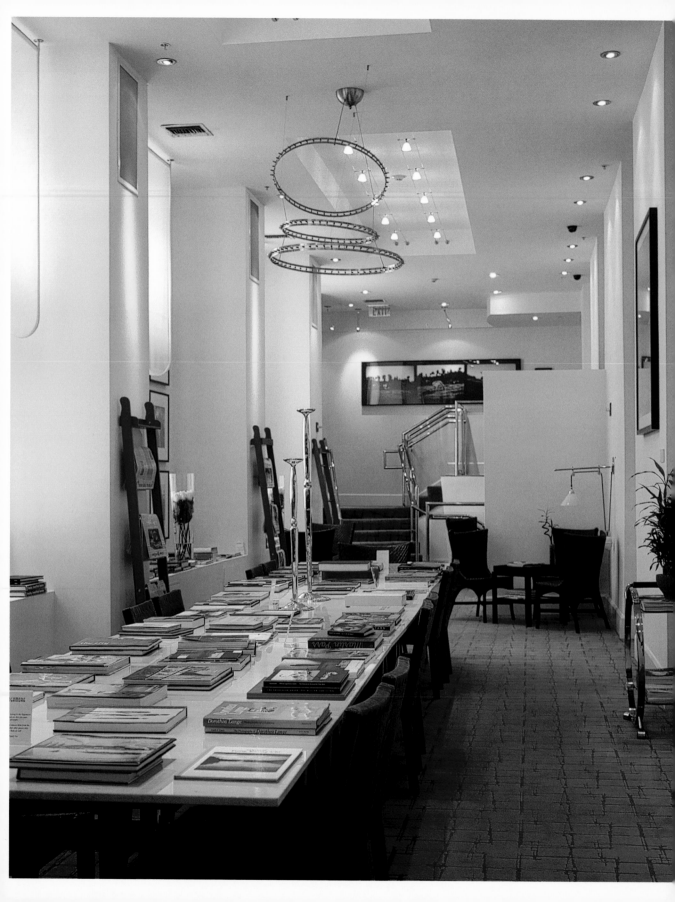

1901 Collins Avenue, Miami Beach, FL 33139, US Tel.: +1 800 258 7503 www.southbeach-usa.com

The Shore Club

Designer: Anda Andrei Photographer: © Pep Escoda Opening date: 2003 Rooms: 322

The interior atmosphere exudes a sensation of lightness, softness, and transparency achieved by the use of very light colors, candles, curtains lit from behind, and a close relationship between exterior and interior.

Die Atmosphäre im Inneren strahlt Leichtigkeit, Weichheit und Transparenz aus. Dies wurde durch den Einsatz heller Töne, durch Kerzen und von hinten beleuchtete Gardinen sowie einem engen Zusammenspiel zwischen draußen und drinnen erreicht.

L'ambiance intérieure dégage une sensation de légèreté, douceur et transparence grâce à l'emploi de teintes claires, de voiles, de rideaux au fond clairs, et à une union étroite entre extérieur et intérieur.

La atmósfera del interior desprende una sensación de ligereza, suavidad y transparencia lograda gracias al uso de los tonos claros, las velas, las cortinas iluminadas de fondo y a una estrecha relación entre el exterior y el interior.

L'ambiente dell'interno effonde una sensazione di leggerezza, morbidezza e trasparenza, ottenuta mediante l'uso di toni chiari, candele, tende illuminate dalla luce di sfondo, e uno stretto rapporto tra l'esterno e l'interno.

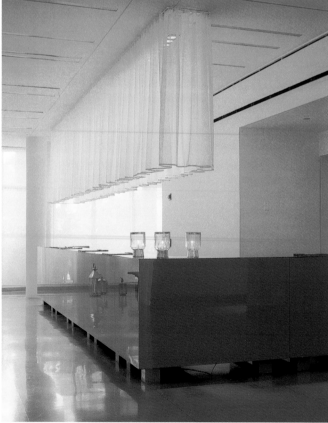
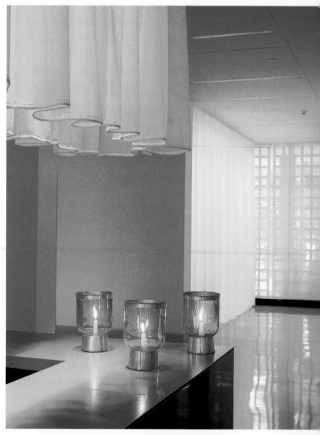

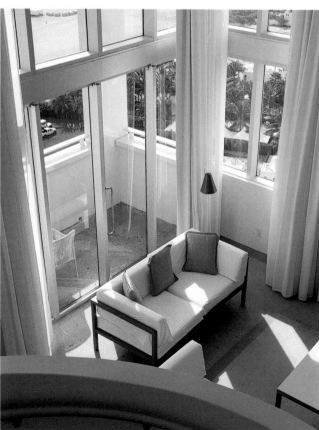

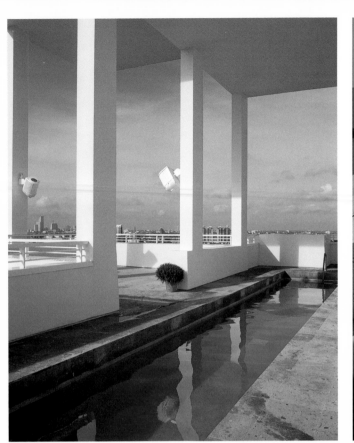

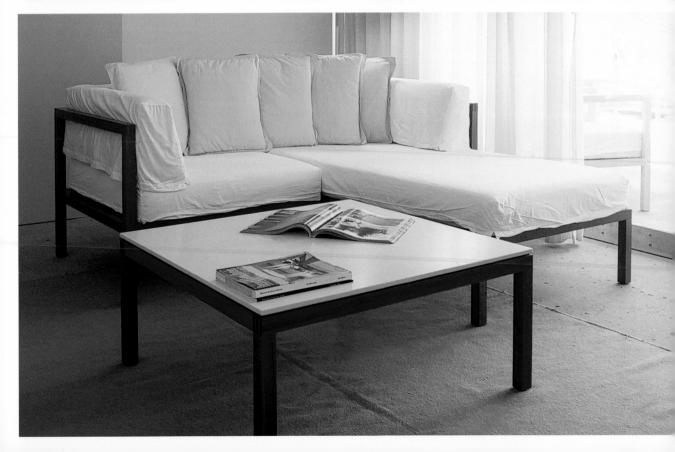

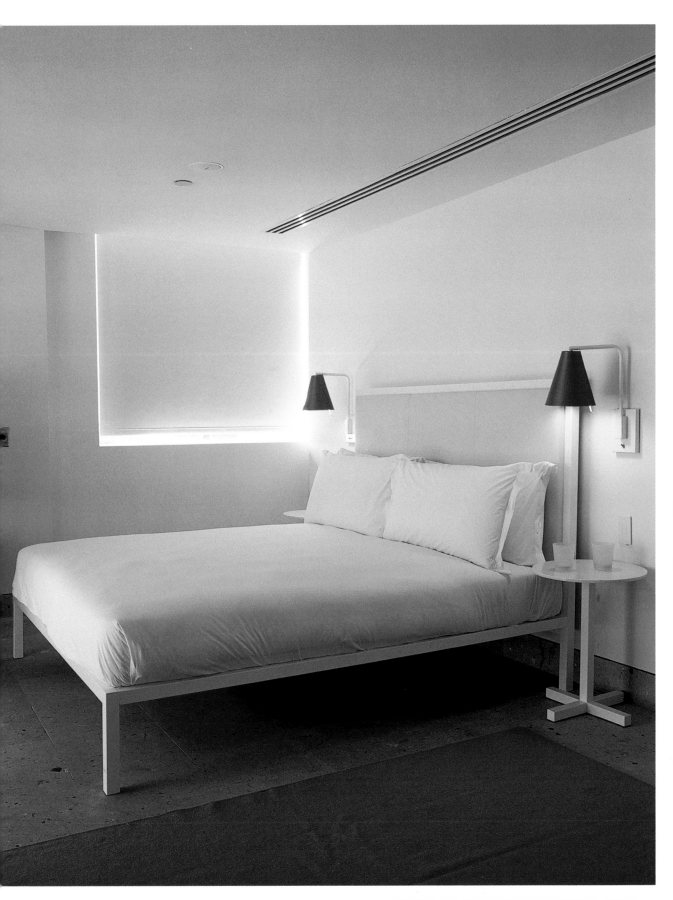

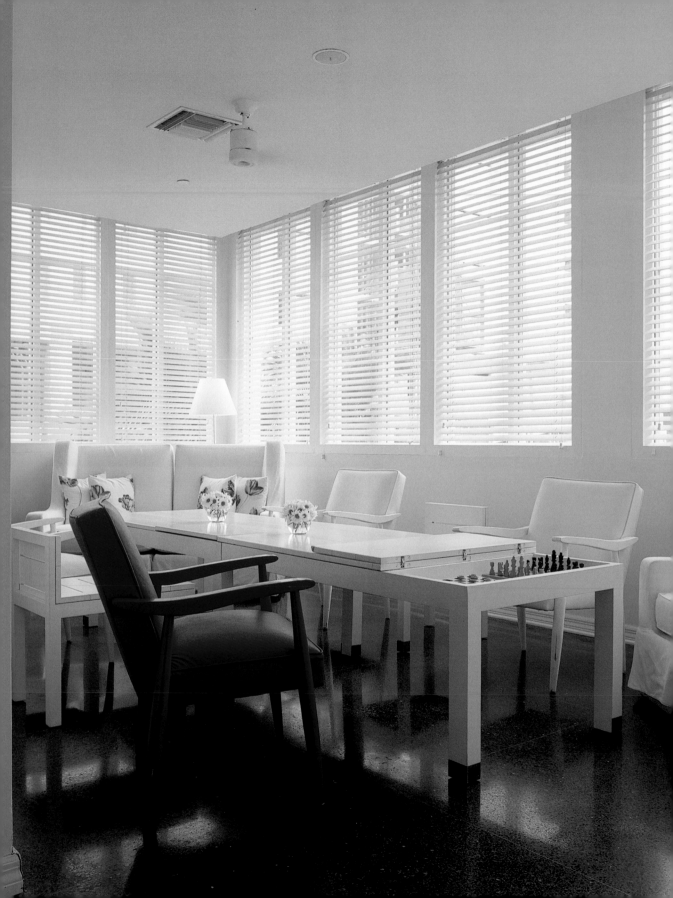

150 20th Street, Miami Beach, FL 33139, US Tel.: +1 305 534 3800 Fax: +1 305 534 3811
info@townhousehotel.com www.townhousehotel.com

Townhouse

Architect: Charles Benson Designer: India Mahdavi Photographer: © Pep Escoda Opening date: 2000
Rooms: 69 and 3 penthouses

Traditional hotel concepts were modified in order to create a warmer, more fun atmosphere in the hotel's 69 rooms. The color red characterizes the hotel's image, both in the interior and exterior design.

Die traditionellen Konzepte des Hotels wurden geändert, um eine wärmere und unterhaltsamere Atmosphäre in den 69 Zimmern zu schaffen. Das Hotel wird sowohl außen als auch innen durch die Farbe Rot charakterisiert.

Les conceptions traditionnelles de l'hôtel furent modifiées pour créer une ambiance plus chaleureuse et plaisante dans les 69 chambres. Le rouge est l'image de marque de l'hôtel, à l'intérieur comme à l'extérieur.

Los conceptos tradicionales del hotel se modificaron para crear una ambiente más cálido y divertido en las 69 habitaciones. El color rojo caracteriza la imagen del edificio, tanto en el interior como en el exterior.

L'idea di un albergo tradizionale è stata modificata per creare un ambiente più accogliente e divertente nelle 69 camere dell'hotel. Il rosso caratterizza l'immagine dell'hotel, sia all'interno che all'esterno.

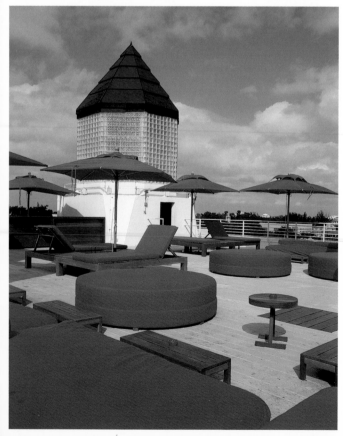
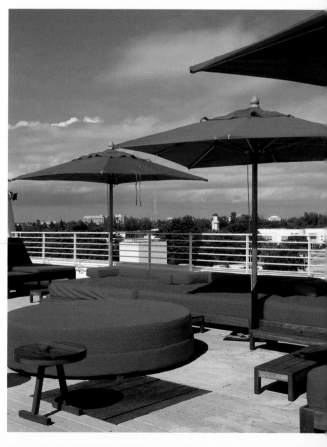

TELEPHONE

ACCESIBLE
TELEPHONE

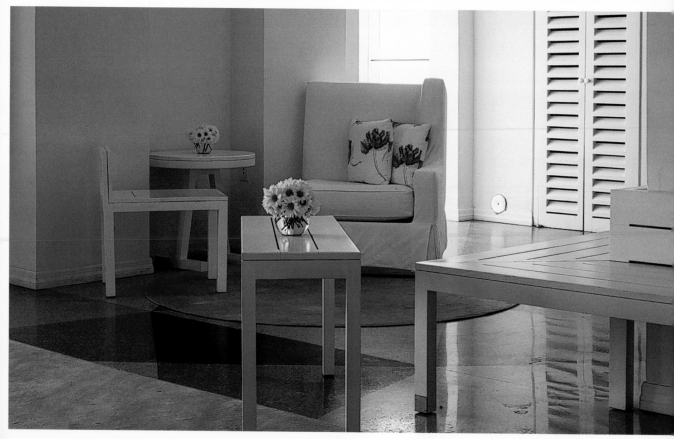

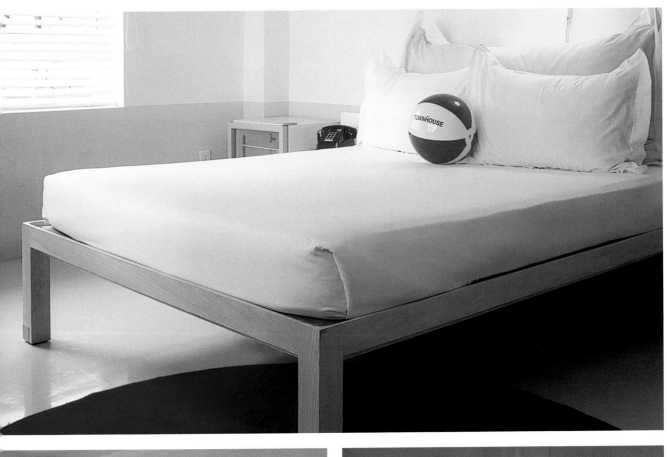

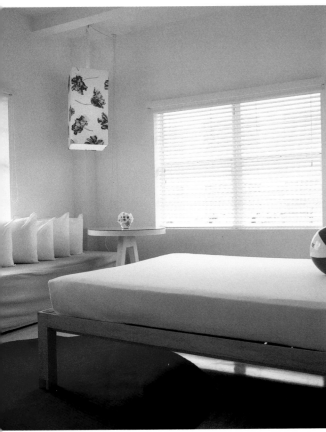

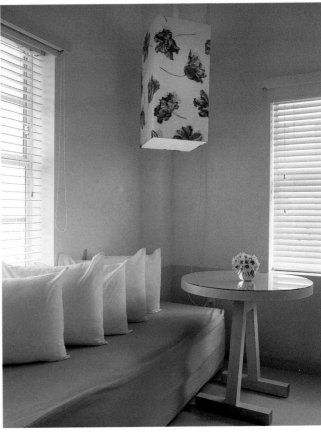

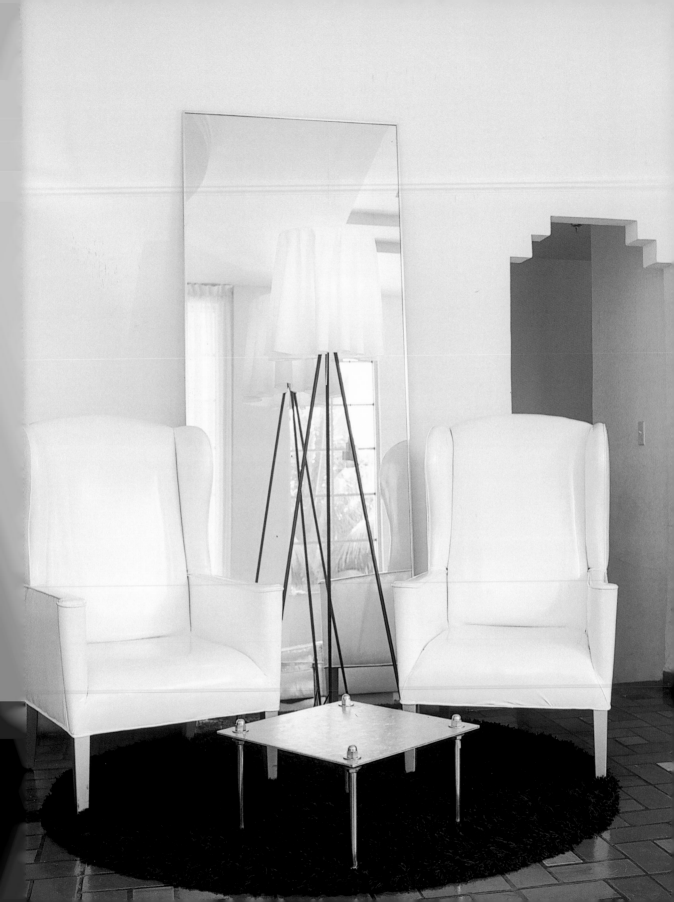

808 Collins Avenue, Miami Beach, FL 33139, US Tel.: +1 305 398 7000 Fax: +1 305 398 7010
www.whitelawhotel.com

Whitelaw

Architect: Alan Liberman Photographer: © Pep Escoda Opening date: 2000 Rooms: 49

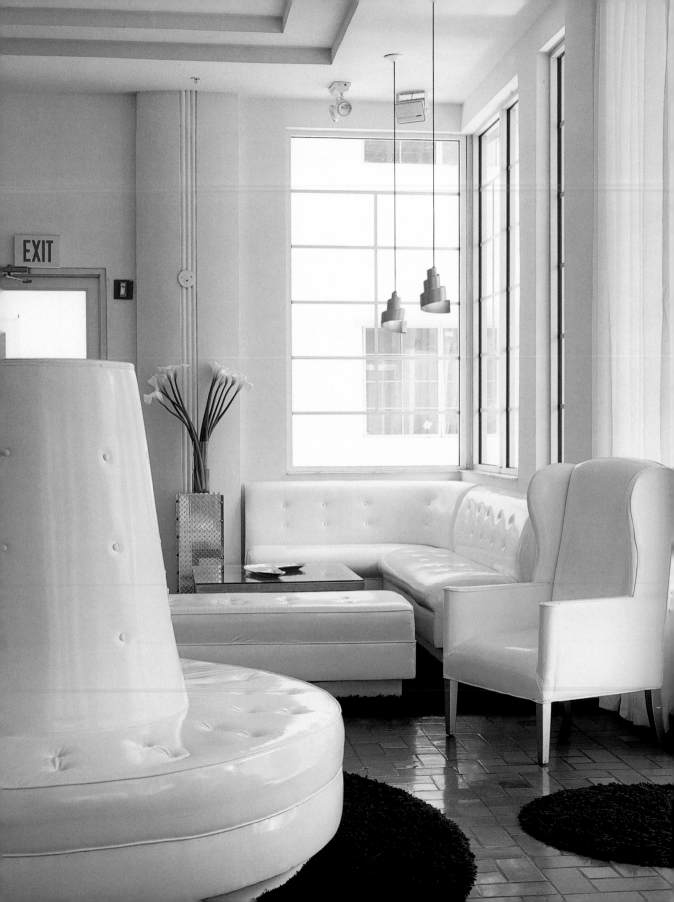

The use of transparency within the vestibule areas and between the interior and exterior generates a sense of openness, despite the relatively small proportions of the space.

Zwischen den verschiedenen Zonen der Empfangshalle findet ein Spiel mit Transparenzen statt. Gleichzeitig entsteht durch die Beziehung des Äußeren zum Inneren ein Gefühl der Weite, auch wenn die Räumlichkeiten gar nicht so groß sind.

Le jeu de transparences qui s'installe entre les différentes zones du vestibule, au moment ou l'intérieur se fond avec l'extérieur, procure une impression de largesse à un espace aux proportions réduites.

El juego de transparencias que se establece en las diferentes zonas del vestíbulo y entre el interior y el exterior dan una sensación de amplitud, aunque se trate de un espacio de reducidas dimensiones.

Il gioco di trasparenze che si crea tra le diverse zone della hall e contemporaneamente tra l'interno e l'esterno, dà una sensazione di ampiezza, sebbene si tratti di uno spazio di proporzioni ridotte.

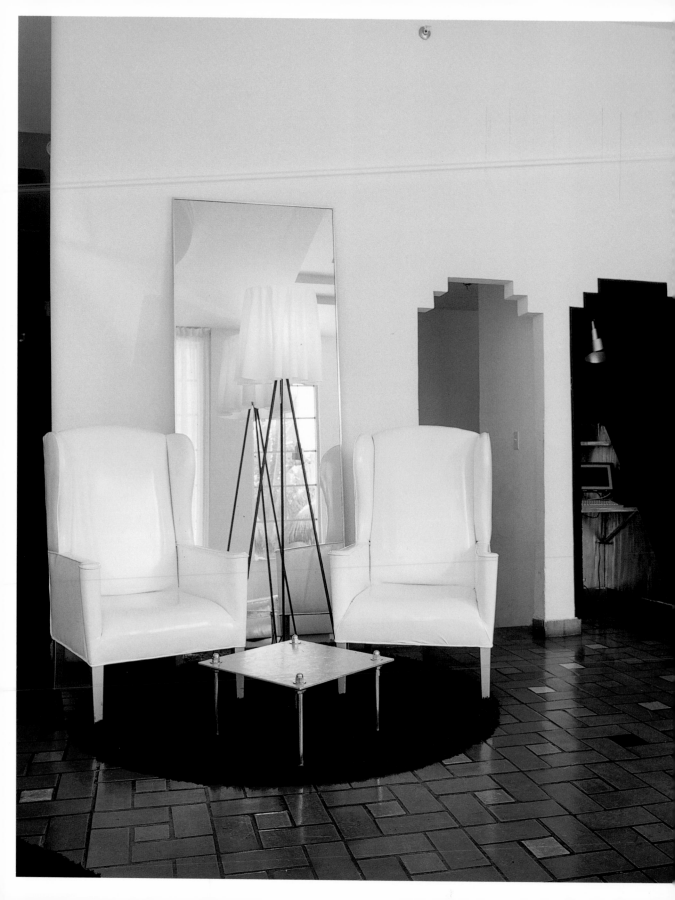

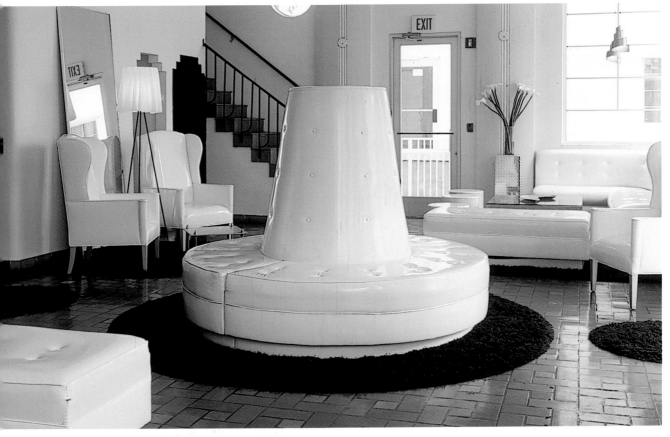

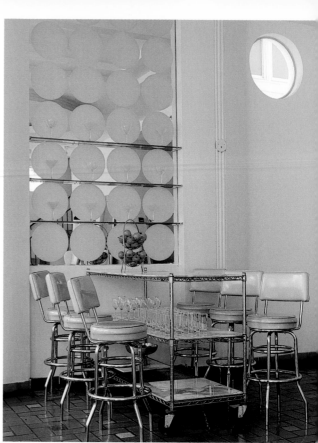
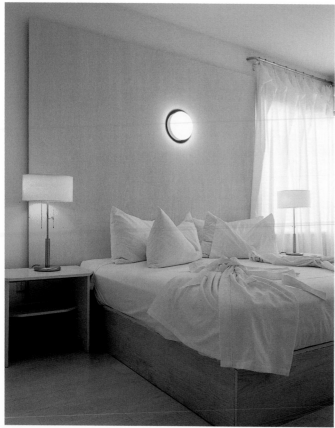
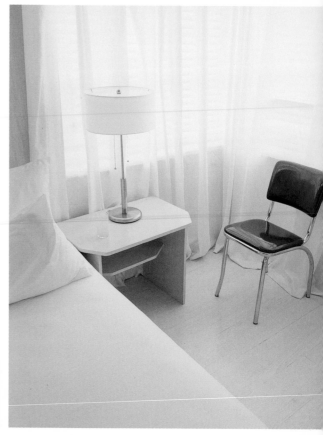

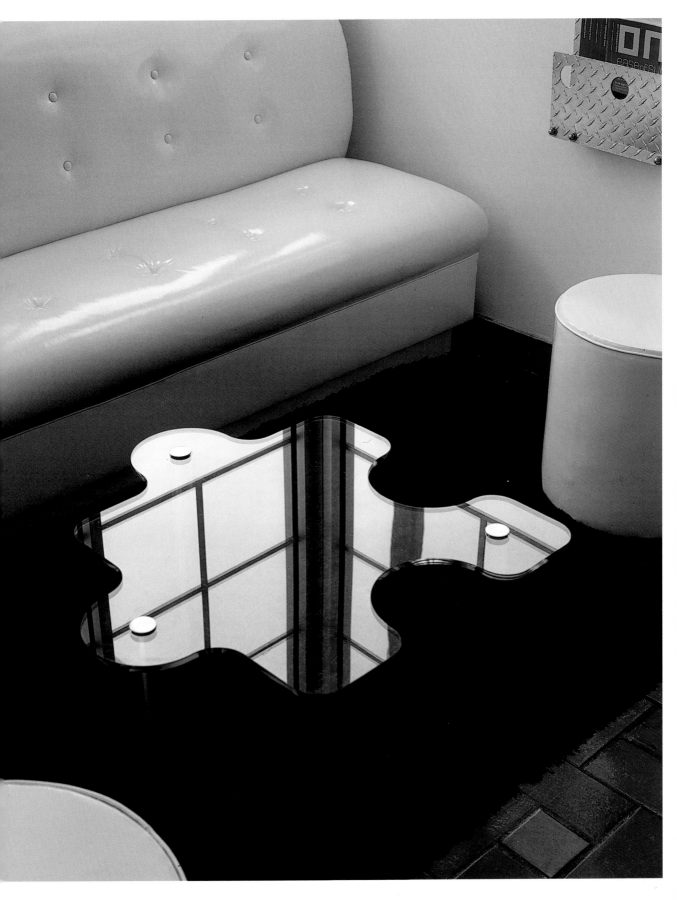

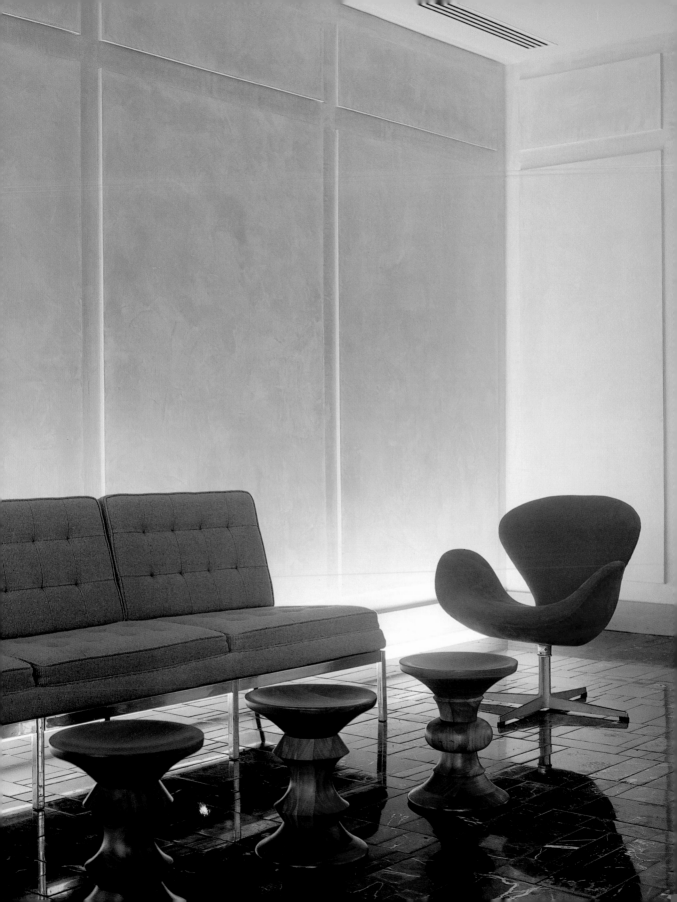

60 Thompson Street, New York, NY 10012, US Tel.: +1 212 431 0400 Fax: +1 212 431 0200
info@thompsonhotels.com www.60thompson.com

60 Thompson

Designer: Thomas O'Brien **Photographer:** © Pep Escoda **Opening date:** 2002 **Rooms:** 100

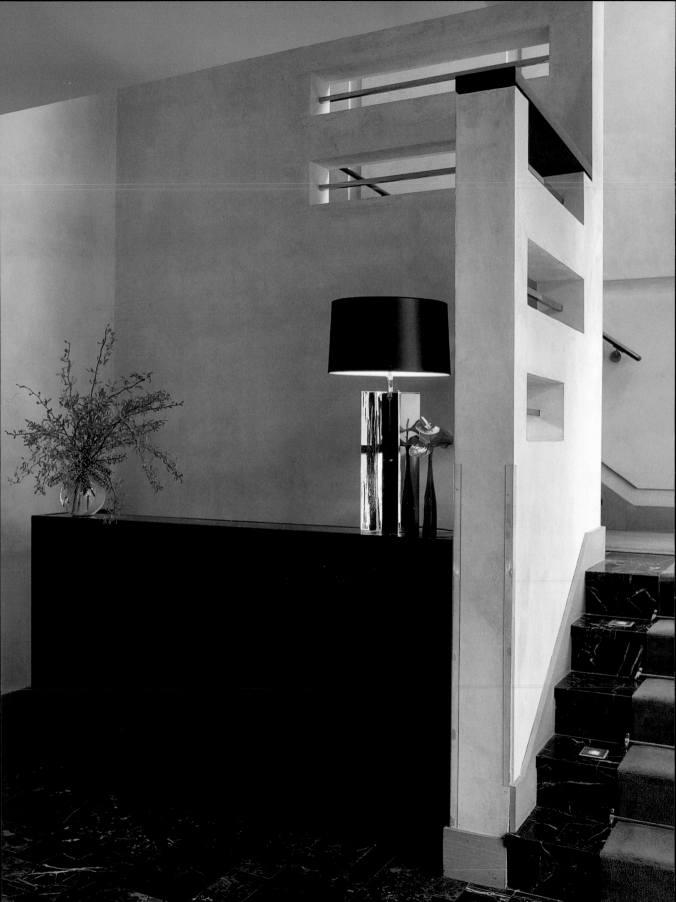

Dark tones have been used to create private corners in the public areas. In the guest rooms, the character of each space is obtained by utilizing very different pieces of furniture and lighting, so that each room is unique.

Die privateren Bereiche der Gemeinschaftszonen sind in dunklen Tönen gehalten. Durch verschiedene Möbelstücke und Beleuchtungen erhält jeder Raum seinen eigenen Charakter.

Des tons foncés règnent dans les coins privés des espaces communs. Divers éléments de mobilier et des éclairages variés impriment chaque chambre d'un sceau personnel.

Se emplearon tonos oscuros en los rincones privados de las zonas comunes. En las habitaciones, la presencia de diferentes piezas de mobiliaro y de iluminación da un carácter original a cada estancia.

Negli angoli privati delle zone comuni sono stati utilizzati dei toni scuri. Nelle camere, la presenza di diversi elementi di arredo e illuminazione conferisce un carattere originale ad ogni ambiente.

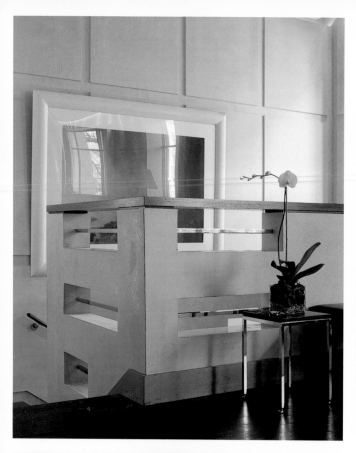
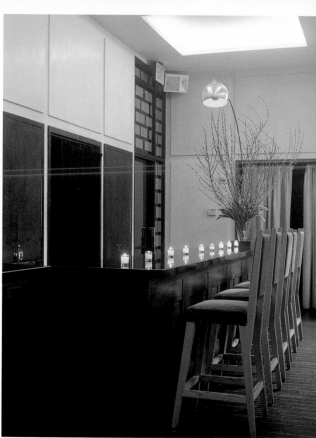
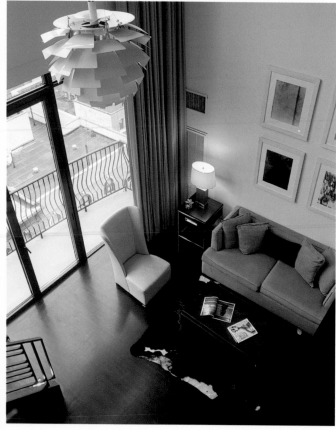
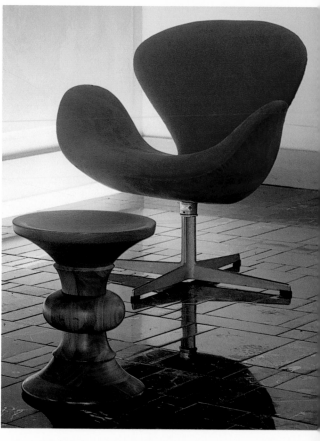

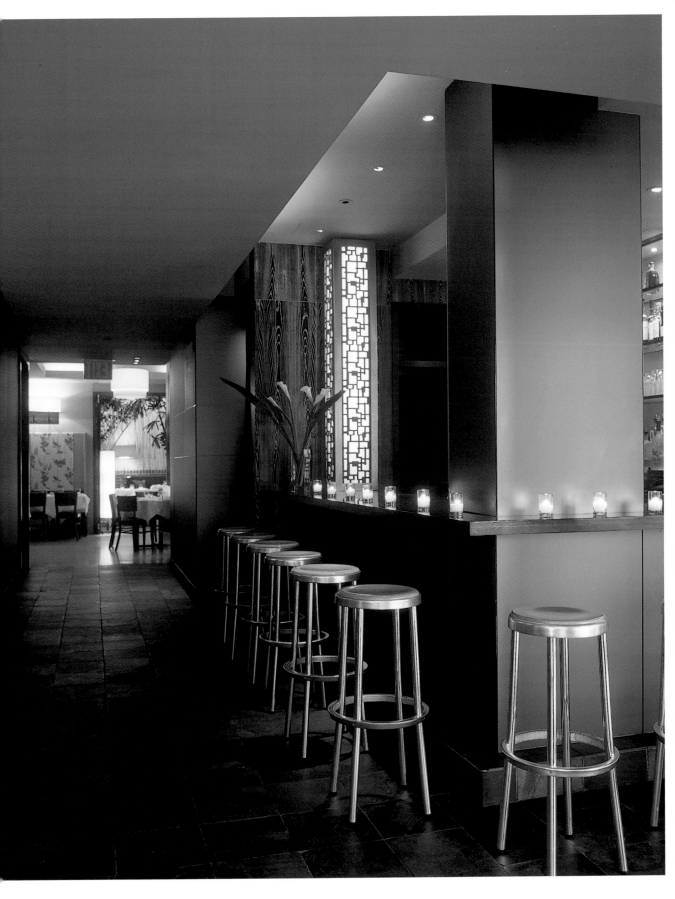

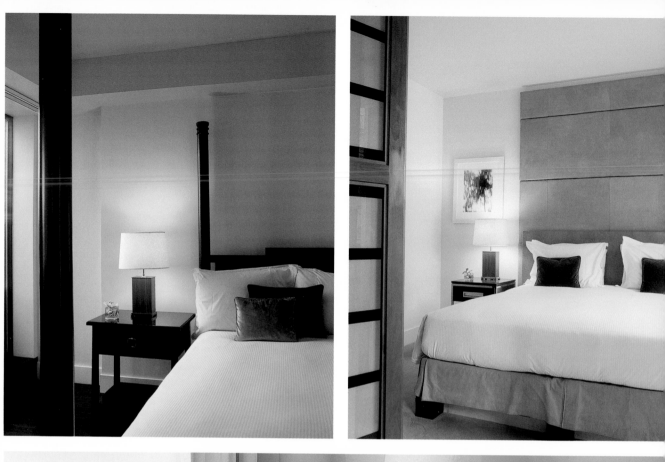

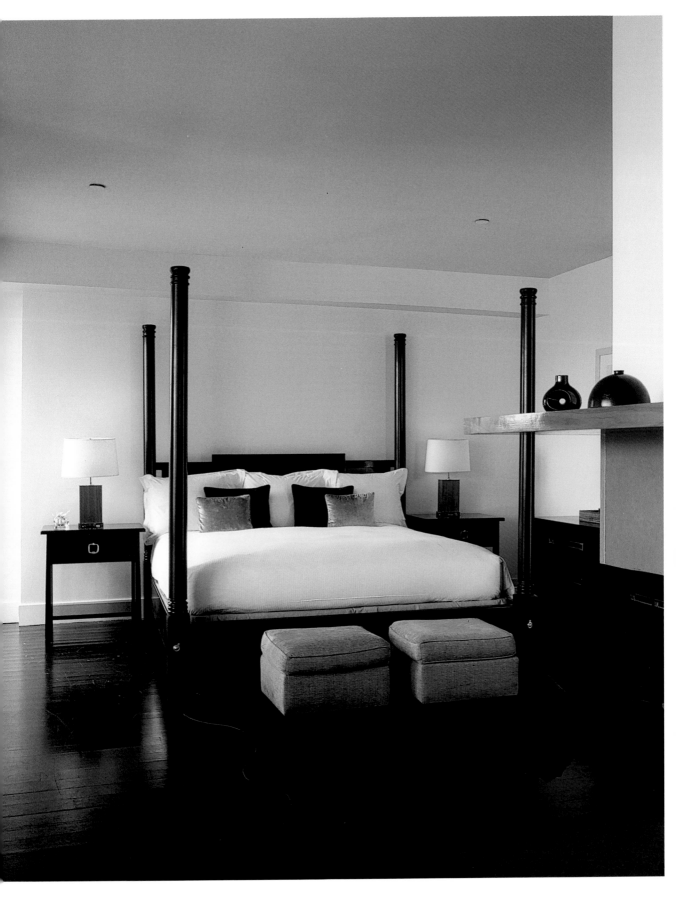

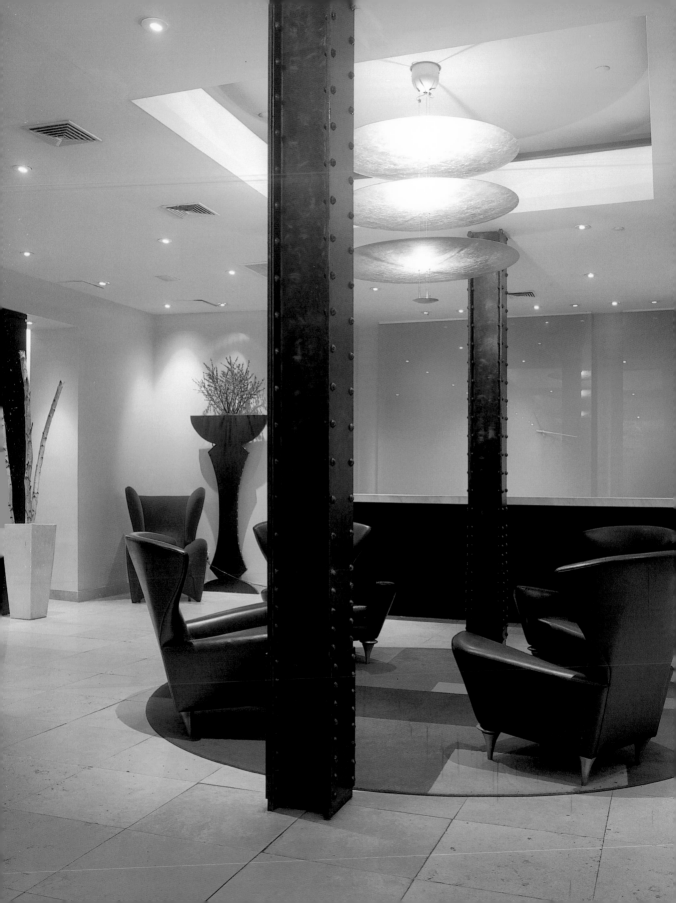

230 West 54th Street, New York, NY 10019, US Tel.: +1 212 247 5000 Fax: +1 212 247 3316
www.ameritaniahotelnewyork.com

Ameritania Hotel

Designer: Philippe Starck Photographer: © Pep Escoda Opening date: 1999
Rooms: 270 (including 12 suites)

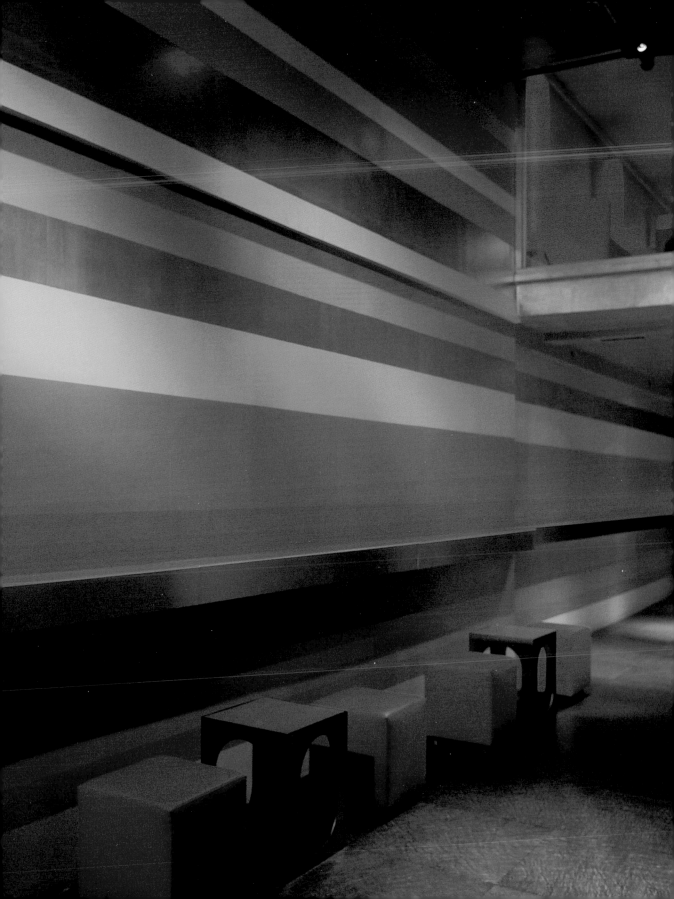

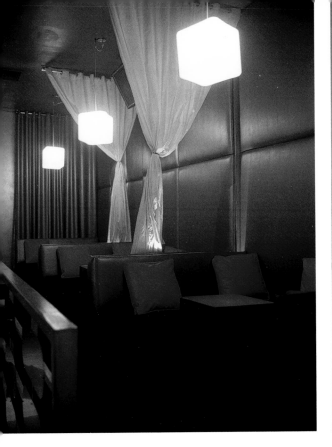

The décor, which features rich materials such as dark-colored woods that grant elegance and sophistication, are combined with more contemporary materials such as plastic or leather with metallic tones.

In der Dekoration mischen sich edle Materialien wie dunkles Holz, das Eleganz und Stil vermittelt, mit Materialien, die eine zeitgenössische Kultur repräsentieren, zum Beispiel Kunststoff und Leder in Metallicfarben.

La décoration unit matériaux nobles, à l'instar du bois aux teintes sombres, créant des touches élégantes et sophistiquées, à des matières représentatives d'une culture beaucoup plus contemporaine comme le plastique ou le cuir aux couleurs métallisées.

En la decoración se mezclan materiales nobles, como maderas de tono oscuro para aportar elegancia y sofisticación, con materiales que representan una cultura más contemporánea, como el plástico o el cuero de tonos metalizados.

Nell'arredamento si mescolano materiali nobili, come legni in toni scuri per conferire eleganza e sofisticazione, con materiali che rappresentano una cultura molto più contemporanea, quali la plastica o il cuoio in toni metallizzati.

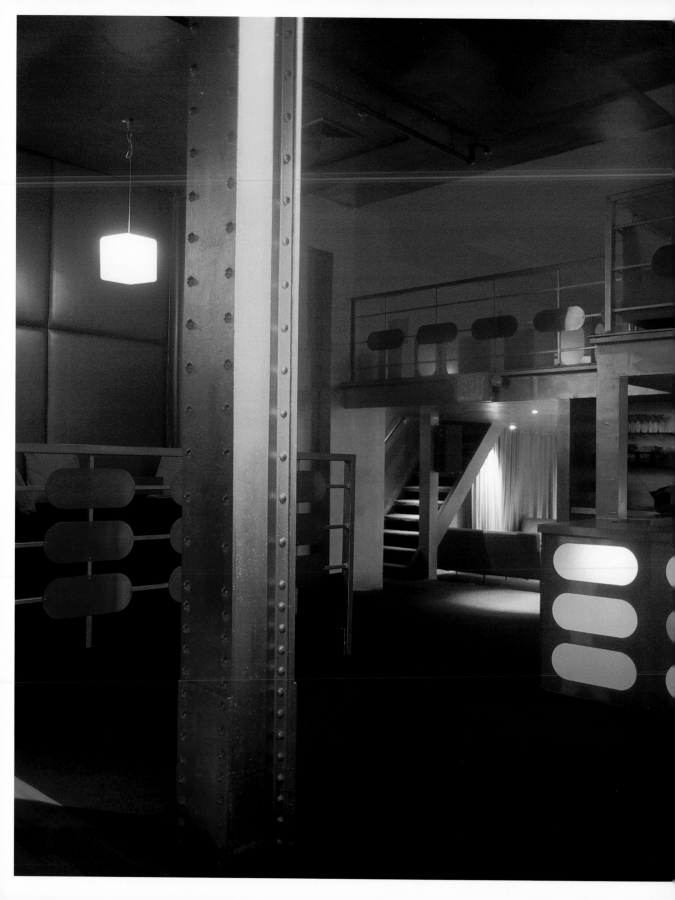

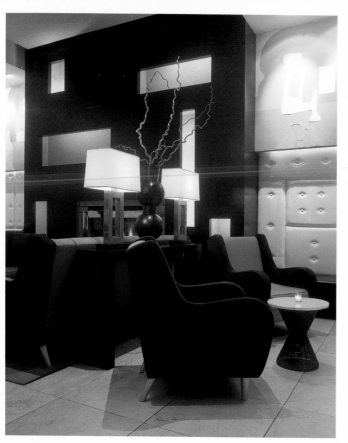
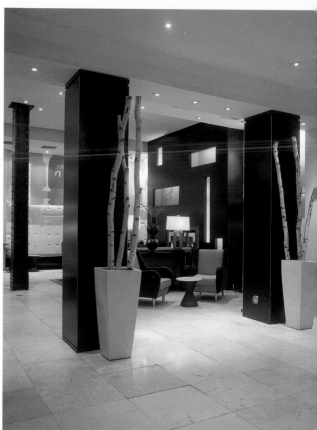
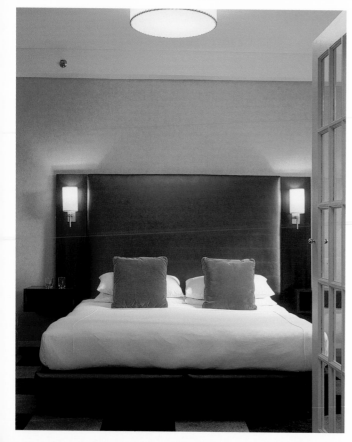
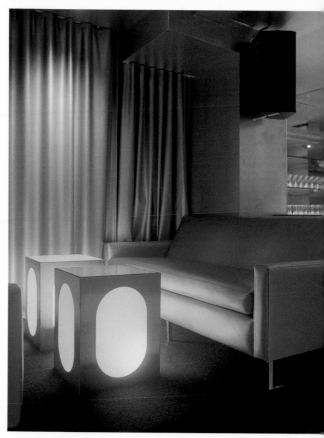

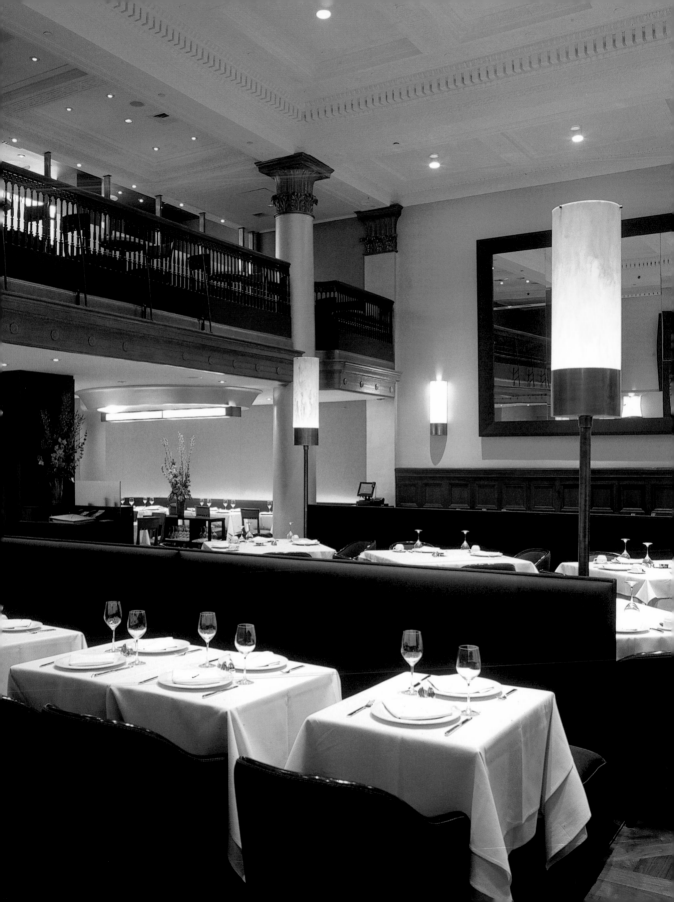

52 East 41st Street, New York, NY 10017, US Tel.: +1 212 338 0500 Fax: +1 212 338 0569

Dylan Hotel

Architect: Manuel R. Castedo Interior Designer: Jeffrey Beers Internacional Photographer: © Jordi Miralles
Opening date: 2000 Rooms: 108

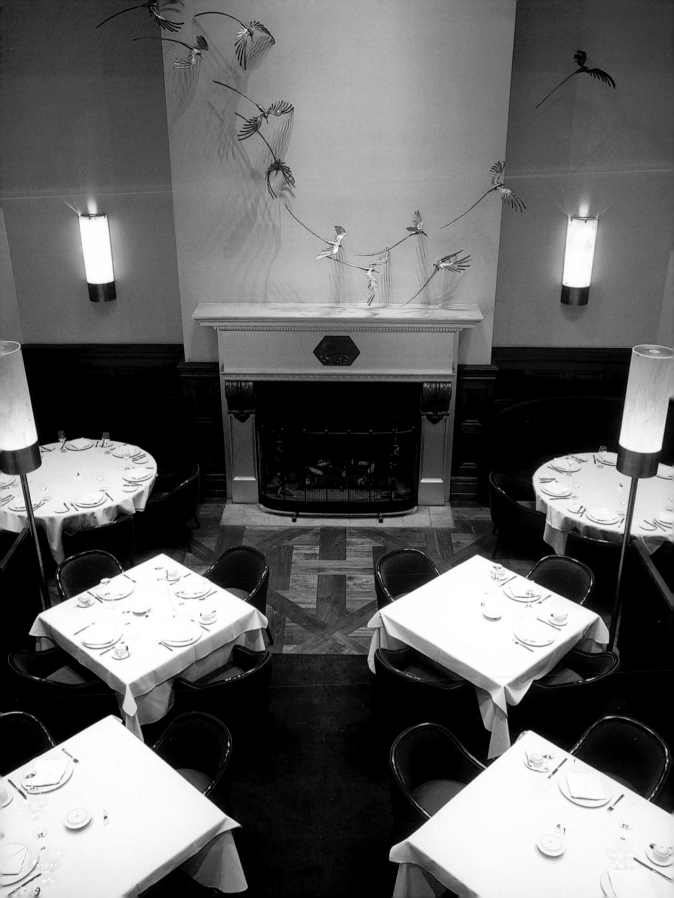

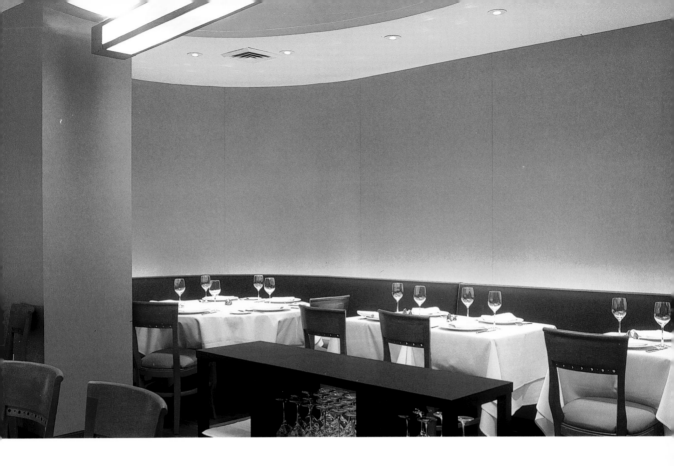

The view from the balcony inside the restaurant focuses on the limestone fireplace that dominates within the space, previously the dance hall of the once Chemist's Club.

Der Blick vom Balkon des Restaurants fällt auf den Kamin aus Kalkstein, der diesen Raum, den ehemaligen Tanzsaal des Chemist's Clubs, beherrscht.

Vue depuis le balcon du restaurant, la cheminée de pierres chaulées domine l'espace et est le point de mire de cet ancien salon de danse du Chemist's Club.

La vista desde el balcón del restaurante se centra en la chimenea de piedra caliza que domina este espacio, antiguo salón de baile del Chemist's Club.

La vista dal balcone del ristorante si concentra sul camino in pietra calcarea che domina questo spazio, antica sala da ballo del Chemist's Club.

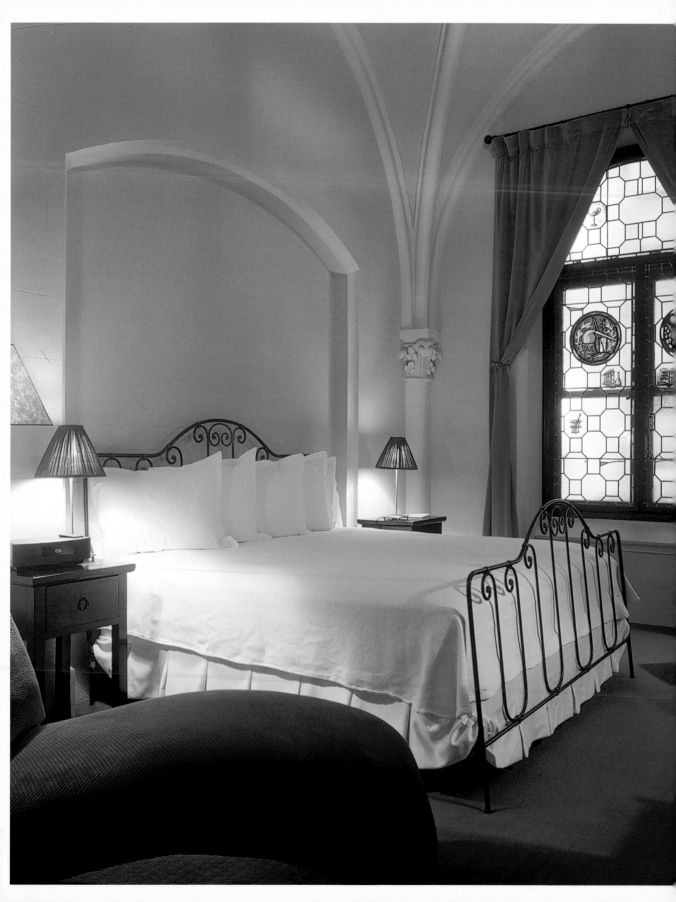

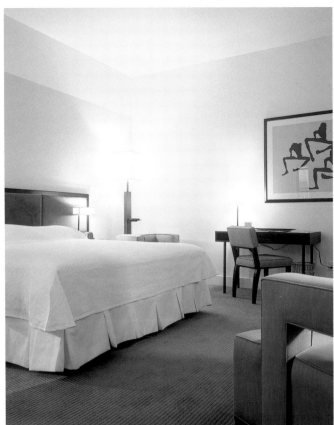
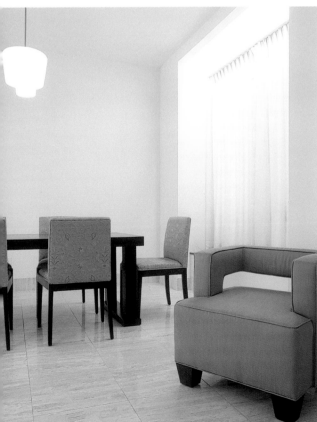

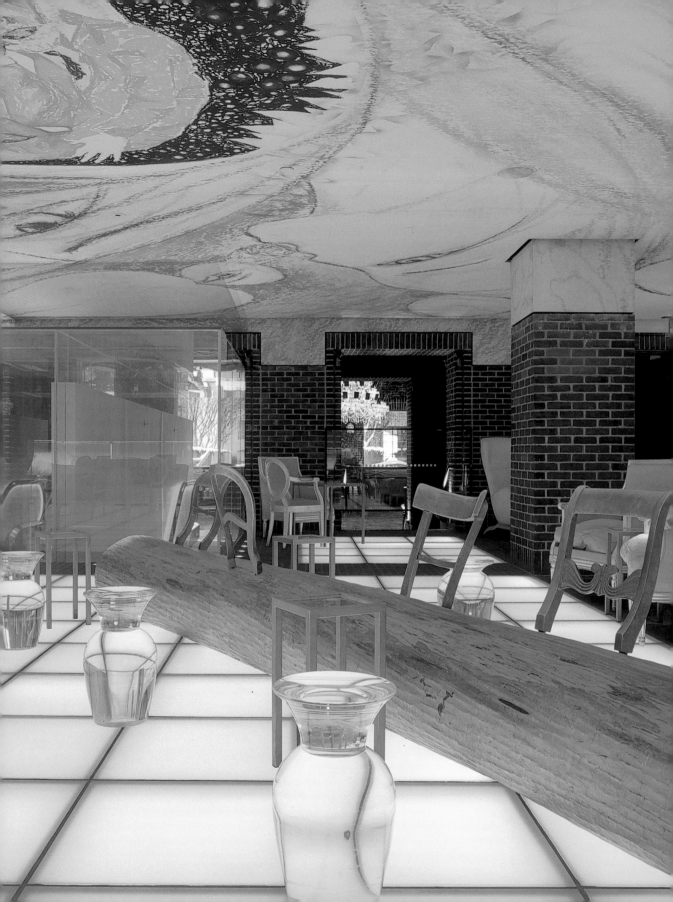

356 West 58th Street, New York, NY 10019, US Tel.: +1 212 554 6000 Fax: +1 212 554 6001

Hudson Hotel

Designer: Philippe Starck Photographer: © Jordi Miralles Opening date: 2000 Rooms: 1.000

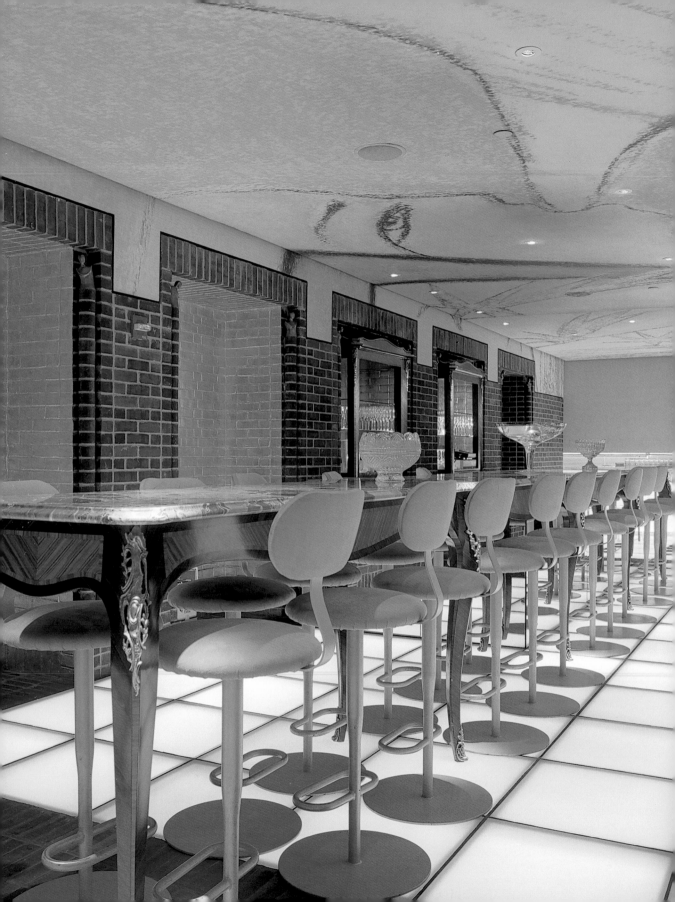

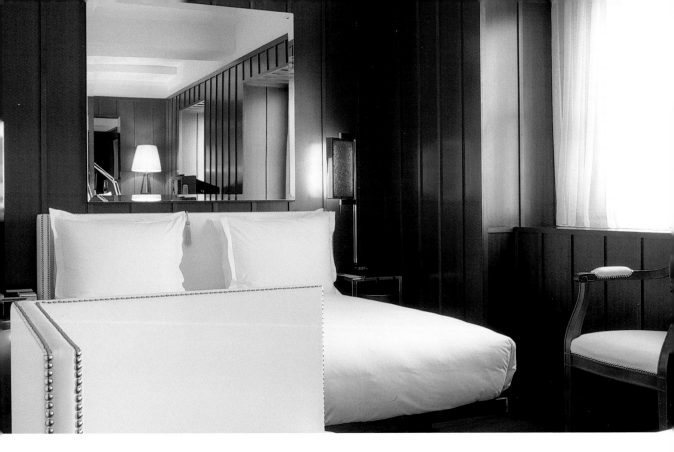

The walls and floors in the rooms are done in makore wood, imported from Africa. The dark wood contrasts with the white curtains, the bedspreads, and the classical lines of the other furnishings.

Die Wände und Böden der Zimmer bestehen aus Makore, das aus Afrika importiert wurde. Das dunkle Holz bildet einen Gegensatz zum Weiß der Gardinen, Überdecken und klassischen Linien der Möbel.

Les murs et les sols des chambres sont en bois de makoré importé d'Afrique. Le bois foncé contraste avec la blancheur des rideaux, des couvre-lits et les lignes classiques du mobilier.

Las paredes y el pavimento de las habitaciones están confeccionados con madera makore importada de África. La madera oscura contrasta con el blanco de las cortinas, los cubrecamas y las líneas clásicas del mobiliario.

Le pareti e il pavimento delle camere sono realizzati in legno di makore importato dall'Africa. Il legno scuro contrasta con il bianco delle tende, dei copriletto e la linea classica della mobilia.

awing of the library

Drawing of the garden

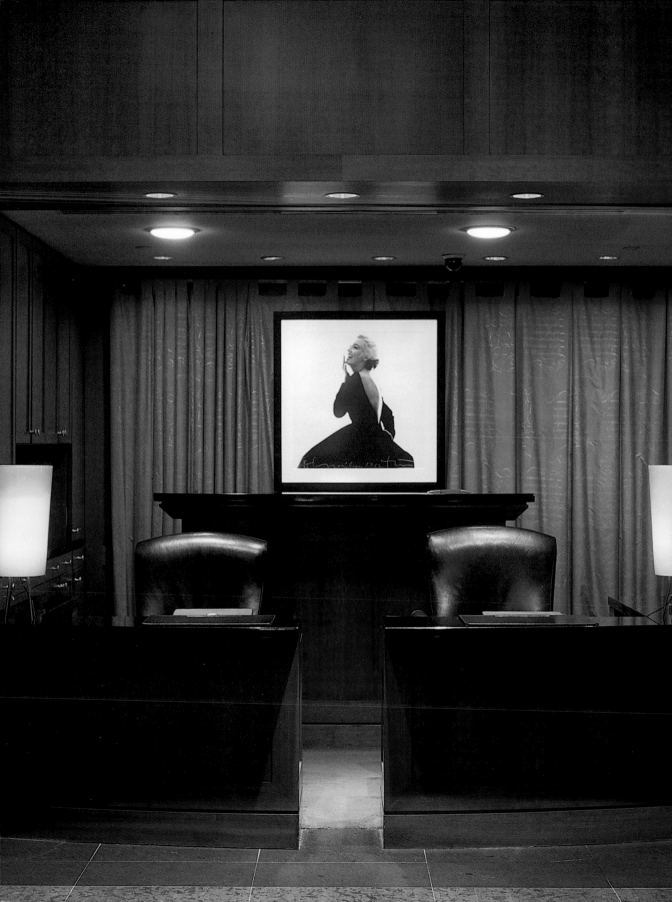

130 West 46th Street, New York, NY 10036, US Tel.: +1 212 485 2400 Fax: +1 212 485 2900
www.themusehotel.com

The Muse

Interior Designer: David Rockwell Photographer: © Pep Escoda Opening date: 2000 Rooms: 181

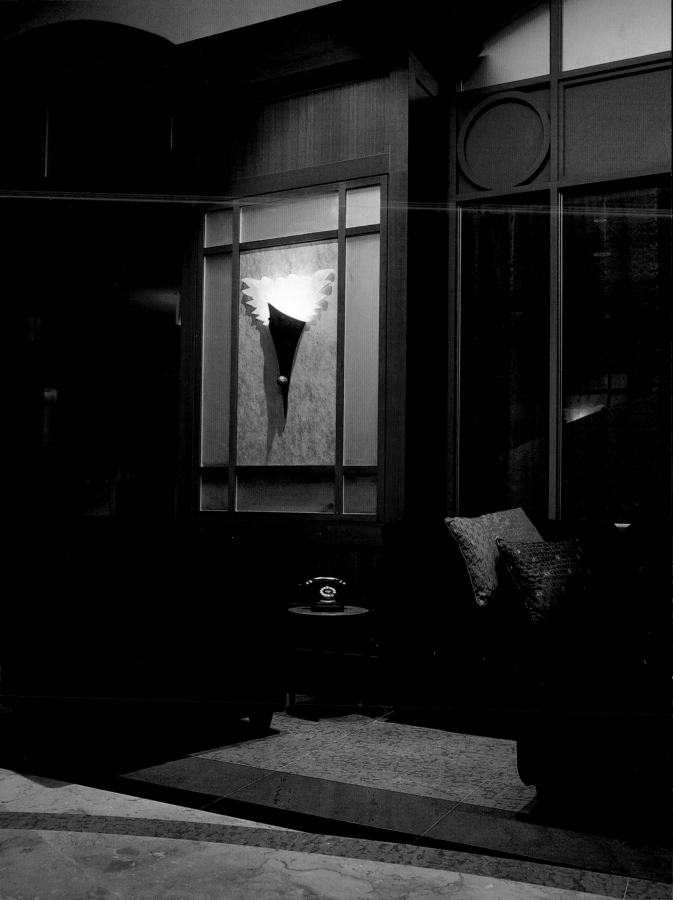

The objective of the design was to immerse the visitor in a glamorous journey through the history of New York show business in the twentieth century. In order to achieve this, the designers drew upon the interior design styles of the Broadway theaters.

Die Raumgestaltung lädt den Gast zu einer glanzvollen Reise durch die Geschichte des Showbusiness in New York im 20. Jahrhundert ein. Dazu ließen sich die Gestalter vom Stil der Theater am Broadway inspirieren.

La conception avait pour mission de plonger l'hôte dans un voyage prestigieux à travers l'histoire du « show business » new-yorkais du 20e siècle. Pour y parvenir, les designers s'inspirèrent du style des théâtres de Broadway.

El objetivo de este diseño consistía en sumergir al huésped en un glamouroso viaje por la historia del "show business" neoyorquino del siglo XX. Para conseguirlo, los diseñadores se inspiraron en el estilo de los teatros de Broadway.

Il progetto aveva come obiettivo quello di immergere gli ospiti in un glamouroso viaggio nella storia del "show business" newyorchese del XX secolo. Per riuscirci, i designer hanno tratto ispirazione dallo stile dei teatri di Broadway.

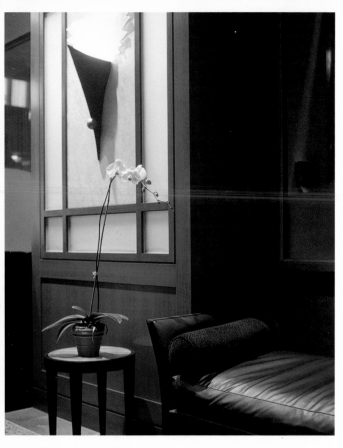

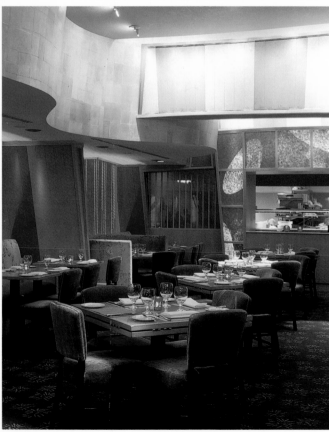
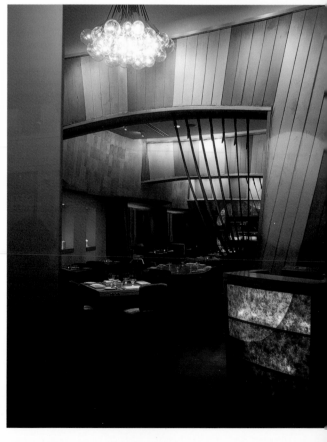

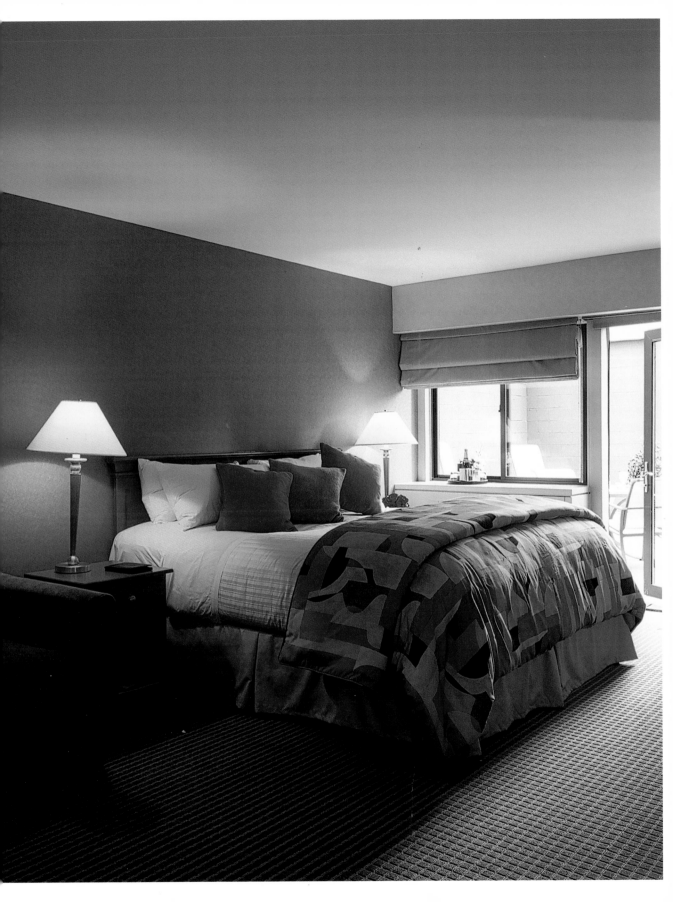

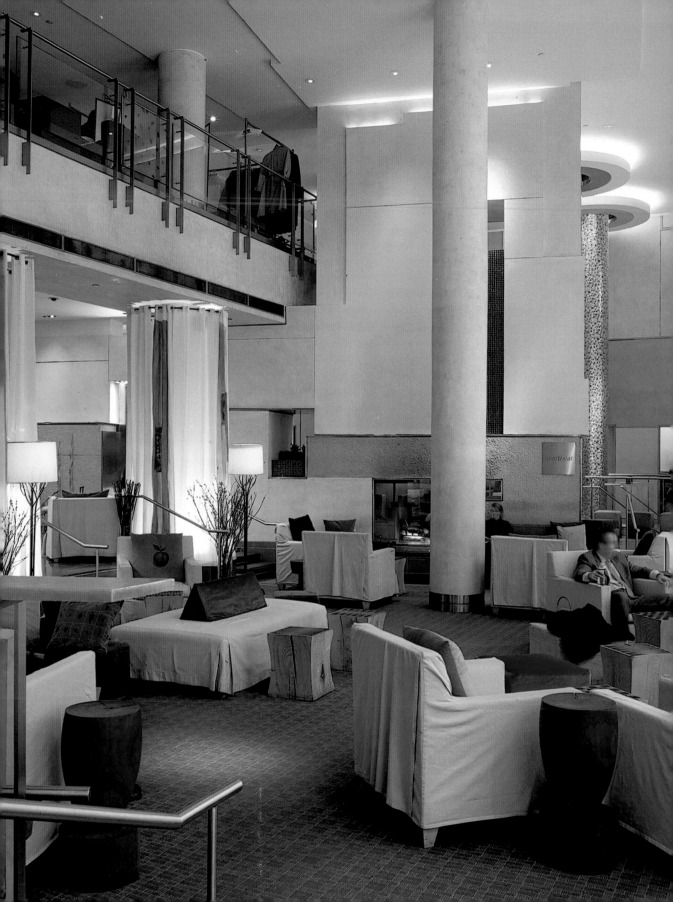

201 Park Avenue South, New York, NY 10003, US Tel.: +1 212 253 9119 Fax: +1 212 253 9229
www.whotels.com

W Union Square

Architect: David Rockwell **Photographer:** © Jordi Miralles **Opening date:** 2000
Rooms: 270 (including 16 luxury suites)

The reception area is a double height space flooded with light and maintains a close relationship between interior and exterior. The monumental character of this space contrasts with the rather informal furnishings, creating a particularly unique atmosphere.

Die Empfangshalle ist ein lichtdurchfluteter Raum von doppelter Höhe, der eine enge Verbindung zwischen außen und innen schafft. Der monumentale Charakter des Raums steht zu den eher schlichten, fast lässigen Möbeln im Gegensatz, was eine ganz besondere Atmosphäre entstehen lässt.

La réception est un espace sur deux niveaux, inondé de lumière, avec un étroit trait d'union entre l'intérieur et l'extérieur. L'espace monumental contraste avec le mobilier simple, presque informel, créant une atmosphère particulière.

El recibidor es un espacio de doble altura inundado de luz con una estrecha relación entre el interior y el exterior. El carácter monumental del espacio contrasta con un mobiliario casual, casi informal, que genera una atmósfera particular.

L'ingresso è uno spazio a doppia altezza, inondato di luce, dove si evidenzia la stretta simbiosi tra l'interno e l'esterno. Il carattere monumentale dello spazio contrasta con un arredamento casual, quasi informale, che crea un'atmosfera davvero particolare.

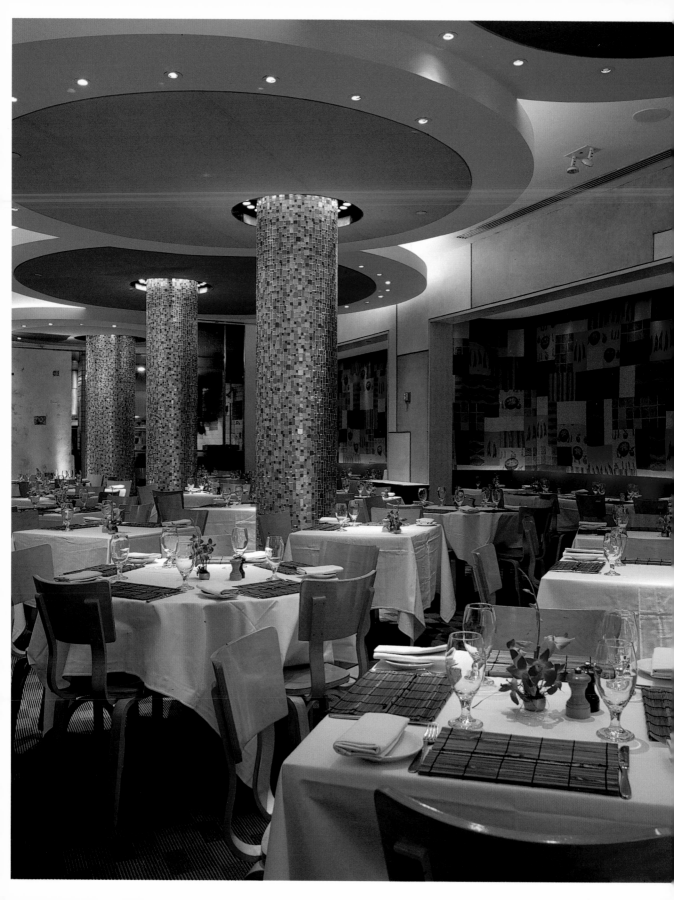

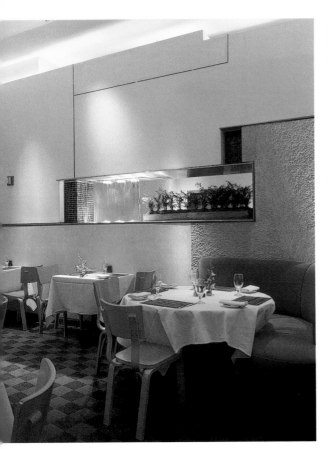
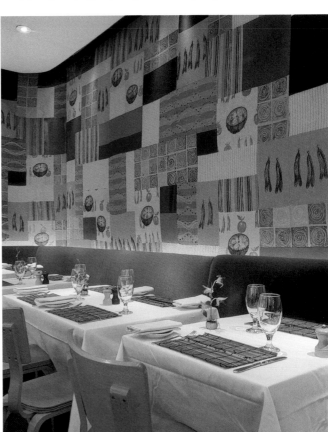
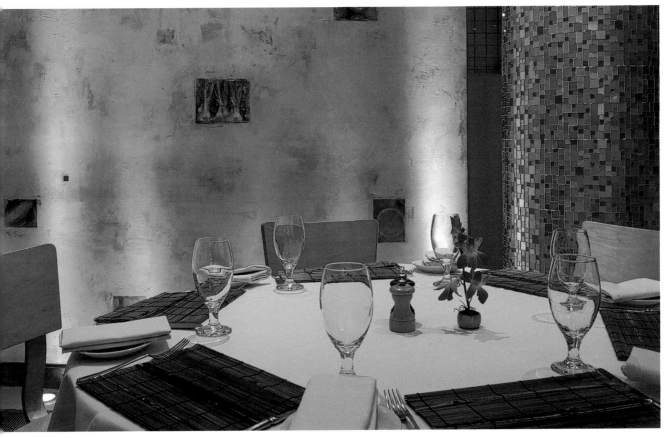

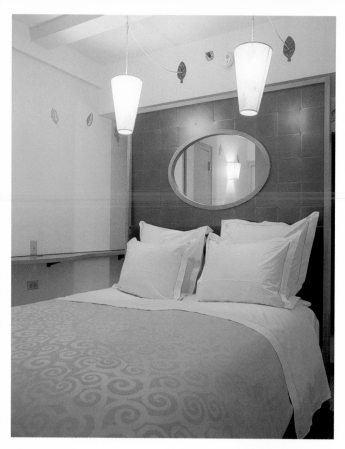
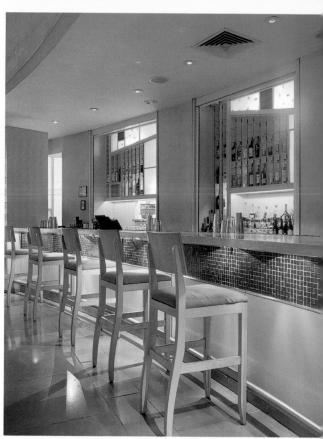
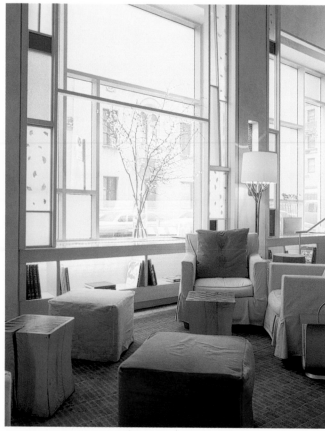
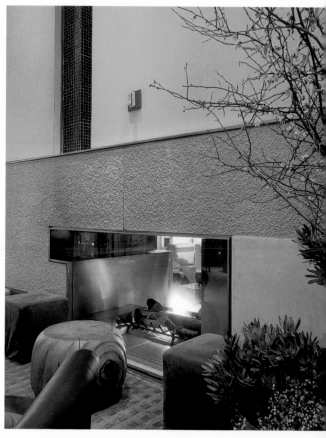

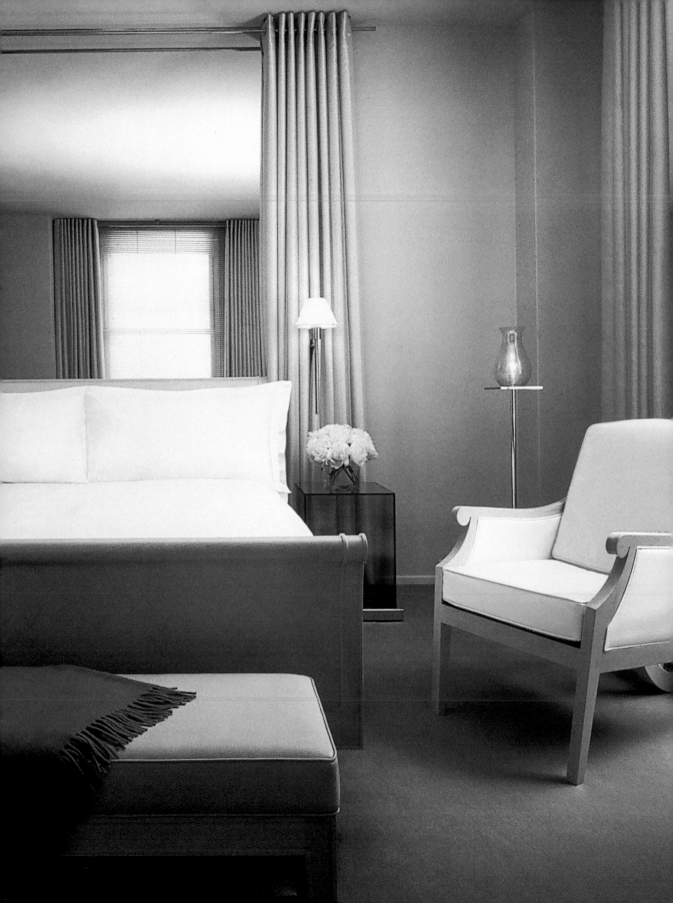

495 Geary Street, San Francisco, CA 94102, US Tel.: +1 415 775 4700 Fax: +1 415 447 6580
clift@morganshotelgroup.com www.morganshotelgroup.com

Clift

Architects: Mc Donald & Applegarth **Interior Designer:** Philippe Starck **Photographer:** © Todd Eberle
Opening date: 2001 **Rooms:** 375

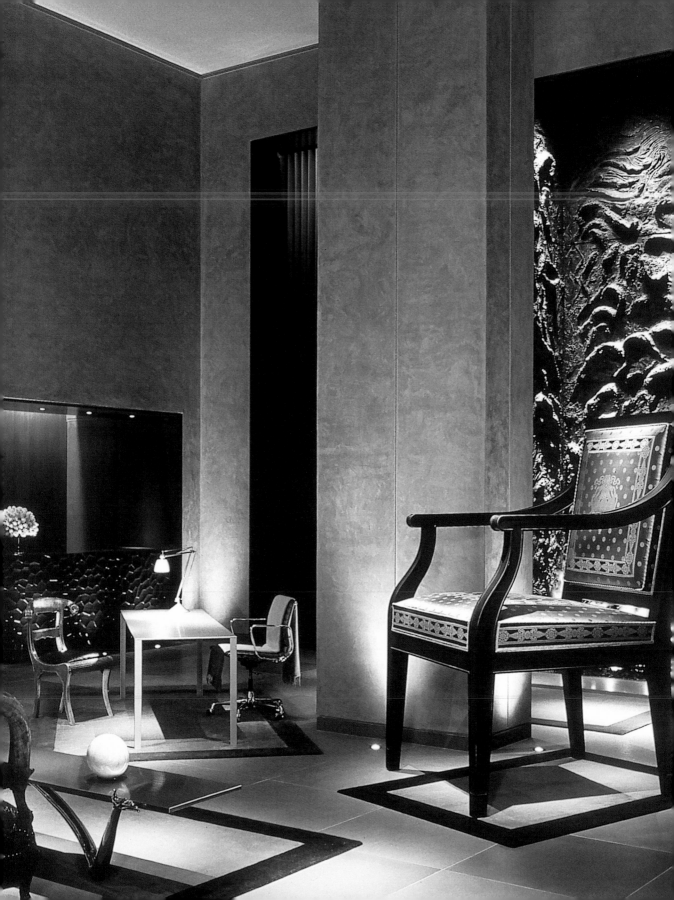

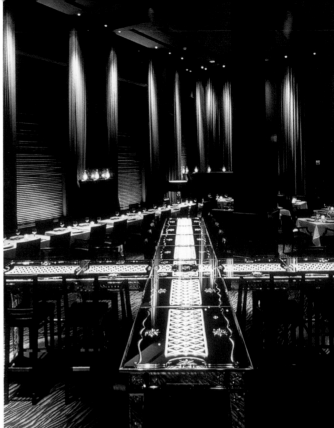

The influence of contemporary design in South Florida, combined with more classic touches and luxurious Asian art, generates an energetic image which takes form in colors, shapes, lights, and well-defined shadows.

Durch den Einfluss des zeitgenössischen Designs im Süden Floridas, kombiniert mit klassischen Elementen und luxuriösen, asiatischen Kunstobjekten, wird ein vibrierendes Klima geschaffen, unterstrichen durch Farben, Formen, Licht und Schatten.

L'influence du design contemporain dans le sud de la Floride, associé à des touches classiques et des œuvres d'art d'Asie, crée une image vibrante par le biais de couleurs, formes, jeux d'ombre et de lumière.

La influencia de diseño contemporáneo en el sur de Florida, combinado con toques clásicos y lujosas piezas de arte asiático, genera una imágen vibrante a través de los colores, las formas, las luces y las sombras.

L'influenza di stile contemporaneo nel sud della Florida, abbinata a dei tocchi classici e lussuosi pezzi di arte asiatica, genera un'immagine vibrante attraverso i colori, le forme, la luce e l'ombra.

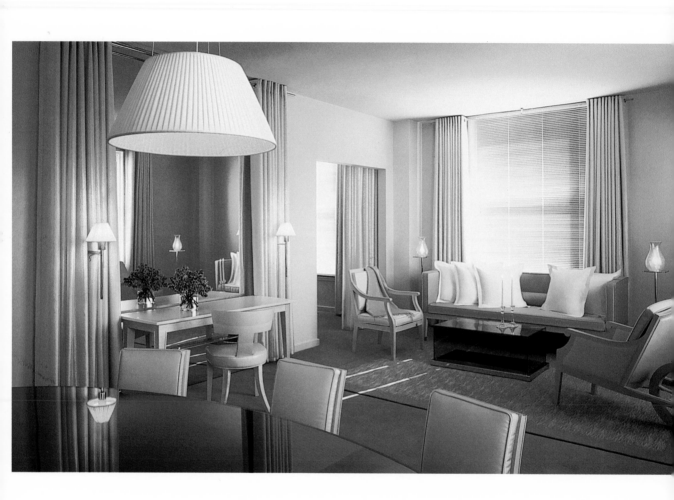

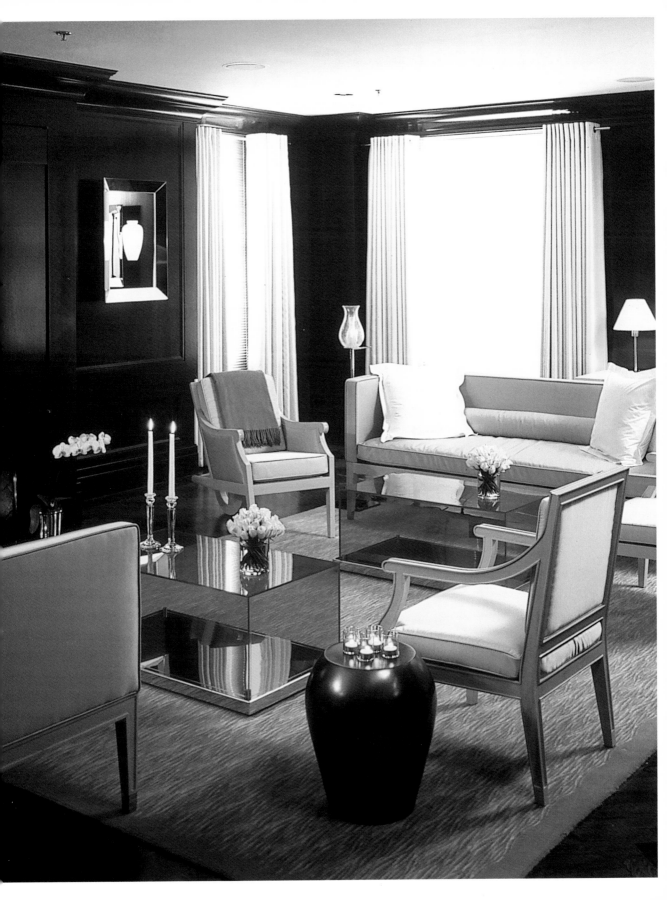

342 Grant Avenue, San Francisco, CA 94108, US Tel.: +1 415 394 0500 Fax: +1 415 394 0555
www.hotel-tritonsf.com

Hotel Triton

Designers: Michael Moore + Various Artists **Photographer:** © Roger Casas **Opening date:** 2001 **Rooms:** 140

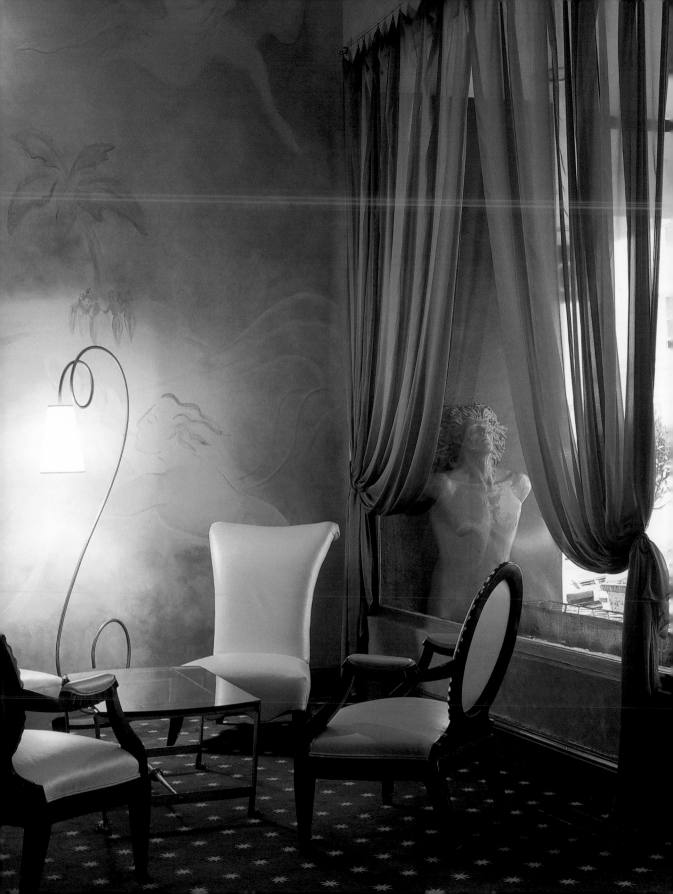

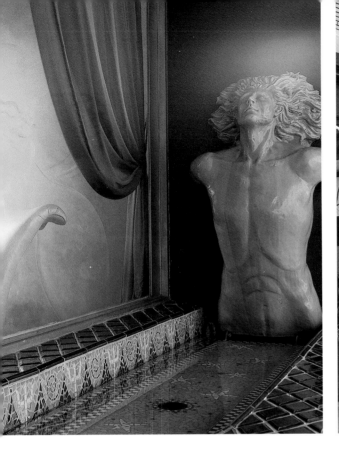
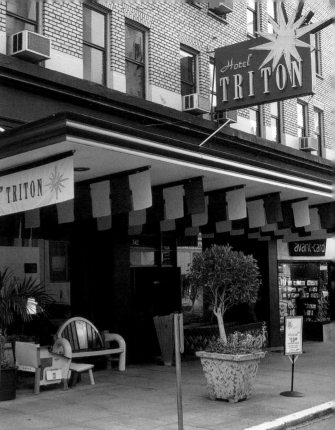

The mythological references and the use of a number of traditional details such as tapestries, rugs, and curtains give the interior a mix of multiple styles and colors.

Die Räume sind durch mythologische Anspielungen und die Verwendung verschiedener traditioneller Elemente wie Wand- und Bodenteppiche und Gardinen geprägt, was der Mischung von Stilen und Farben noch mehr Ausdruck verleiht.

Les allusions à la mythologie et l'utilisation de divers détails traditionnels, à l'instar de tapisseries, tapis et rideaux, accentuent le mélange de styles et de couleurs qui caractérise l'intérieur.

Las referencias mitológicas y la implementación de distintos detalles tradicionales, como los tapices, las alfombras y las cortinas, acentúan la combinación de estilos y colores que caracteriza el interior.

I riferimenti mitologici e l'uso di diversi dettagli tradizionali come gli arazzi, i tappeti e le tende sottolineano la mescolanza di stili e colori che caratterizza l'interno.

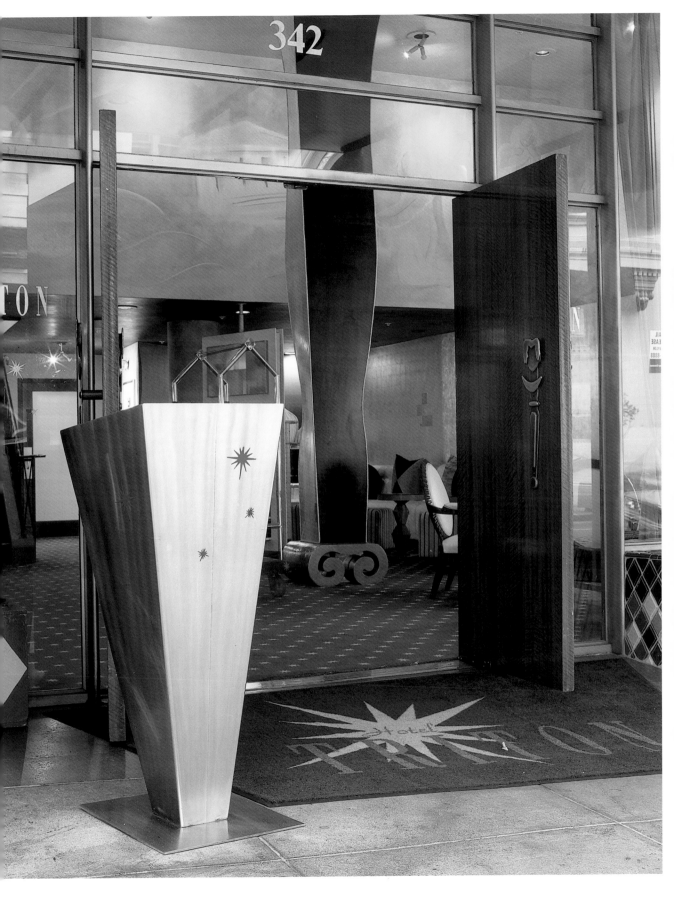

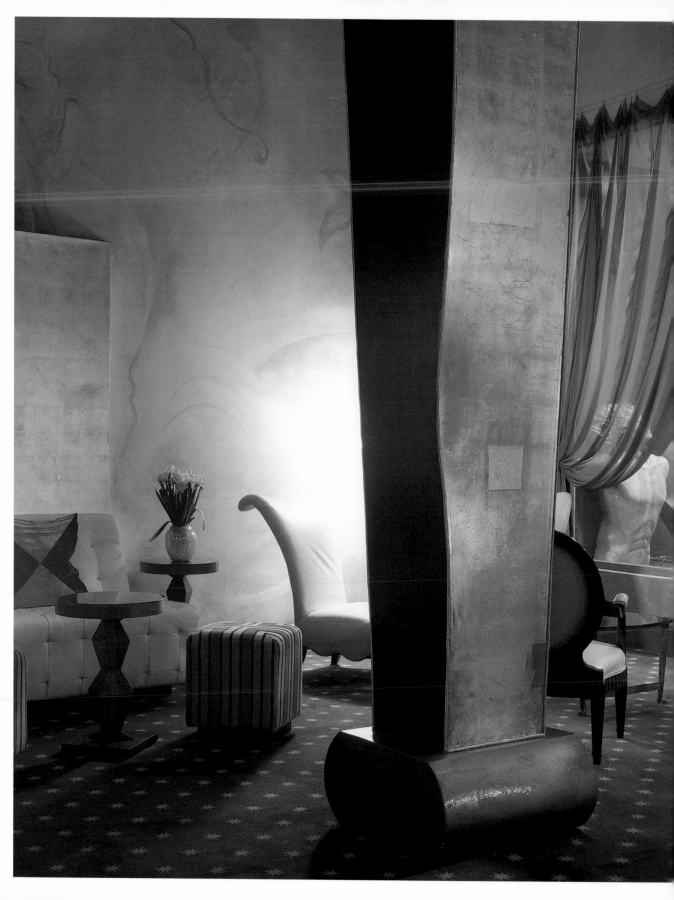

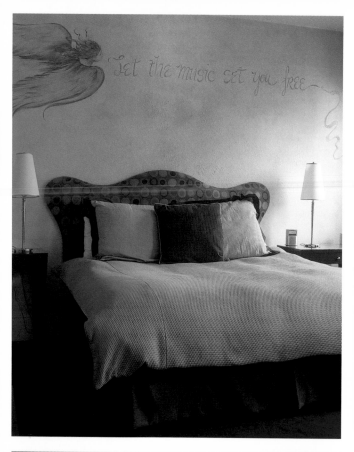

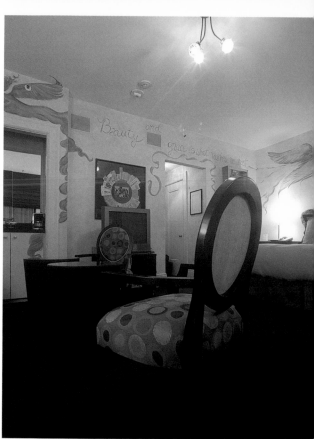

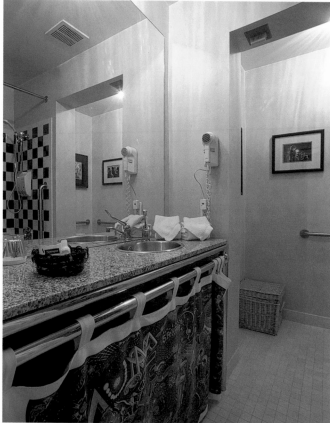

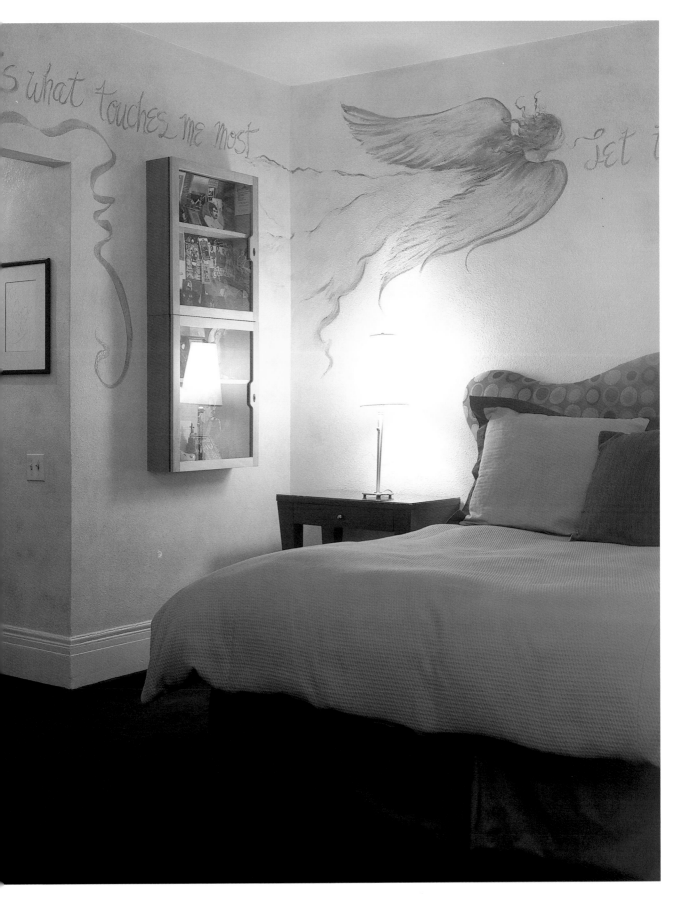

2423 1st Avenue, Seattle, WA 98121, US Tel.: +1 206 448 4721 Fax: +1 206 374 0745
reservations@theacehotel.com www.theacehotel.com

Ace Hotel

Architect: Eric Hentz Mallet Photographers: © Jim Henkens and Chad Brow Opening date: 1999 Rooms: 34

Light, ethereal materials such as aluminum or glass in conjunction with soft tones would have produced an unwanted coldness and are thus combined with warmer, natural textures and tones.

Die Kombination von ätherischen und leichten Materialien wie Aluminium oder Glas und sehr hellen Tönen würde eine zu kalte Atmosphäre entstehen lassen. Deshalb wurden hier wärmere Texturen und Töne eingesetzt.

L'association de matières éthérées et légères comme l'aluminium ou le cristal, à des teintes très claires aurait crée une ambiance trop froide, d'où le choix de textures et tons plus chauds.

La combinación de materiales etéreos y ligeros, como el aluminio o el cristal, con tonos muy claros hubiera generado un ambiente demasiado frío, por lo que se optó por texturas y tonalidades más cálidas.

L'accostamento di materiali eterei e leggeri come l'alluminio o il vetro, a toni molto chiari avrebbe prodotto un ambiente troppo freddo, perciò si è optato per delle texture e tonalità più calde.

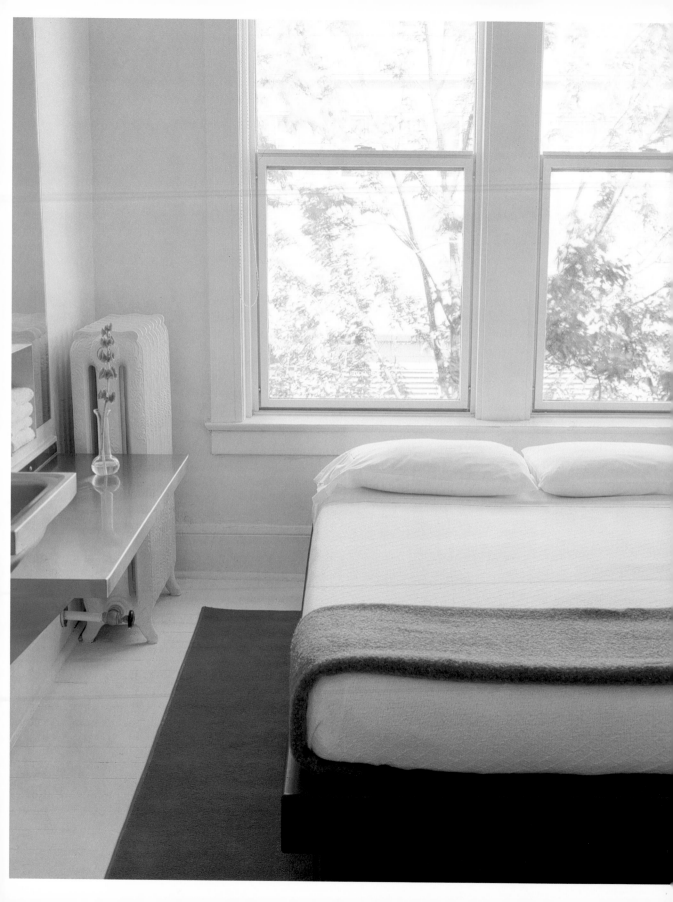

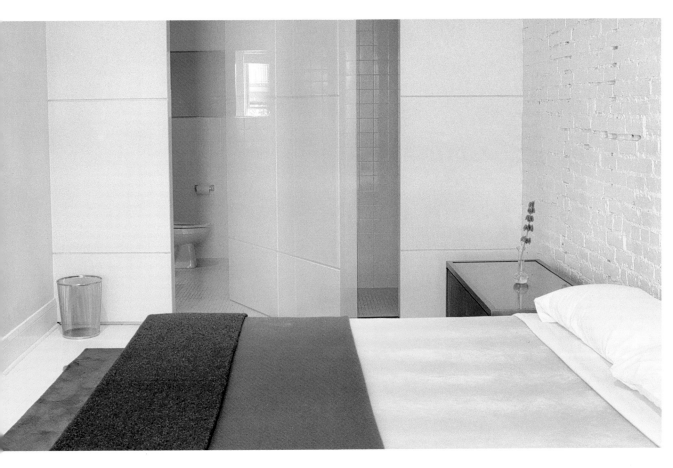

Layout of upper floors

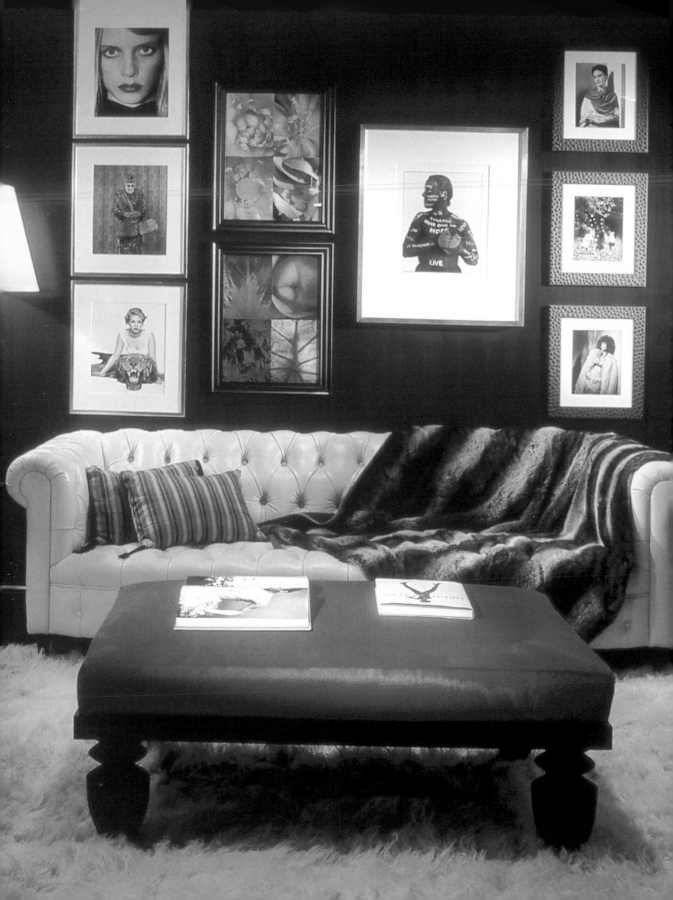

1315 16th Street, Washington DC 20036, US Tel.: +1 202 232 8000 Fax: +1 202 667 9827
www.rougehotel.com

Hotel Rouge

Interior Designer: Michael Moore Photographer: © David Phelps Opening date: 2001 Rooms: 137

The color red is the characteristic feature in the common areas—the lobby and the bar—as well as in the halls and private areas, where coverings and upholstery in red Chinese silk and leopard pattern rugs are used.

Die Farbe Rot als eine Art Identitätszeichen hebt sich in den Gemeinschaftsräumen, also Empfangshalle und Bar, und in den privaten Zimmern und Fluren in Form von Verkleidungen mit roter, chinesischer Seide in Kombination mit Leopardenteppichen ab.

La couleur rouge est la caractéristique qui se dégage des espaces communs – vestibule et bar – et des espaces privés, y compris les couloirs – tendus de soie rouge de Chine alliée à des tapis de léopard.

El color rojo destaca como rasgo de identidad tanto en los espacios comunes –vestíbulo y bar– como en los espacios privados y los pasillos, donde están revestidos de seda roja china y alfombras de leopardo.

Il rosso come segno di identità predomina negli spazi comuni – hall e bar – e nelle zone private, compresi i corridoi – foderati di seta cinese rossa e abbinati a dei tappeti di leopardo.

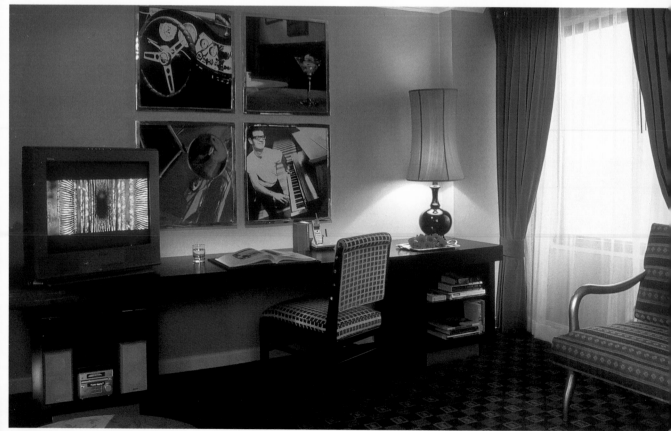

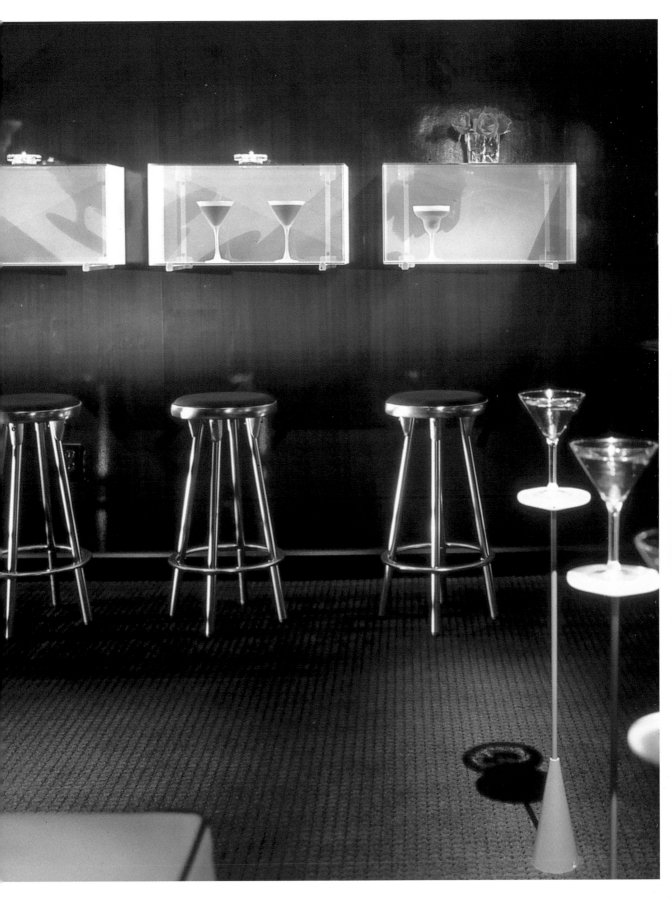

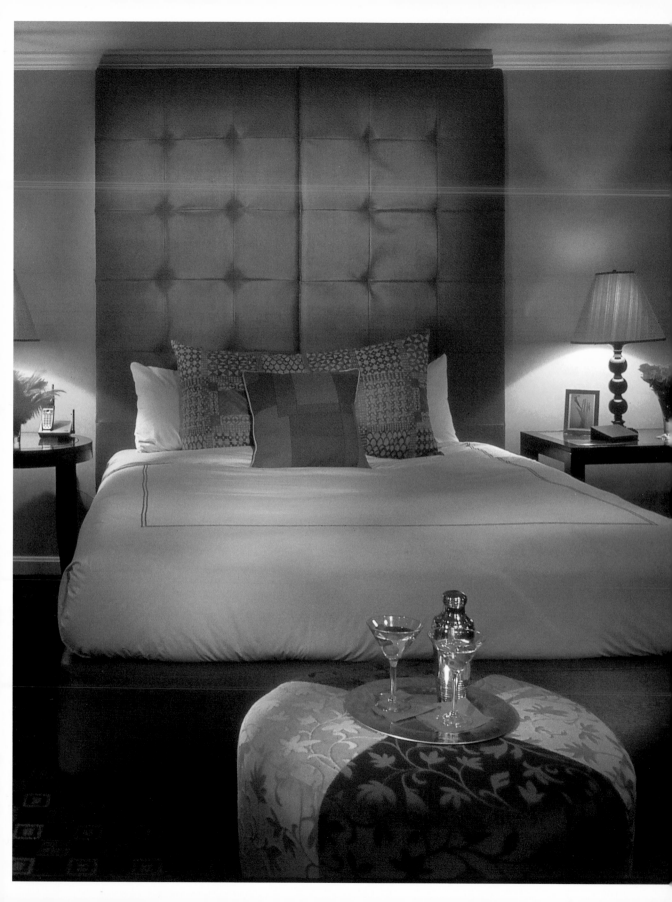

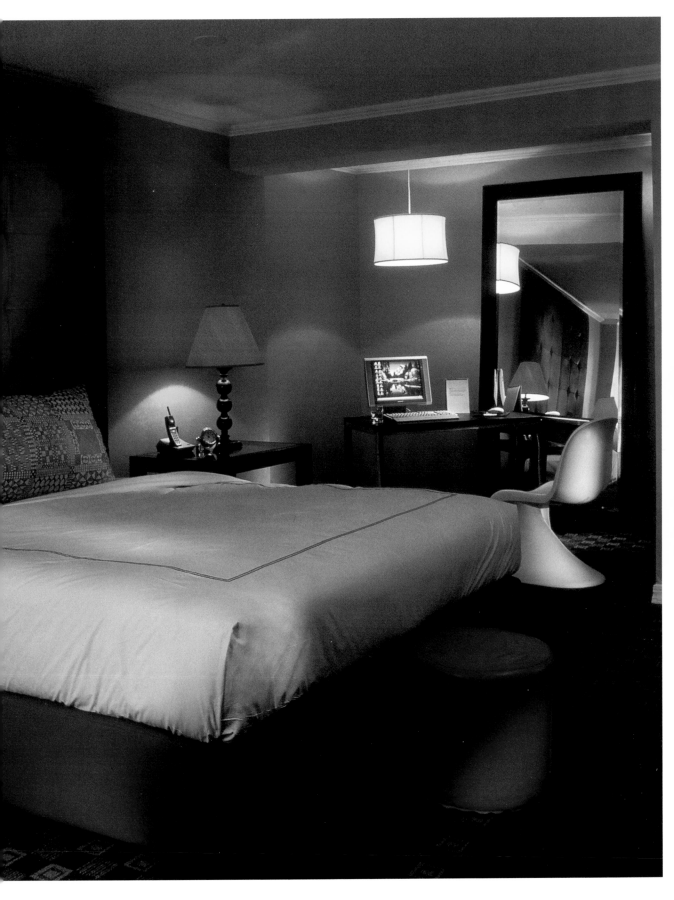

Avenida de los Cangrejos and Avenida del Mar, Punta del Este, 20001 La Barra, Uruguay
Tel.: +59 842 77 2082 Fax: +59 842 77 0246 leclub@fibertel.com.ar www.leclubposada.com

Le Club

Architect: Horacio Ravazzani Photographers: © Ricardo Labougle and Victor Carro
Opening date: 2002 Rooms: 10

Restrained, rational lines characterize the building. In the common areas, such as the lobby and restaurant, the idea of open, continuous space predominates.

Die nüchternen und rationalen Linien prägen das Gebäude. In den Gemeinschaftszonen wie in der Empfangshalle und im Restaurant herrschen offene und durchgehende Räume vor.

Les lignes dépouillées et rationnelles marquent le caractère de l'édifice. La prédominance d'espaces ouverts et continus caractérise les zones communes, à l'instar du vestibule et du restaurant.

Las líneas sobrias y racionales caracterizan el edificio. En las zonas comunes, como en el vestíbulo y el restaurante, predominan los espacios abiertos y continuos.

Le linee sobrie e razionali danno carattere all'edificio. Nelle zone comuni, come la hall e il ristorante, predominano gli spazi aperti e continui.

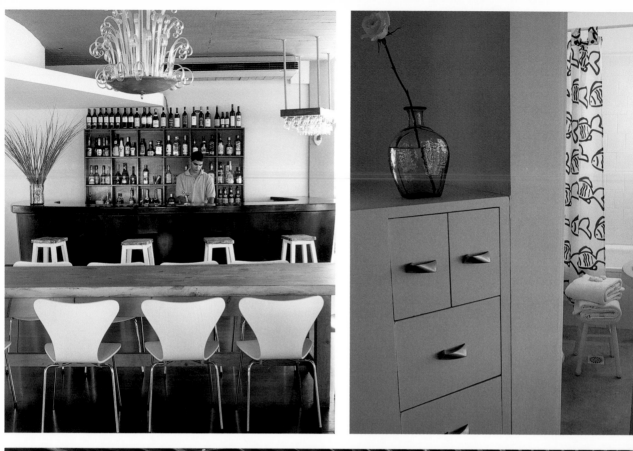

 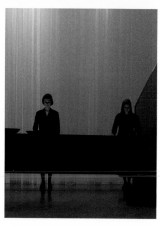 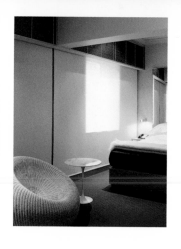 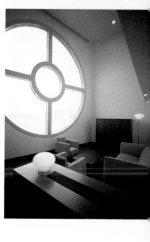

Australia / Asia

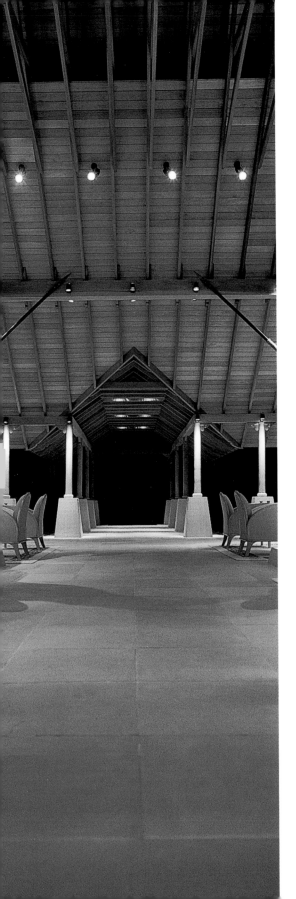

Australia

China

Japan

Malaysia

2 Acland Street, St. Kilda, Victoria 3182, Melbourne, Australia Tel.: +61 3 9536 1111
Fax: +61 3 9536 1100 thedesk@theprince.com.au www.theprince.com.au

The Prince

Architect: Alan Powell Interior Designer: Paul Hecker Photographer: © Earl Carter
Opening date: 1999 Rooms: 40

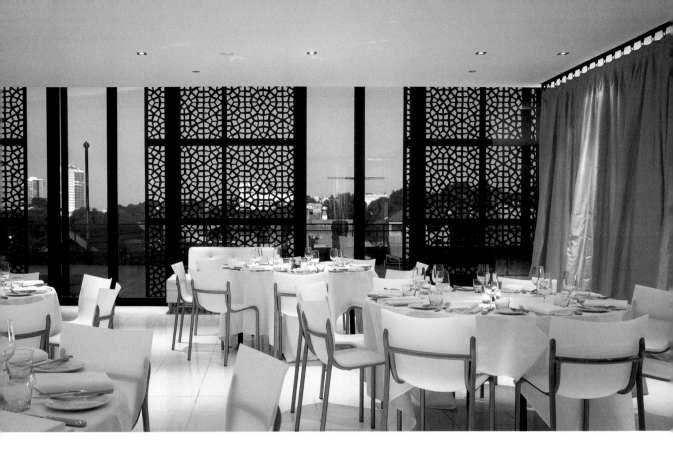

The restaurant enjoys a great deal of natural light from the glass windows that surround the space. A sense of intimacy is achieved by the use of dividers in front of the windows, while the salmon-colored curtains add a splash of color to the all white space.

Durch die großen Fenster des Saals dringt viel Tageslicht in das Restaurant. Durch Paneele, die die Fenster bedecken, wurde eine intimere Atmosphäre geschaffen. Die lachsfarbenen Gardinen geben dem weißen Raum etwas Farbe.

Le restaurant reçoit une abondance de lumière naturelle grâce aux baies vitrées de la salle. Les panneaux qui couvrent les fenêtres créent une impression d'intimité et les rideaux saumon égaient l'espace blanc d'une touche de couleur.

El restaurante goza de abundante luz natural gracias a los ventanales de la sala. Una sensación de intimidad se logra a través de los paneles que cubren las ventanas, mientras que las cortinas de color salmón aportan un toque de colorido al espacio blanco.

Grazie ai grandi finestroni della sala, il ristorante riceve luce naturale in abbondanza. La sensazione di intimità è data dai pannelli che rivestono le finestre, mentre le tende color salmone aggiungono una nota di colore allo spazio bianco.

First floor

Layout of upper floors

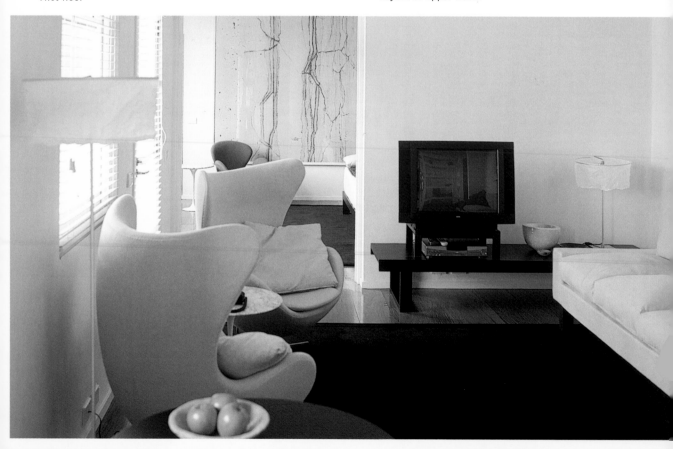

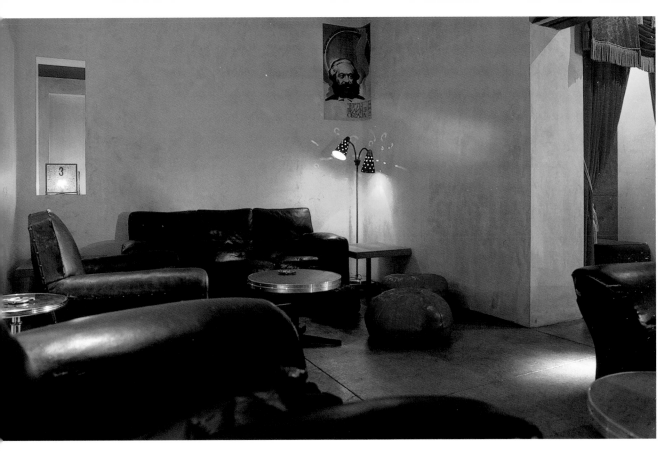
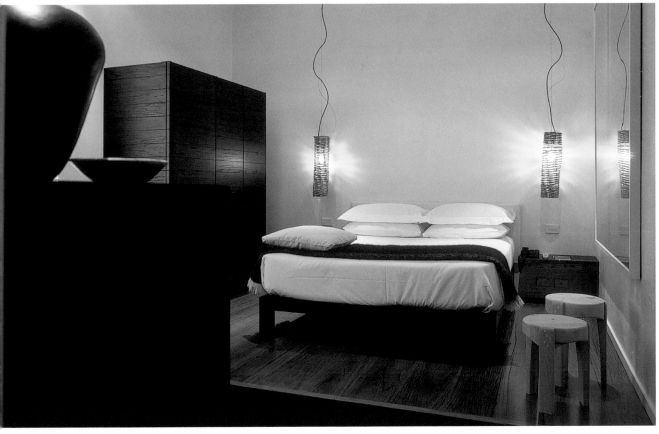

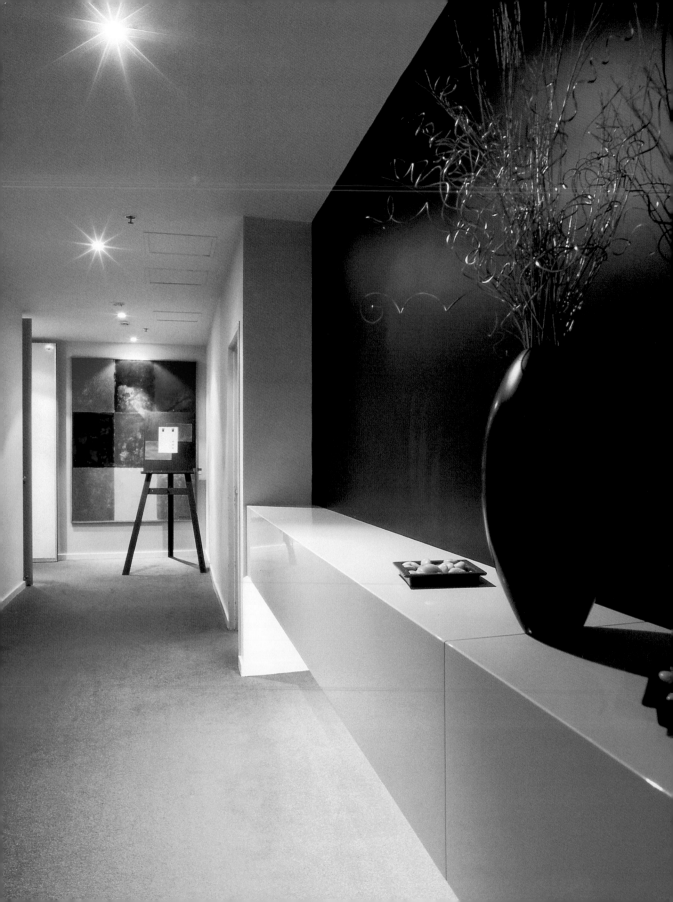

70 King Street, Sydney, NSW 2000, Australia Tel.: +61 2 9279 3030 Fax: +61 2 9279 3020
theblacket@theblacket.com www.theblacket.com

Blacket Hotel

Designer: John Harrs **Photographer:** © Marian Riabic **Opening date:** 2001 **Rooms:** 42

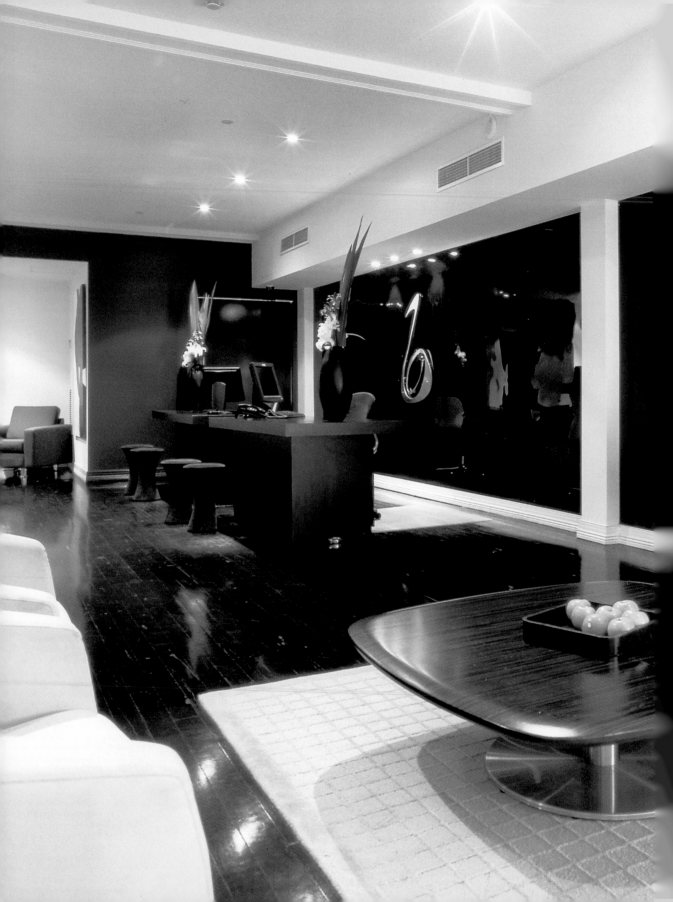

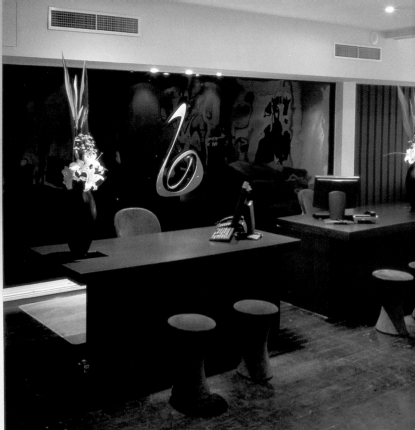

The interior design projects a decidedly renewed image, employing pieces of contemporary art and design and a range of soft, neutral tones among which cream, gray, and chocolate prevail.

Durch die Gestaltung der Räume entstand ein neues Erscheinungsbild, das von zeitgenössischen Kunstwerken und Möbeln geprägt ist, unterstrichen durch neutrale Töne. Die Farben Cremeweiß, Grau und Schokoladenbraun heben sich hervor.

Le design intérieur projette une nouvelle image qui met en valeur des œuvres d'art et mobilier contemporains grâce à une gamme de tons neutres, comme le blanc cassé, le gris et le brun chocolat.

El diseño interior proyecta una imagen renovada que exhibe piezas contemporáneas de arte y diseño junto con una gama de tonos neutros de los que destacan los colores blanco roto, el gris y el marrón chocolate.

Lo stile dell'interno progetta un'immagine rinnovata che sfoggia opere d'arte contemporanee ed elementi di arredo assieme ad una gamma di toni neutri tra i quali spiccano il bianco avorio, il grigio e il color cioccolato.

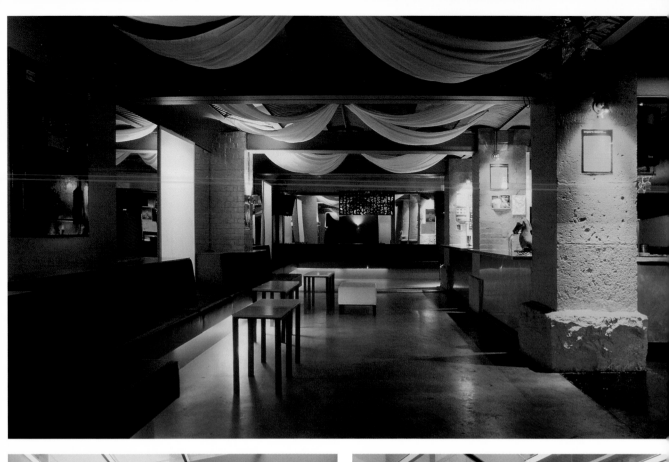

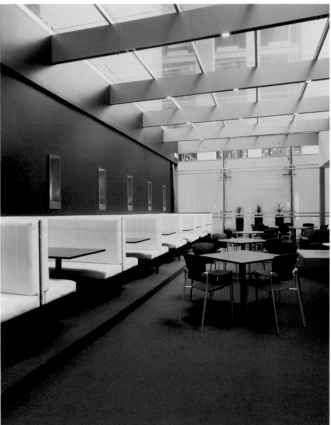

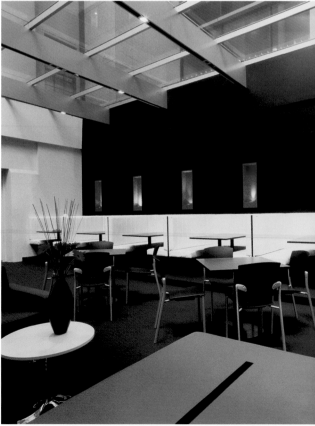

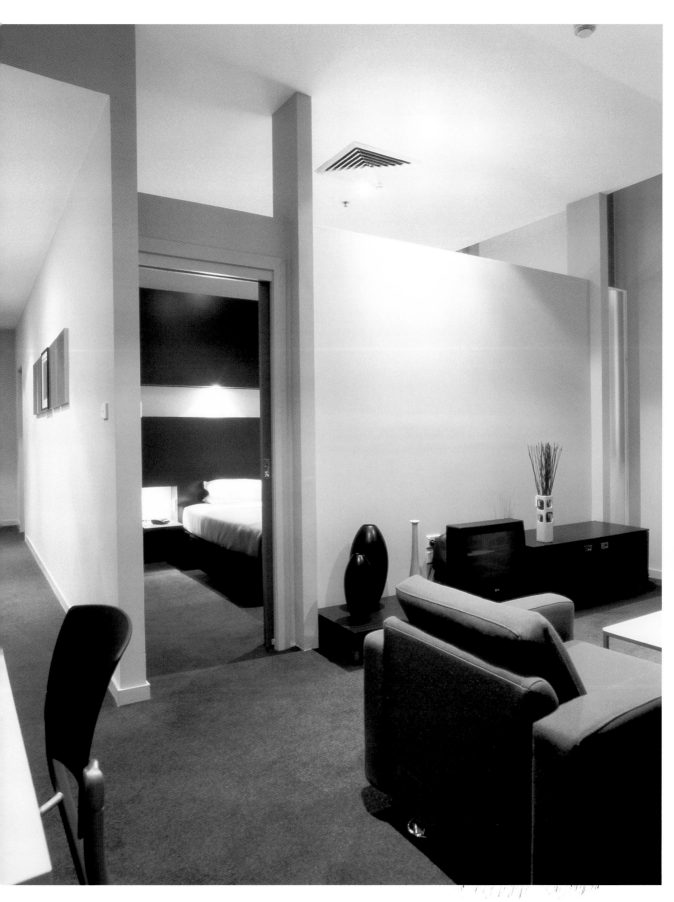

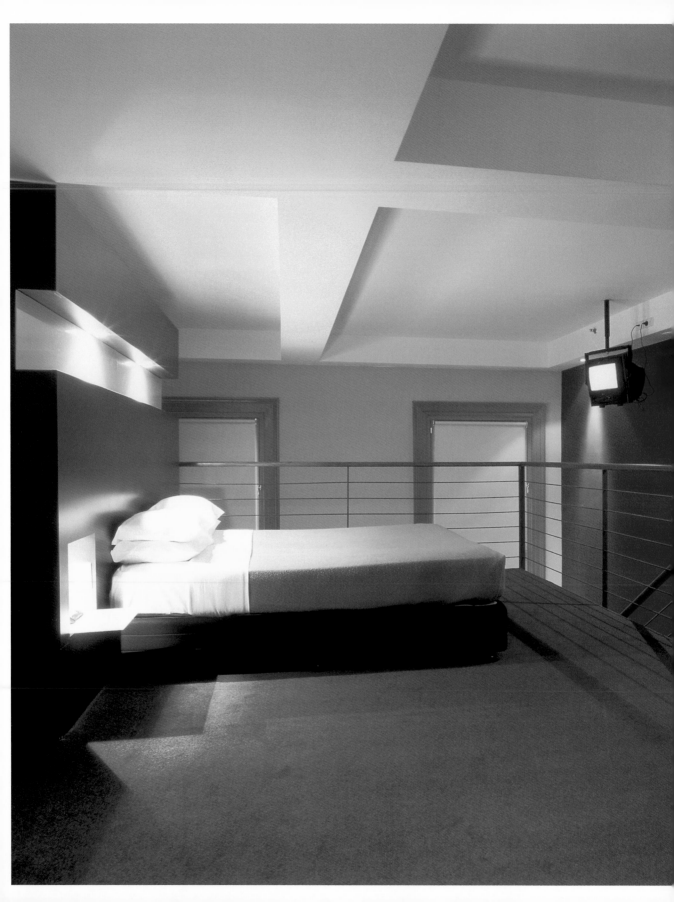

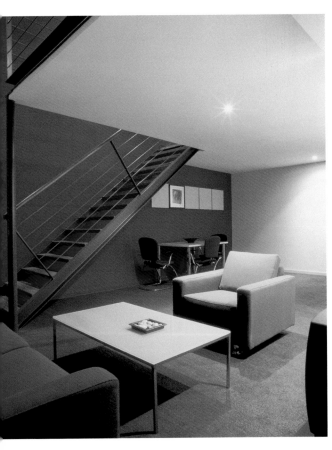
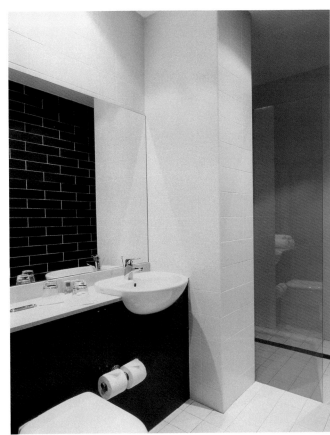
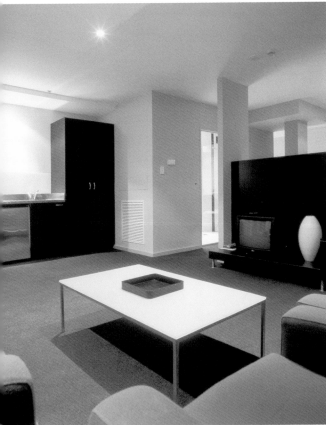
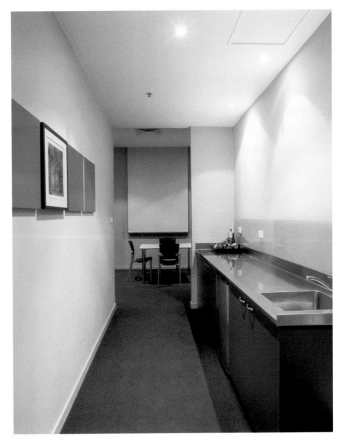

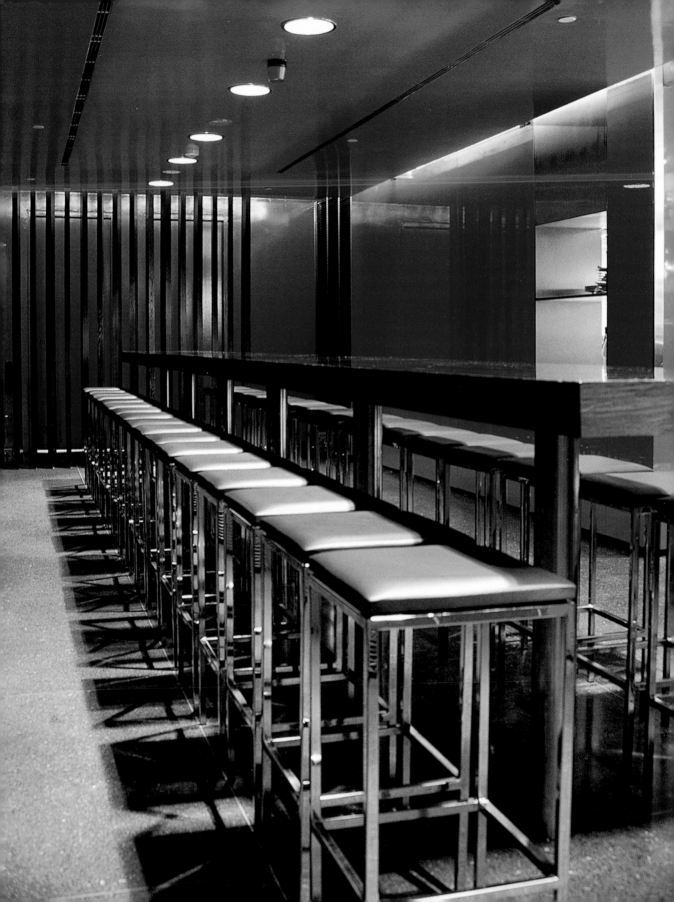

229 Darlinghurst Road, NSW 2010, Sydney, Australia Tel.: +61 2 9332 2011 Fax: +61 2 9332 2499
info@kirketon.com.au www.kirketon.com.au

Kirketon

Architects: Burley Katon Halliday Architects Photographer: © Sharin Rees
Opening date: 1999 Rooms: 40

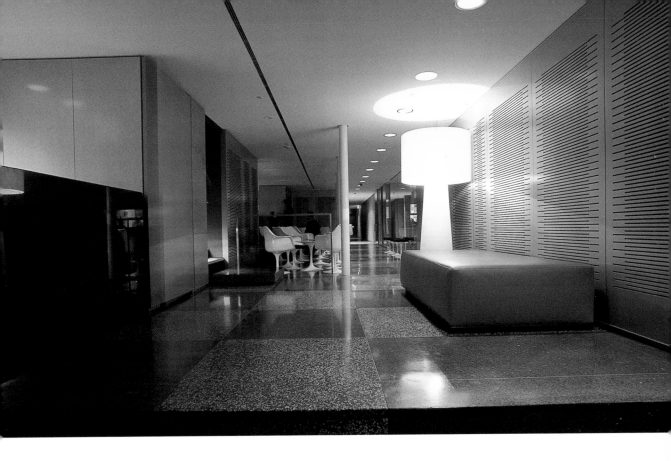

The chromatic uniformity of the space and the scarcity of decorative elements create a tranquil and sophisticated atmosphere in the entrance and reception area.

Die einheitlichen Farben der Räumlichkeiten und die sparsam eingesetzten Dekorationselemente schaffen im Eingangsbereich und am Empfang eine ruhige und gleichzeitig erlesene Atmosphäre.

L'unité chromatique de l'espace et les rares éléments décoratifs qui s'y greffent créent une atmosphère à la fois calme et sophistiquée dans la zone d'accès et de réception.

La uniformidad cromática del espacio, así como los escasos elementos decorativos, crean una atmósfera tranquila y a la vez sofisticada en la zona de acceso y recepción.

L'uniformità cromatica dello spazio, nonché gli scarsi elementi decorativi, creano un'atmosfera tranquilla e al contempo sofisticata nella zona di ingresso e della reception.

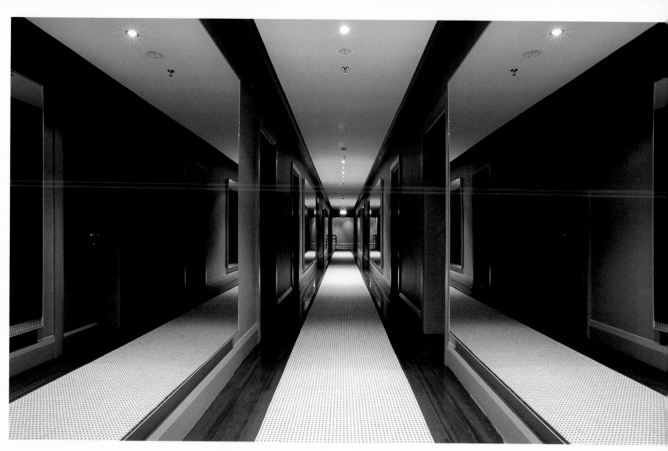

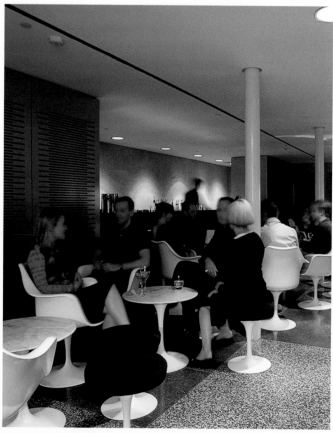

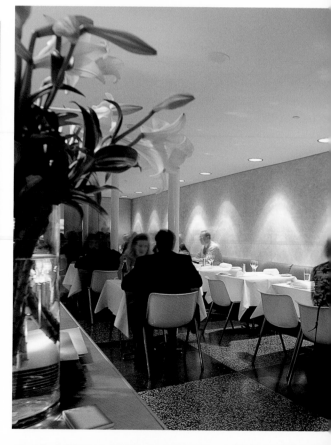

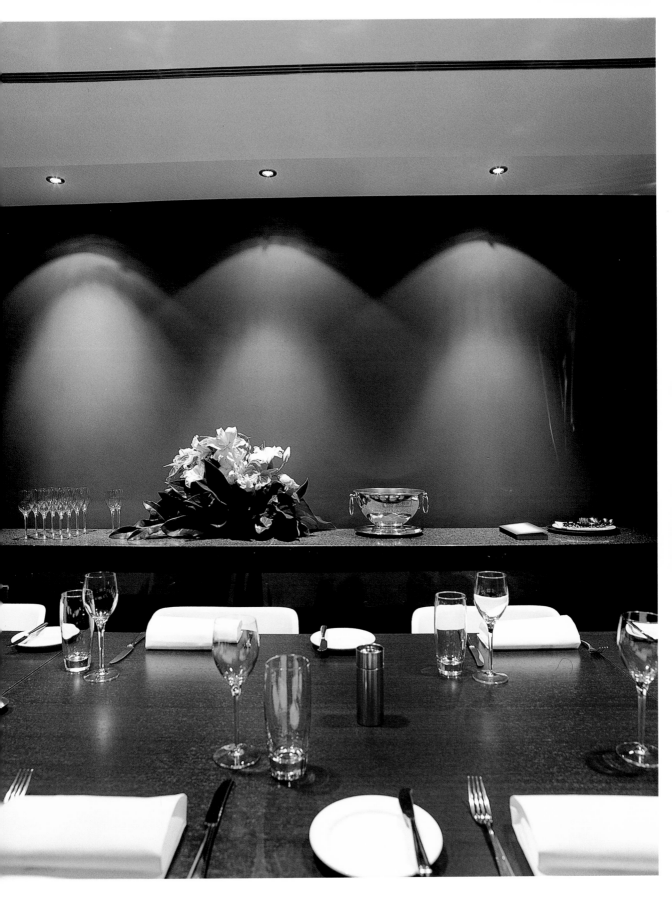

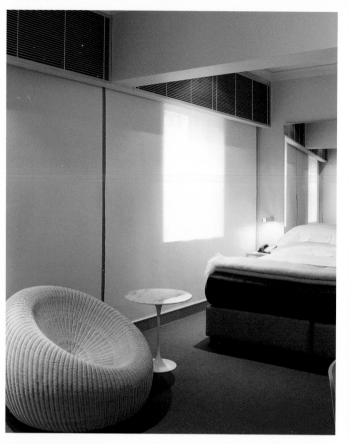
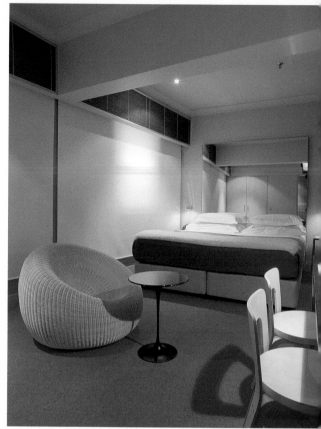
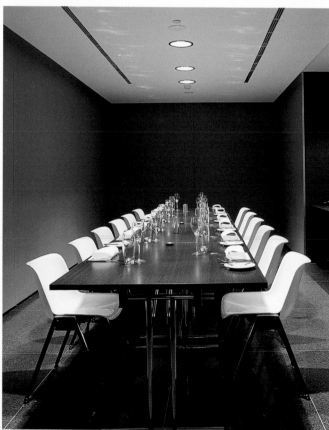

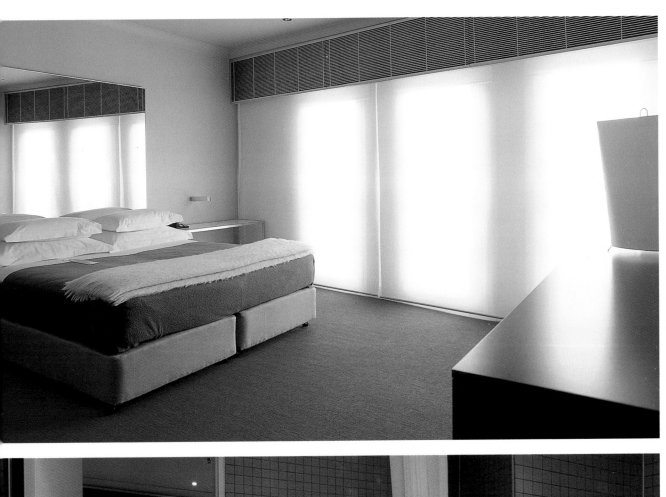
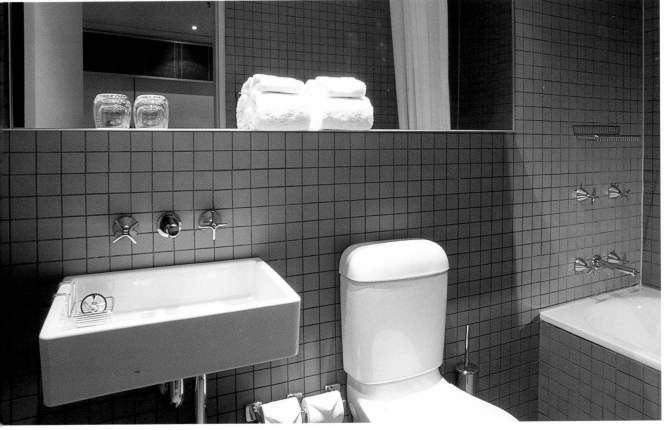

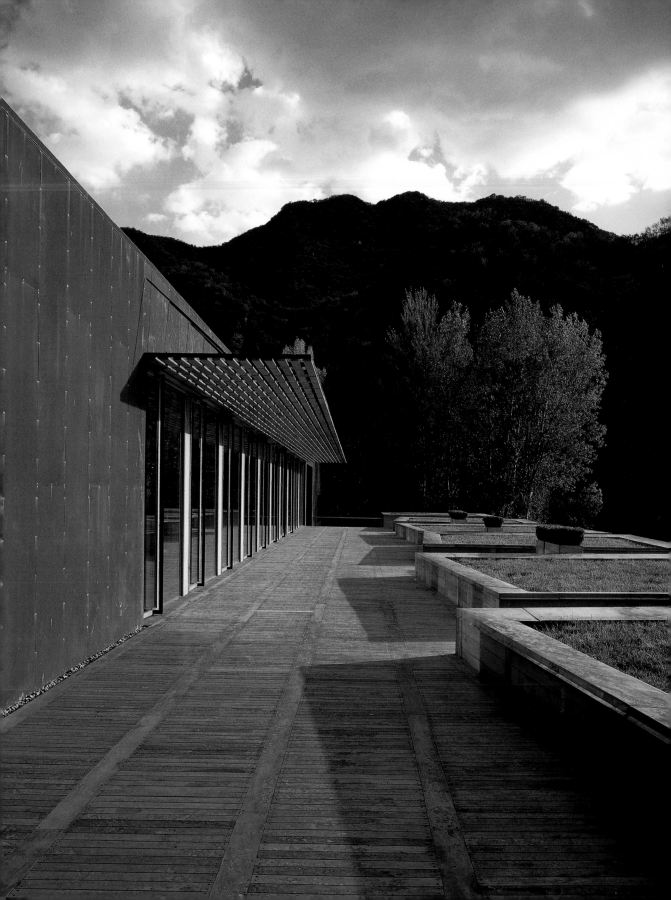

Badaling Highway, Beijing 102102, China Tel.: +86 10 8118 1888 Fax: +86 10 8118 1866
reservation@commune.com.cn www.commune.com.cn

The Commune
by the Great Wall

Architects: G. Chang, S. Ban, C. Kai, R. Yim, Ch. Hsueh Yi, A. Ochoa, K. Kuma, K. R'Kul, T. Kay Ngee, N. Furuya, Ch. Yung Ho, S. H Sang **Interior Designers:** H. Zimmern, S. Mouille, T. Hoppe, V. Robinson, Ph. Starck, A. Strub, C. Colucci, R. Menuez, K. Okajima, J. Damon, K. Rashid, M. Hilton, M. Newson and M. Young **Photographers:** © Satoshi Asakawa and Ma Xiaochun **Opening date:** 2002

Rooms: 59 villas and 1 clubhouse; from 4 to 6 bedrooms in each house

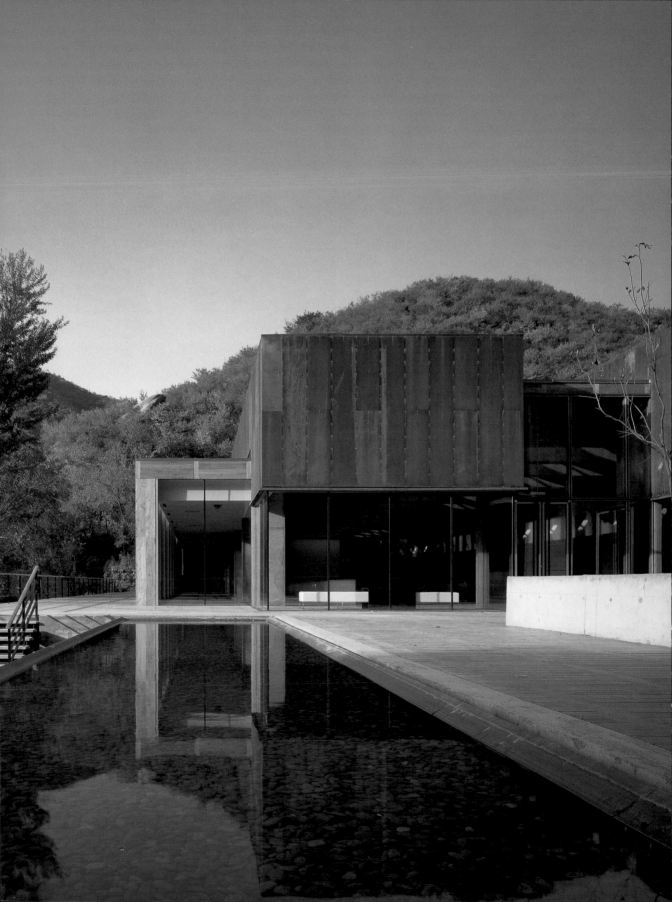

Situated on a tip where the south valley meets the east one, the Clubhouse stands facing the Great Wall in the west in a most elegant pose. The Clubhouse serves multiple purposes such as holding parties and various other events.

Das sehr elegante Clubhouse befindet sich an der Stelle, wo das südliche Tal auf das östliche trifft. Im Westen blickt man auf die Große Mauer. In diesem Gebäude werden Feste und andere Veranstaltungen organisiert.

Situé sur le point de convergence entre la vallée de l'est et celle du sud, le Clubhouse s'élève flanqué d'une élégance particulière, tourné vers la Grande Muraille à l'ouest. Cet espace est conçu pour abriter fêtes et autres évènements.

El Clubhouse, situado en el extremo donde el valle del sur se encuentra con el del este, se erige con majestuosa elegancia mirando la Gran Muralla ubicada al oeste. El espacio está concebido para albergar fiestas y otros eventos.

Situato nell'estremità dove la valle del sud si incontra con quella dell'est il Clubhouse si erge con singolare eleganza guardando verso la Grande Muraglia ad ovest. Lo spazio è stato concepito per ospitare feste ed altri tipi di eventi.

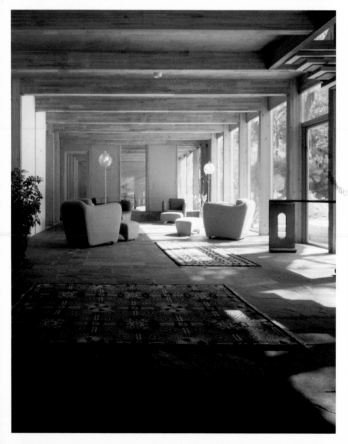
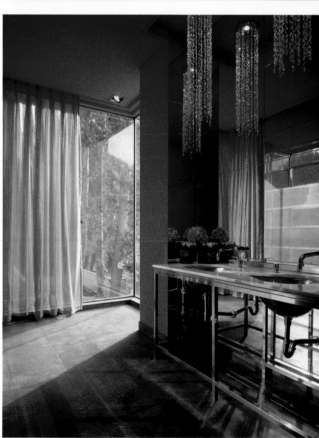

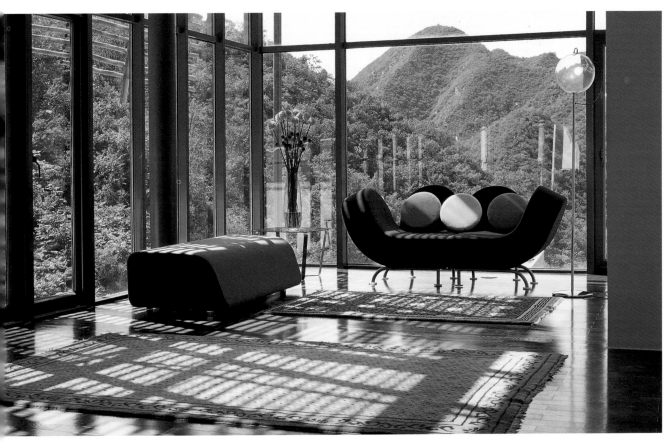
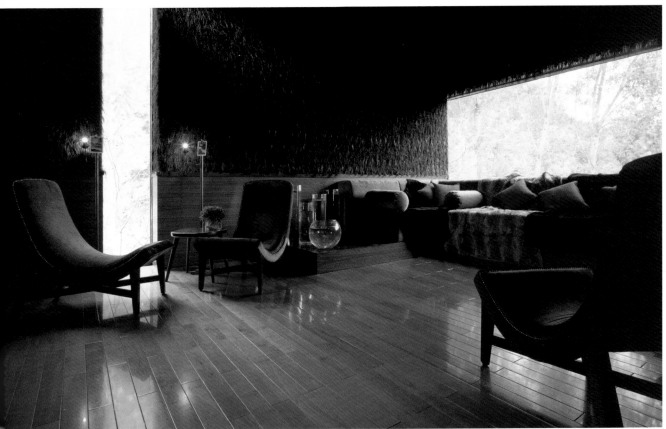

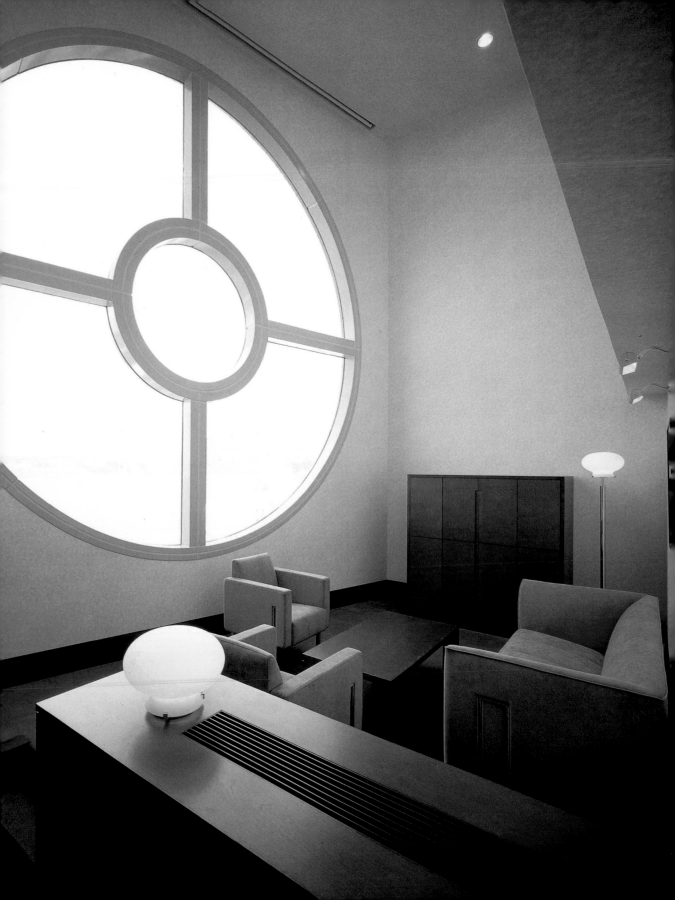

9-11 Minatomachi, Moji Ku, Kitakyushu, 801-0852 Fukuoka, Japan Tel.: +81 93 321 1111
Fax: +81 93 321 7111 info@mojiko-hotel.com www.mojiko-hotel.com

Mojiko Hotel

Architect and Interior Designer: Aldo Rossi Photographer: © Shigeru Uchida
Opening date: 1998 Rooms: 134

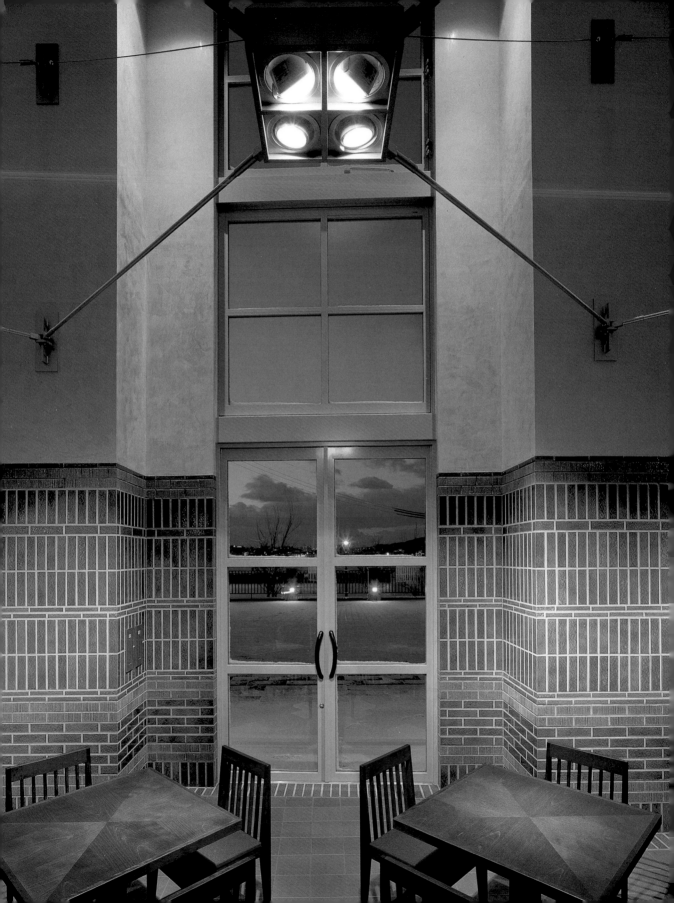

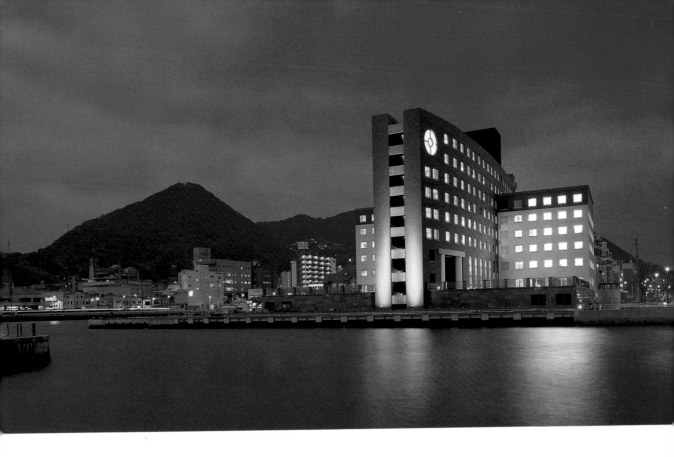

Designed by the late internationally acclaimed Italian architect Aldo Rossi, the exterior of the building, resembling a large ship, overlooks the Kanmon Strait and blends into the peaceful harbor scene.

Der ehemals sehr berühmte italienische Architekt Aldo Rossi hat dieses Gebäude geschaffen, dessen Äußeres der Struktur eines Schiffes gleicht. Es blickt auf die Kanmon-Meerenge und verschmilzt mit der ruhigen Landschaft.

L'extérieur de l'édifice, conçu par le célèbre architecte italien déjà disparu, Aldo Rossi, est semblable à la structure d'une barque et donne sur le détroit de Kanmon en se fondant dans le paysage paisible.

Diseñado por el ya desaparecido y renombrado arquitecto italiano Aldo Rossi, el exterior del edificio, que se asemeja a la estructura de un barco, mira al estrecho de Kanmon y se funde en el sosegado paisaje.

Progettato dal famoso architetto italiano ormai scomparso Aldo Rossi, l'esterno dell'edificio, simile alla struttura di una nave, dà sullo stretto di Kanmon e si fonde in un tranquillo paesaggio.

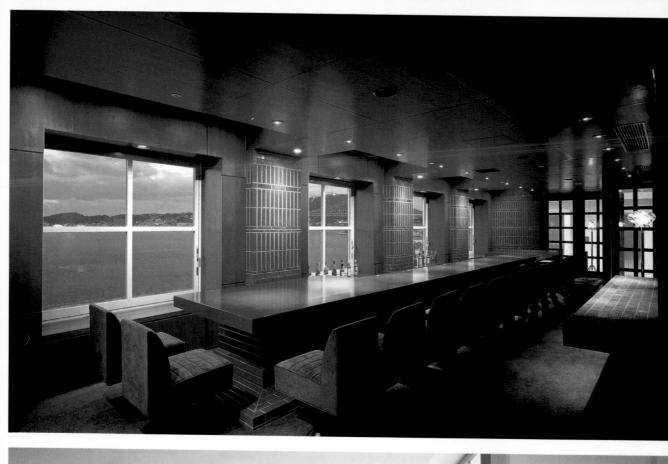

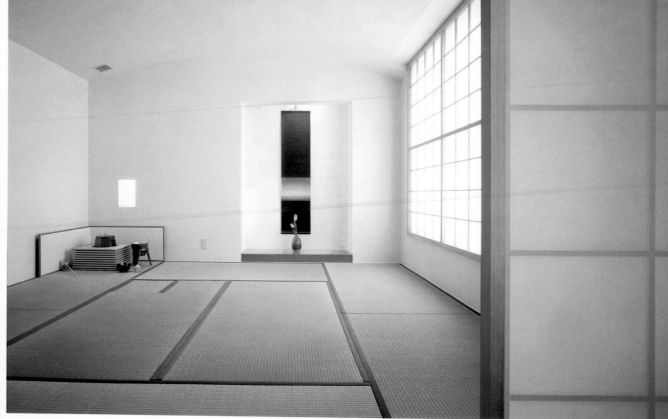

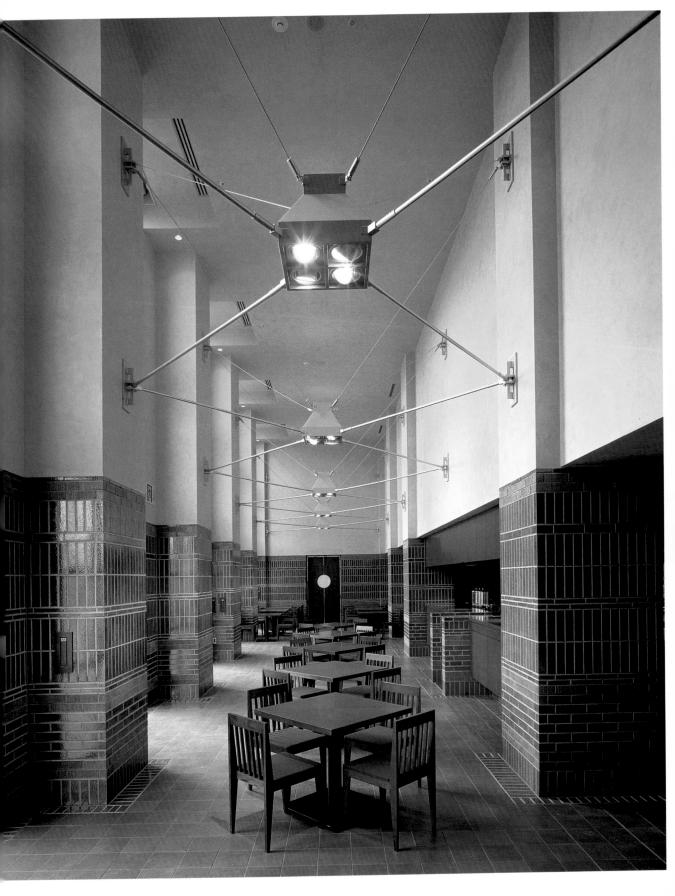

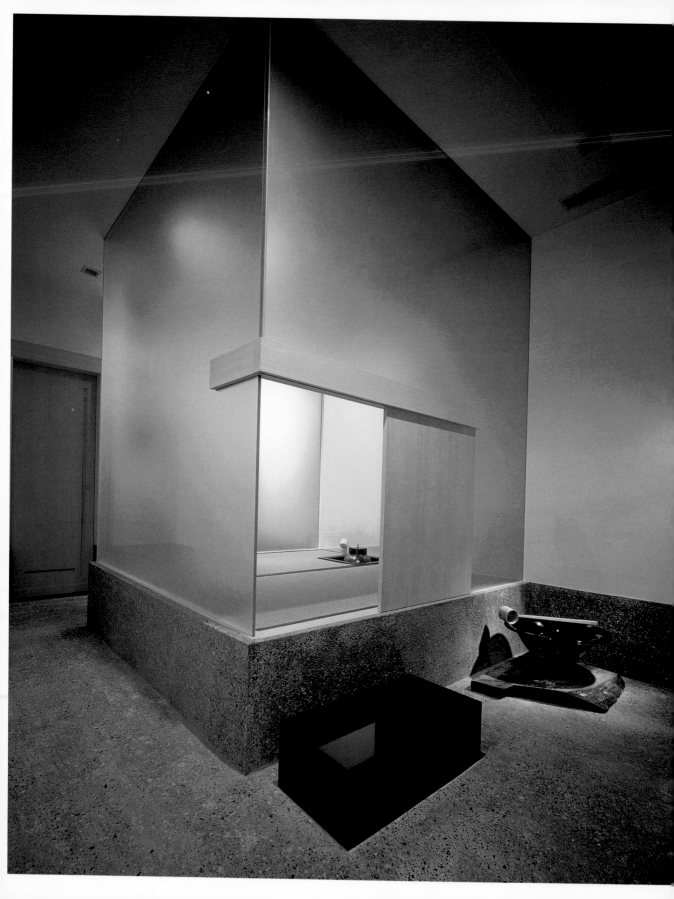

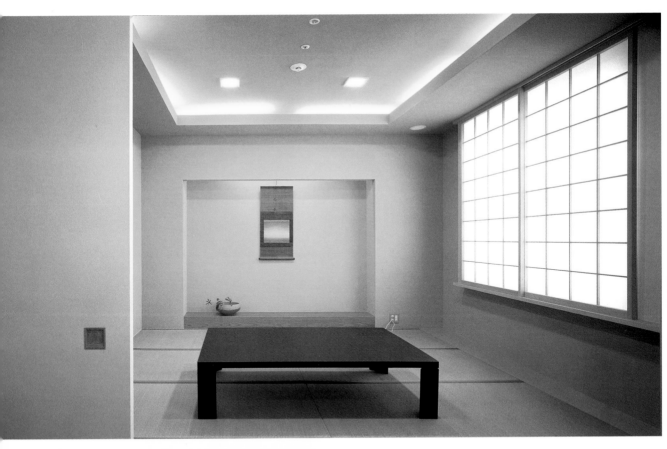

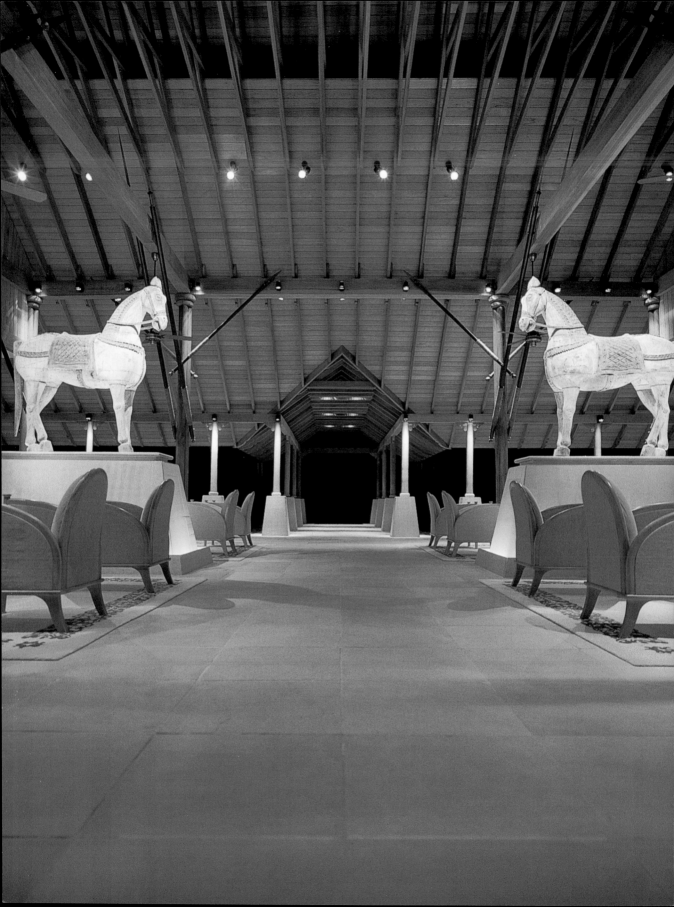

Jalan Teluk Datai, 07000 Pulau Langkawi, Kedah Darul Aman, Malaysia Tel.: +604 959 2500
Fax: +604 959 2600 datai@ghmhotels.com www.ghmhotels.com

Datai Langkawi

Architects: Kerry Hill and Victor Choo **Designers:** Didier Lefort and Jay Yeung
Photographers: © Barney Studio **Opening date:** 1993 **Rooms:** 112

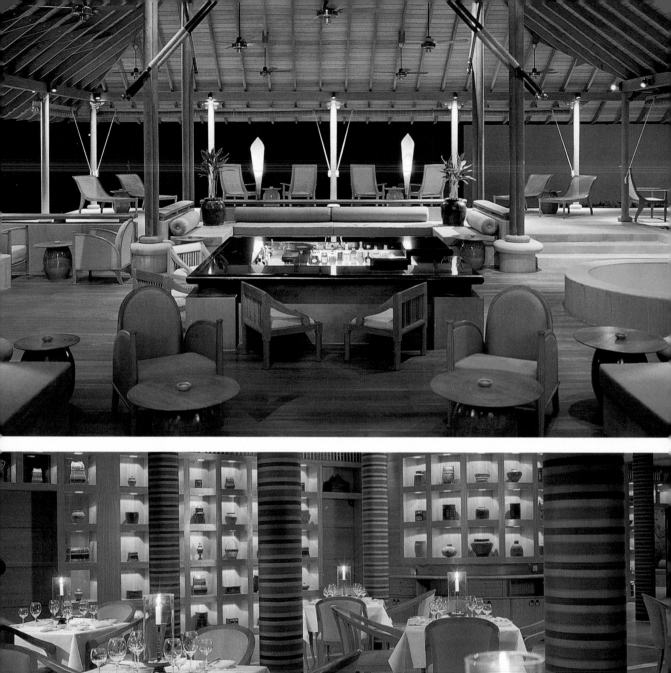
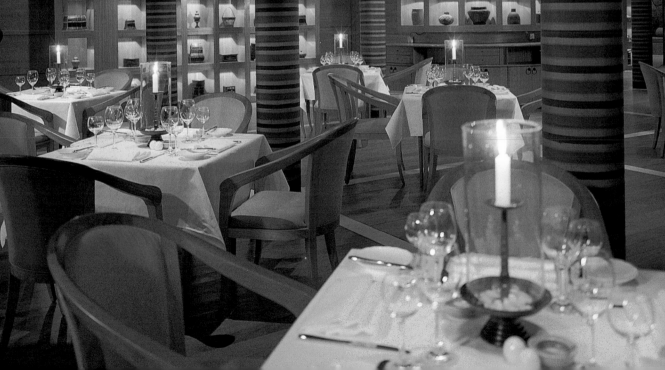

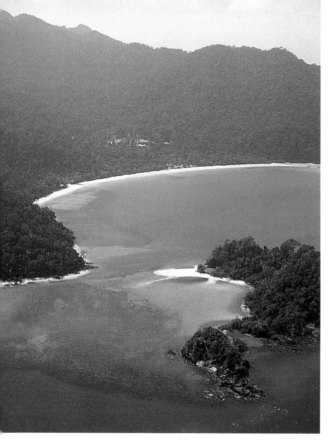
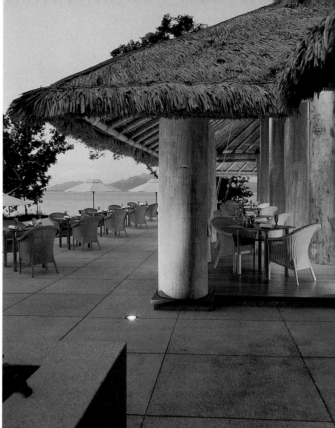

The traditional architecture and typical materials employed in the construction of this hotel are skill-fully combined with a contemporary aesthetic to achieve a refreshingly authentic hideaway situated in a priveleged and stunning landscape.

Die traditionelle Architektur und die typischen Materialien, die beim Bau dieses Hotels verwendet wur-den, sind mit einer zeitgenössischen Ästhetik kombiniert, durch die ein einladender und angenehmer Zufluchtsort in einer besonders schönen und beeindruckenden Landschaft entstand.

L'architecture et les matériaux typiques employés dans la construction de cet hôtel se sont fondus en une esthétique contemporaine pour réussir à créer un véritable havre de fraîcheur situé au cœur d'un paysage privilégié impressionnant.

La arquitectura tradicional y los materiales típicos que se emplearon en la construcción de este hotel se combinaron con una estética contemporánea para lograr un refugio auténtico y fresco situado en un privilegiado e impresionante paisaje.

L'architettura tradizionale e i materiali tipici utilizzati per la costruzione di questo hotel sono stati abbinati ad un'estetica contemporanea al fine di ottenere un rifugio fresco ed autentico situato in una zona privilegiata e con un paesaggio a dir poco sbalorditivo.

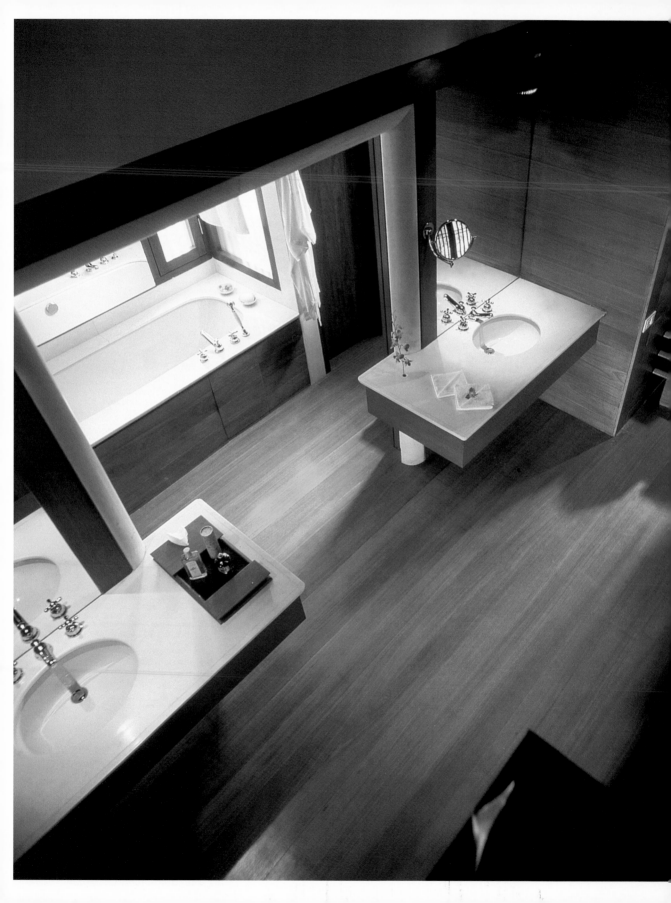

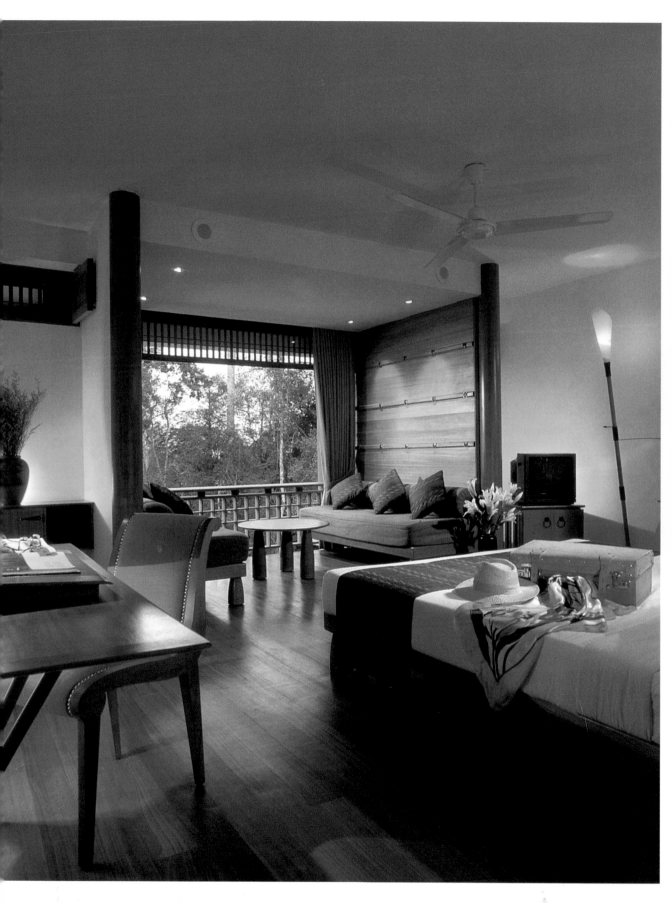

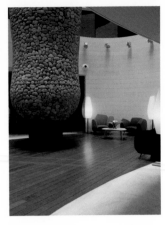

Europe

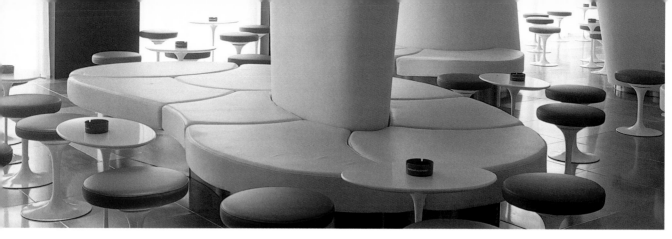

Austria

St. Anton
am Arlberg Anton

France

Paris Hotel Square

Germany

Berlin Propeller Island
Düsseldorf Düsseldorf Seestern
Hamburg Side Hotel

Ireland

Dublin Morrison Hotel

Italy

Florence Una Hotel Vittoria
Milan Enterprise Hotel
 Straf Hotel
Rome Es.Hotel Roma

Monaco

Monte Carlo Columbus Monaco

Portugal

Crato Flor da Rosa

Spain

Barcelona Banys Orientals
 Hotel AC Diplomatic
 Hotel Omm
 Hotel Prestige Paseo de Gracia
Bilbao Gran Domine
 Miróhotel
Madrid Hotel Aitana
 Hotel Bauzá
Palma
de Mallorca Convent de la Missió

The Netherlands

Maastricht Derlon Hotel
 La Bergère

United Kingdom

Brighton Blanch House
London Great Eastern Hotel
 Kensington House Hotel
 Myhotel Bloomsbury
 One Aldwych London
 Saint Martin's Lane
 Sanderson Hotel
 The Hempel
 The Westbourne Hotel

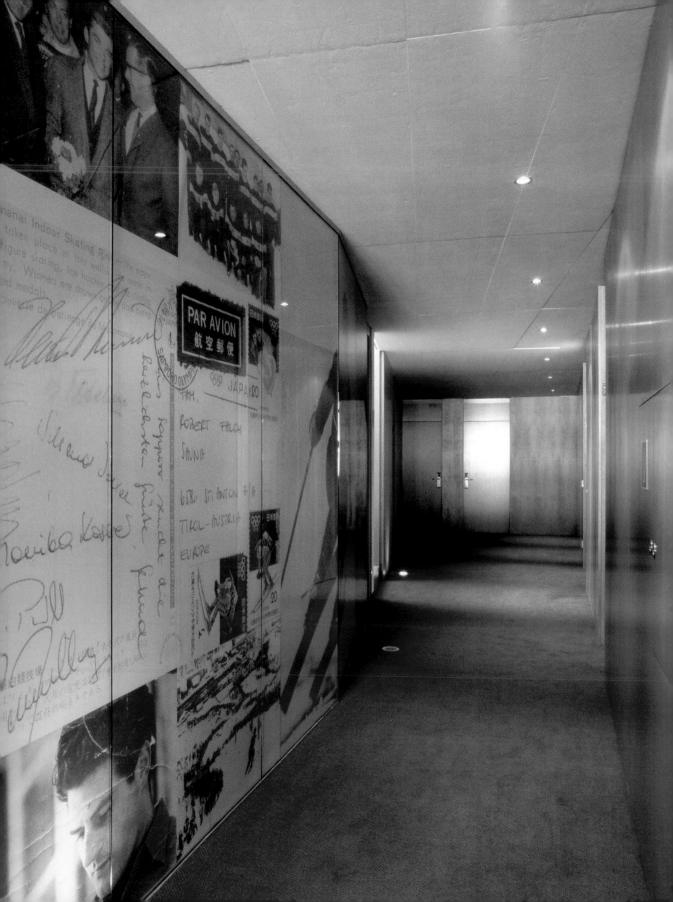

Kandaharweg 4, 6580 St. Anton am Arlberg, Austria Tel.: +43 5446 2408 Fax: +43 5446 2408 – 19
info@anton-aparthotel.com www.anton-aparthotel.com

Anton

Architects: Wolfgang Pöschol, Dieter Comploj and Thomas Thum **Photographer:** © Paul Ott
Opening date: 2000 **Rooms:** 71 rooms and 3 apartments

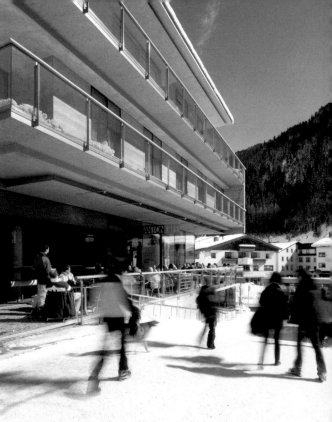

Long balconies that run along the length of the facade emphasize the flexibility of the interior while allowing for a better view of the magnificent landscape that surrounds the building.

Die länglichen Balkone an der Fassade unterstreichen die Flexibilität des Inneren. Gleichzeitig hat man einen wundervollen Ausblick auf die Landschaft, die das Gebäude umgibt.

De larges balcons courent le long de la façade et mettent en valeur la flexibilité de l'intérieur tout en permettant de jouir de la vue du paysage splendide qui encadre l'édifice.

Los balcones alargados que recorren la prolongada fachada acentúan la flexibilidad del interior y obtienen a la vez las mejores vistas del magnífico paisaje que circunda el edificio.

I balconi allungati che percorrono l'intera facciata sottolineano la flessibilità dell'interno e al contempo agevolano la vista del magnifico paesaggio che circonda l'edificio.

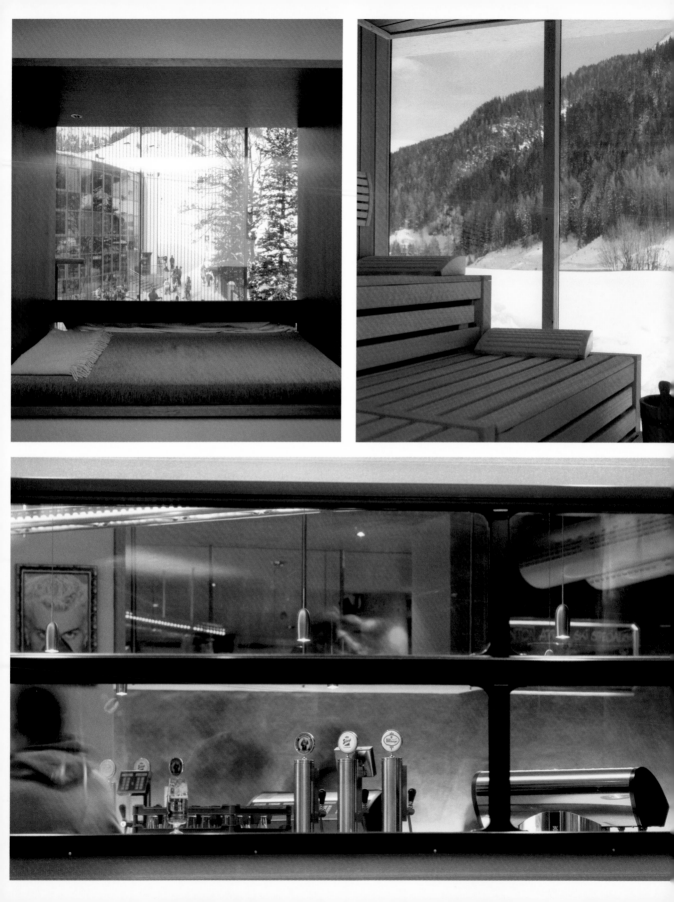

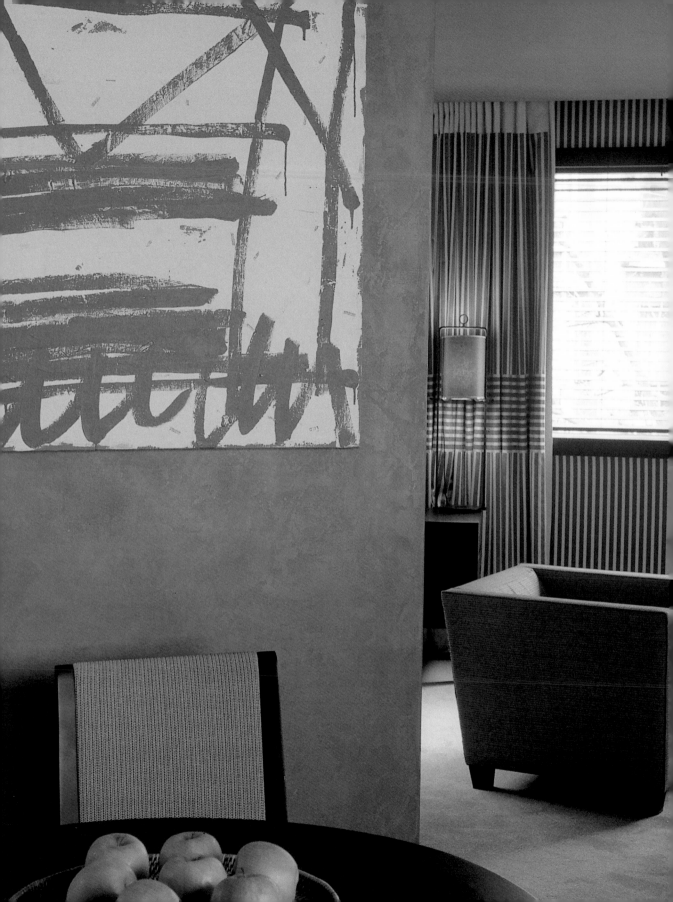

3 rue de Boulainvilliers, 75016 Paris, France Tel.: + 33 1 44 14 91 90
reservation@hotelsquare.com www.hotelsquare.com

Hotel Square

Architect: F. X. Evellin **Designer:** Patrick Derderian **Photographer:** © Roger Casas
Opening date: 1997 **Rooms:** 22

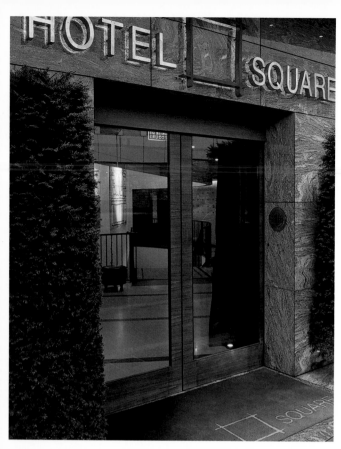
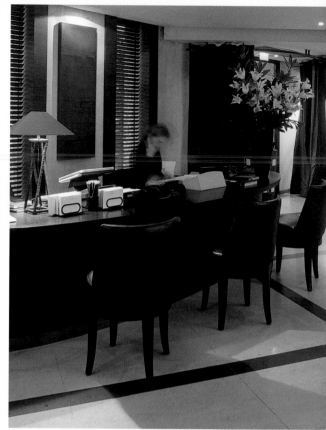
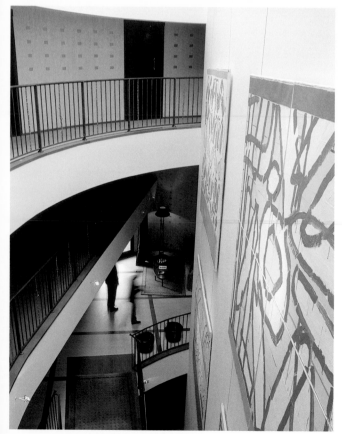
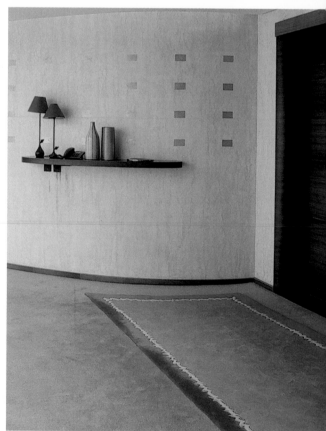

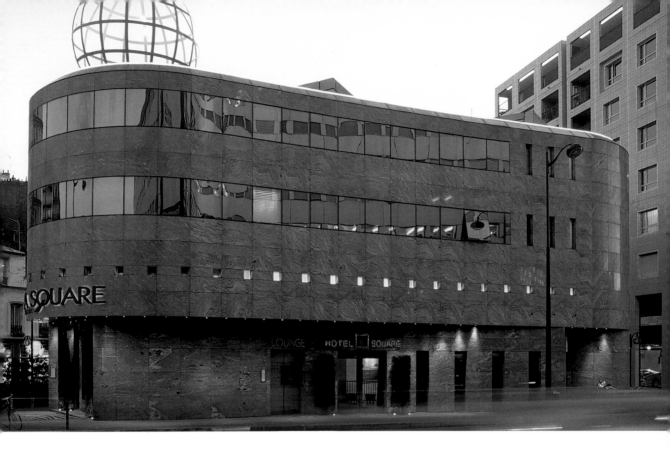

The volume that conforms the building is a hermetic object with basic lines, clad in granite and glass.

Die Form dieses Gebäudes wirkt wie ein hermetisches Objekt mit einigen Grundlinien, die von einer durchgehenden Haut aus Granit und Glas überzogen sind.

Le volume de l'édifice crée une forme hermétique, aux lignes simples, entourée d'une enveloppe uniforme déclinant granit et cristal.

El volumen que conforma el edificio es un objeto hermético, de líneas básicas, revestido de un material continuo de granito y cristal.

Il volume che forma l'edificio è un oggetto ermetico, dalle linee essenziali, rivestito da una pelle continua di granito e vetro.

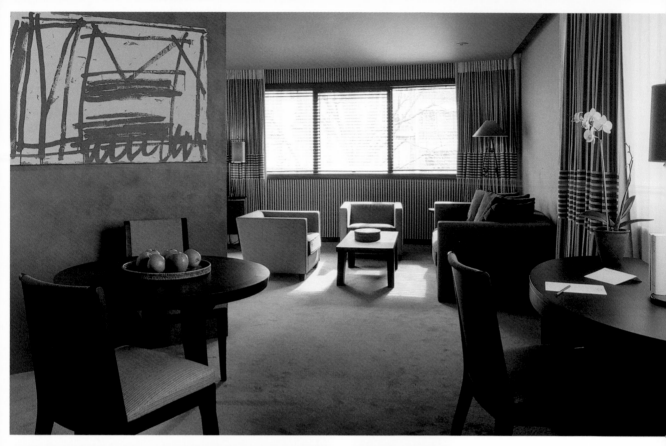

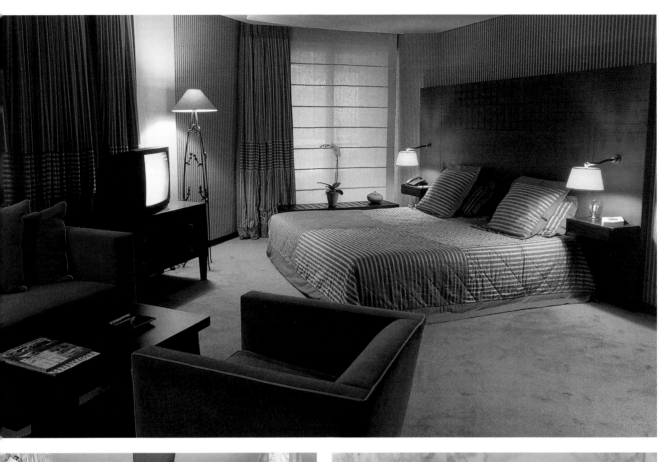

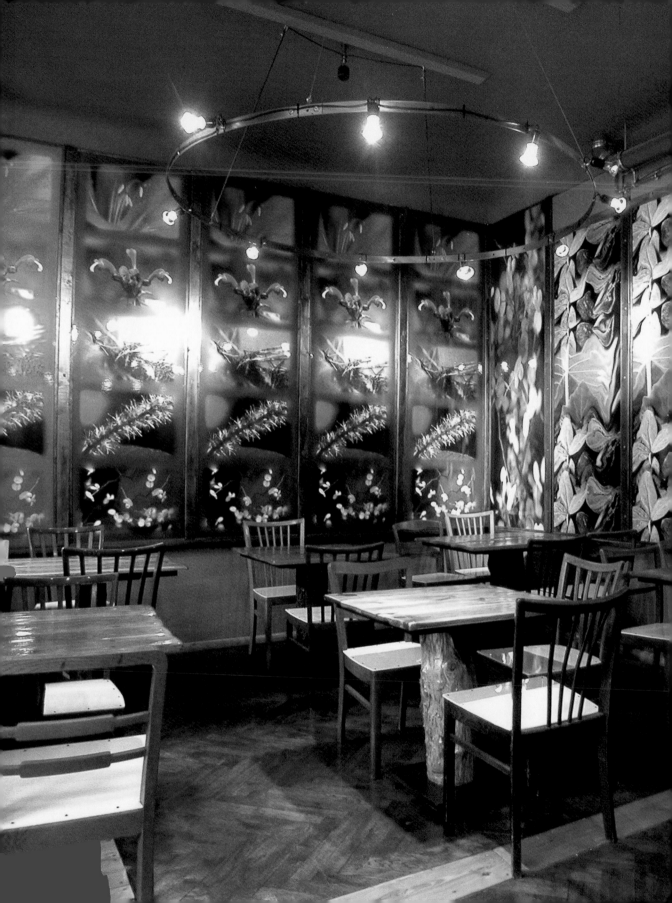

Albrecht-Achilles-Str. 58, 10709 Berlin, Germany Tel.: +49 30 8 91 90 16 Fax: +49 30 8 92 87 21
www.propeller-island.de

Propeller Island

Designer: Lars Stroschen Photographer: © Lars Stroschen Opening date: 2002 Rooms: 45

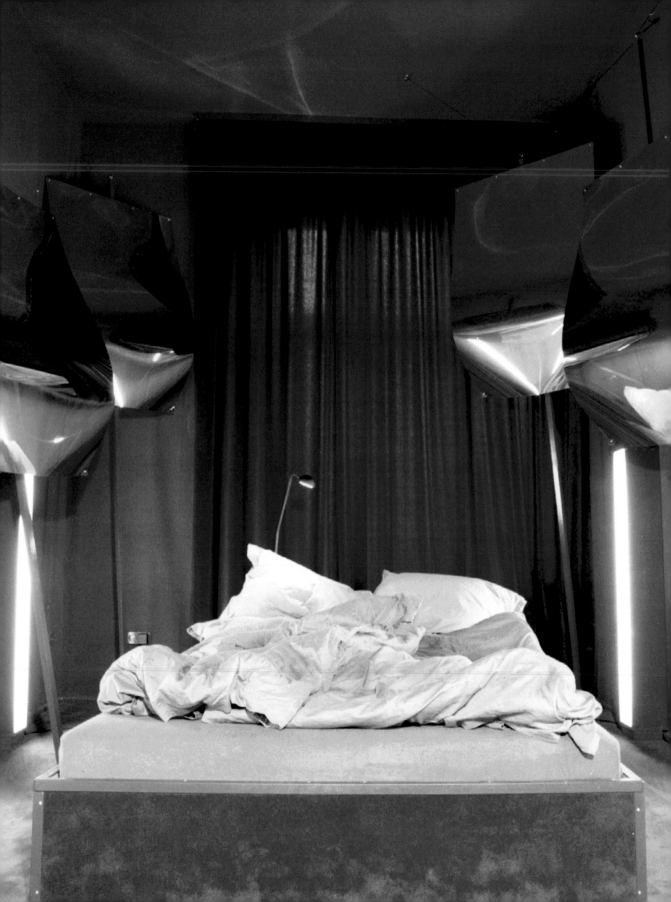

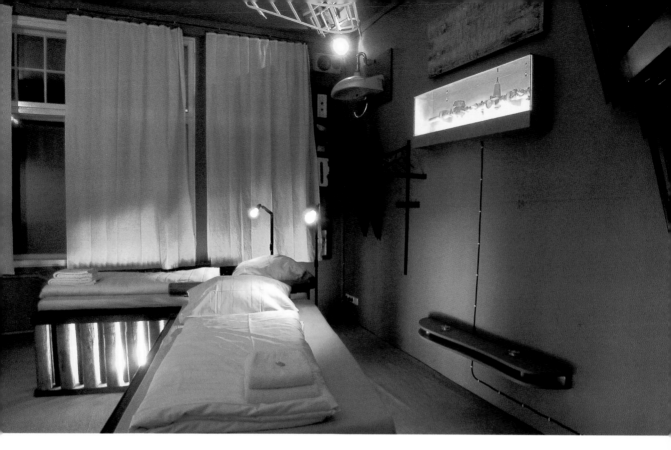

The theme of each room is varied—from conventional domestic concepts to contemporary and futurist ideas—so that they create an entire world of interior landscapes full of contrasts.

Jedes Zimmer ist einem anderen Thema gewidmet, manche sind traditioneller und häuslicher, andere zeitgenössischer und futuristischer. So entstand eine Welt aus inneren Landschaften voller Kontraste.

Chaque chambre a un thème dont l'éventail varie du conventionnel et rustique à ce qu'il y a de plus contemporain et futuriste, pour créer ainsi un monde de paysages intérieurs où foisonnent les contrastes.

La temática de cada habitación varía desde lo convencional y doméstico hasta lo más contemporáneo y futurista, para así crear un mundo de paisajes interiores lleno de contrastes.

Il tema dominante in ogni camera va dal convenzionale al domestico fino al contemporaneo e futurista, il tutto per creare un mondo di paesaggi interni pieni di contrasti.

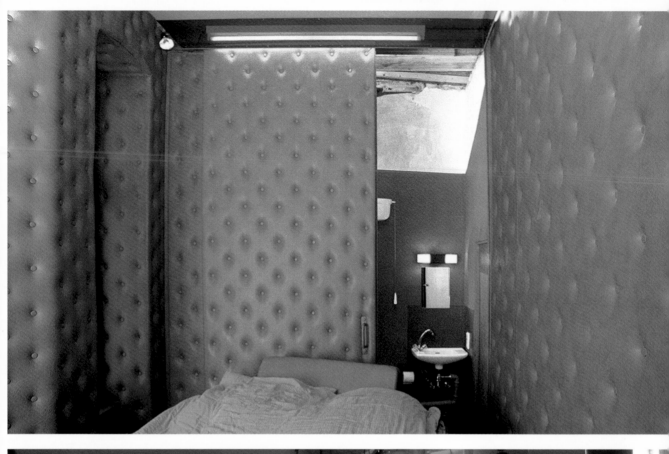
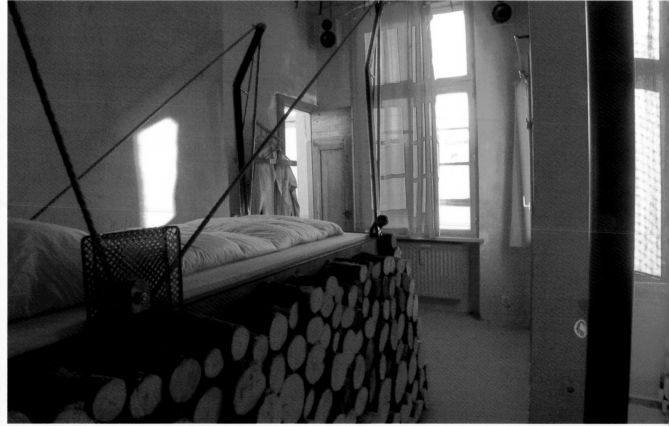

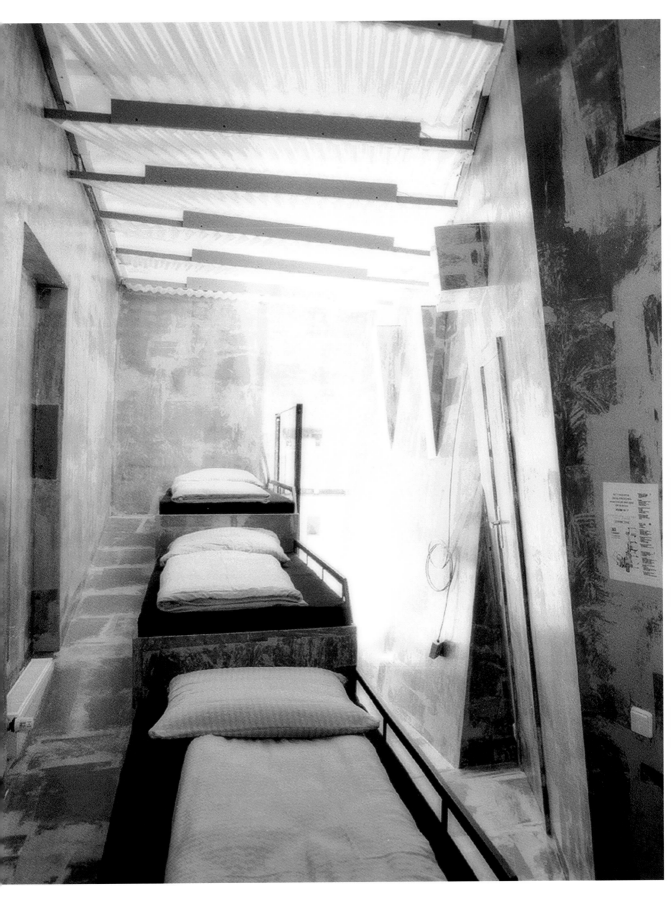

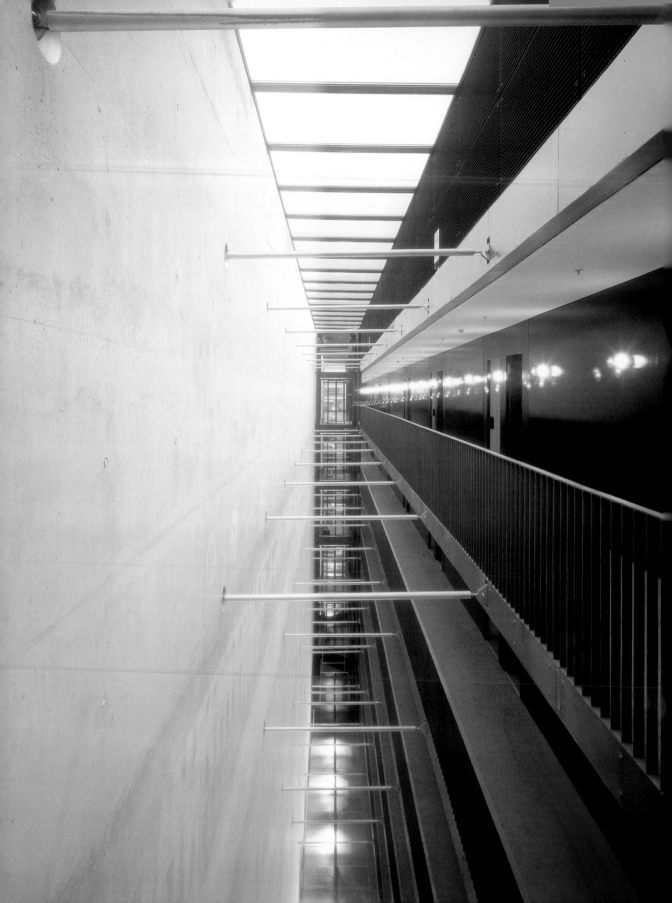

Niederkasseler Lohweg 18a, 40547 Düsseldorf, Germany Tel.: +49 211 5 22 99 – 0
Fax: +49 211 5 22 99 522 duesseldorf@innside.de www.innside.de

Düsseldorf Seestern

Architects: Schneider + Schumacher Photographer: © Jörg Hempel Opening date: 2001 Rooms: 126

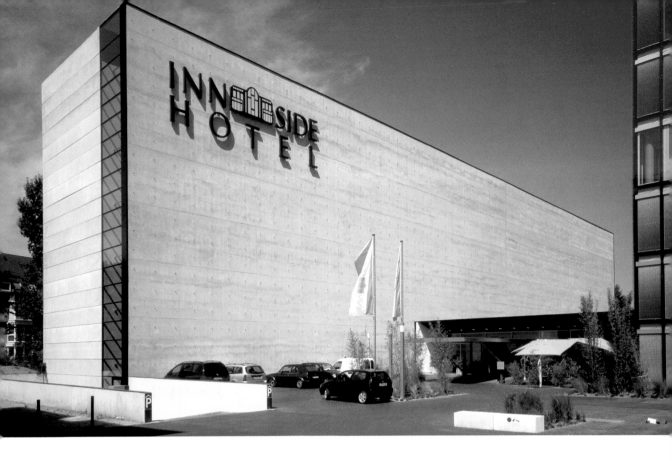

The diaphanous spaces and the soft combinations of the decorations and the forms and colors of the furniture endow it with a sense of relaxation and harmony. Purity and discreet elegance is the basis of the design of the Düsseldorf Seestern.

Die durchscheinenden Räume und die sanften Kombinationen der Dekoration und der Formen und Farben der Möbel vermitteln Ruhe und Harmonie. Klarheit und diskrete Eleganz sind die Grundlagen der Gestaltung des Düsseldorf Seestern.

Les espaces diaphanes et la douceur des mélanges, tant dans la décoration que dans les formes et couleurs du mobilier, offrent repos et harmonie. Pureté des lignes et élégance discrète sont les caractéristiques du design du Düsseldorf Seestern.

Los espacios diáfanos y las combinaciones suaves, tanto en la decoración como en las formas y los colores de su mobiliario, aportan descanso y armonía. Pureza y elegancia discreta son las bases del diseño del Düsseldorf Seestern.

Gli spazi diafani e gli accostamenti delicati, sia nell'arredamento che nelle forme e i colori della mobilia, trasmettono una sensazione di riposo ed armonia. La purezza e l'eleganza discreta stanno alla base dello stile del Düsseldorf Seestern.

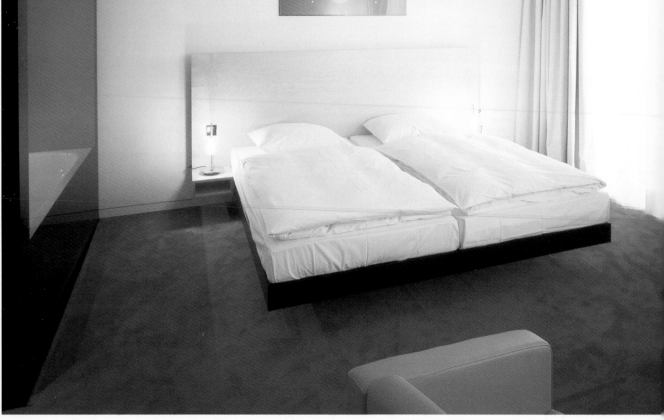

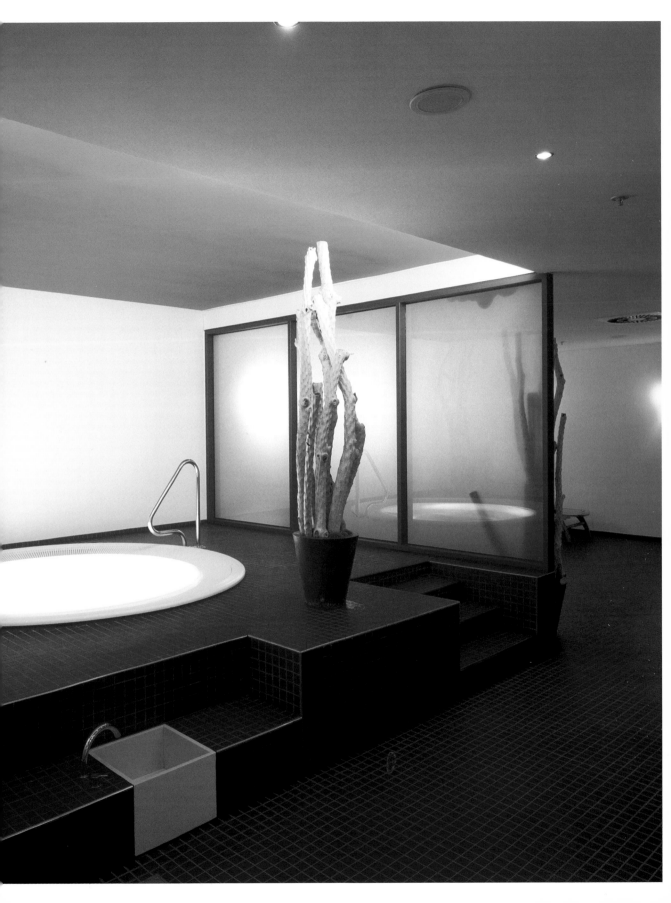

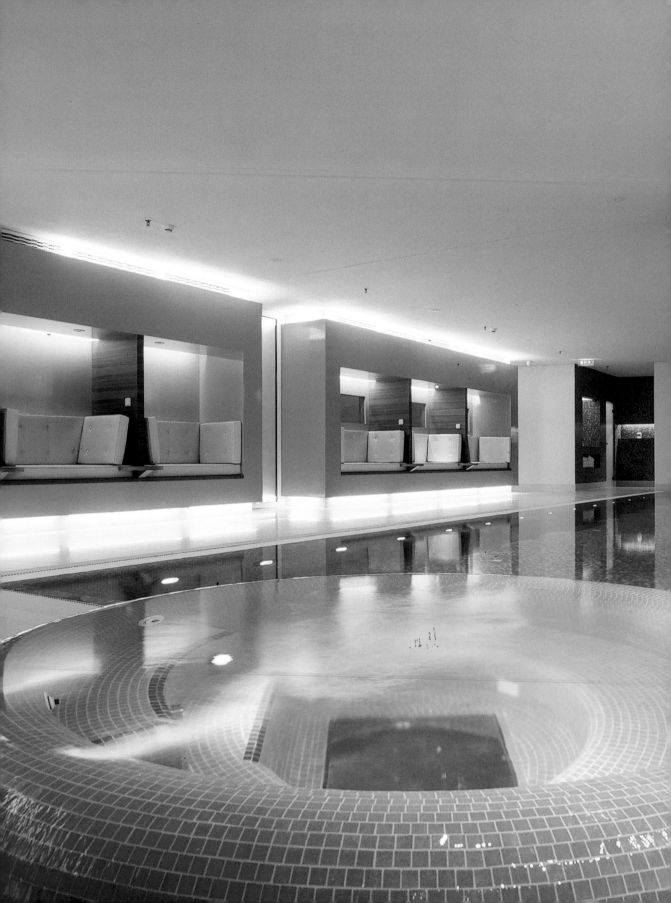

Drehbahn 49, 20354 Hamburg, Germany Tel.: +49 40 30 99 90 Fax: +49 40 30 99 93 99
info@side-hamburg.de www.side-hamburg.de

Side Hotel

Architects: Störmer Architekten **Designer:** Matteo Thun **Photographer:** © Gunnar Knechtel
Opening date: 2001 **Rooms:** 178 (76 superior rooms, 80 deluxe rooms,
12 executive rooms and 10 suites XXL)

The premise of comfort, simplicity, and functionality rules the design of the guest rooms. In the interior the pure lines, minimalist styles, and personal touches create extremely warm and cozy environments.

Die Gestaltung der Zimmer beruht auf Komfort, Einfachheit und Funktionalität. Klare Linien, minimalistischer Stil und persönliche Elemente lassen eine sehr warme und einladende Atmosphäre entstehen.

Le concept des chambres est parti de l'idée de confort, simplicité et fonctionnalité. Lignes épurées, styles minimalistes et touches personnelles créent une atmosphère extrêmement chaleureuse et accueillante.

El diseño de las habitaciones se basa en la comodidad, la sencillez y la funcionalidad. Líneas puras, estilos minimalistas y toques personales crean ambientes extremadamente cálidos y acogedores.

Lo stile delle camere si basa sul confort, la semplicità e la funzionalità. Linee pure, stili minimalisti e tocchi personali creano ambienti estremamente piacevoli ed accoglienti.

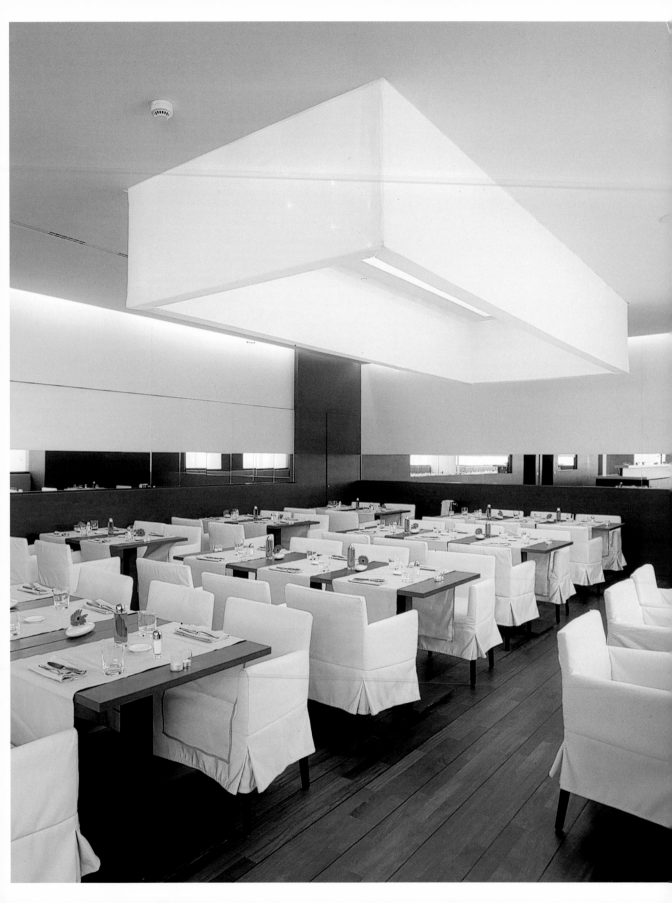

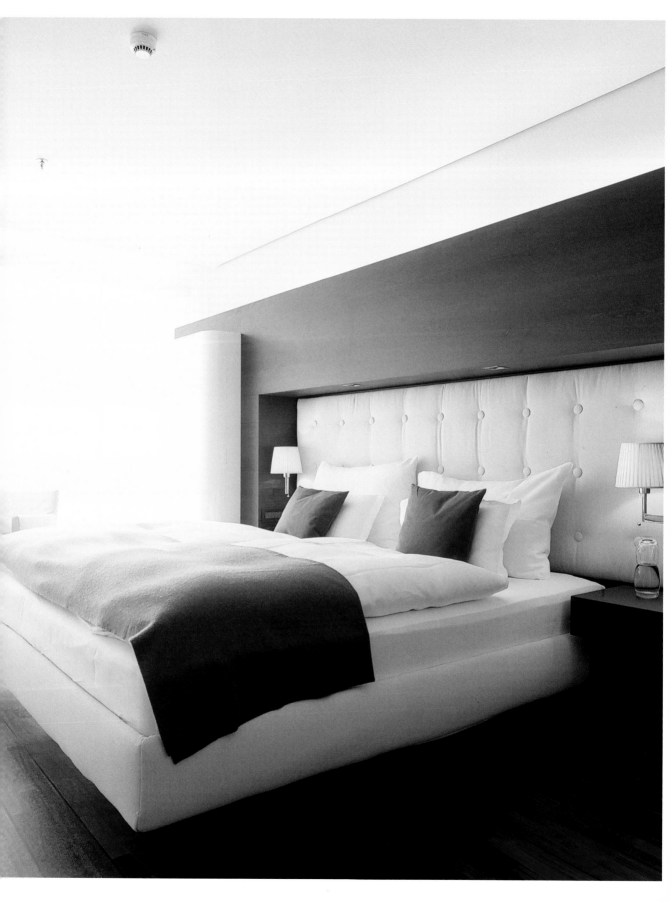

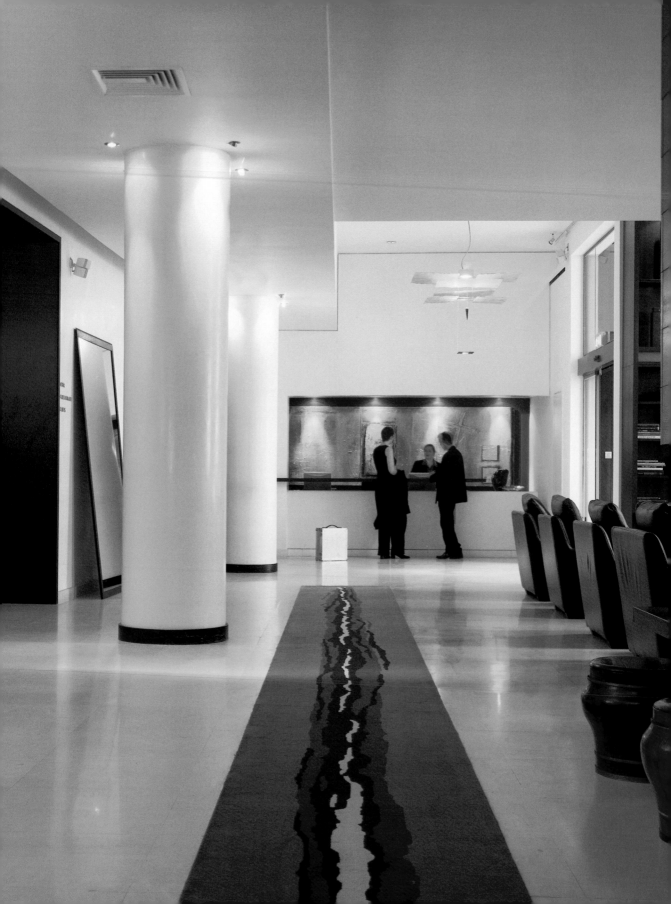

Ormond Quay, Dublin 1, Ireland Tel.: + 35 31 887 2400 Fax: + 35 31 878 3185
info@morrisonhotel.ie www.morrisonhotel.ie

Morrison Hotel

Architect: Douglas Wallace **Designer:** John Rocha **Photographer:** © Andrew Bradley **Rooms:** 94

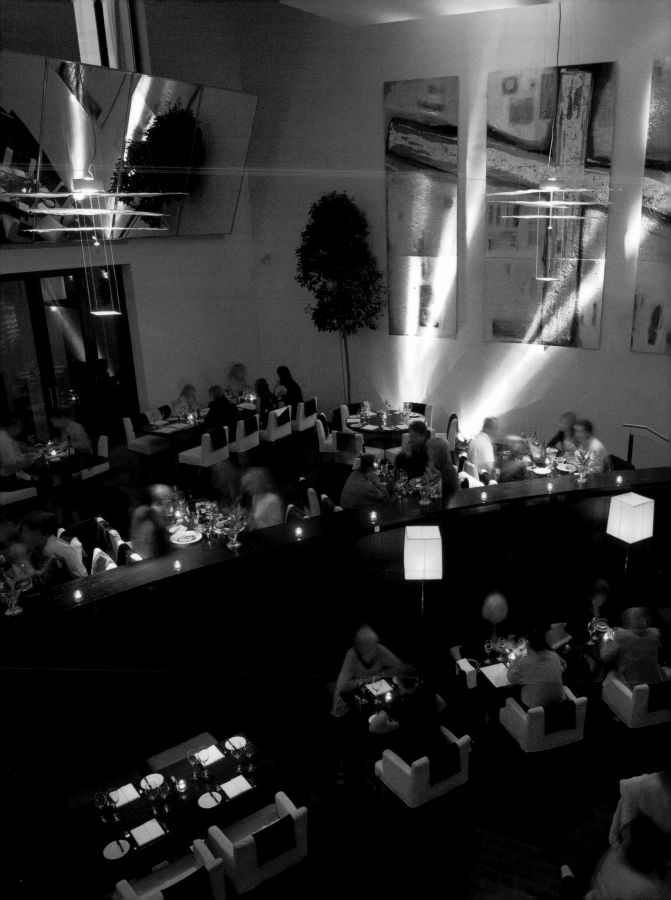

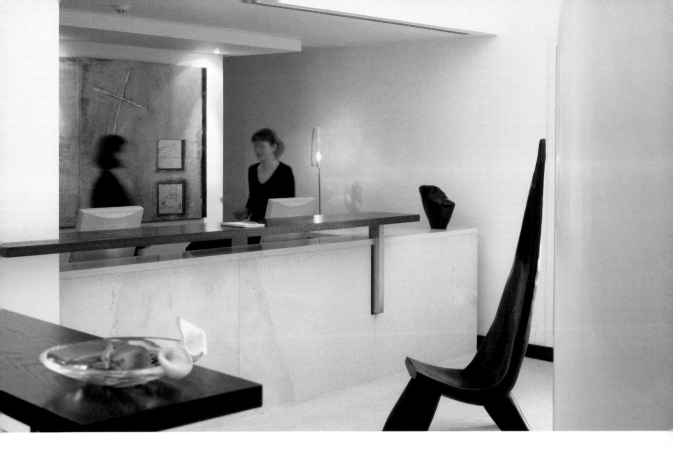

The hotel is organized along the length of a north-south axis that runs through the entire building. This is reflected in the longitudinal sense of the vestibule and upper floors, and is used to generate interesting visual effects.

Die Räumlichkeiten des Hotels werden durch eine Nord-Süd-Achse unterteilt, die sich durch das ganze Gebäude zieht. Das spiegelt sich in der Längsausrichtung der Empfangshalle und den Fluren der oberen Stockwerke wider. Durch diese Verteilung wurden auch interessante, visuelle Effekte geschaffen.

L'hôtel est organisé autour d'un axe nord sud qui traverse l'édifice. Ceci se reflète dans la longueur du vestibule et des couloirs des étages supérieurs et crée d'intéressants angles de vue.

El hotel se organiza a lo largo de un eje en sentido norte-sur que recorre todo el edificio. Esto se refleja en la forma longitudinal del vestíbulo y los pasillos de los pisos superiores, y se aprovecha para generar interesantes efectos visuales.

L'hotel si struttura attorno ad un asse, in senso nord-sud, che percorre l'intero edificio. Ciò viene evidenziato dalla disposizione longitudinale della hall e dagli spazi di disimpegno dei piani superiori; ci si avvale inoltre di questa struttura per creare interessanti coronamenti visivi.

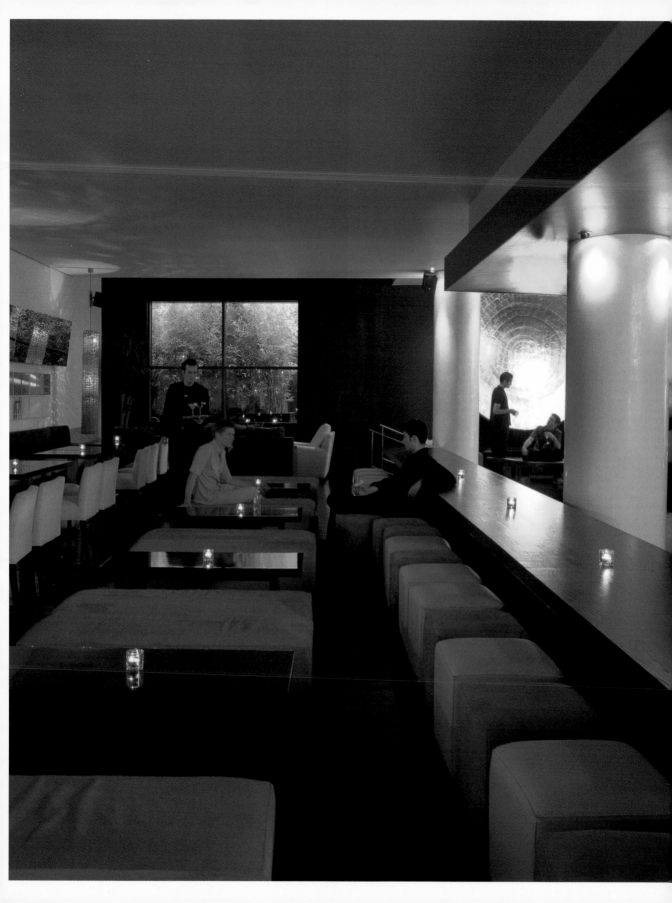

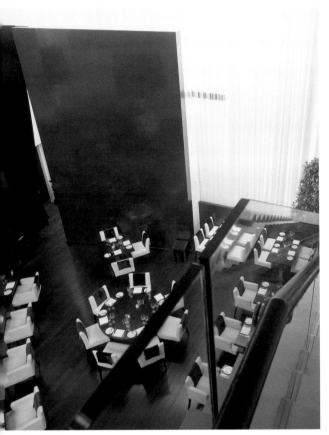
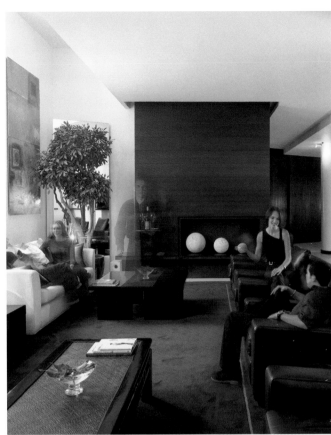
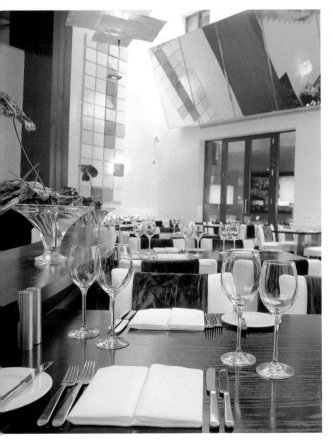
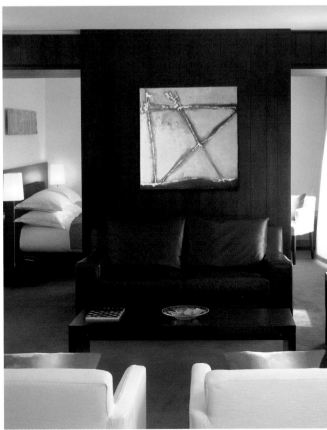

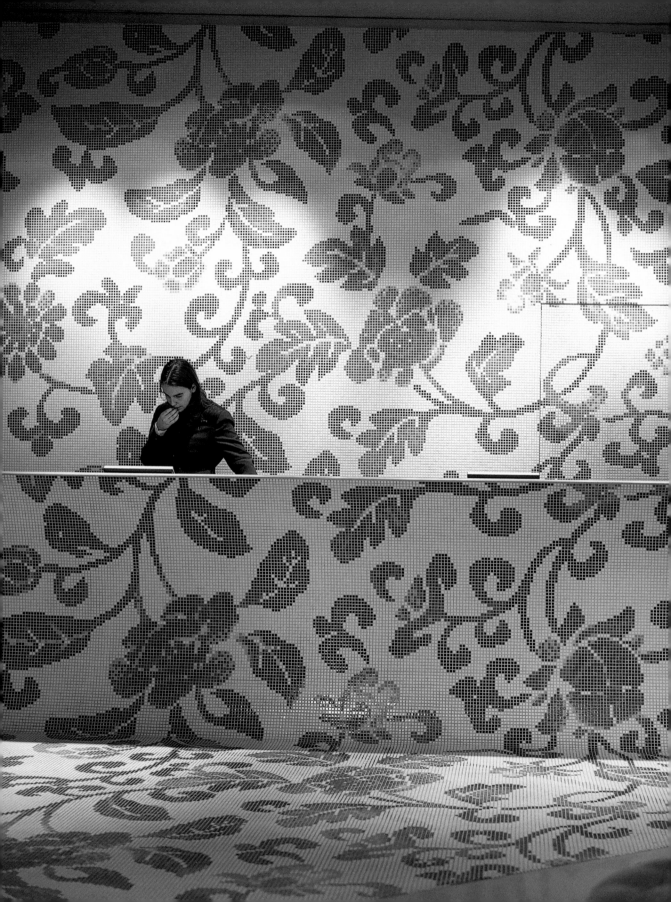

Via Pisana 59, 50143 Florence, Italy Tel.: +39 055 22771 Fax: +39 055 22772
una.vittoria@unahotels.it www.unahotels.it

Una Hotel Vittoria

Architect: Fabio Novembre **Photographer:** © Yael Pincus **Opening date:** 2003 **Rooms:** 84

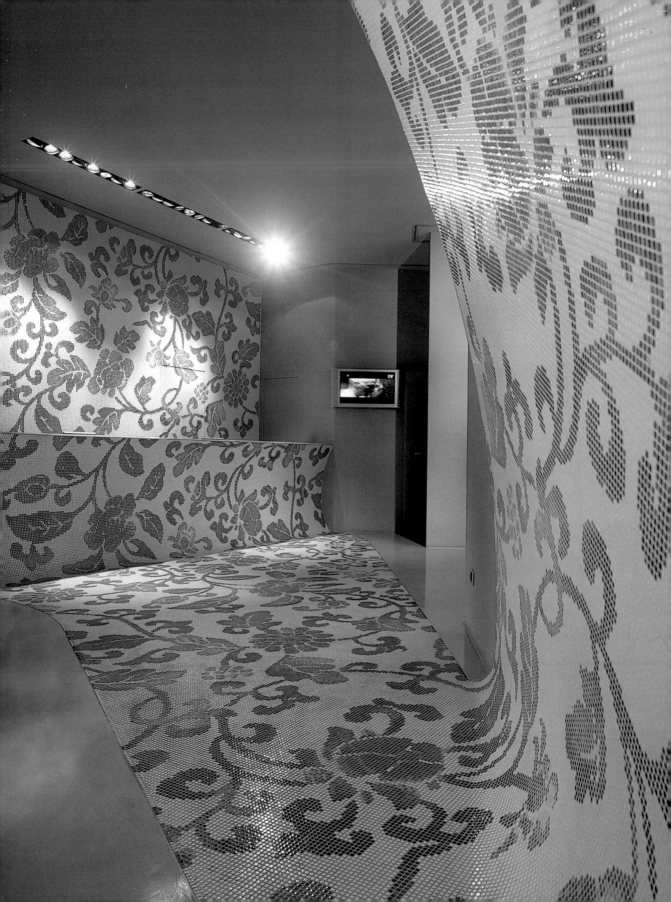

The architect drew on the idea of Florence as a fertile territory where art has flourished; he imagined the hotel as a large tree that stretches out its branches to provide its guests with a space that is both functional and inspirational.

Der Architekt ging von der Idee aus, dass die Stadt Florenz ein fruchtbarer Grund für das Erblühen der Kunst war. So entstand ein Hotel in Form eines großen Baumes, der seine Äste ausstreckt, um funktionelle und inspirierende Räumlichkeiten anzubieten.

L'architecte s'est inspiré de l'idée selon laquelle Florence a été un terrain fertile à l'épanouissement des arts : il a donc imaginé l'hôtel à l'instar d'un grand arbre qui étend ses branches pour offrir un espace fonctionnel et fascinant.

El arquitecto trabajó la idea de que la ciudad de Florencia ha sido un terreno fértil para el florecimiento de las artes; así pues, imaginó el hotel como un gran árbol que extiende sus ramas para ofrecer un espacio funcional e inspirador.

L'architetto ha preso spunto dall'idea secondo cui la città di Firenze sia stata un terreno fertile per la fioritura delle arti; quindi ha immaginato l'hotel come un grande albero che stende i suoi rami per offrire uno spazio funzionale e ricco di ispirazione.

Corso Sempione 91, 20154 Milan, Italy Tel.: +39 02 318181 Fax: +39 02 31818811
info@enterprisehotel.com www.enterprisehotel.com

Enterprise Hotel

Architects: Chris Redfern and Cristina Di Carlo **Promotion:** MN Studio **Photographer:** © Santi Caleca
Opening date: 2002 **Rooms:** 109

The colors, as well as certain materials such as the marble, the ceramic pieces, or even the vegetation used in the exterior areas, allude to the classic traditions of Italian architecture.

Die verwendeten Farben und Materialien wie Marmor, Keramik oder die Vegetation der Außenanlagen spielen auf die klassischen Traditionen der italienischen Architektur an.

Les couleurs et matériaux employés, comme le marbre, les céramiques ou la végétation des espaces extérieurs ne sont pas sans rappeler les traditions classiques de l'architecture italienne.

Los colores y materiales empleados, como el mármol, las piezas cerámicas o la vegetación de las zonas del exterior, hacen referencia a las tradiciones clásicas de la arquitectura italiana.

I colori e i materiali utilizzati, come il marmo, i pezzi in ceramica o la vegetazione delle zone esterne, si rifanno ai motivi classici dell'architettura italiana.

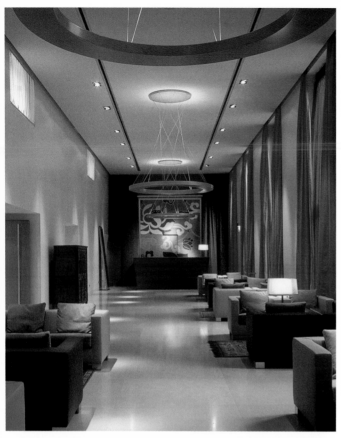
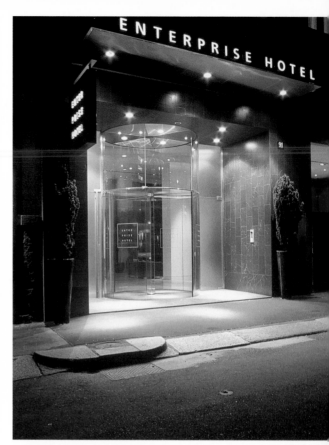
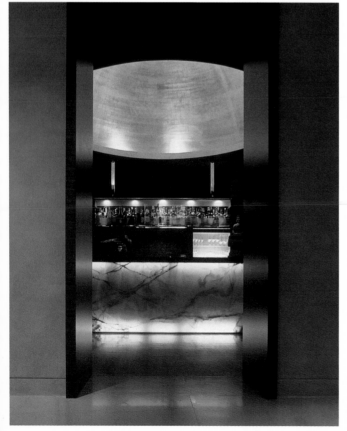
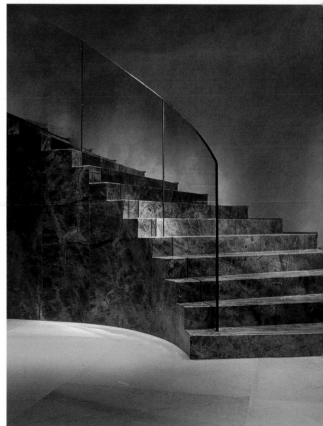

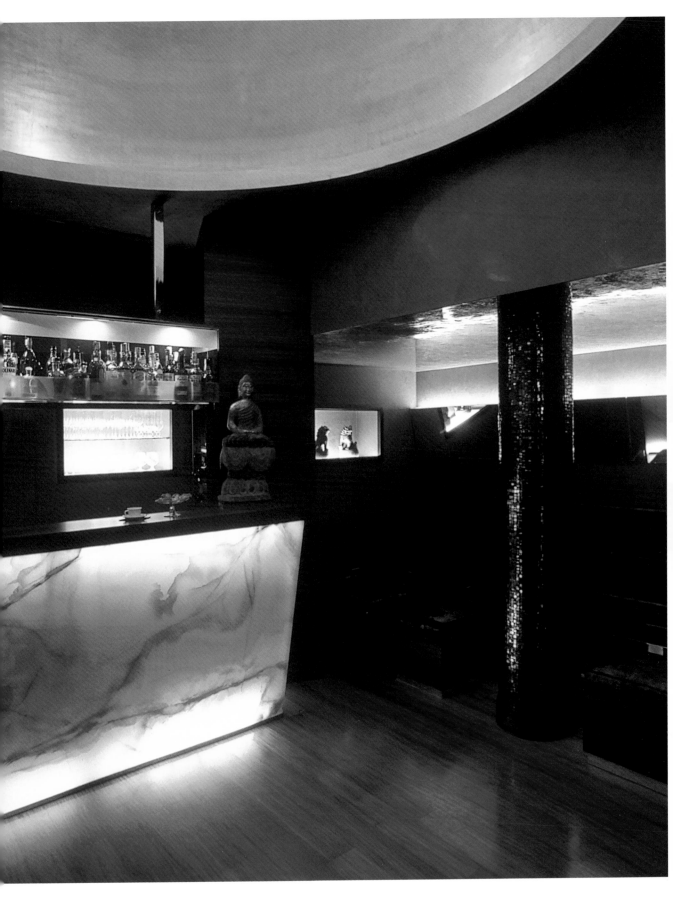

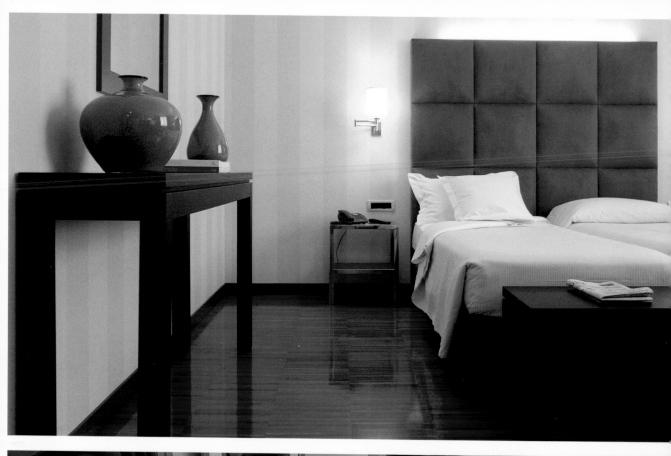

Via San Raffaele 3, 20121 Milan, Italy Tel.: +39 02 805081 Fax: +39 02 89095294
reservations@straf.it www.straf.it

Straf Hotel

Architect: Vincenzo De Cotiis **Photographer:** © Yael Pincus **Opening date:** 2003
Rooms: 66 (including 2 suites and 2 junior suites)

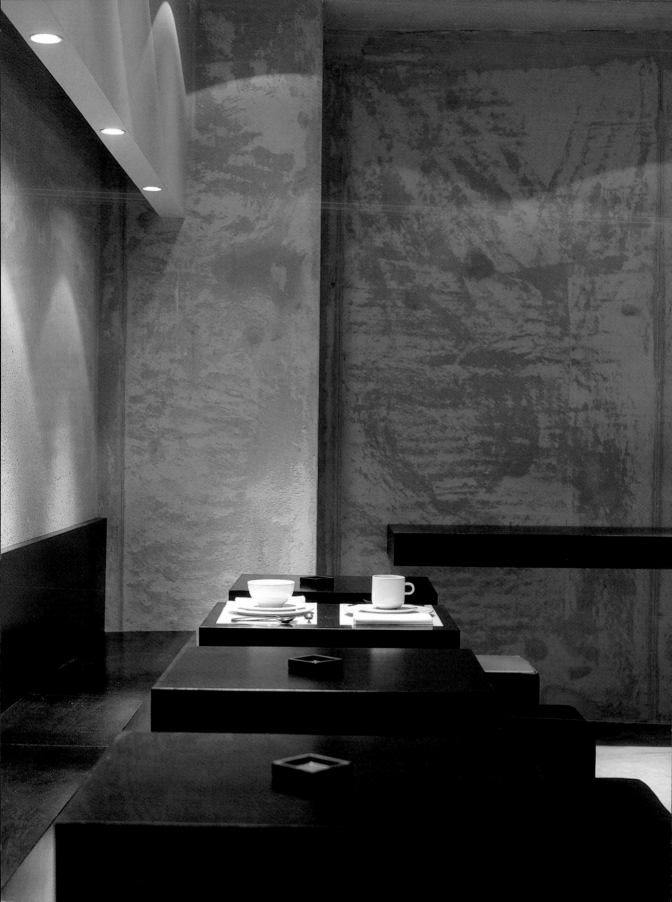

The architect De Cotiis selected materials such as iron, cement, chalk, mirrors treated with acid, polished tin and even gauze, inserted between glass panels to achieve an effect of transparency.

Der Architekt De Cotiis wählte Materialien wie Eisen, Zement, Schiefer, mit Säure behandelte Spiegel, poliertes Messing und sogar Gaze zwischen Glasscheiben, um die Räume transparent wirken zu lassen.

L'architecte De Cotiis a choisi des matériaux comme le fer, le ciment, l'ardoise, les miroirs traités à l'acide, le laiton poli et même la gaze entre des panneaux de verre pour créer un effet de transparence.

El arquitecto De Cotiis seleccionó materiales como el hierro, el cemento, la pizarra, los espejos tratados al ácido, el latón lustrado o, incluso, la gasa entre paneles de vidrio para introducir un efecto de transparencia.

L'architetto De Cotiis ha selezionato materiali come il ferro, il cemento, l'ardesia, gli specchi trattati con acido, l'ottone lucidato o, persino, il voile tra i pannelli di vetro per ottenere un effetto trasparenza.

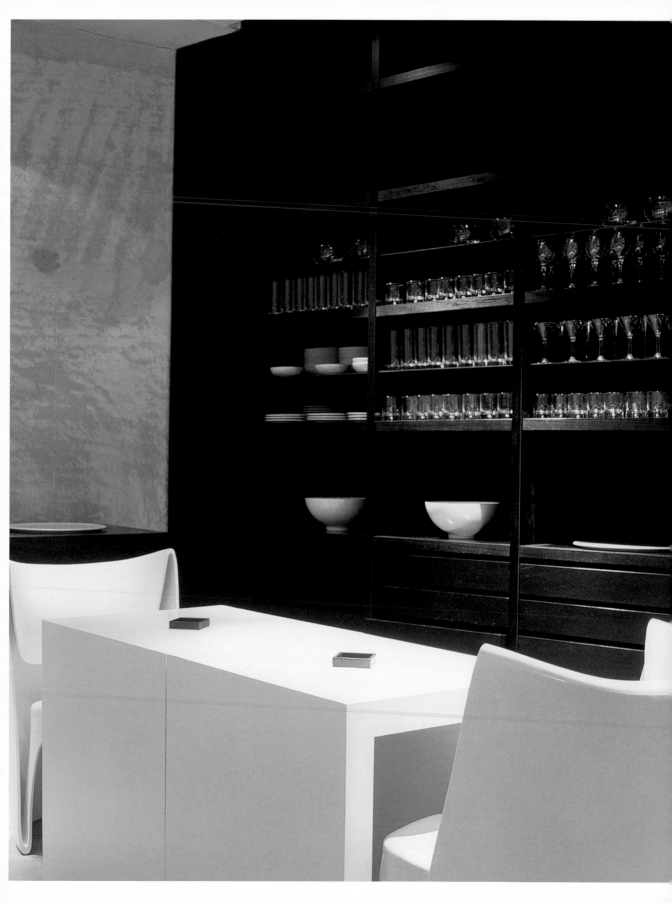

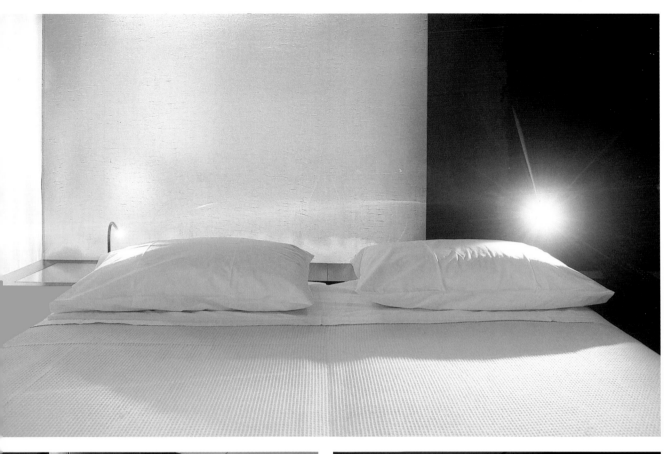

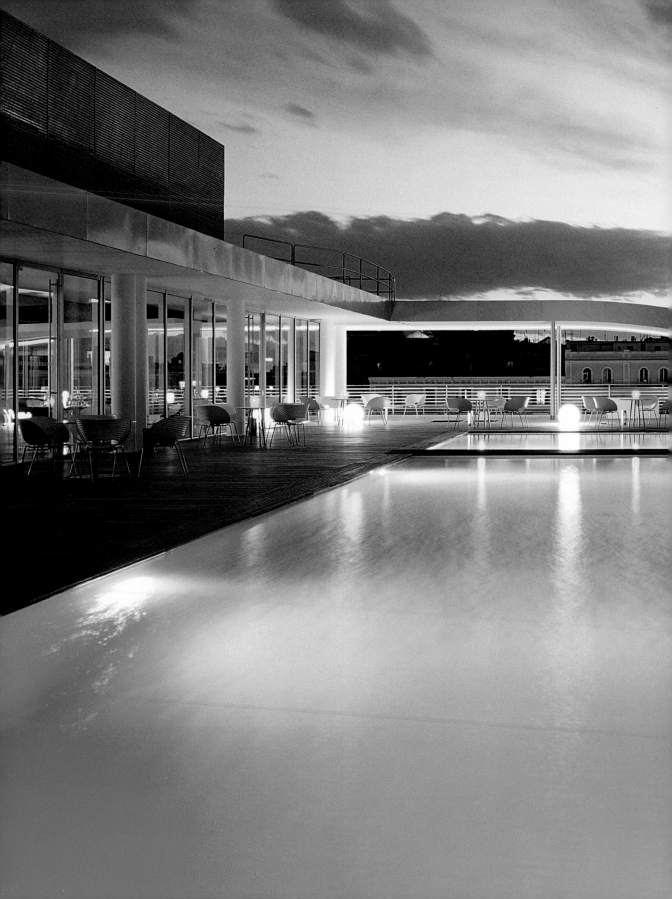

Via Turati 171, 00185 Rome, Italy Tel.: +39 06 444 841 Fax: +39 06 443 41396
info@eshotel.it www.eshotel.it

Es.Hotel Roma

Architects: King & Roselli Architetti Associati **Photographers:** © Santi Caleca and José King
Opening date: 2002 **Rooms:** 235 (including 27 suites)

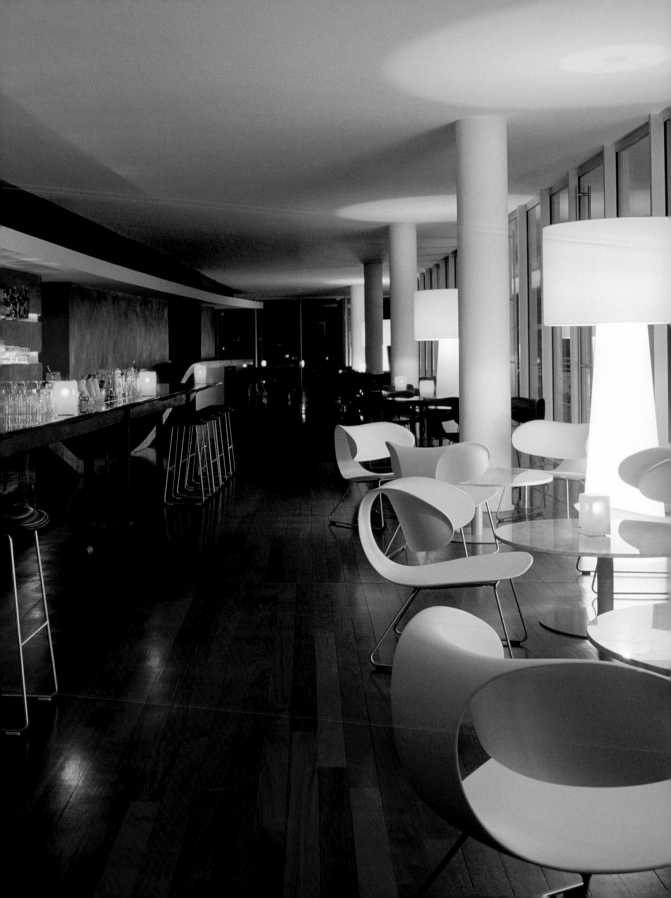

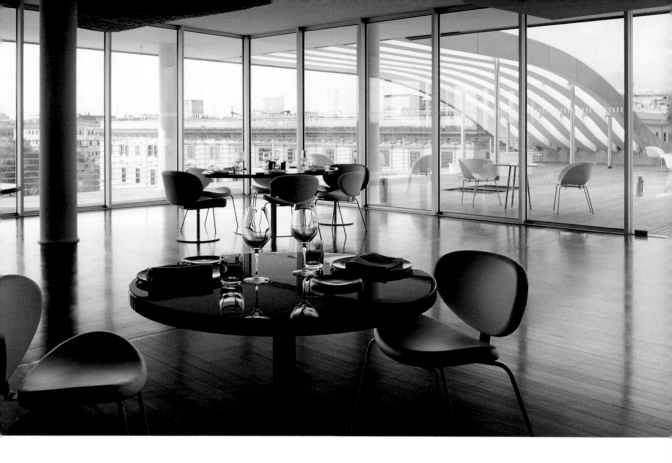

The objective of Es.Hotel is to cater to and satisfy the expectations of its guests with a new concept of luxury hotel where style, design and technology are at their service. The interior design also includes furnishings by Jean Nouvel.

Das Es.Hotel möchte seine Gäste verwöhnen und ihnen ein neues Konzept des Luxushotels anbieten, in dem Stil, Design und Technologie aufeinandertreffen. In den Räumen befinden sich einige Möbel, die von Jean Nouvel entworfen wurden.

Le but de l'Es.Hotel est de répondre et satisfaire les attentes de ses hôtes avec un nouveau concept d'hôtel de luxe, où le style, le design et la technologie sont à leurs services. Le design intérieur offre aussi quelques meubles dessinés par Jean Nouvel.

El objetivo del Es.Hotel es mimar y satisfacer las expectativas de sus huéspedes en un nuevo concepto de hoteles de lujo, en donde el estilo, el diseño y la tecnología se encuentran a su servicio. El diseño de interiores también incluye algunos muebles ideados por Jean Nouvel.

L'obiettivo dell'Es.Hotel è quello di coccolare i propri ospiti e soddisfare le loro aspettative grazie a un nuovo concetto di albergo di lusso, dove lo stile, il design e la tecnologia sono a loro completa disposizione. L'arredamento degli interni include pure alcuni mobili ideati da Jean Nouvel.

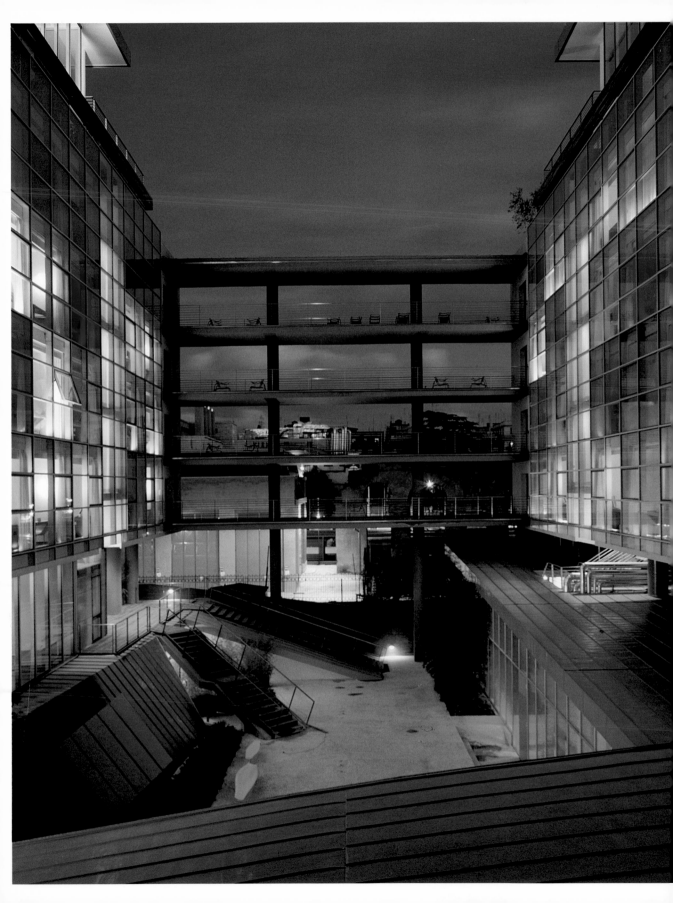

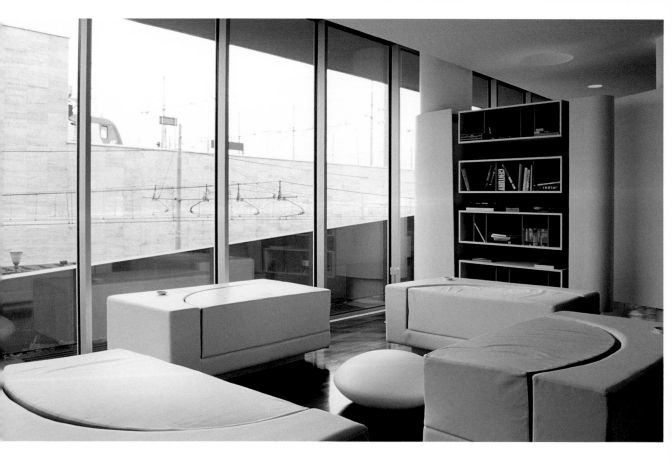

Plans

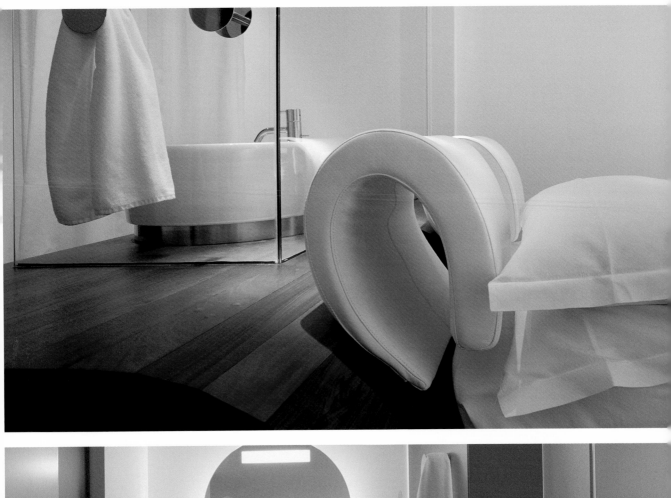
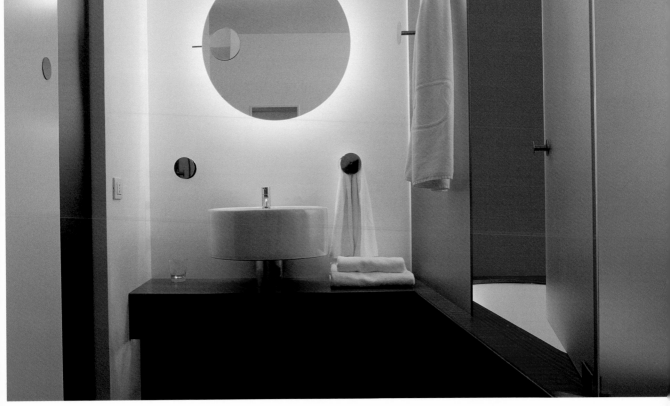

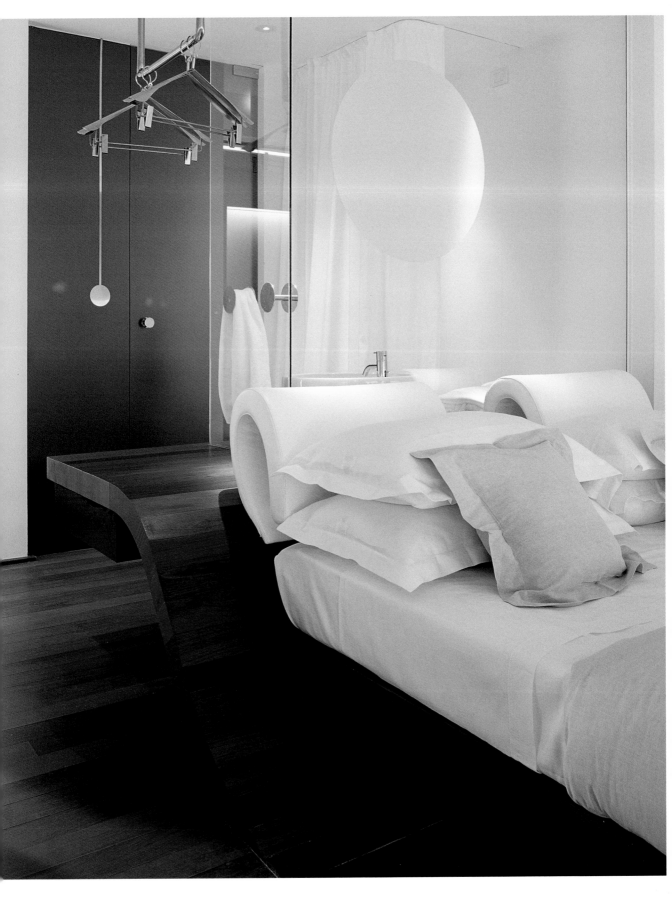

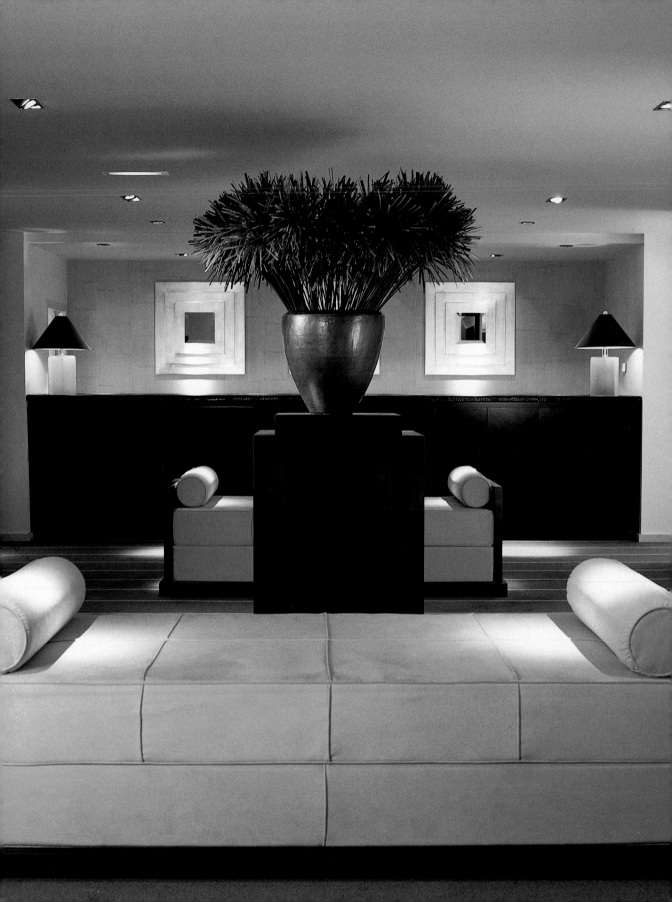

23 Avenue Des Papalins, 98000 Monte Carlo, Monaco Tel.: +377 92 05 9000 Fax: +377 92 05 9167
info@columbushotels.com www.columbushotels.com

Columbus Monaco

Designer: Amanda Rosa Photographer: © Richard Waite Opening date: 2001 Rooms: 181

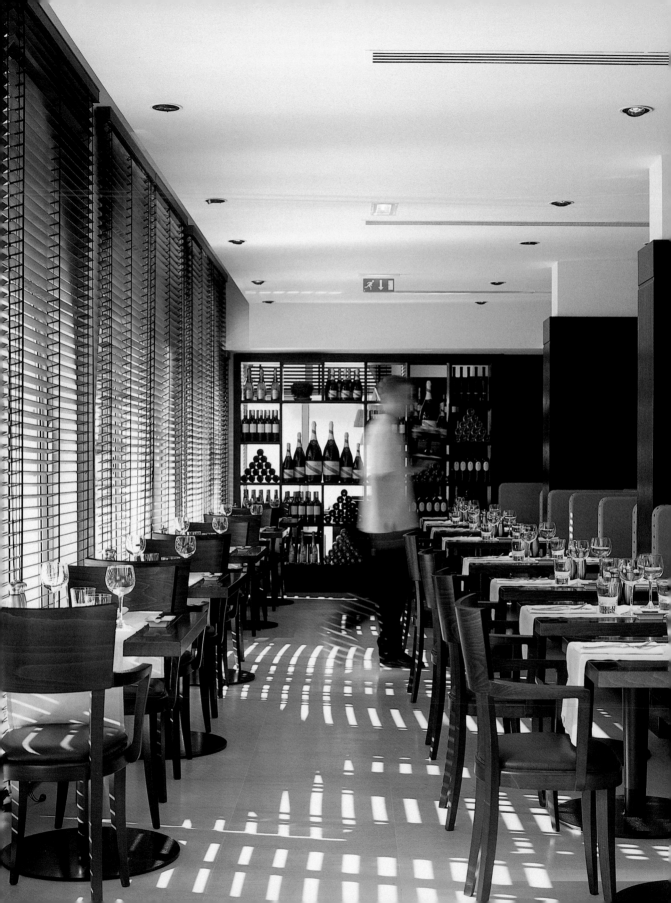

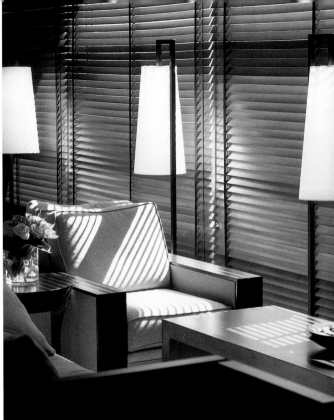

The bar and restaurant have a warm ambience, created by the natural light filtering through wooden shutters. All the furniture was designed especially for the hotel and many pieces can be purchased through the hotel gift shop.

Die Bar und das Restaurant wirken durch das Tageslicht, das durch die Holzjalousien dringt, sehr einladend. Alle Möbel wurden exklusiv für diese Räume entworfen und einige der Modelle können im Shop im gleichen Hotel erworben werden.

La lumière naturelle filtrée à travers les persiennes de bois confère au bar et au restaurant une ambiance chaleureuse. Le mobilier a été entièrement dessiné pour ce projet et il est possible d'en acquérir certaines pièces dans la boutique de l'hôtel.

El bar y el restaurante adquieren un ambiente cálido debido a la luz natural que se filtra a través de las persianas de madera. Todo el mobiliario se diseño especialmente para este proyecto y algunas piezas se pueden adquirir en la tienda del mismo hotel.

Il bar e il ristorante si riempiono di un'atmosfera calda e accogliente grazie alla luce naturale filtrata attraverso le persiane in legno. Tutta la mobilia è stata concepita appositamente per questo progetto e alcuni pezzi si possono acquistare presso il negozio dello stesso hotel.

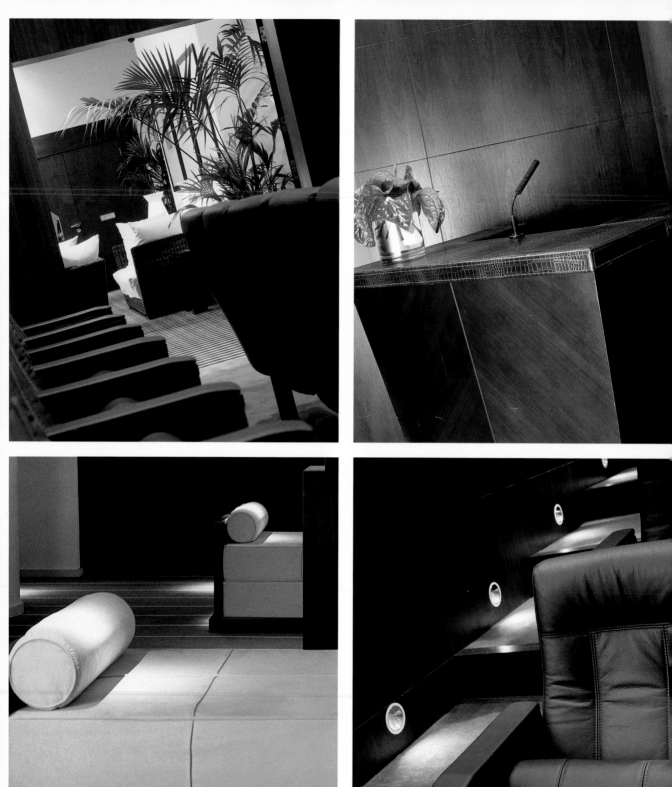

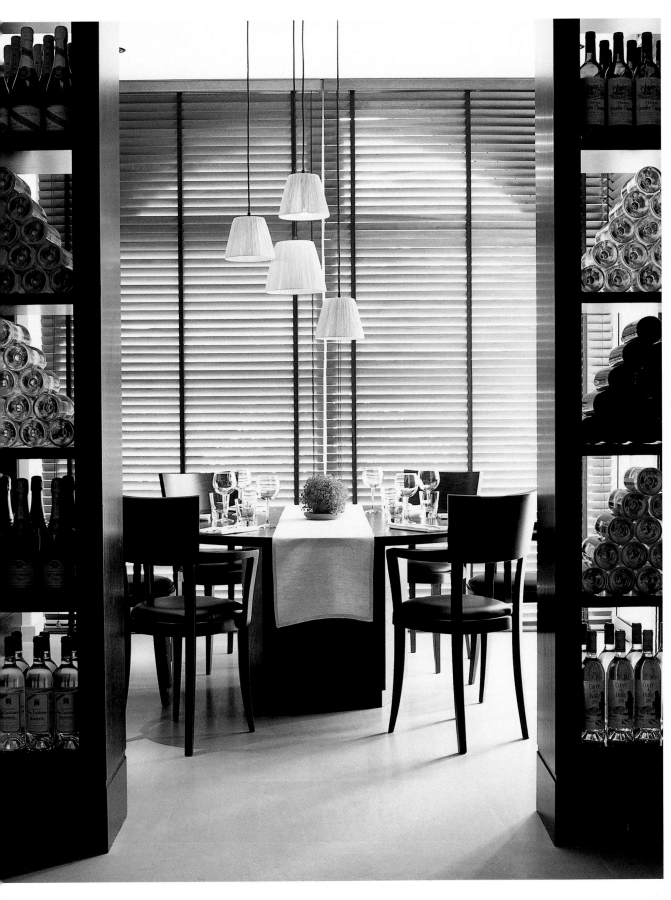

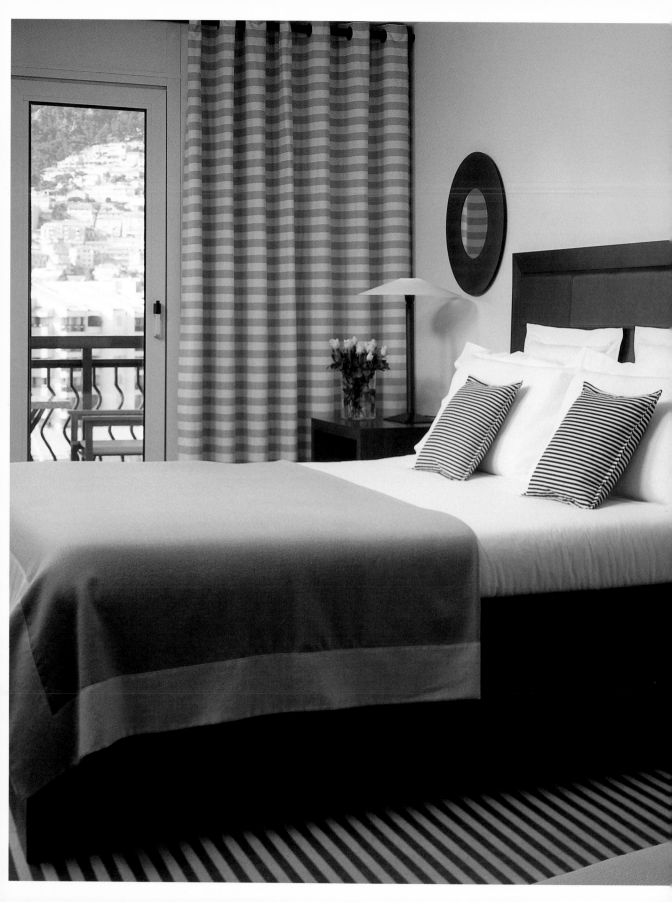

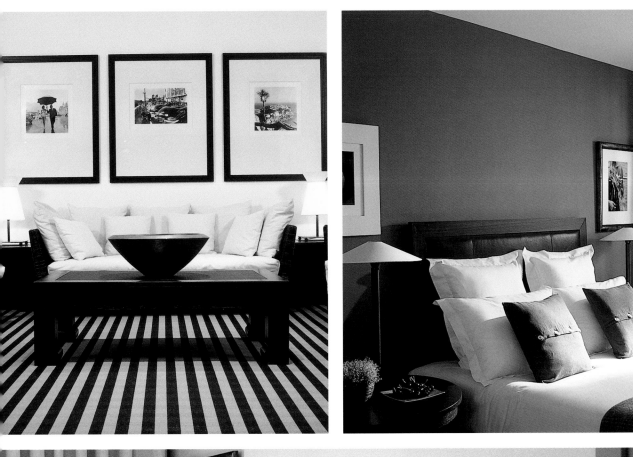
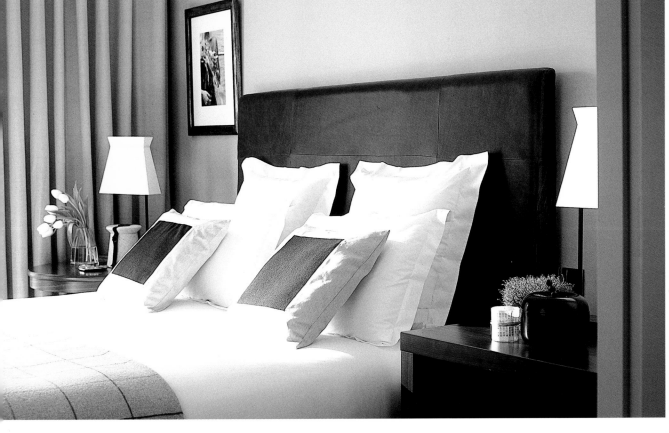

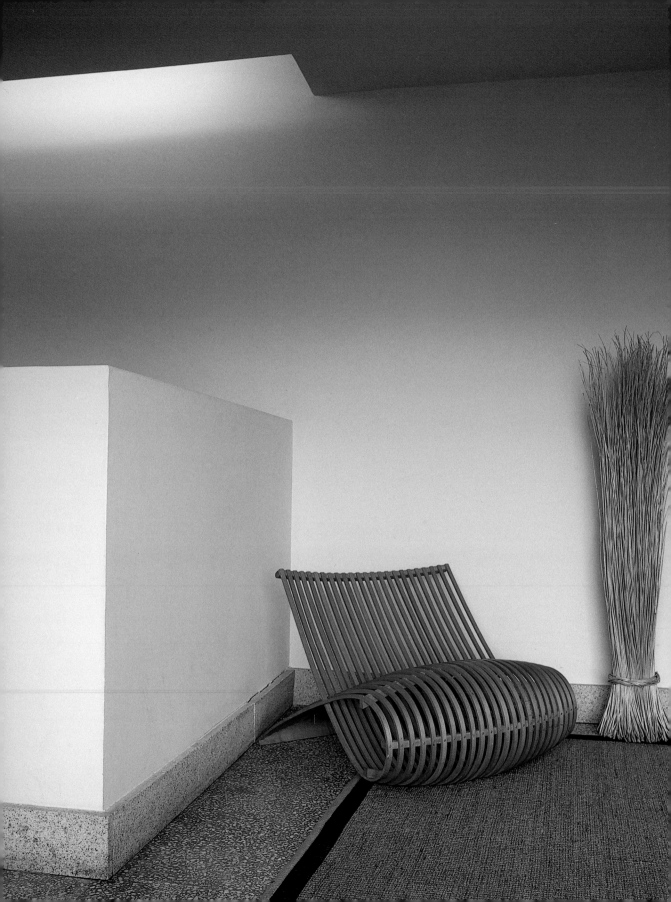

Mosteiro de Nossa Senhora da Rosa, 7430-999 Crato, Portugal Tel.: +35 124 599 7210
Fax: +35 124 599 7212 guest@pousadas.pt www.pousadasofportugal.com/portugal/crato.html

Flor da Rosa

Architect: Carrilho da Graça Photographer: © Pep Escoda Opening date: 1999 Rooms: 24

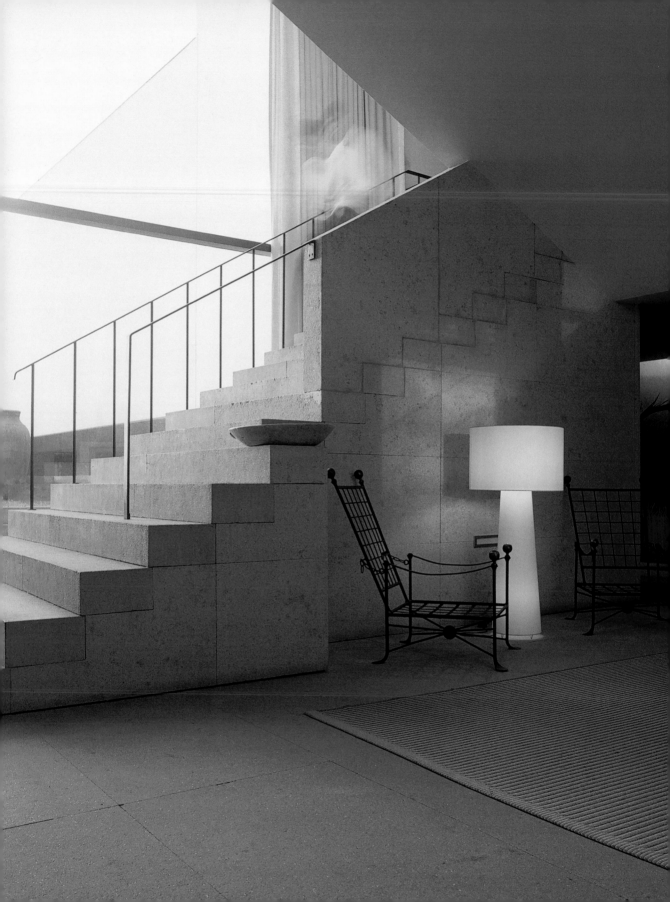

Some of the materials used in the annex are the same as those used in the original structure, such as the natural stone in the flooring, the iron for the banister, and some of the furniture, creating continuity between the buildings.

Einige der im Anbau verwendeten Materialien stimmen mit denen der Originalstruktur überein, zum Beispiel die Steine des Bodens, das Eisen der Geländer und die Materialien der Möbel, durch die eine Kontinuität zwischen den beiden Gebäuden entsteht.

Certains matériaux utilisés dans l'annexe sont analogues à ceux employés dans la structure originale, comme la pierre du sol, le fer de la main courante ou les matières du mobilier créant ainsi une unité entre les deux édifices.

Algunos materiales utilizados para el anexo coinciden con los que se emplearon en la estructura original, como la piedra del pavimento, el hierro del pasamanos o los materiales del mobiliario, creando una continuidad entre los dos edificios.

Alcuni materiali utilizzati per l'annesso coincidono con quelli adoperati nella struttura originale, come la pietra del pavimento, il ferro del passamano o i materiali dei mobili, creando pertanto una continuità tra i due edifici.

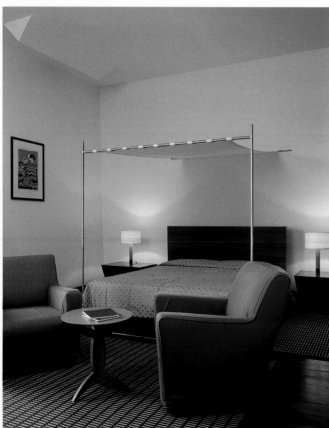
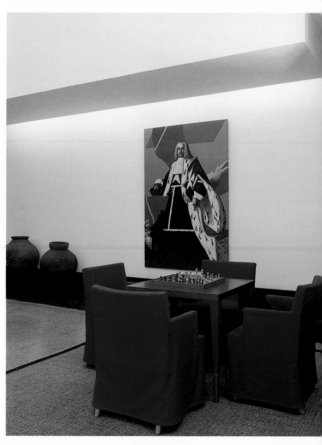

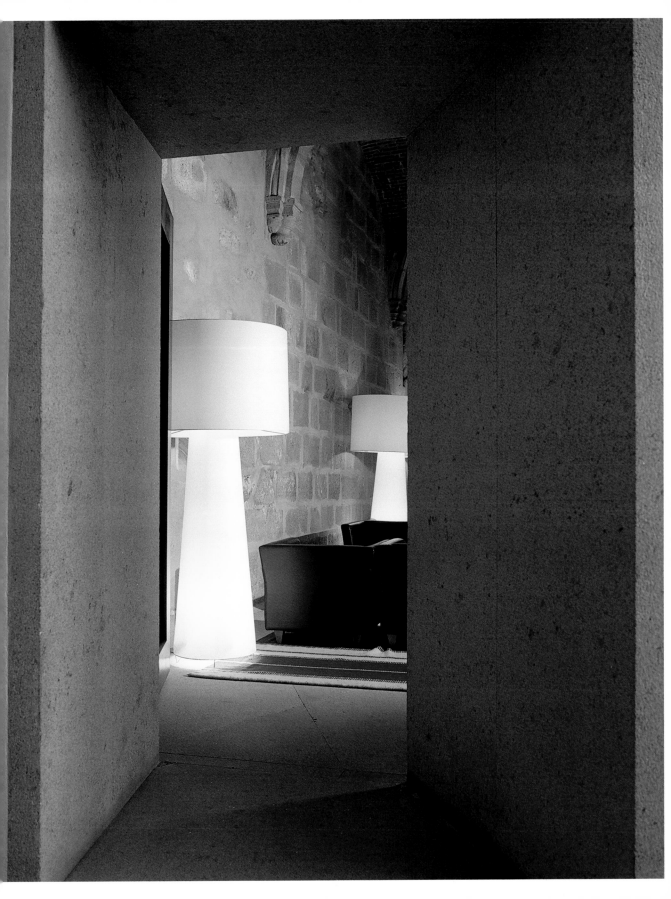

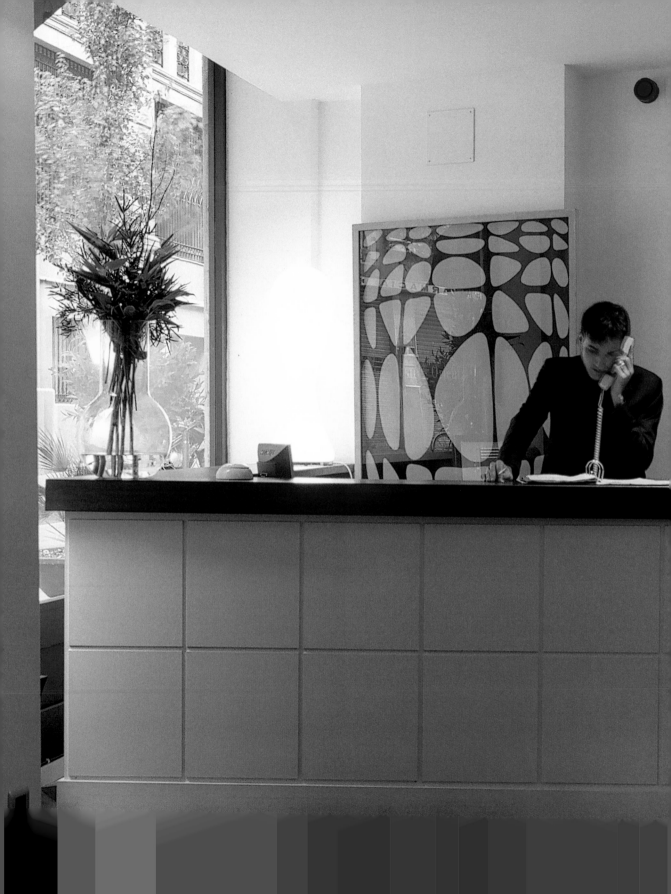

Carrer Argenteria 37, 08003 Barcelona, Spain Tel.: +34 93 268 8460 Fax: +34 93 268 8461
reservas@hotelbanysorientals.com www.hotelbanysorientals.com

Banys Orientals

Designer: Lázaro Rosa Violán Photographer: © Pere Planells Opening date: 2002 Rooms: 43

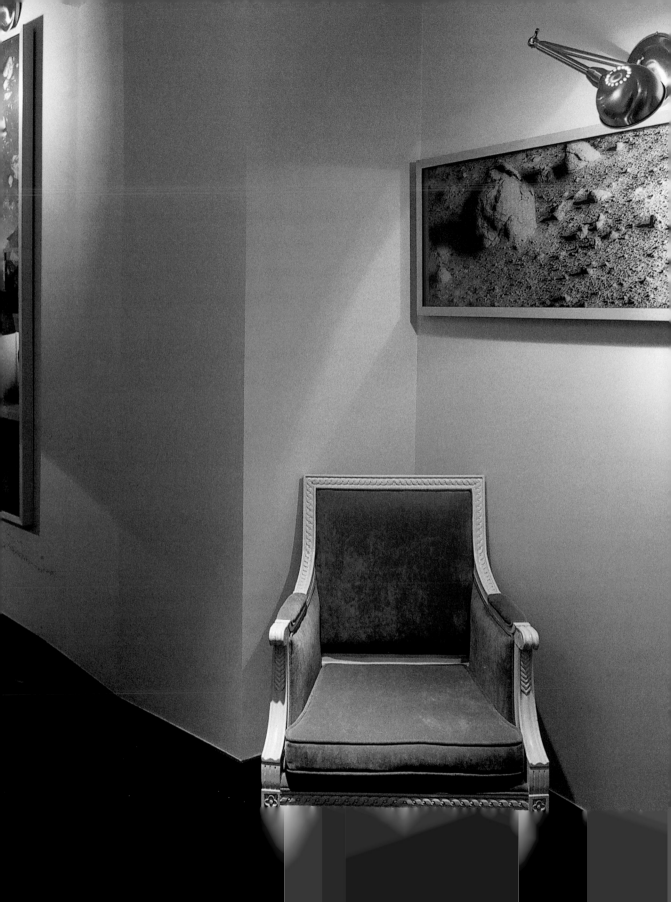

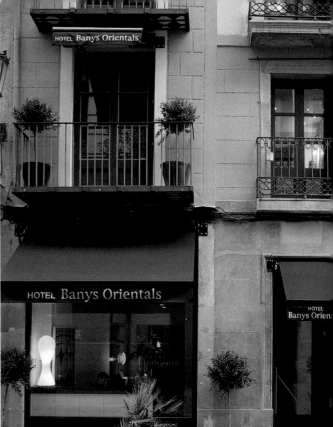

Old engravings of Eastern architecture and large-scale photos of the surface of the moon hang in the hallways. Although historical references are present, hotel guests find themselves in a modern, timeless space.

Alte Stiche der Architektur des Ostens und großformatige Fotografien der Mondoberfläche dienen als Dekoration der Flure. Trotz der historischen Anspielungen herrscht in dem Hotel eine moderne und zeitlose Atmosphäre vor.

Les couloirs sont ornés de gravures antiques de l'architecture de l'Est et de photographies à grande échelle de la surface lunaire. Fort de ses références historiques, l'hôtel garde toutefois une ambiance moderne et intemporelle.

Los grabados antiguos de la arquitectura del Este y las fotografías a gran escala de la superficie lunar adornan los pasillos de este edificio. A pesar de las referencias históricas, el hotel mantiene un ambiente moderno e intemporal.

Antiche incisioni dell'architettura orientale e fotografie a grande scala della superficie della luna adornano i corridoi. Nonostante i riferimenti storici, l'hotel mantiene un ambiente moderno e atemporale.

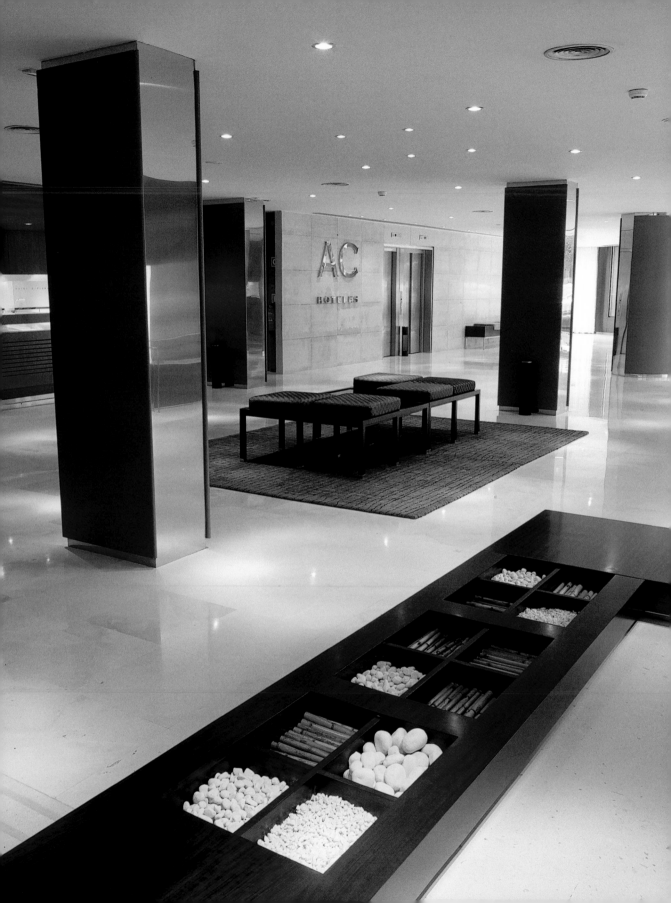

Carrer Pau Claris 122, 08009 Barcelona, Spain Tel.: +34 93 272 3810 Fax: +34 93 272 3811
diplomatic@ac-hotels.com www.ac-hotels.com

Hotel AC Diplomatic

Architects: GCA Arquitectes Associats **Photographer:** © Jordi Miralles
Opening date: 1999 **Rooms:** 211

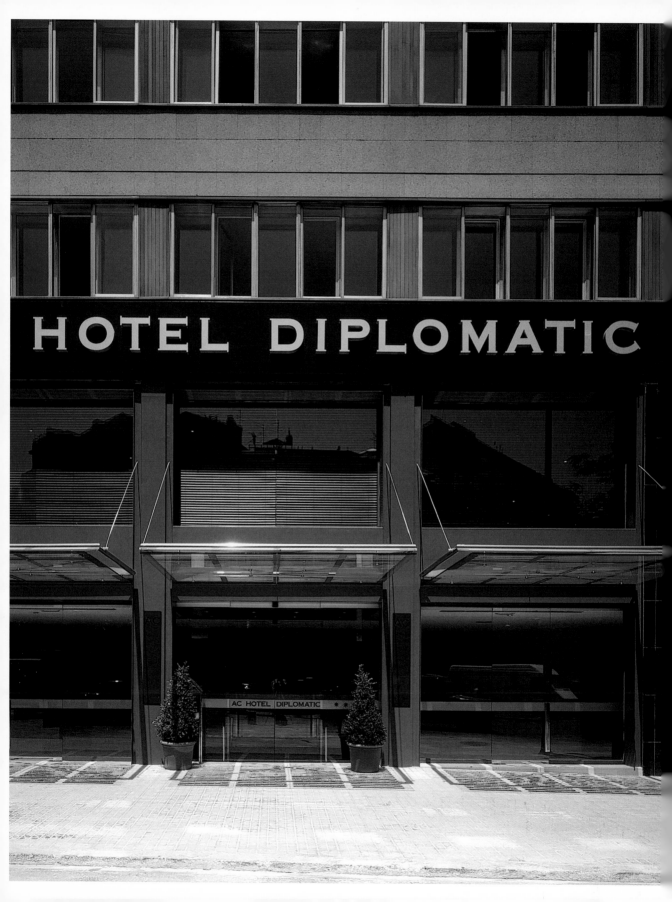

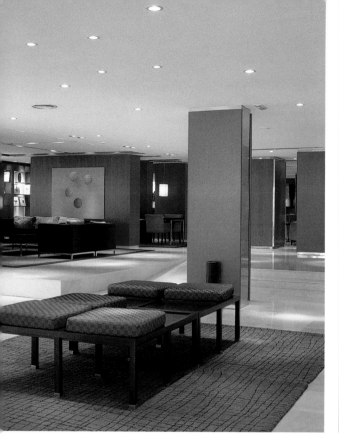
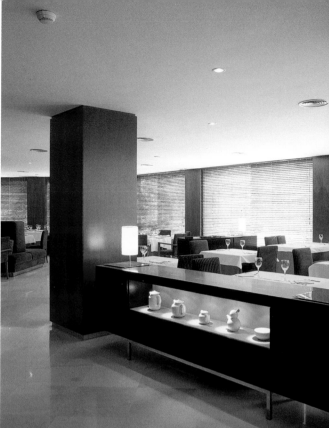

The furnishings that divide the various areas of the bar include display cabinets made of dark wood that also serve as sources of indirect light for the surrounding space.

Die Möbel, die die verschiedenen Bereiche der Bar unterteilen, sind Vitrinen aus dunklem Holz, die gleichzeitig für die indirekte Beleuchtung genutzt werden.

Les différents espaces du bar sont organisés autour de vitrines encadrées de bois foncé qui sont aussi sources de lumière indirecte dans ce lieu de vie.

Los muebles que dividen las diferentes estancias del bar son vitrinas de madera oscura que al mismo tiempo funcionan como fuentes de iluminación indirecta del espacio.

I mobili che dividono i diversi ambienti del bar sono teche di legno oscuro che al tempo stesso fungono da fonti di illuminazione indiretta dello spazio.

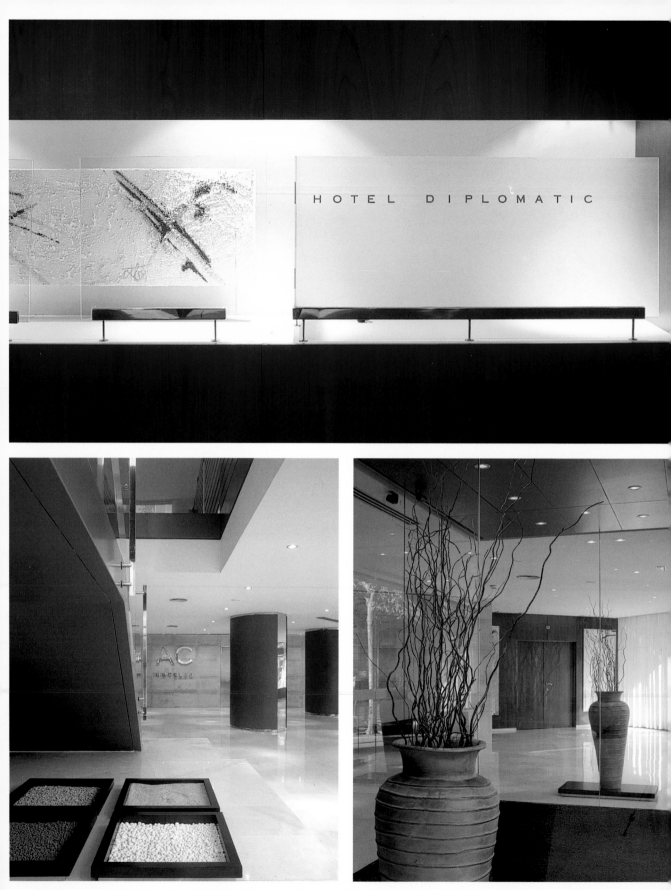

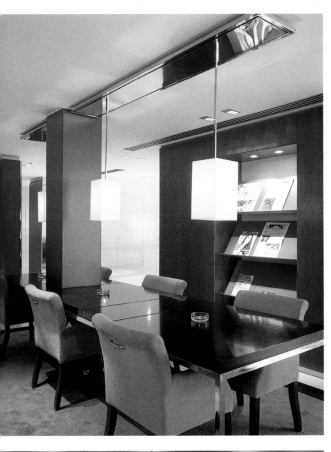

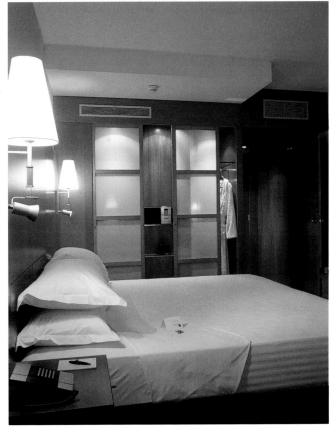

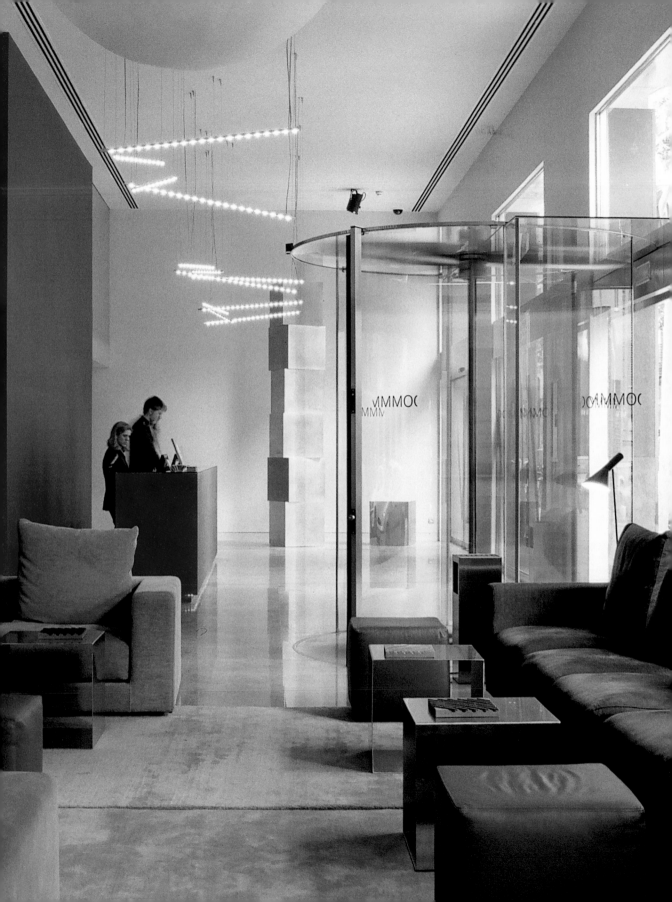

Carrer Rosselló 265, 08008 Barcelona, Spain Tel.: +34 93 445 4000 Fax: +34 93 445 4004
www.hotelomm.es

Hotel Omm

Architects: Juli Capella and Miquel García (collaborating architect)
Interior Designers: Sandra Tarruella and Isabel López **Photographer:** © Pere Planells **Opening date:** 2003
Rooms: 52 doubles, 6 penthouses and 1 suite

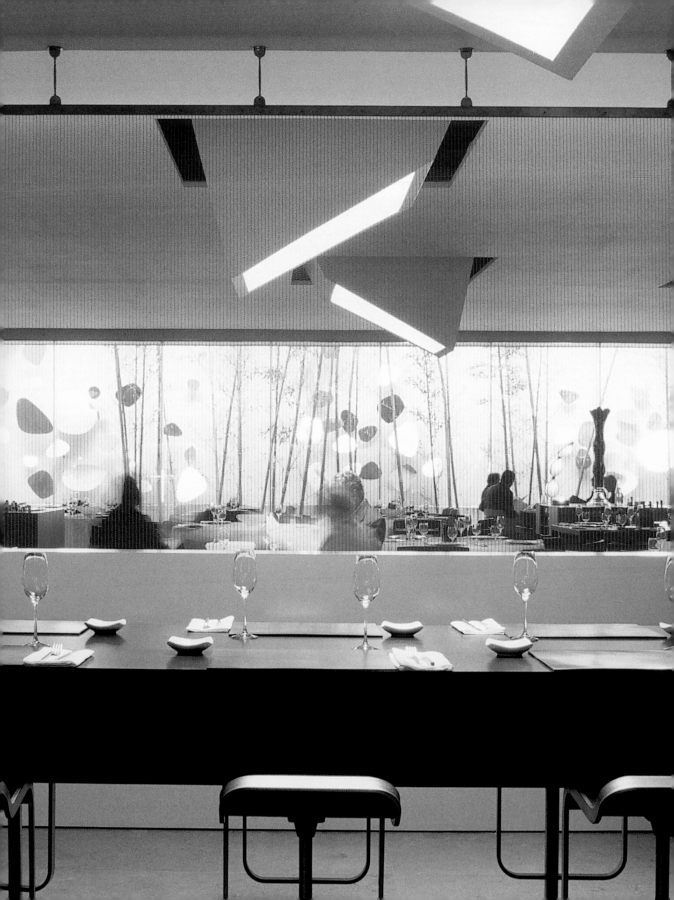

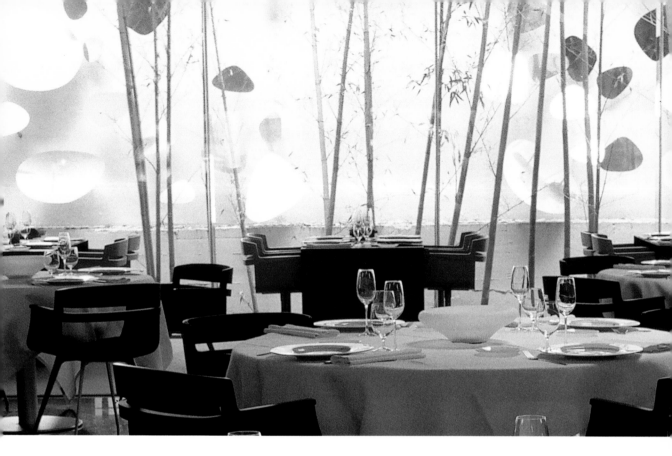

The choice of the name of 0mm, the mantric syllable recited as an aid to meditation, defines this hotel, conceived as a serene and relaxing setting that tends to focus on the essential and forswear luxury and ostentation.

Der Name 0mm, die Silbe eines Mantras, das man während der Meditation rezitiert, definiert dieses Hotel. Hier entstand eine gelassene und entspannende Atmosphäre, die das Grundlegende sucht und auf Luxus und Zurschaustellung verzichtet.

Le choix du nom 0mm, syllabes symboliques du mantra, récitation propice à la méditation, caractérise cet hôtel, conçu pour créer une ambiance sereine et relaxante qui tente à chercher l'essentiel faisant abstraction du luxe et de l'étalage ostentatoire.

La elección del nombre de 0mm, sílaba del mantra recitada como apoyo a la meditación, define este hotel, concebido para crear un ambiente sereno y relajante que tiende a buscar lo esencial prescindiendo del lujo y la ostentación.

La scelta del nome 0mm, sillaba del mantra recitata come supporto alla meditazione, definisce lo spirito di questo hotel, concepito per creare un ambiente sereno e rilassante che tende a cercare l'essenziale tralasciando il lusso e l'ostentazione.

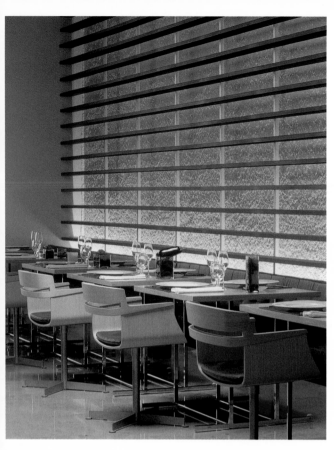
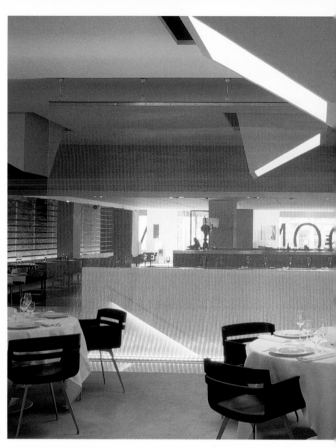
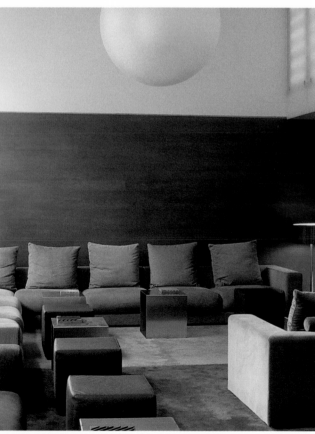
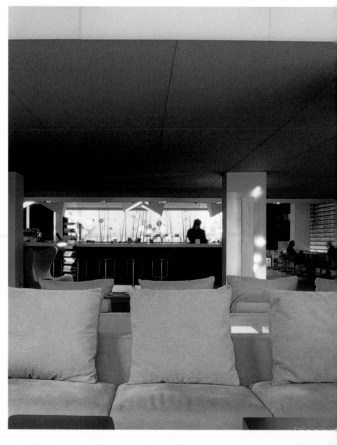

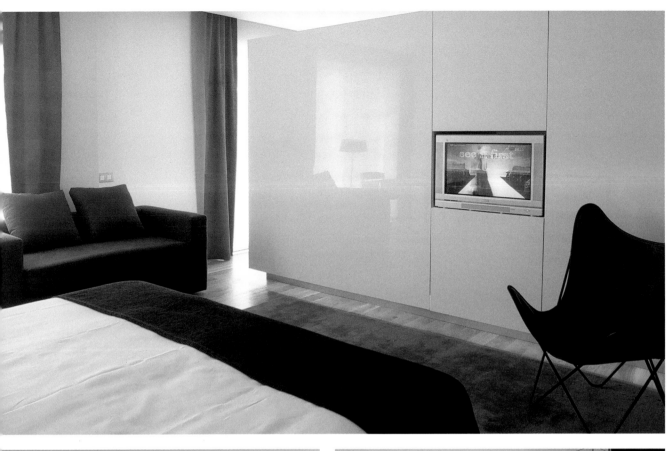

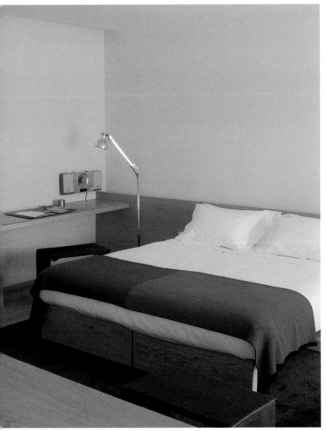

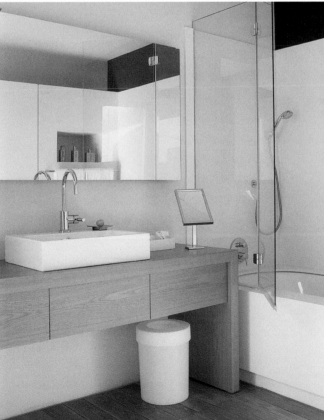

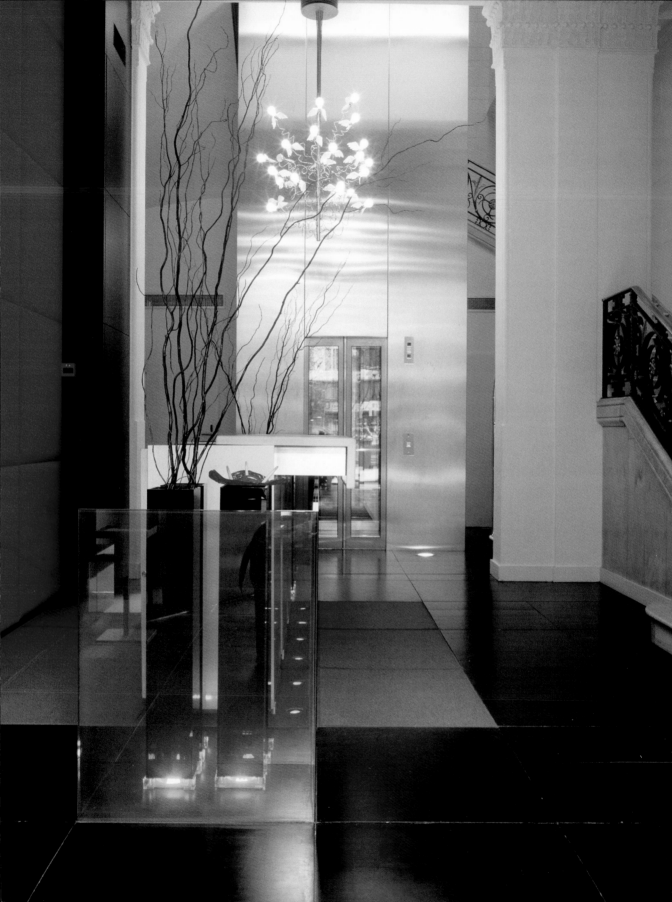

Paseo de Gracia 62, 08007 Barcelona, Spain Tel.: +34 93 272 4180 Fax: +34 93 272 4181
paseodegracia@prestigehotels.com www.prestigepaseodegracia.com

Hotel Prestige
Paseo de Gracia

Architects: GCA Arquitectes Associats, Josep Juanpere Miret (associate architect) and
María Vives Ybern (project director) **Photographer:** © Jordi Miralles **Opening date:** 2002
Rooms: 45 (including 2 suites)

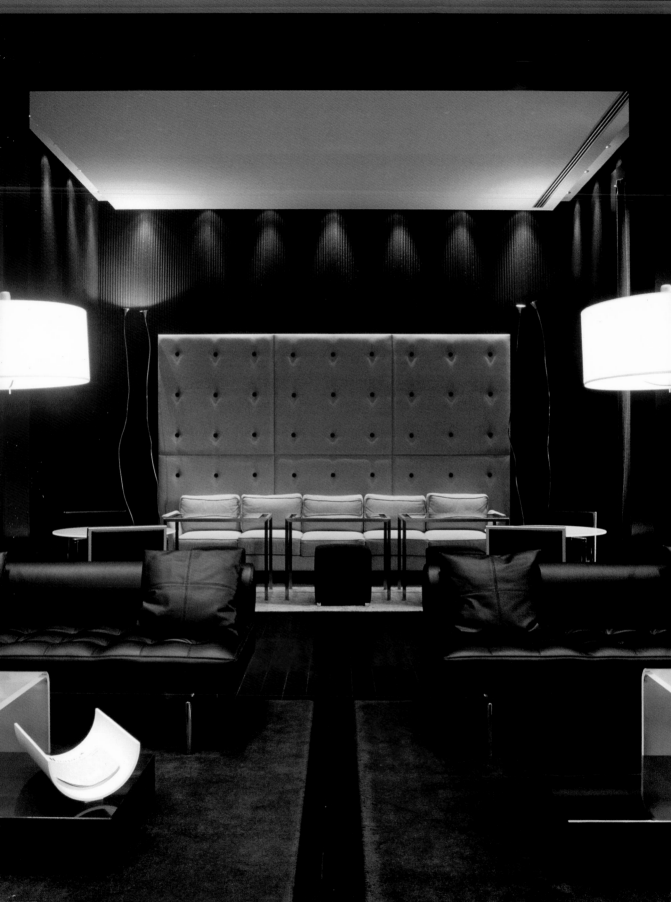

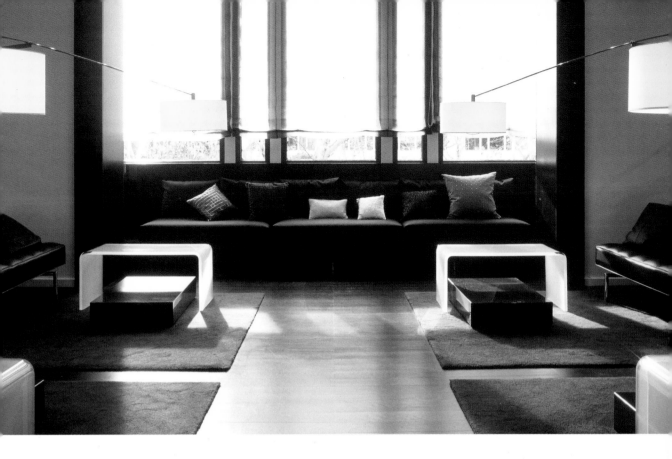

From the start the attempt was to combine architecture and design as distinguishing features. The furniture of uncommon dimensions that accentuates the high ceilings, and superimposed beams of light, help to imbue it with a very warm atmosphere.

Von Anfang an sollte aus dem Zusammenspiel von Architektur und Innenarchitektur etwas Besonderes werden. Möbel mit außergewöhnlichen Proportionen unterstreichen die Höhe der Räumlichkeiten und schaffen eine einladende Atmosphäre, die durch Lichteffekte unterstrichen wird.

L'idée de départ était de conjuguer architecture et design pour créer un espace différent. Des meubles aux proportions peu habituelles rehaussent la hauteur significative de l'espace créant une atmosphère accueillante par le jeu de tâches de lumière superposées.

Desde el principio se optó por conjugar arquitectura y diseño como objetivo diferencial. Los muebles de inusuales dimensiones acentúan la altura de los techos y crean una acogedora atmósfera con la ayuda de manchas de luz superpuestas.

Dall'inizio si è scelto di conciliare architettura e design come tratto differenziale. Mobili dalle dimensioni poco correnti mettono in risalto la gran altezza dello spazio creando un'atmosfera accogliente, mediante delle macchie di luce sovrapposte.

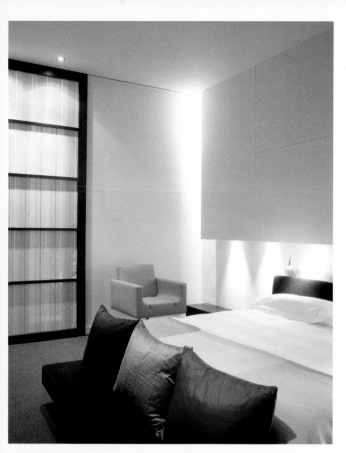

First floor

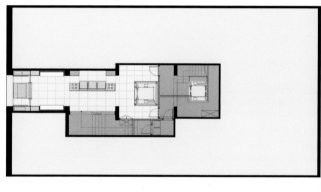

Mezzanine

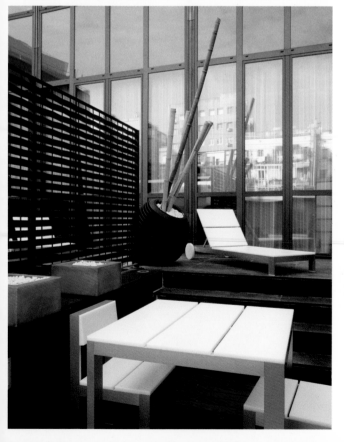

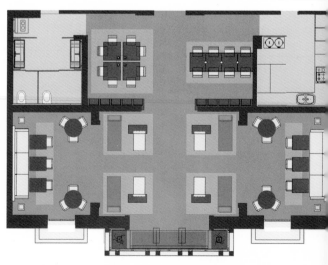

Ground floor

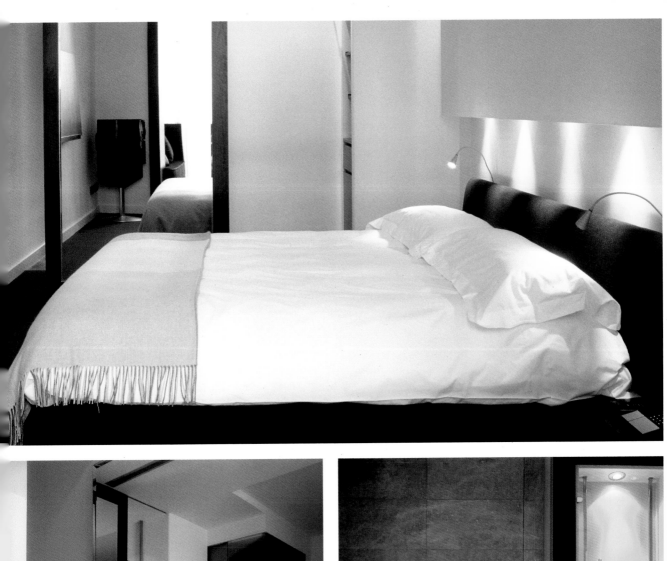
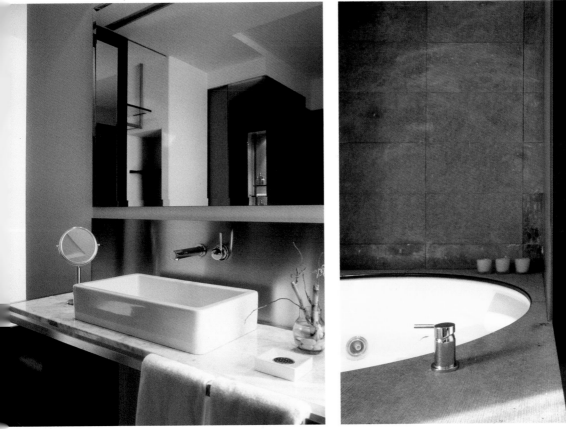

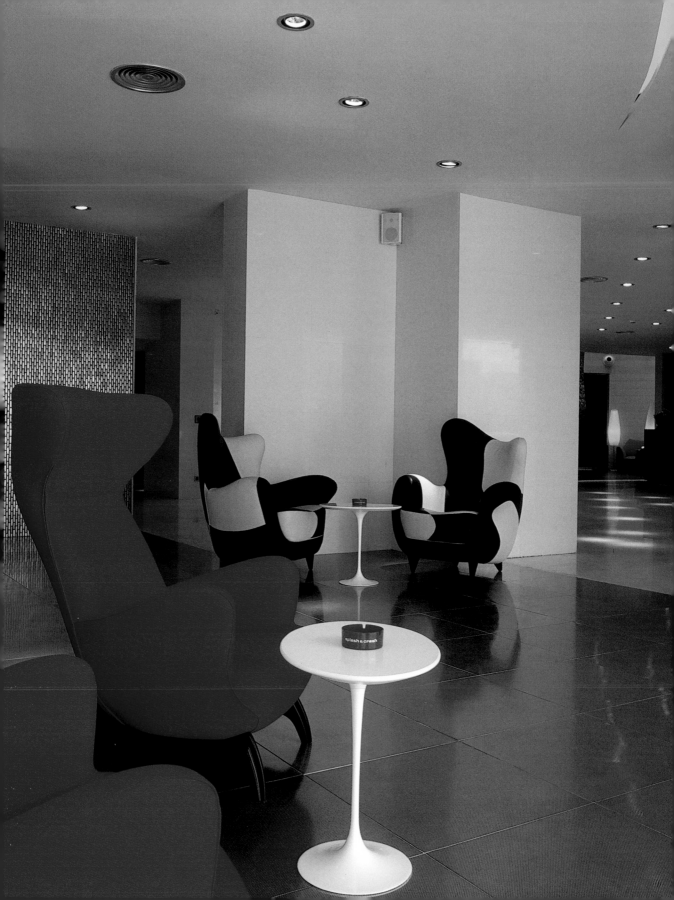

Kalea Alameda de Mazarredo 61, 48009 Bilbao, Spain Tel.: +34 94 425 3300 Fax: +34 94 425 3301
www.hoteles-silken.com

Gran Domine

Architect: Iñaki Aurrecoetxea **Designer:** Javier Mariscal **Photographer:** © Pep Escoda
Opening date: 2002 **Rooms:** 145 (including 10 suites)

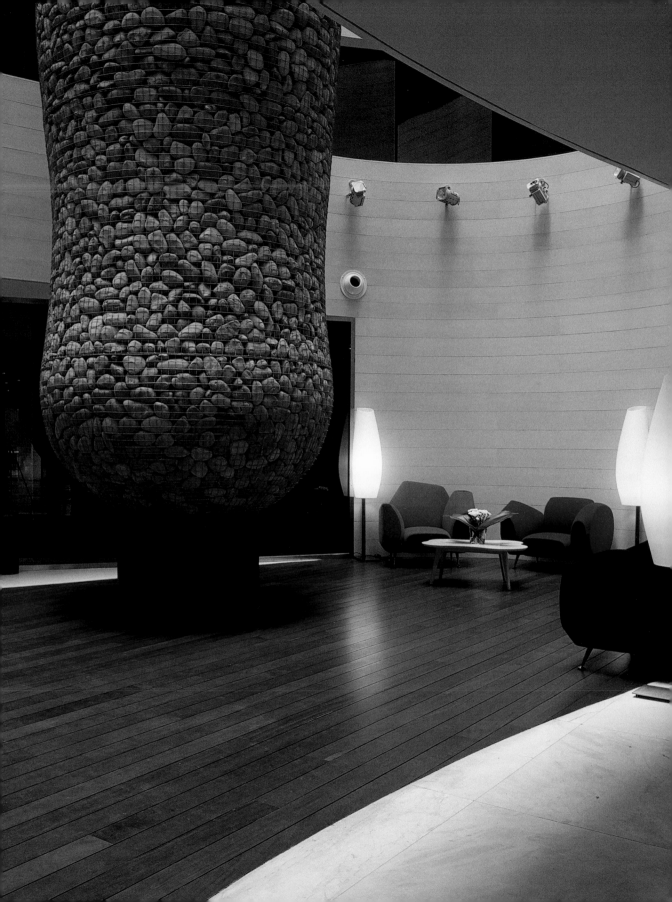

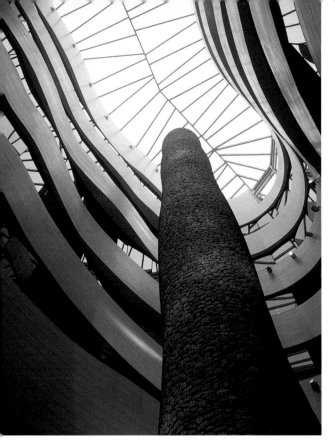

Perhaps the most emblematic element here is the "Ciprés Fósil", a large sculpture of stone and metal mesh that rises up the entire height of the central atrium.

Wahrscheinlich ist das emblematischste Element dieses Hotels die „Ciprés Fósil", eine Skulptur aus Stein und Metallnetz, die aus der Empfangshalle bis zum obersten Stockwerk des Gebäudes ragt.

Le « Ciprés Fósil », sculpture de pierre et maille métallique érigée dans le vestibule jusqu'au dernier étage de l'édifice, est sans doute l'élément le plus emblématique de l'hôtel.

Quizás el elemento más emblemático del hotel sea el "Ciprés Fósil", una escultura de piedra y malla metálica que se erige en el vestíbulo hasta el último piso del edificio.

Forse l'elemento più emblematico dell'hotel è il "Ciprés Fósil", una scultura in pietra e maglia metallica che si erge nella hall fino all'ultimo piano dell'edificio.

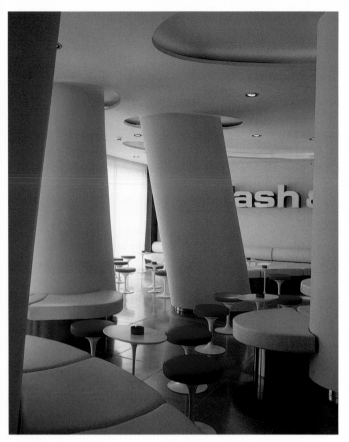
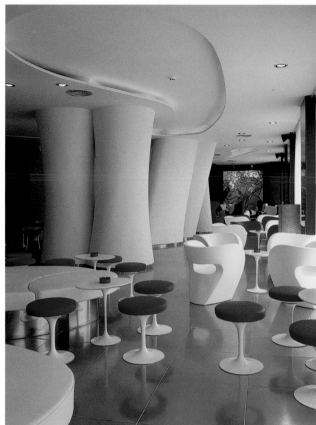

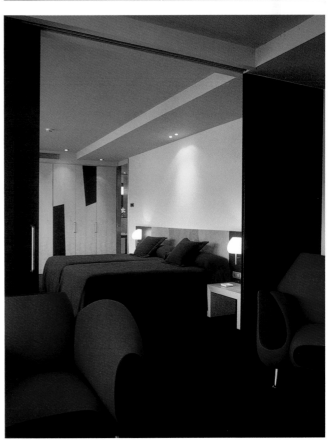

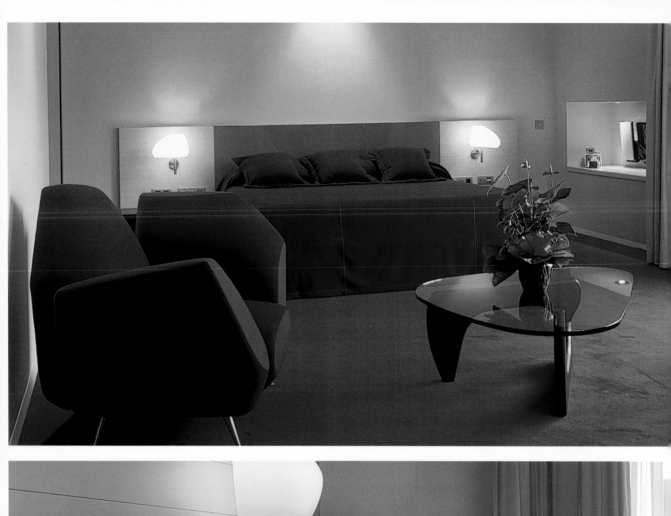
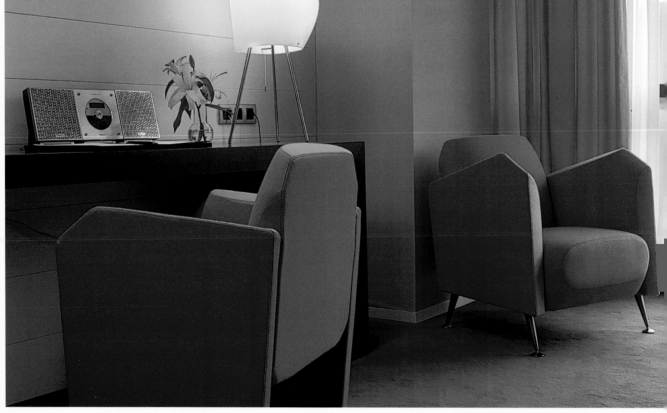

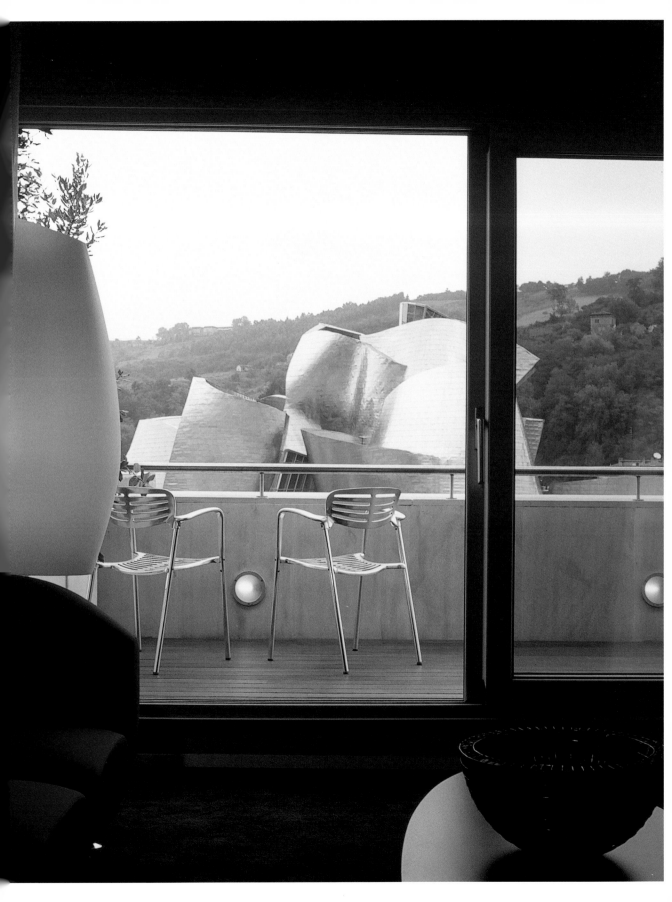

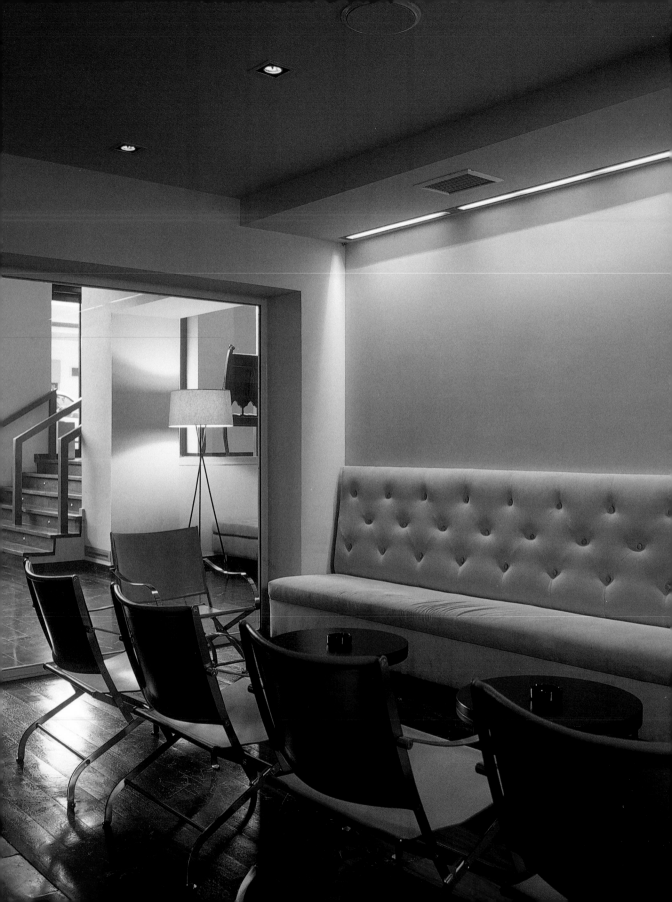

Kalea Alameda de Mazarredo 77, 48009 Bilbao, Spain Tel.: +34 94 661 1880 Fax: +34 94 491 4320
www.mirohotelbilbao.com

Miróhotel

Architect: Carmen Abad **Interior Designer:** Pilar Líbano **Designer:** Antonio Miró
Photographer: © Pep Escoda **Opening date:** 2002 **Rooms:** 50

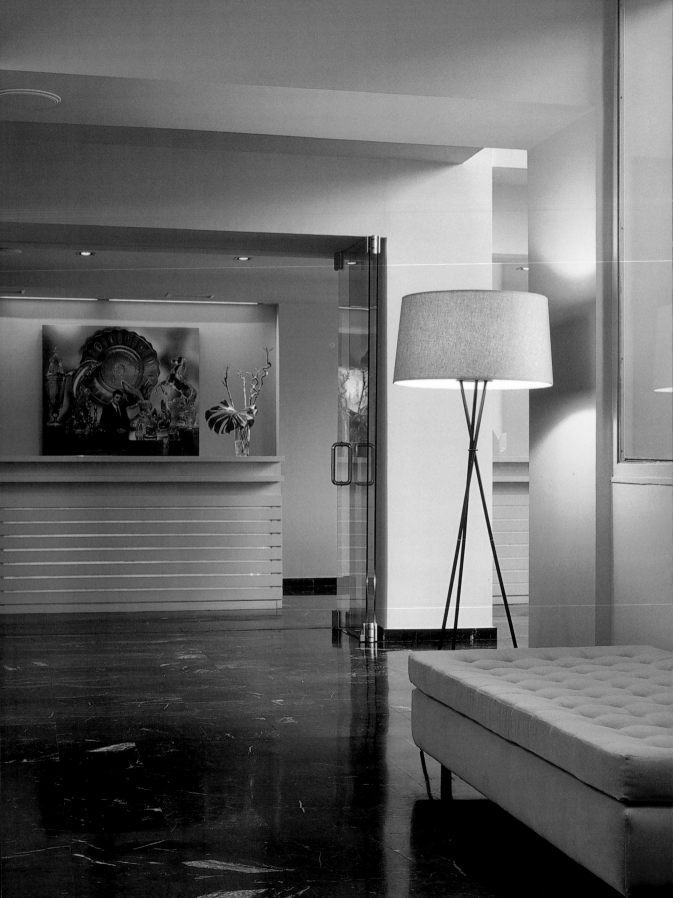

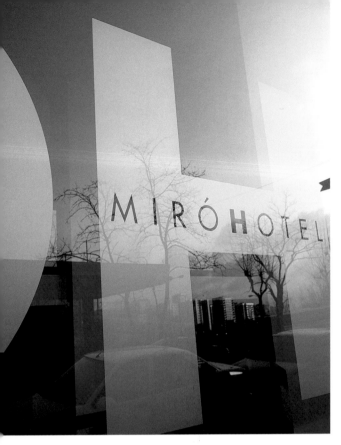
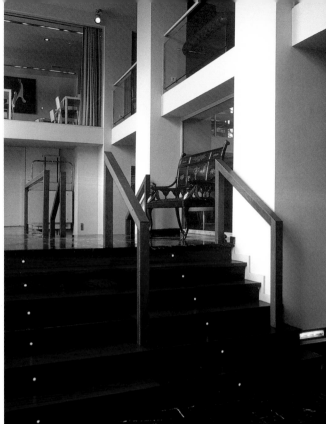

Miróhotel is a decidedly cutting-edge and modern space where practicality and discretion stand out. In order to achieve this, an almost monochromatic palette was chosen and occasionally contrasted by bright colors and eye-catching shapes.

Miróhotel ist eine sehr moderne Anlage, die sich durch Funktionalität und Diskretion auszeichnet. Dieser Effekt wurde durch eine fast einfarbige Gestaltung erreicht, die durch Farbtupfer in vibrierenden Tönen und auffälligen Formen unterbrochen wird.

Miróhotel est un projet extrêmement moderne où règnent fonctionnalité et discrétion. Ceci a été possible grâce à l'emploi d'une seule couleur, ou presque, émaillée de teintes vibrantes et de formes étonnantes.

Miróhotel es un proyecto decididamente moderno en el que destacan la funcionalidad y la discreción. Esto se consiguió a través de la utilización de un solo color salpicado de colores vibrantes y formas llamativas.

Miróhotel è un progetto decisamente moderno dove spiccano la funzionalità e la discrezione ottenute mediante l'uso di tonalità quasi monocromatiche costellate da colori vibranti e forme appariscenti.

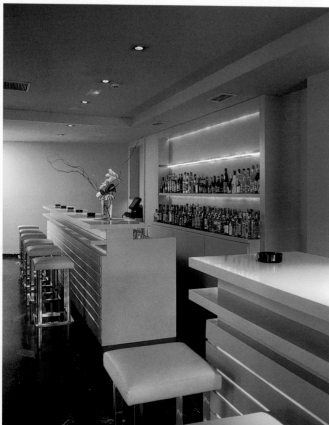

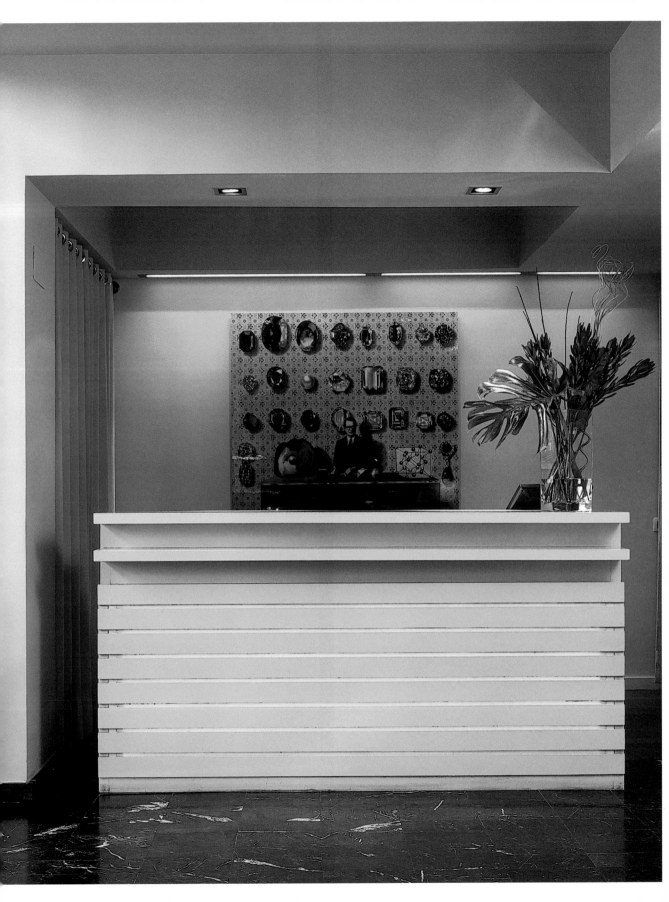

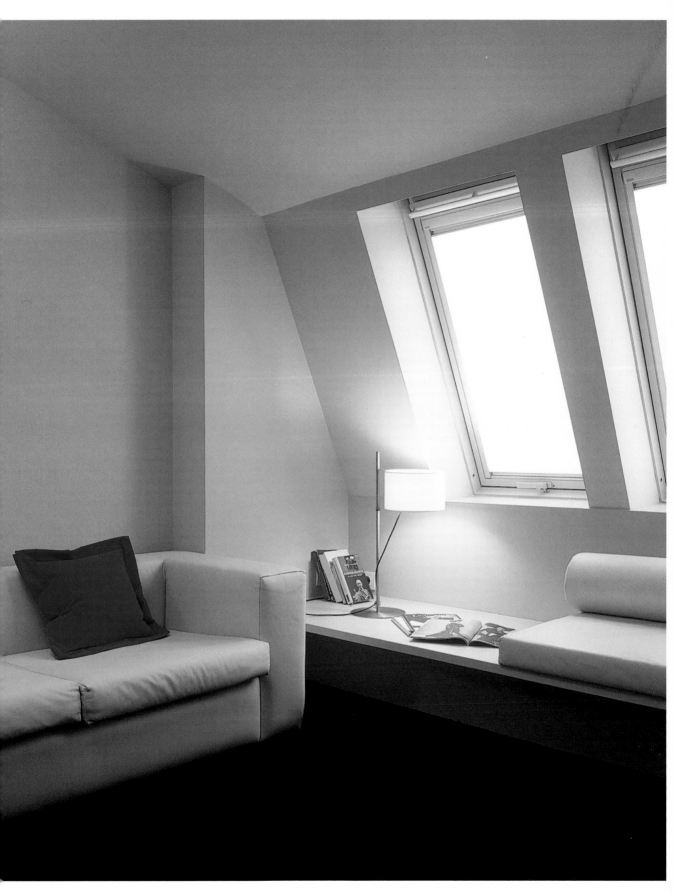

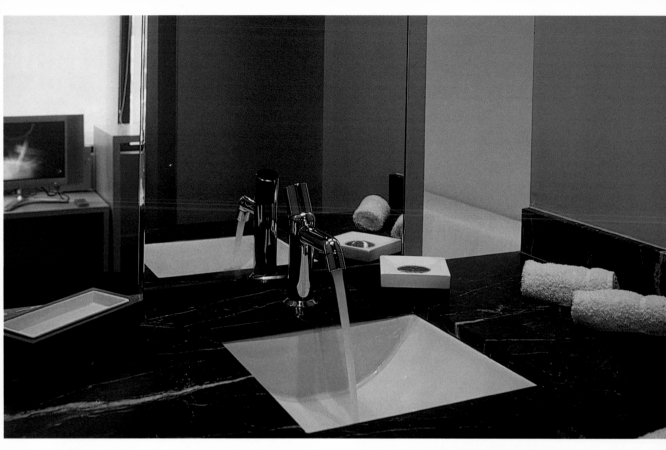

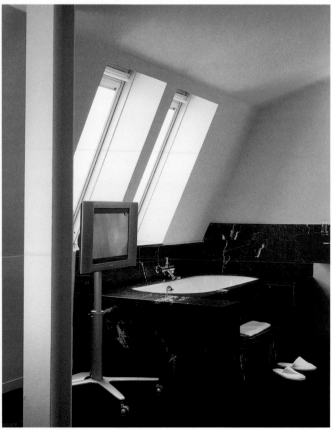

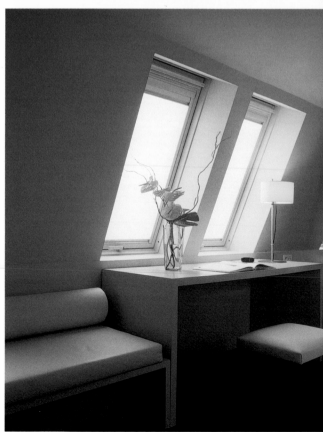

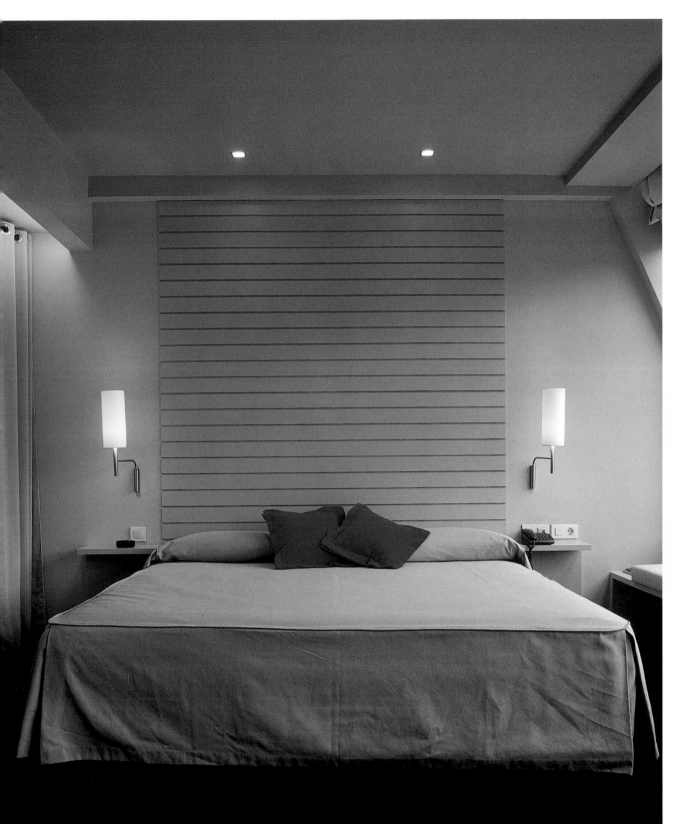

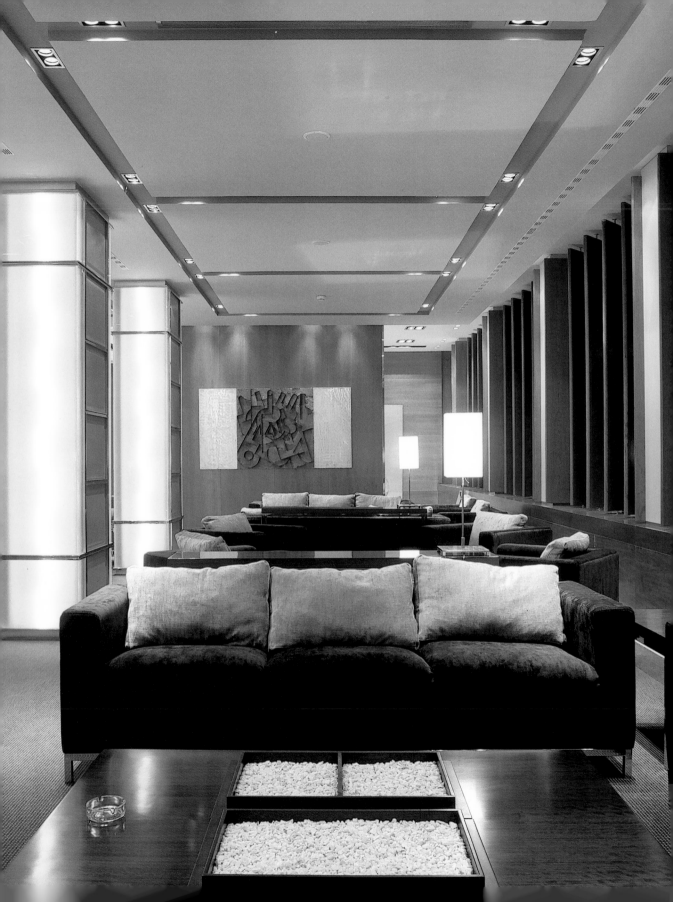

Paseo de la Castellana 152, 28046 Madrid, Spain Tel.: +34 91 4584 970 Fax: +34 91 4584 971
www.ac-hoteles.com

Hotel Aitana

Architects: GCA Arquitectes Associats **Interior Designer:** Flora Rafel **Photographer:** © Jordi Miralles
Opening date: 1999 **Rooms:** 112 (including 24 for non-smokers). Services for the disabled available

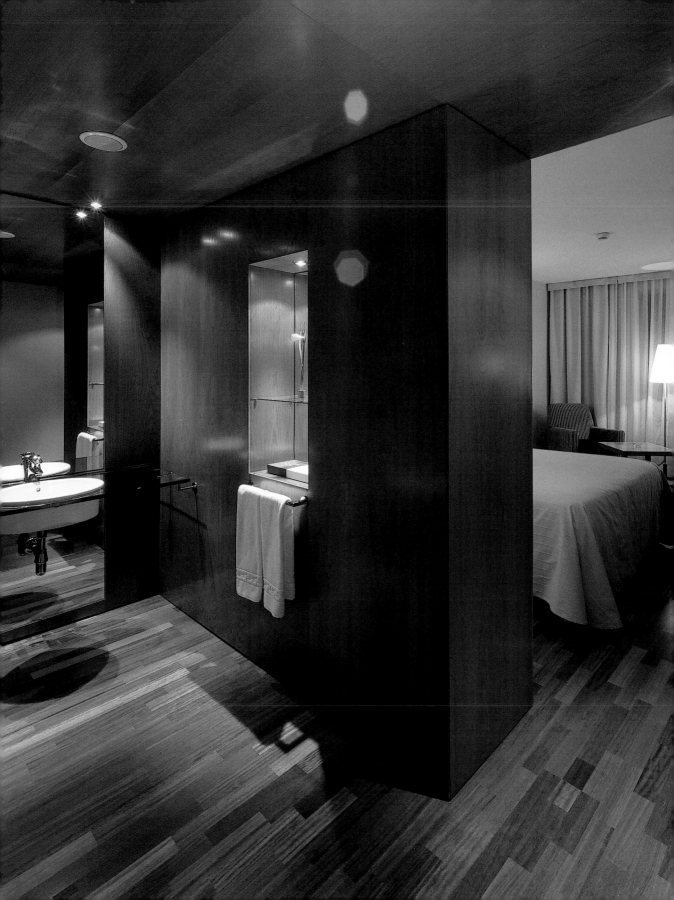

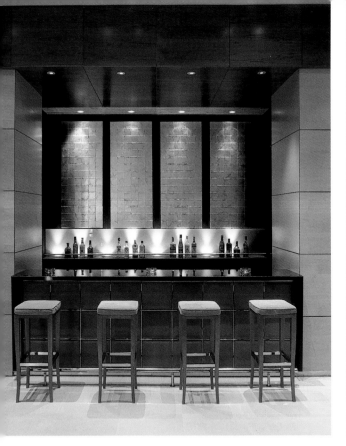
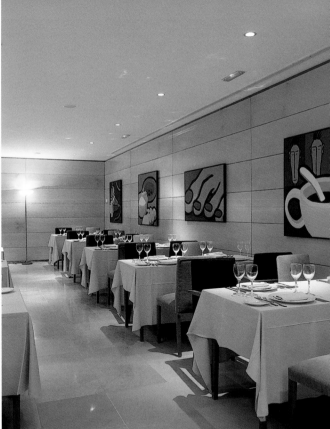

Wood takes on a special protagonism in this hotel as the material that covers walls, many ceilings, and some of the floors. It is used for the implementation of partitions and other furnishings, both in the public and private spaces.

Holz spielt die Hauptrolle in den meisten Räumen dieses Hotels. Mit diesem Material wurden Wände, zahlreiche Decken und einige Böden verkleidet. Außerdem gibt es sowohl in den öffentlichen und Gemeinschaftszonen als auch in den Schlafzimmern Holzmöbel.

Le bois est l'essence exclusive de la majorité des espaces de l'hôtel. C'est la matière par excellence qui recouvre murs, toits et certains sols et que l'on retrouve dans les éléments du mobilier, dans les zones publiques et communes comme dans les chambres.

La madera es la protagonista en la mayoría de los espacios del hotel. Este es el material con el que se cubren paredes, numerosos techos y algunos pavimentos, y dan forma a numerosas piezas de mobiliario, tanto en zonas públicas y comunes como en los dormitorios.

Il legno si erge a vero protagonista nella maggior parte degli spazi dell'hotel. È il materiale con cui sono stati rivestiti numerosi soffitti, alcuni pavimenti, pareti, dando forma a vari elementi della mobilia, sia nelle zone pubbliche e comuni che nelle camere da letto.

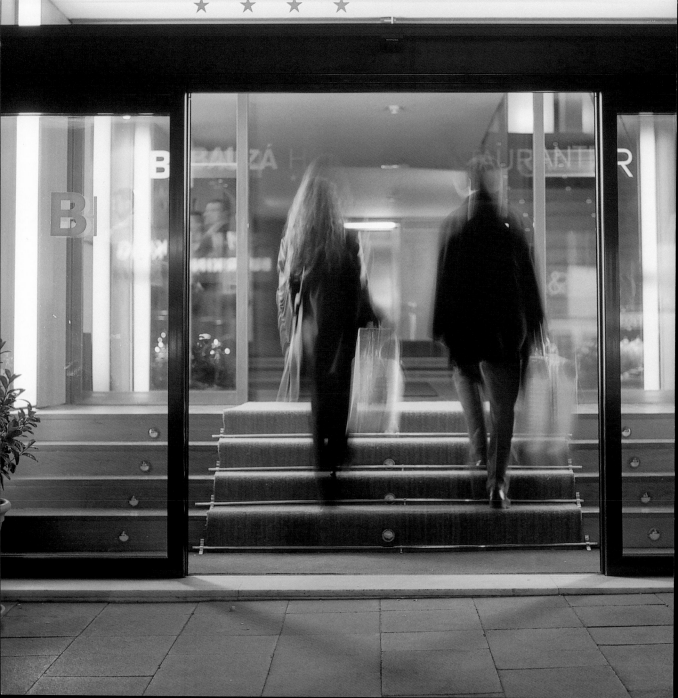

Calle Goya 79, 28001 Madrid, Spain Tel.: +34 91 435 7545 Fax: +34 91 431 0943
info@hotelbauza.com www.hotelbauza.com

Hotel Bauzá

Architect: Virginia Figueras **Collaborators:** Franco Corada, Ramón Pujol, Josep Bagá and Loles Durán
Photographer: © Jordi Sarrà **Opening date:** 1999 **Rooms:** 167 (including 149 standard rooms, 3 suites,
8 superior rooms and 7 non-smoking rooms)

The proportions of the spaces and the density of the furnishing create an inviting and intimate environment. The grayish color of the walls and dark tones of the natural wood contrast with the natural light that illuminates the space.

Die Größe der Räumlichkeiten und die Verteilung der Möbel schaffen eine anziehende und intime Atmosphäre. Die grauen Wände und dunklen Töne des Echtholzes kontrastieren mit dem Tageslicht, das die Räume erhellt.

Les proportions de l'espace et la densité du mobilier créent une ambiance à la fois attractive et intime. Le gris des murs et les tons foncés du bois naturel contrastent avec la lumière naturelle qui illumine l'espace.

Las proporciones de los espacios y la densidad del mobiliario crean un ambiente atractivo e íntimo. El color gris de las paredes y los tonos oscuros de la madera natural contrastan con la luz natural que ilumina el espacio.

Le proporzioni degli spazi e la densità dei mobili creano un ambiente attraente ed intimo. Il grigio delle pareti e i toni scuri del legno naturale contrastano con la luce naturale che illumina lo spazio.

Biblioteca

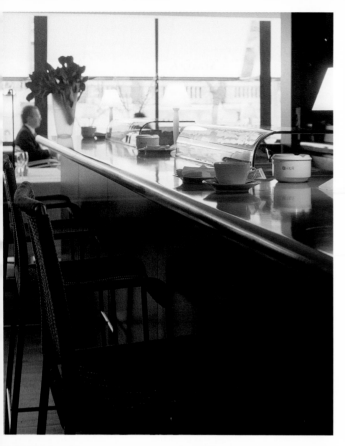

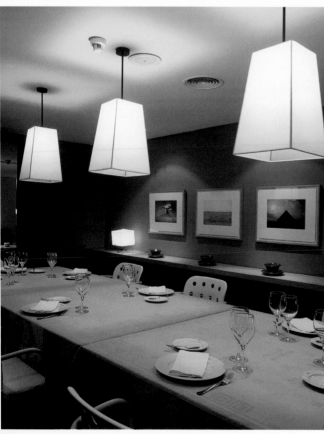
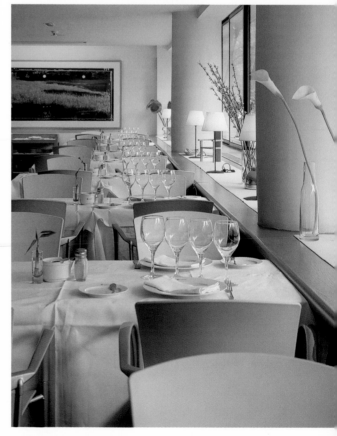

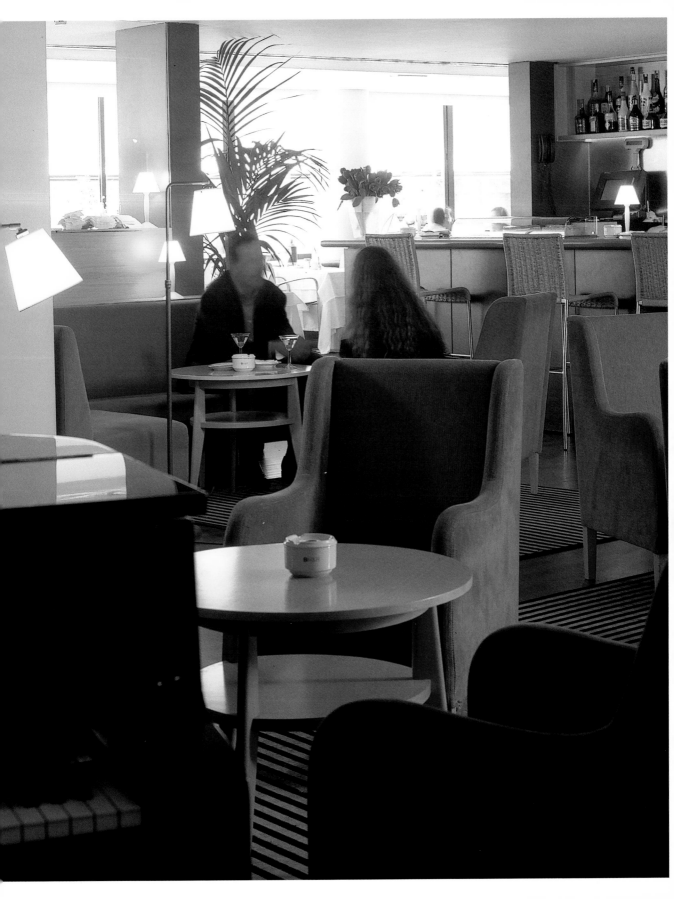

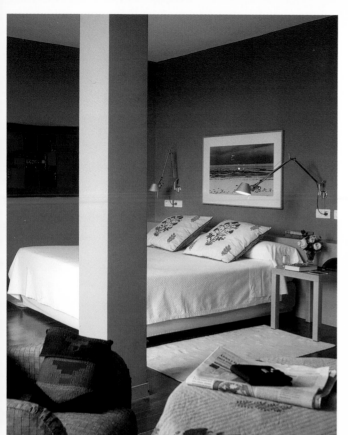

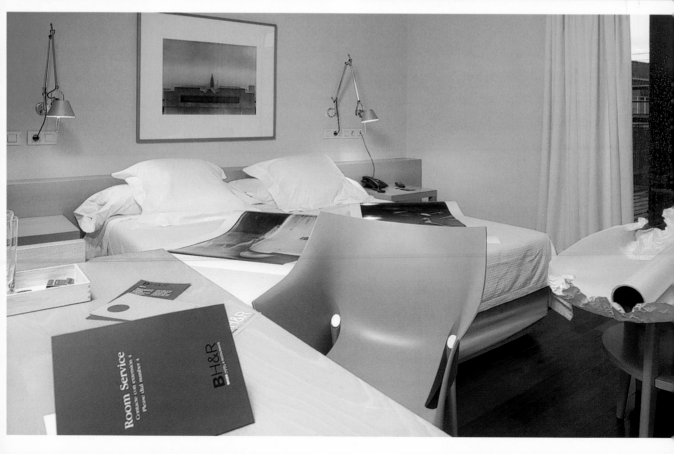

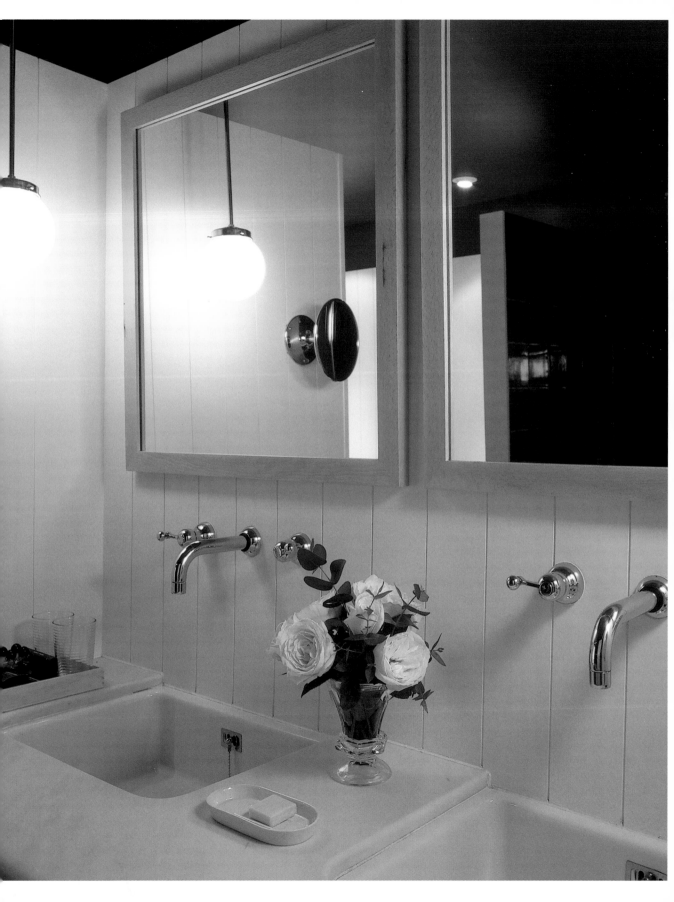

Carrer de la Missió 7A, 07003 Palma de Mallorca, Spain Tel.: +34 97 1227 347 Fax: +34 97 1227 348
www.conventdelamissio.com

Convent de la Missió

Architects: Antoni Esteva and Rafael Balaguer **Photographer:** © Pere Planells **Opening date:** 2002
Rooms: 17

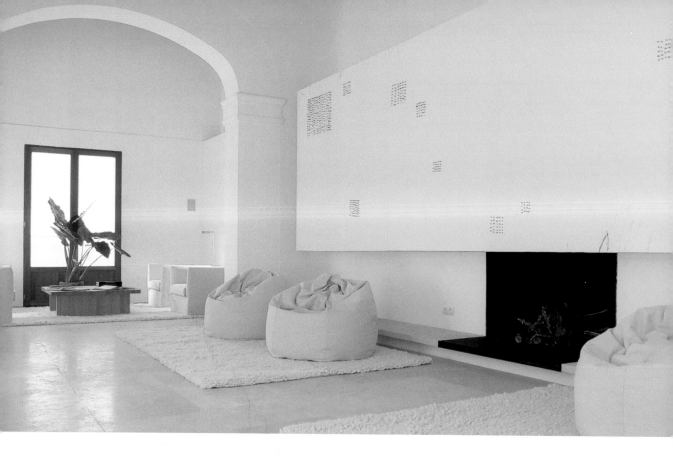

The interior atmosphere of withdrawal, which is enhanced by the soft color tones and the furniture of friendly design and discreet elegance, is favored even more by the exclusive vistas, all of which help to further meditative contemplation and feed the spirit.

Die ruhige Atmosphäre der Räumlichkeiten mit ihrer Dekoration in sanften Farben und angenehm geformten Möbeln, die diskrete Eleganz ausstrahlen, wird durch den außergewöhnlichen Ausblick verstärkt. Ein Ort zum Meditieren und Öffnen des Geistes.

L'atmosphère de recueillement de l'intérieur, accentuée par une décoration aux tons doux et de meubles aux lignes agréables et à l'élégance discrète, est parachevée par les vues sublimes qui portent à la contemplation méditative et nourrissent l'esprit.

Como complemento al ambiente de recogimiento del interior, y que ayuda una decoración en tonos suaves y un mobiliario de líneas amable y de discreta elegancia, las exclusivas vistas propician la contemplación meditativa y la alimentación del espíritu.

L'atmosfera raccolta dell'interno, favorita da un arredamento in toni delicati e mobili dalla linea armoniosa e discreta eleganza, viene corredata dalla fantastica vista che invoglia alla contemplazione meditativa e all'alimentazione dello spirito.

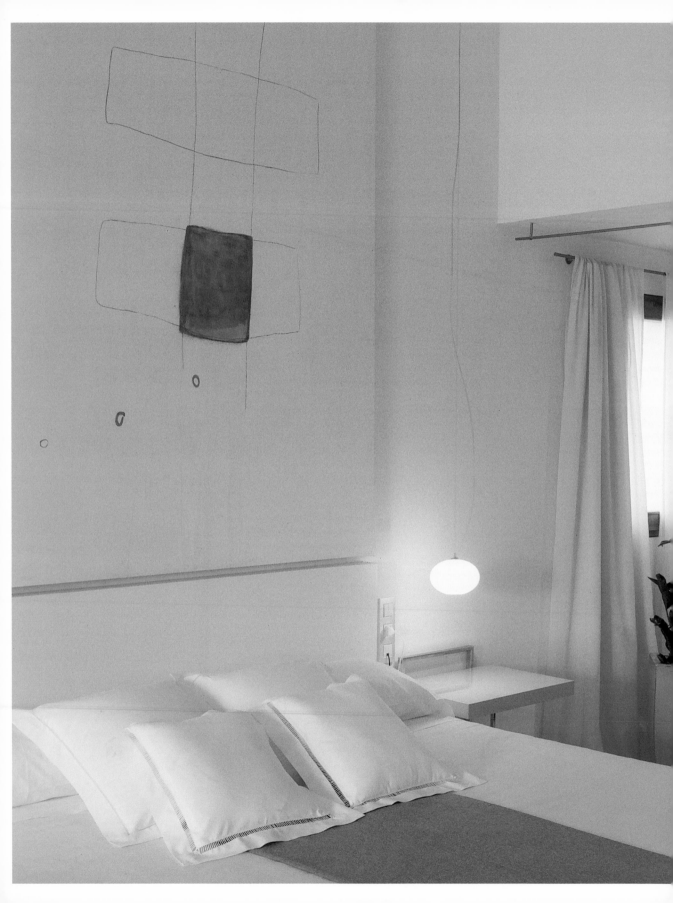

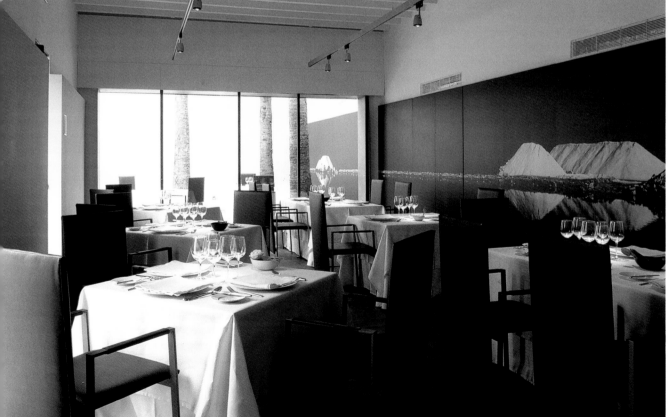

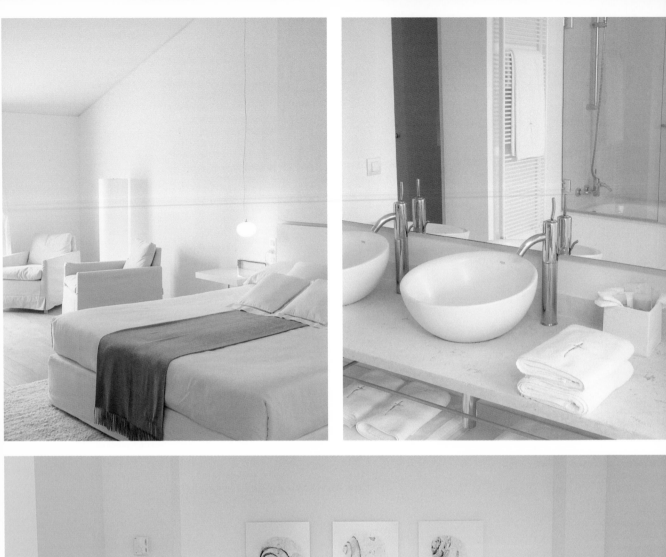
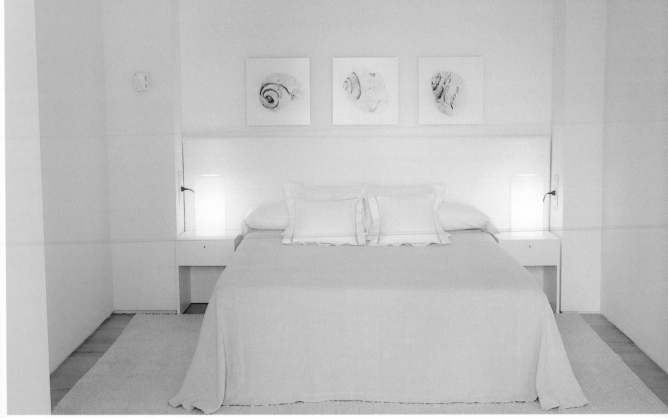

Onze Lieve Vrouweplein 6, 6211 HD Maastricht, The Netherlands Tel.: +31 43 321 6770
Fax: +31 43 325 1933 info@derlon.com www.derlon.com

Derlon Hotel

Architects: Arn Meijs Architects and Ger Rosier **Interior Designer:** Edward van Vliet
Photographer: © Hugo Thomassen **Opening date:** 2003 **Rooms:** 41

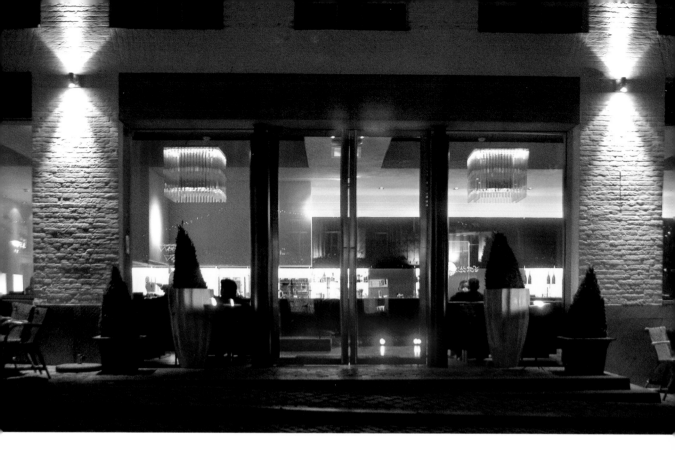

The Derlon Hotel was built on ruins that date back to Roman times; these archeological remains are combined with a contemporary style as originally intended.

Das Derlon Hotel wurde auf römischen Ruinen errichtet. Die archäologischen Fundstätten wurden in die zeitgenössische Gestaltung integriert, die ursprünglich vorgesehen war.

Le Derlon Hotel fût édifié sur des ruines qui datent de l'époque romaine; les trouvailles archéologiques mises à jour sur les lieux de l'excavation furent intégrées dans le concept de décoration contemporaine prévu initialement.

El Derlon Hotel fue edificado sobre unas ruinas que datan de la época romana; los hallazgos arqueológicos procedentes de las excavaciones se integraron en el diseño decorativo contemporáneo inicialmente previsto.

Il Derlon Hotel è stato edificato su alcune rovine che risalgono all'epoca romana; i resti archeologici provenienti dagli scavi sono stati inseriti nella decorazione contemporanea prevista inizialmente.

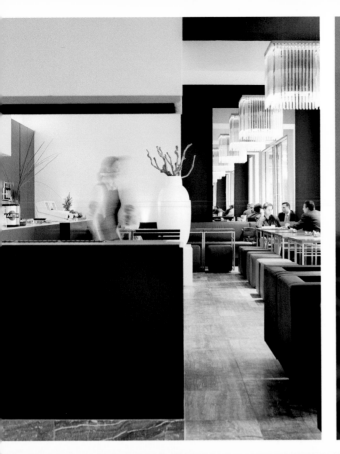
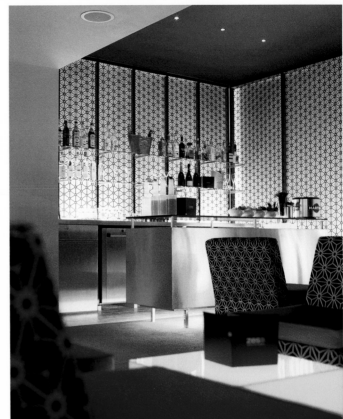
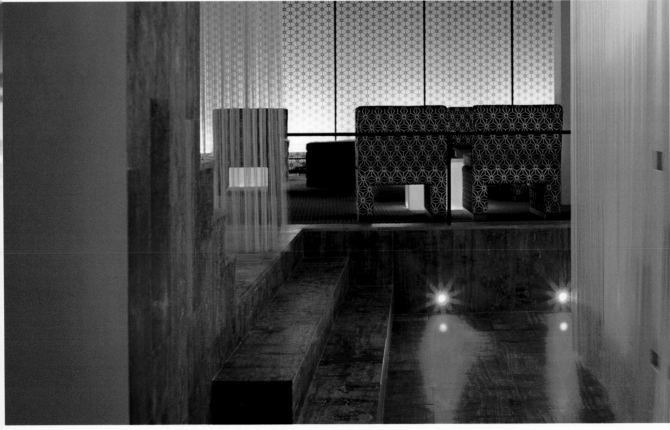

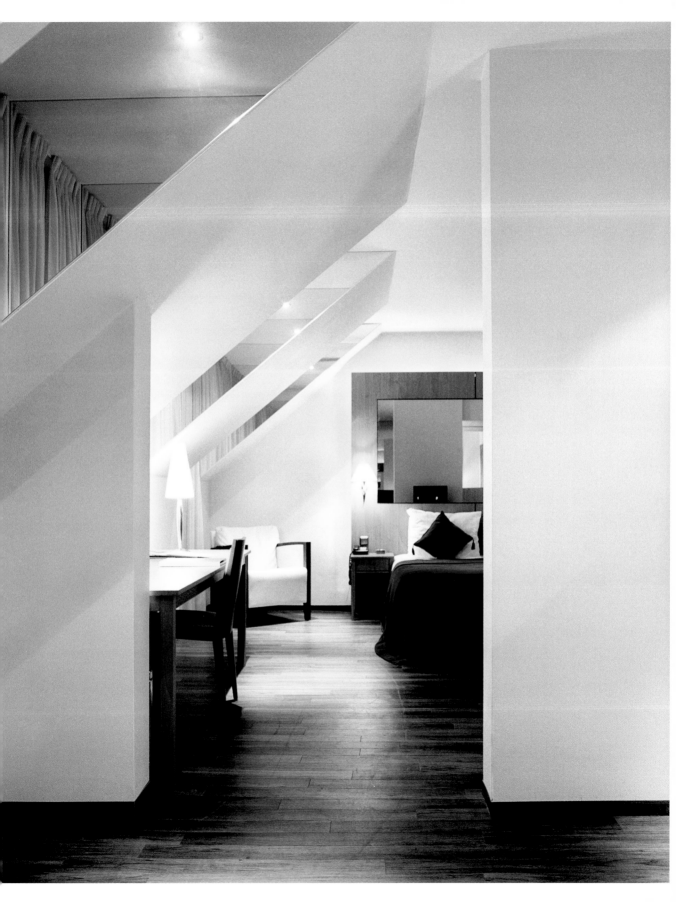

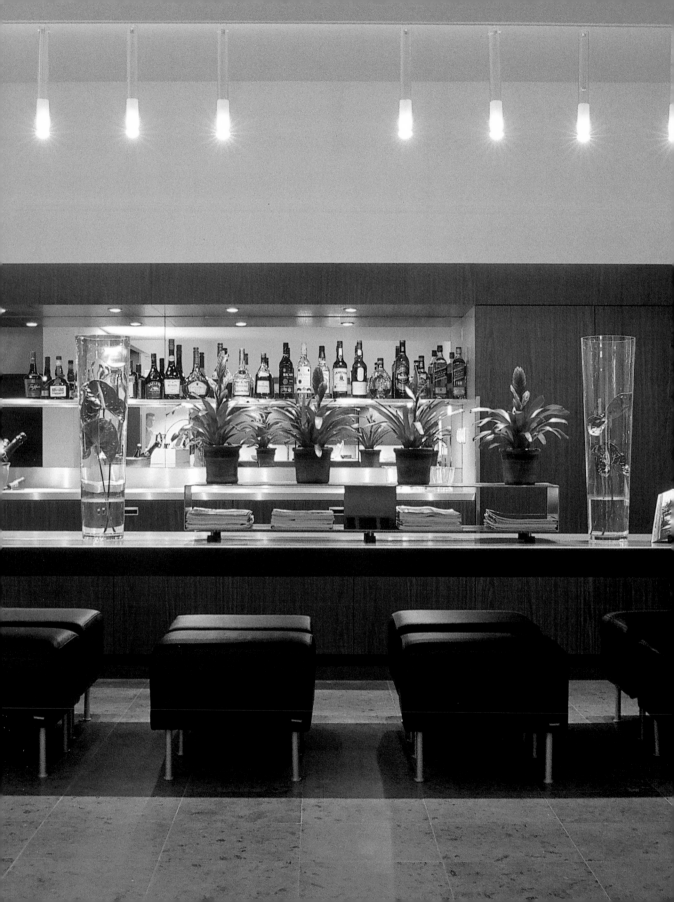

Stationsstraat 40, 6221 BR Maastricht, The Netherlands Tel.: +31 43 328 25 25 Fax: +31 43 328 25 26
info@la-bergere.com www.la-bergere.com

La Bergère

Architect: Maarten Engelman Interior Designer: Feran Thomassen Photographer: © Pere Planells
Opening date: 2001 Rooms: 76

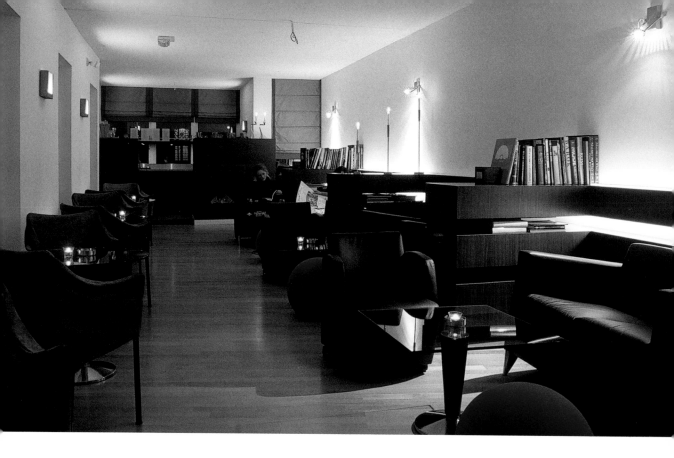

The furniture details and accessories complement the decoration through blotches of color that liven up the space. The common areas are characterized by colorful elements that stand out in a predominantly white space.

Sorgfältig gewählte Möbel und Objekte ergänzen die Dekoration wie Farbflecken, die die Räume heiter wirken lassen. Die Durchgangsbereiche werden durch einige farbige Elemente markiert, die sich in den von der Farbe Weiß dominierten Räumen hervorheben.

Les détails du mobilier et les accessoires, florilèges de la décoration, sont autant de tâches de couleurs qui animent l'espace. Dans un espace où le blanc l'emporte, quelques éléments de couleur délimitent les zones de passage.

Los detalles de mobiliario y los accesorios complementan la decoración dando toques de color que alegran el espacio. Las zonas de paso están marcadas por algunos elementos cromáticos que resaltan en un espacio donde predomina el blanco.

I particolari della mobilia e gli accessori completano l'arredamento sul piano cromatico, ravvivando al contempo lo spazio. Le zone di passaggio sono contraddistinte da alcuni elementi cromatici che spiccano in uno spazio dove predomina il bianco.

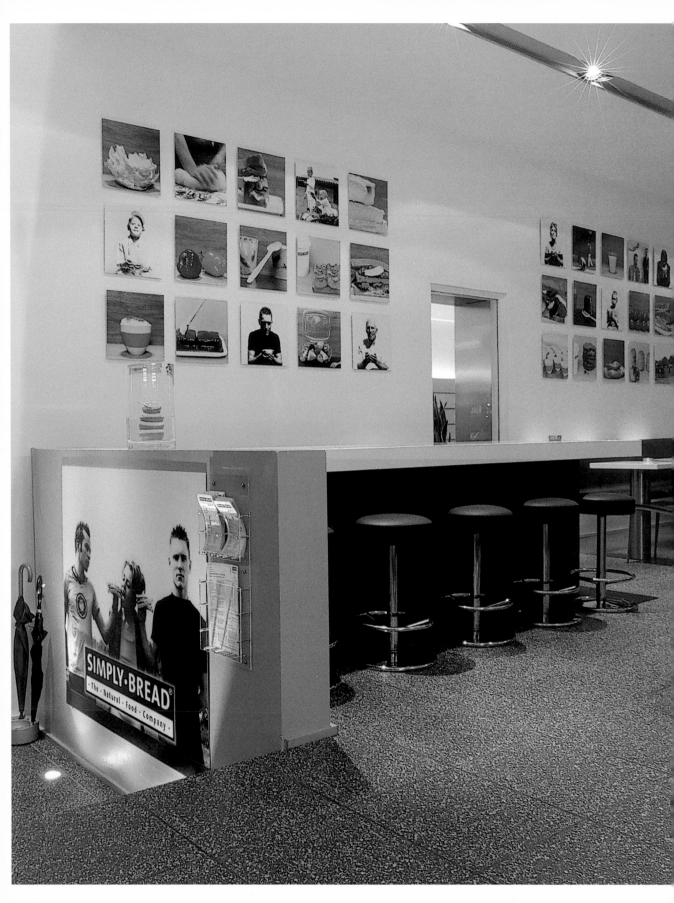

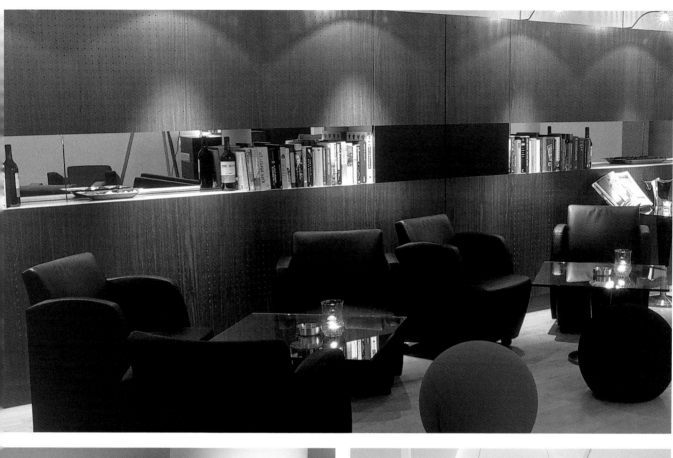

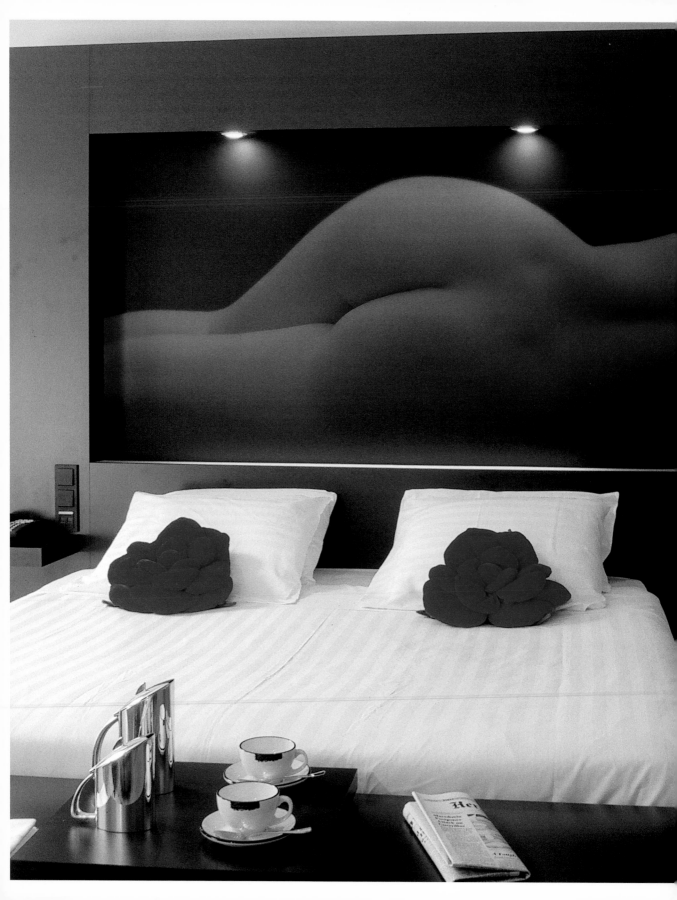

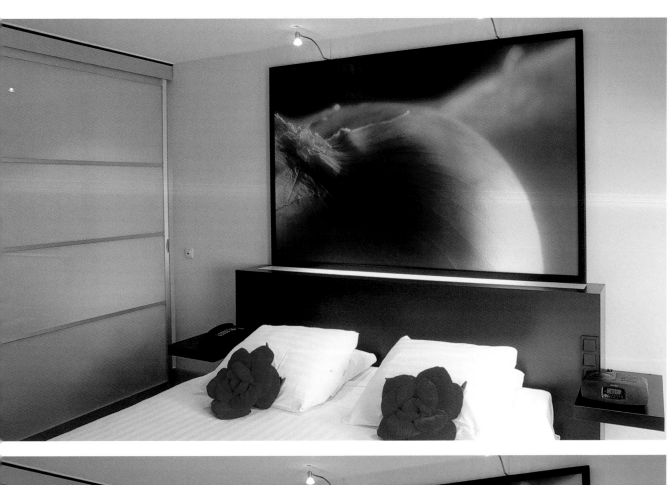
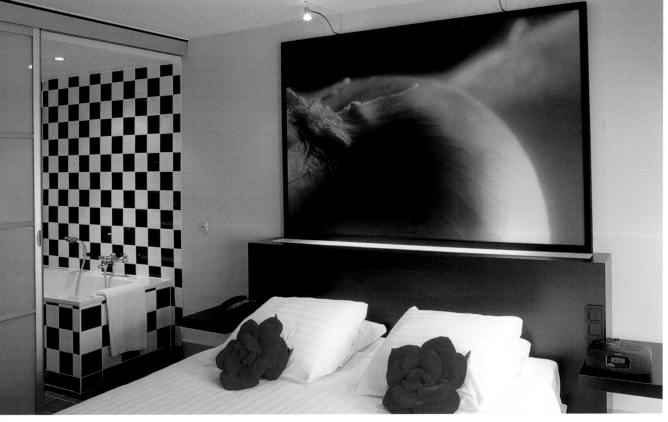

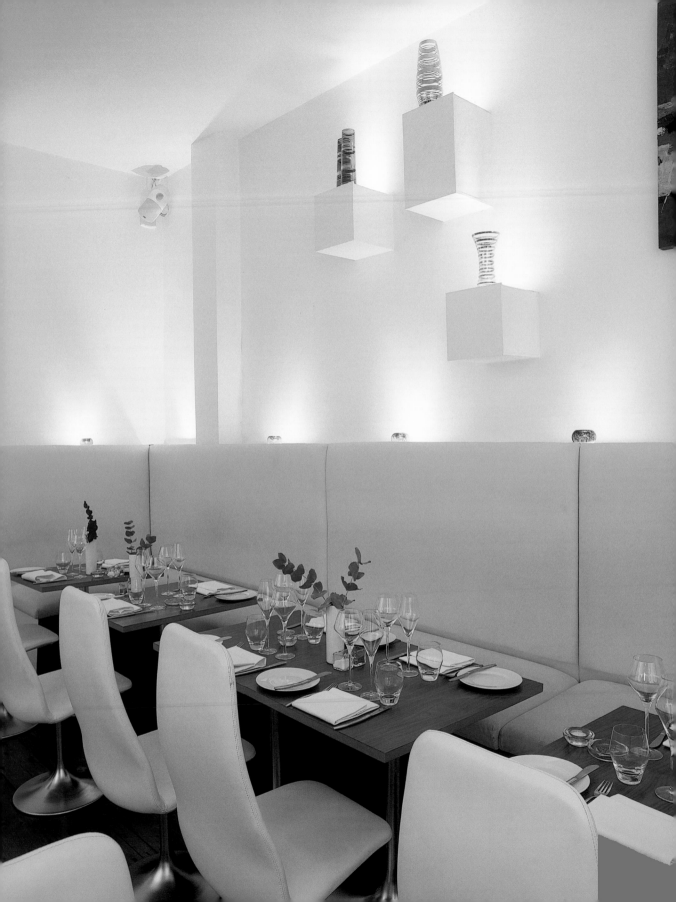

17 Atlingworth Street, Brighton BN2 1PL, UK Tel.: +44 1273 603504 Fax: +44 1273 689813
www.blanchhouse.co.uk

Blanch House

Designer: Amanda Blanch Photographer: © Leigh Simpson Opening date: 2000 Rooms: 12

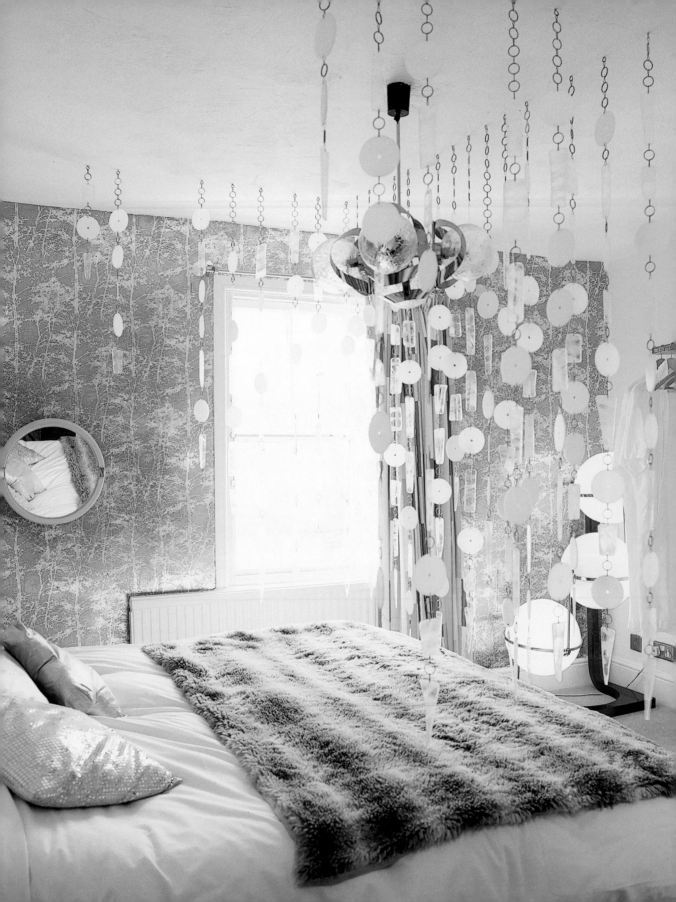

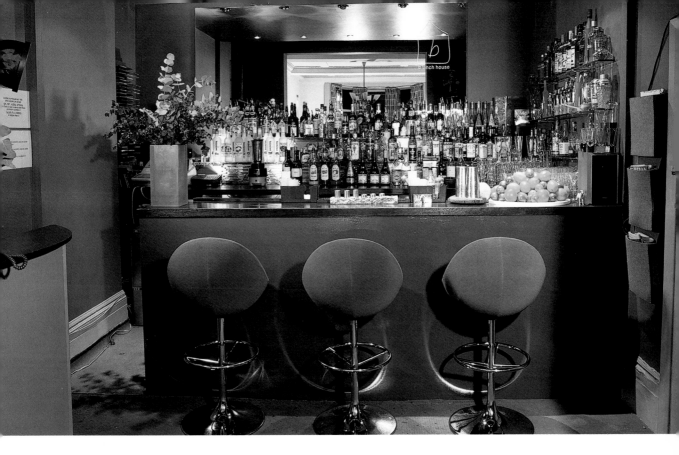

The owners' goal of designing original guest rooms is clearly achieved. Various themes reminiscent of landscapes, other countries, or periods of art history comprise the decoration of each room.

Ziel der Eigentümer war es, originelle Zimmer zu entwerfen. Die Gestalter ließen sich von Landschaften, Kulturen fremder Länder oder Epochen der Kunstgeschichte inspirieren.

Les propriétaires avaient pour objectif de concevoir des chambres originales. Ils y parvinrent en s'inspirant des paysages, des cultures d'autres pays ou des époques de l'histoire de l'art.

El objetivo de los propietarios de diseñar unas habitaciones originales se logró al inspirarse en los paisajes, las culturas de otros países o épocas de la historia del arte.

L'obiettivo dei proprietari di realizzare delle camere originali è stato raggiunto grazie all'ispirazione tratta da paesaggi, culture di altri paesi e da diversi periodi della storia dell'arte.

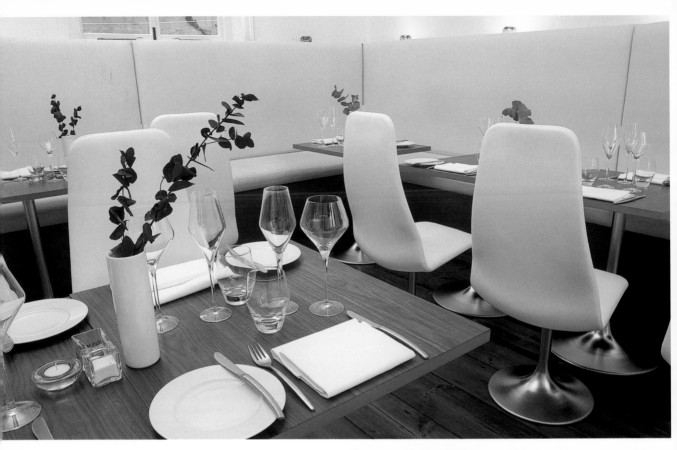

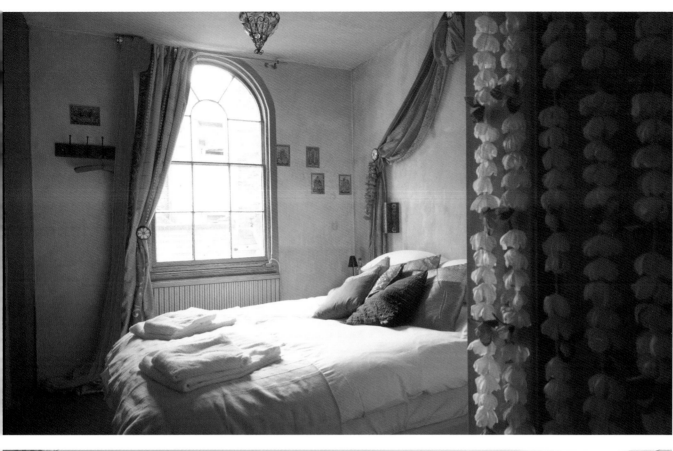

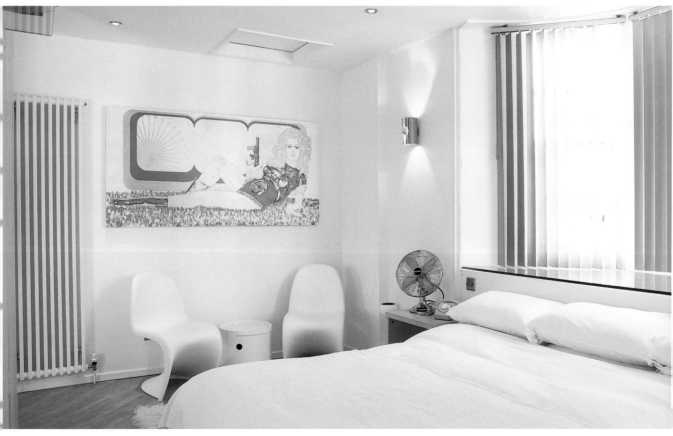

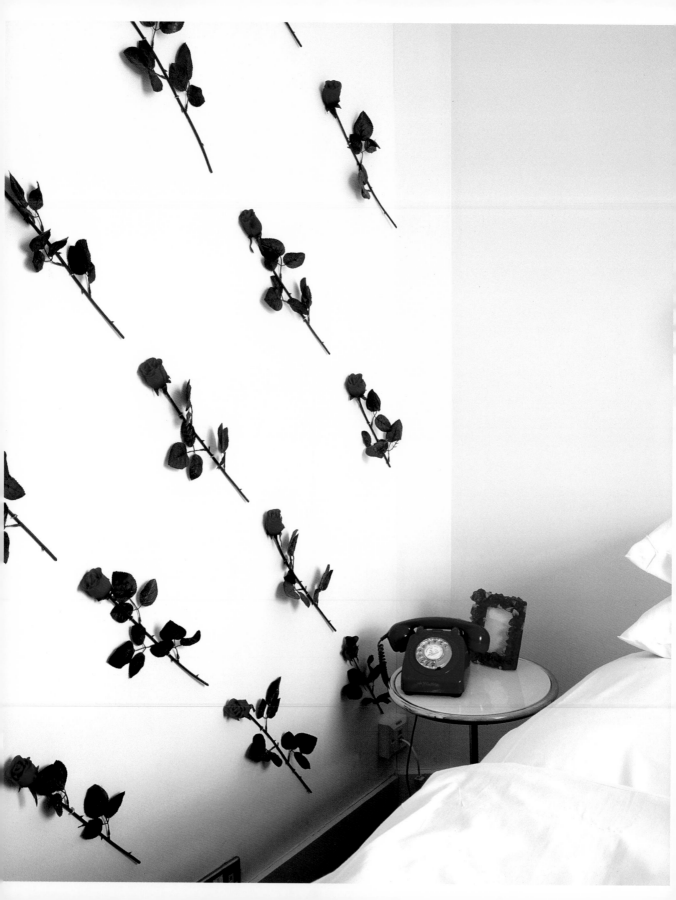

Liverpool Street, London EC2M 7QN, UK Tel.: +44 207 618 5000 Fax: +44 207 618 5001
www.great-eastern-hotel.co.uk

Great Eastern Hotel

Architects: Manser Associates **Interior Designer:** Conran & Partners **Photographers:** © Peter Cook, Jean Cazals, James Merell and Tim Winter **Opening date:** 2000 **Rooms:** 267 (including 21 suites)

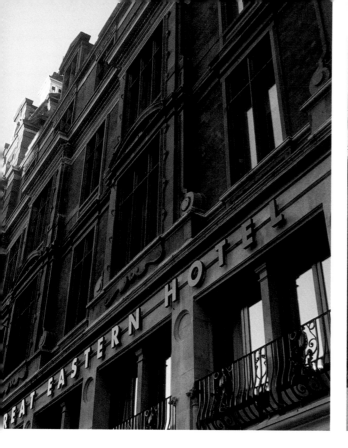
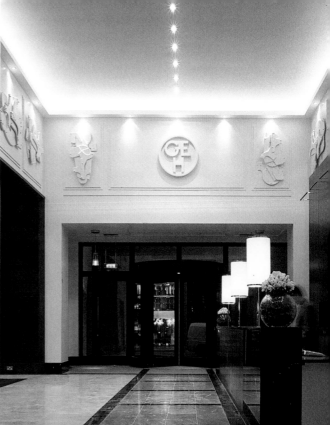

The interior of the entrance hall, with its clean and simple design, recovers the use of original materials like marble, plaster, and wooden panels, generating a space that is both classical and modern.

Die Empfangshalle ist ein klarer und einfacher Raum, in dem die ursprünglichen Materialien wie Marmor, Gips und Holzpaneele erneut eingesetzt wurden, um eine Atmosphäre zwischen Klassik und Moderne zu schaffen.

L'intérieur du vestibule est un espace aux lignes claires et dépouillées employant des matériaux originaux à l'instar du marbre, du gypse et de panneaux de bois, pour créer un art de vivre qui vogue entre classique et moderne.

El interior del vestíbulo se muestra como un espacio limpio y sencillo que recupera materiales originales, como el mármol, el yeso y los paneles de madera, para generar un lugar entre lo clásico y lo moderno.

L'interno della hall appare come uno spazio puro e semplice che recupera materiali originali, come il marmo, il gesso e i pannelli in legno, per dar vita a un luogo tra il classico e il moderno.

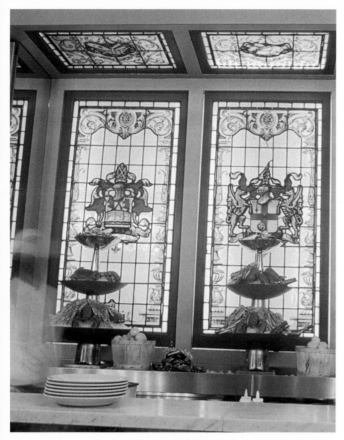
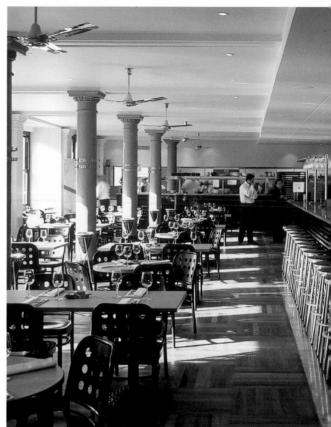
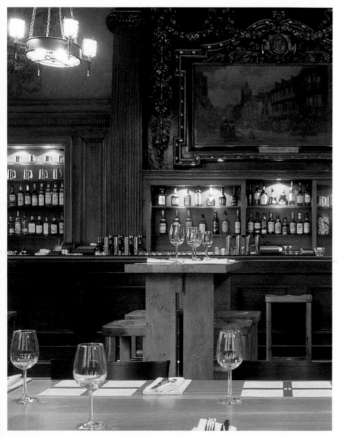
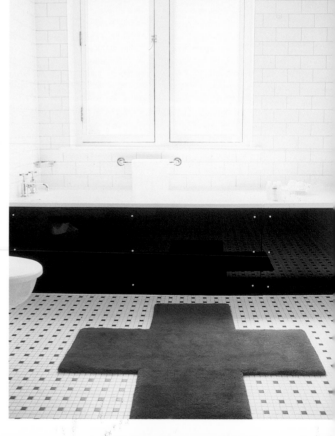

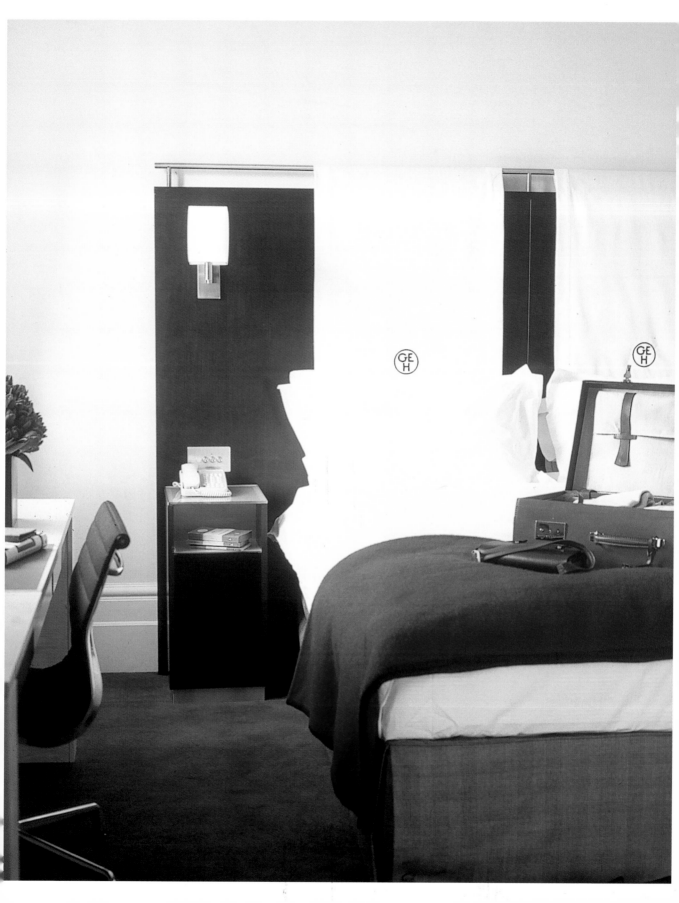

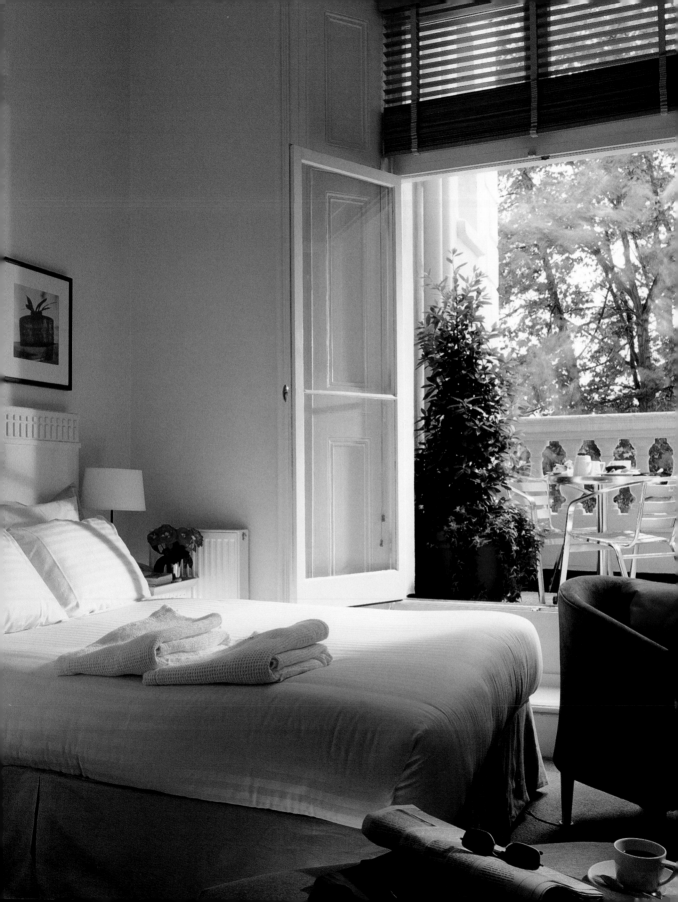

15-16 Prince of Wales Terrace, London W8 5PQ, UK Tel.: + 44 207 937 2345 www.hotels-london.co.uk

Kensington House Hotel

Architects: Charles Campbell Associates **Photographer:** © Gunnar Knechtel
Opening date: 2000 **Rooms:** 41

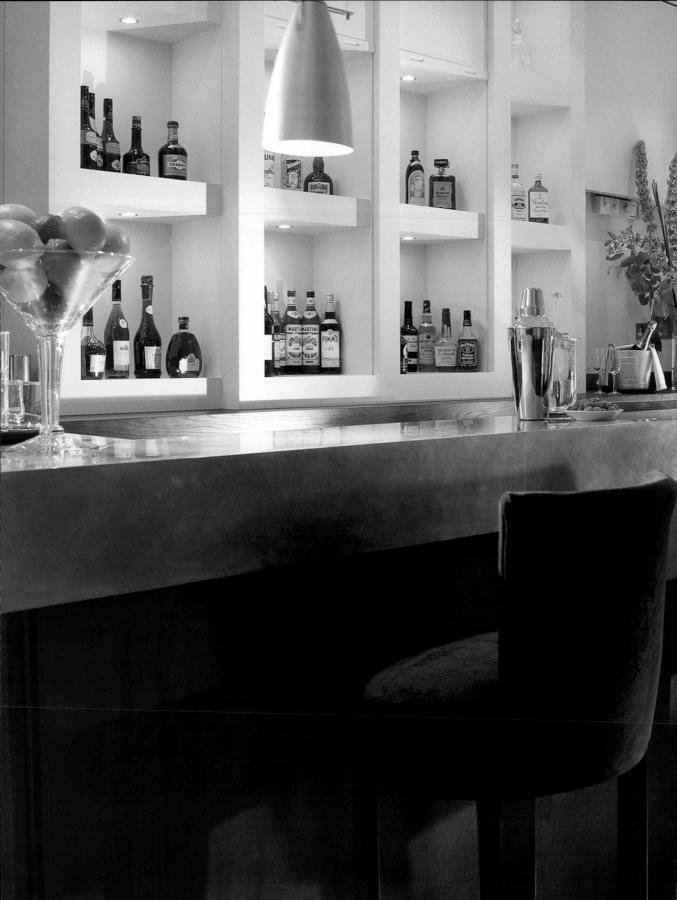

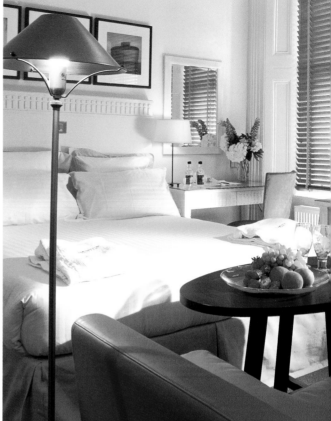

Although the decoration creates a modern atmosphere, it is inspired by classic furnishings and lighting techniques that maintain a dialogue with the original character of the building.

Die Dekoration ist von klassischen Möbeln und Beleuchtungstechniken inspiriert, was gut zu dem eigentlichen Charakter dieses Gebäudes passt. Dennoch wurde gleichzeitig eine moderne Atmosphäre geschaffen.

La décoration intérieure réussit à créer une ambiance de modernité, tout en déclinant éléments de mobilier et luminaires aux lignes classiques qui entrent en dialogue avec l'originalité de l'édifice.

La decoración, aunque logra generar un ambiente moderno, está inspirada en piezas de mobiliario e iluminación de líneas clásicas que dialogan con el carácter original del edificio.

Sebbene riesca a generare un ambiente moderno, l'arredamento si ispira a dei mobili e a un'illuminazione dalle linee classiche che dialogano con il carattere originale dell'edificio.

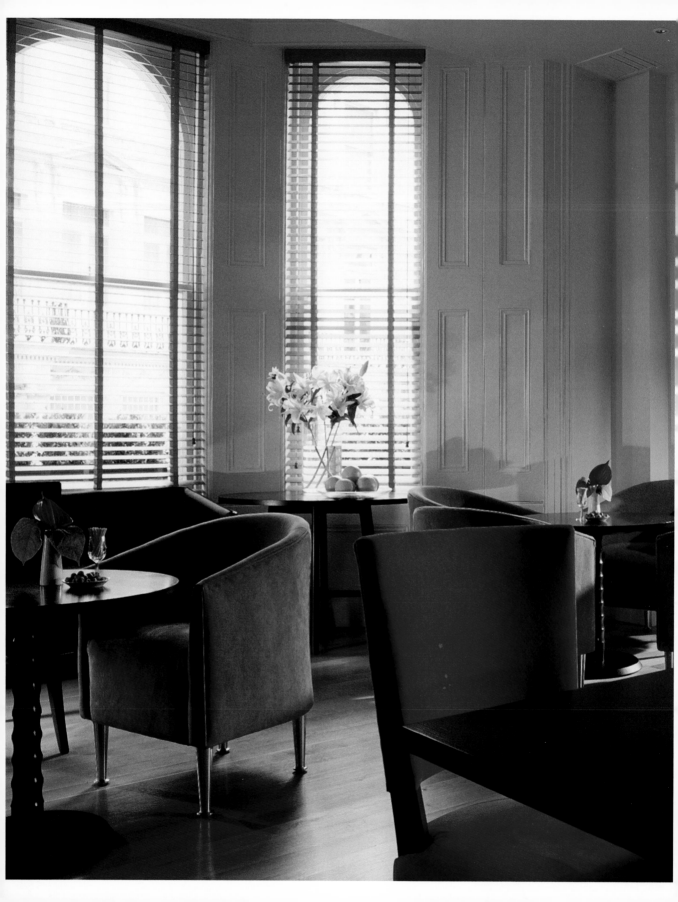

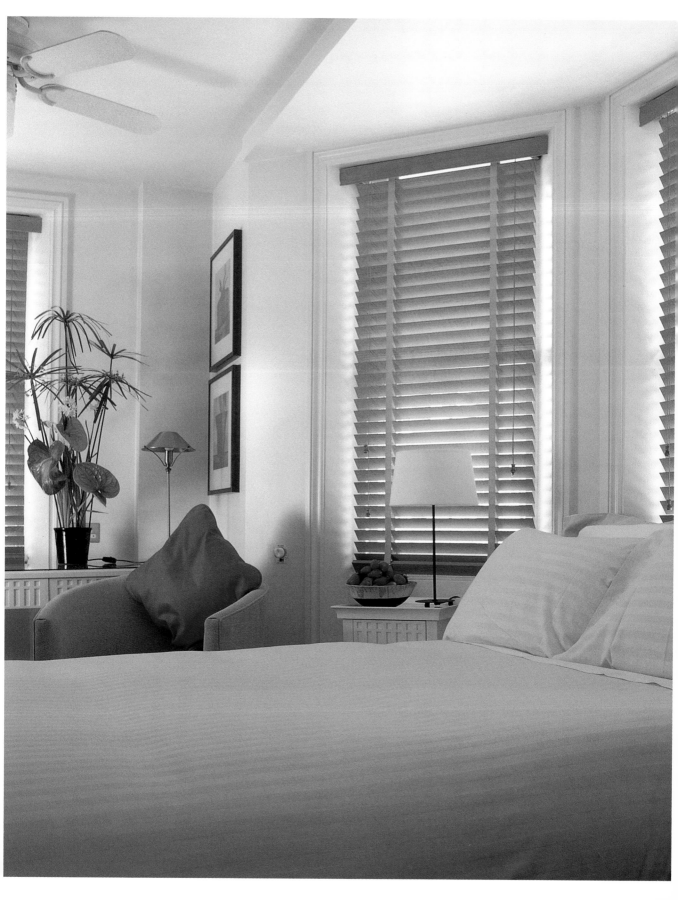

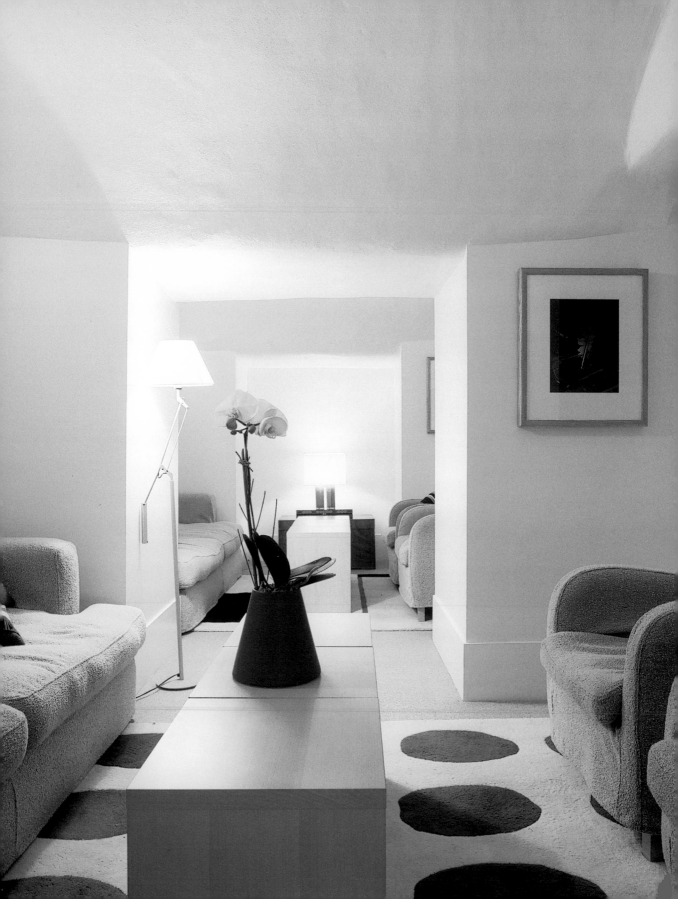

11–13 Bayley Street, Bedford Square, London WC1B 3HD, UK Tel.: +44 207 667 6000
Fax: +44 207 667 6044 / 7667 6001 www.myhotels.co.uk

Myhotel Bloomsbury

Architects: Conran & Partners Photographer: © Gunnar Knechtel Opening date: 1999
Rooms: 68 (including 8 suites)

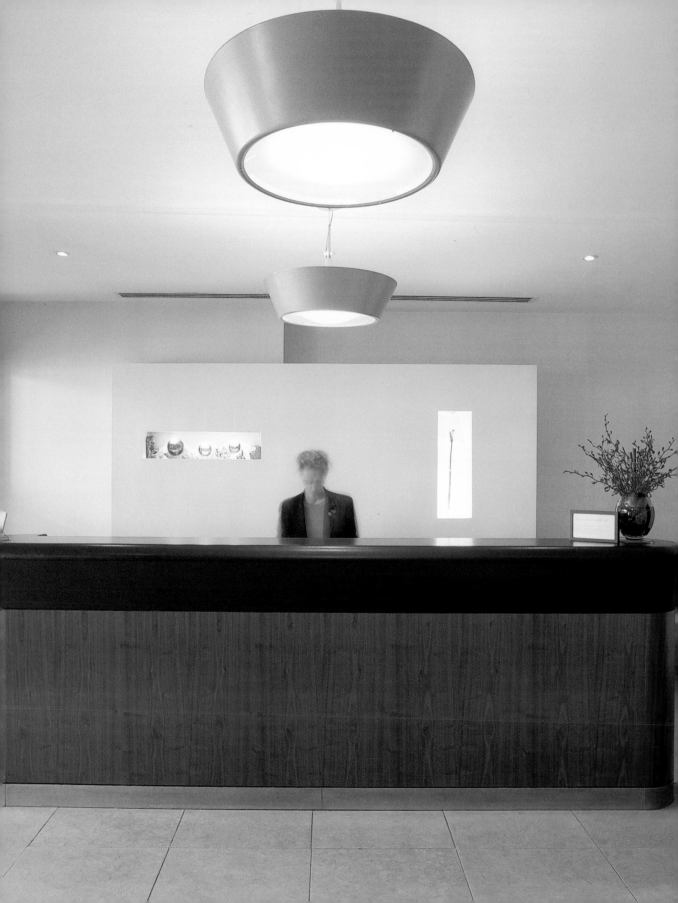

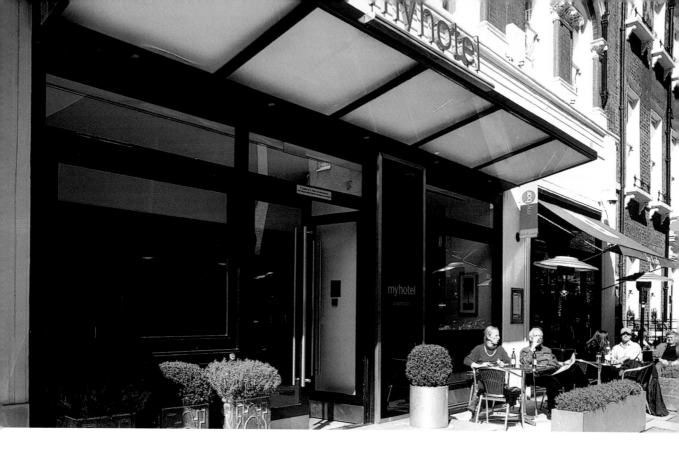

The bar is not exclusive to guests, and also open to the public. Designed for informality, its color scheme is in keeping with the hotel's blending of Eastern and Western styles.

Die Bar, die nicht nur für Hotelgäste geöffnet ist, wurde zwanglos gestaltet. Die Möbel sind funktionell und die farbliche Gestaltung ist sehr gelungen.

Le bar, accessible également à des personnes extérieures à l'hôtel, a été conçu comme un espace convivial qui met en relief, outre un mobilier fonctionnel, une gamme de couleurs très réussie.

El bar, accesible también para personas no alojadas en el hotel, se ha proyectado como un espacio informal en el que destaca, además de un mobiliario funcional, la acertada combinación cromática empleada.

Il bar, aperto anche al pubblico generale, è stato concepito come uno spazio informale dove, oltre ad una mobilia funzionale, spicca l'ottimo abbinamento cromatico scelto per l'occasione.

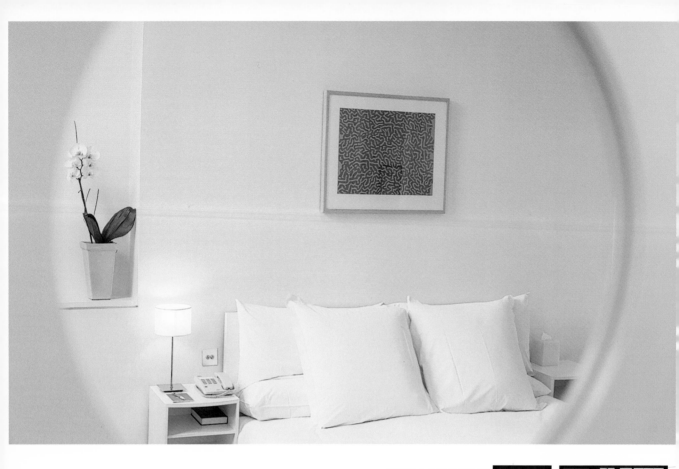

First floor

Layout of upper floors

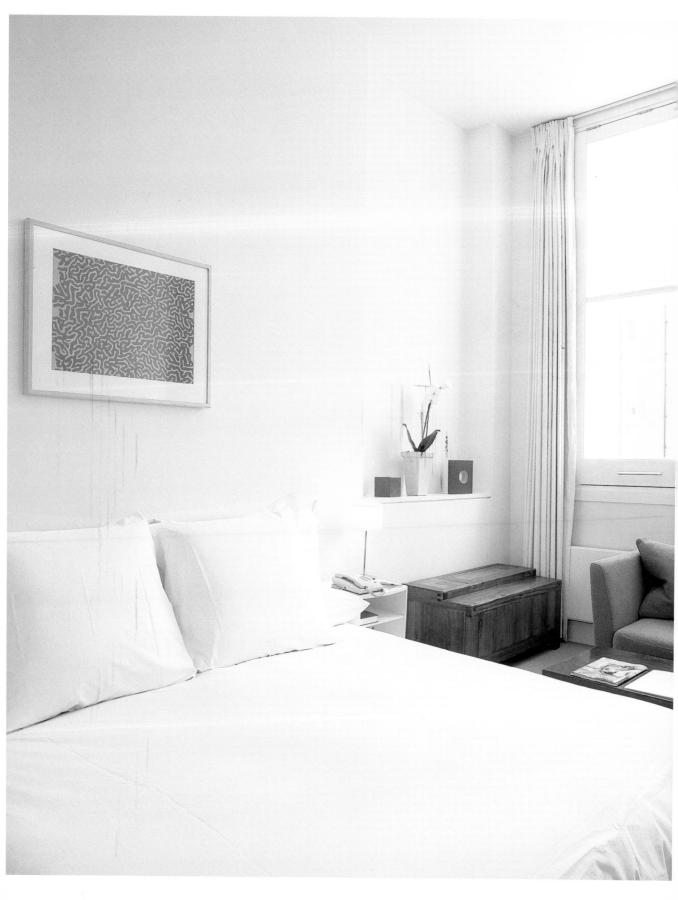

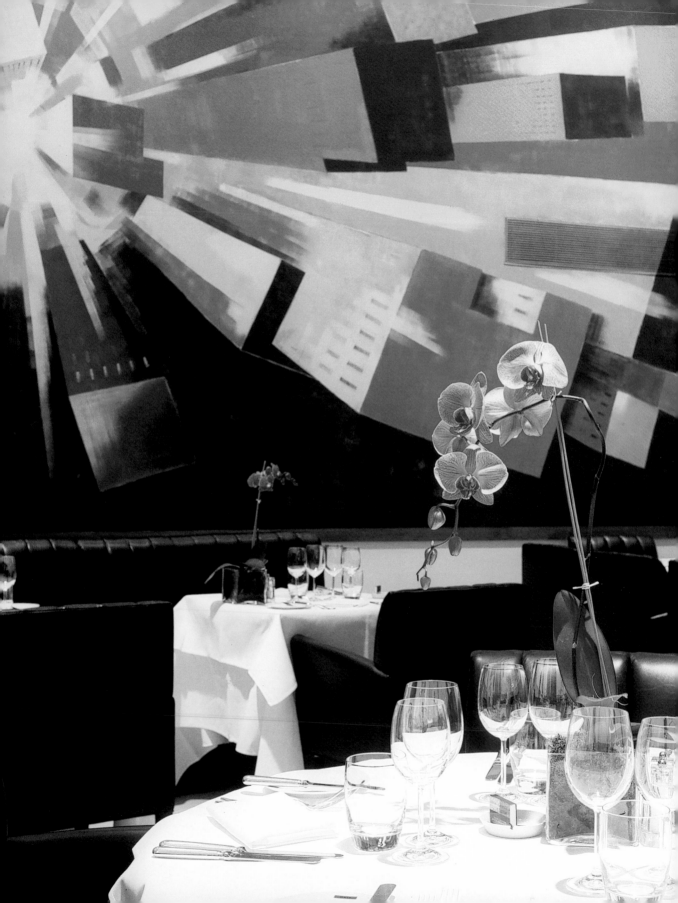

One Aldwych, London WC2B 4RH, UK Tel.: +44 207 300 1000 Fax: +44 207 300 1001
www.onealdwych.com

One Aldwych London

Architects: Gordon Campbell Gray and Mary Fox-Linton **Photographers:** © Herbert Ypma and Archive One Aldwych **Opening date:** 1998 **Rooms:** 105 (including 2 suites with private gyms)

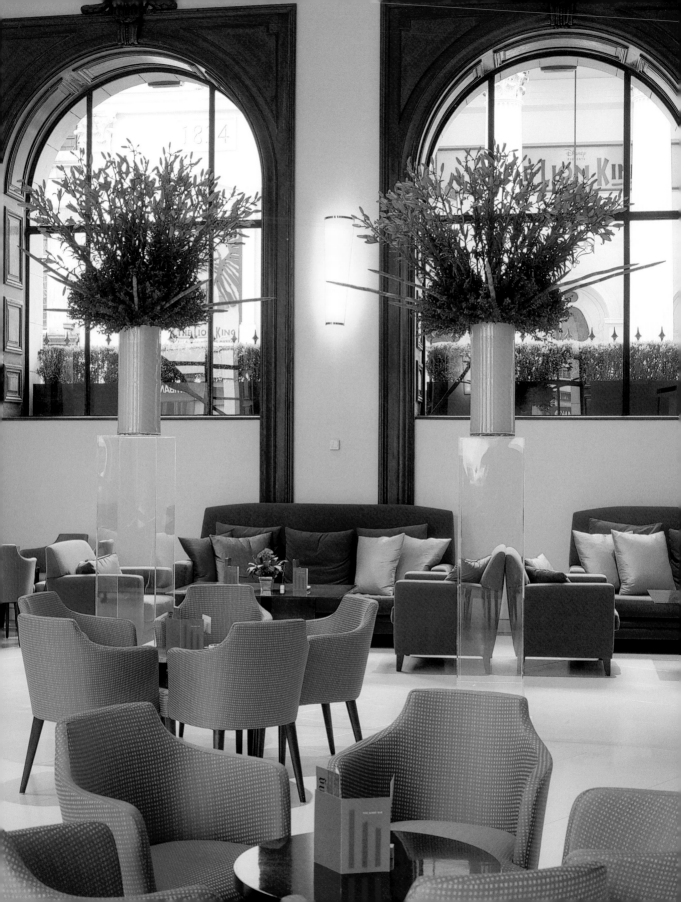

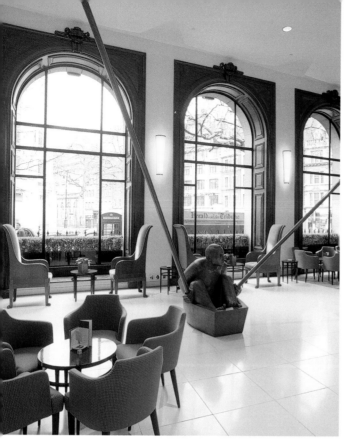

The Axis restaurant and bar is strongly reminiscent of the twenties and thirties and takes on a completely different style than the rest of One Aldwych. The restaurant is predominated by the mural backdrop, titled "Secret City", which occupies the full height of the space.

Das Bar-Restaurant Axis spielt stark auf die Zwanziger- und Dreißigerjahre an und hebt sich so völlig vom Stil der übrigen Räume des One Aldwych ab. Das Restaurant wird von einem Wandbild im Hintergrund beherrscht, das den Namen „Secret City" trägt und so hoch wie das Lokal ist.

Le bar restaurant Axis, aux fortes réminiscences des années vingt et trente, diffère complètement du style du reste du One Aldwych. Le restaurant est dominé par la peinture murale du fond, intitulée « Secret City » qui occupe toute la hauteur du local.

El bar restaurante Axis, con intensas reminiscencias de los años veinte y treinta, se aleja completamente del estilo del resto del One Aldwych. El restaurante está dominado por el mural de fondo, titulado "Secret City", que ocupa toda la altura del local.

Il bar ristorante Axis rievoca chiaramente gli anni venti e trenta e si scosta completamente dallo stile del resto del One Aldwych. Il ristorante è dominato dal murale del fondo, intitolato "Secret City", che occupa fino in alto la parete del locale.

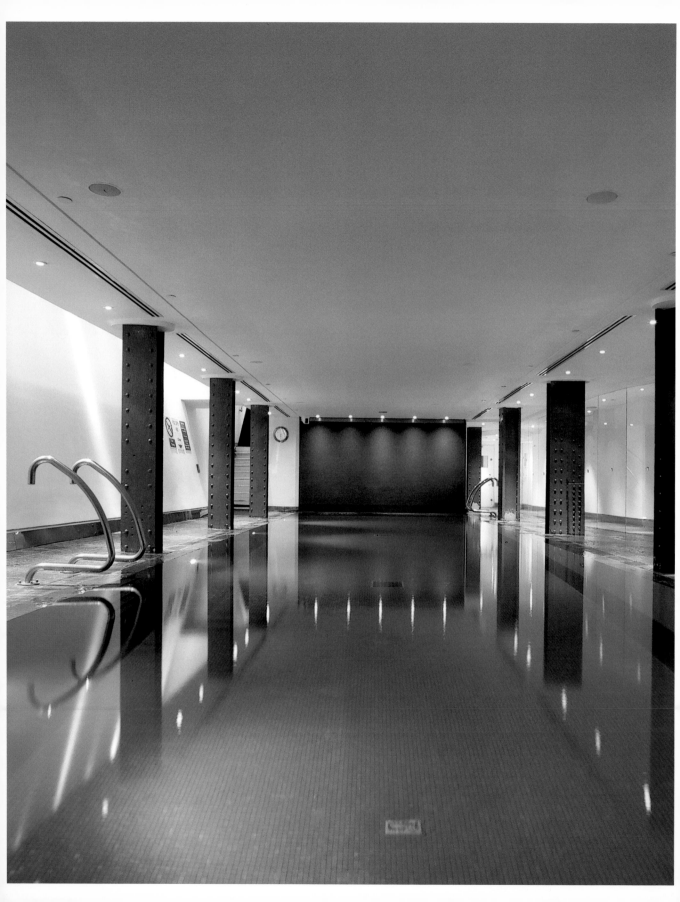

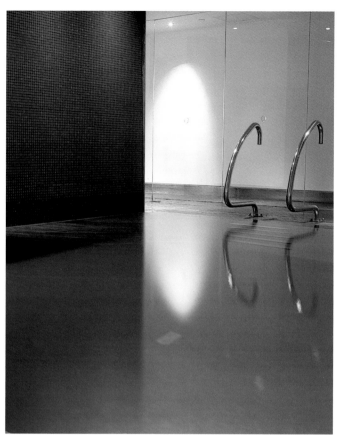

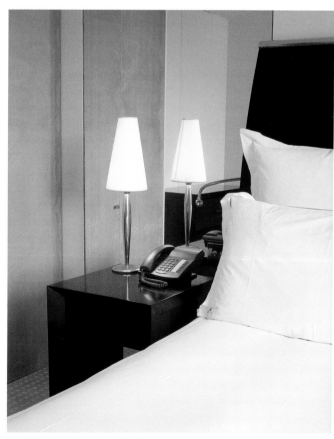

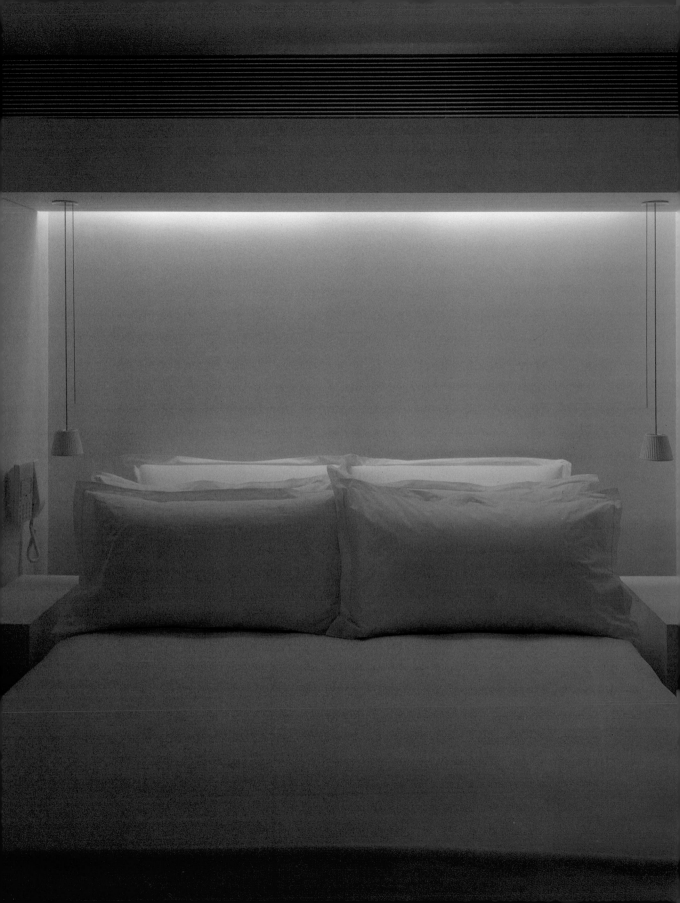

45 St. Martin's Lane, London WC2N 4HX, UK Tel.: +44 207 300 5500
Fax: +44 207 300 5501

Saint Martin's Lane

Designer: Philippe Starck Photographer: © Todd Eberle Opening date: 1999 Rooms: 204

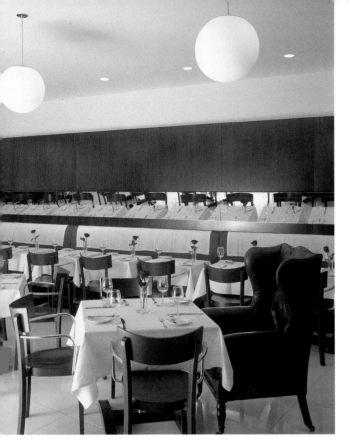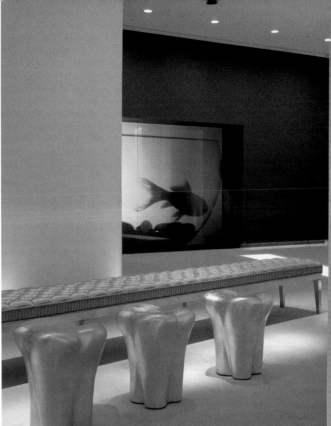

The common areas of the hotel, such as the vestibule, also combine exquisite works of art and hand-crafted African objects. The mixture of decorative styles in every area of Saint Martin's Lane generates a singular and unconventional style.

In den Gesellschaftsräumen des Hotels wie zum Beispiel der Empfangshalle werden erlesene Kunstwerke mit afrikanischem Kunsthandwerk kombiniert. Diese Vermischung von Stilen zieht sich durch die Dekoration aller Räume in Saint Martin's Lane. So entstand ein einzigartiger, schwer zu definierender Stil.

Les lieux de rencontre de l'hôtel, à l'instar du vestibule, réunissent aussi œuvres d'arts et objets d'artisanat africain. Le mélange des styles dans la décoration de toutes les pièces du Saint Martin's Lane, crée un style original difficile à définir.

Las zonas de encuentro del hotel, como el vestíbulo, también mezclan exquisitas obras de arte con objetos de artesanía africana. La combinación de estilos en la decoración de todas las estancias del Saint Martin's Lane origina un estilo singular difícil de catalogar.

Anche le zone di ritrovo dell'hotel, come la hall, abbinano pregiate opere d'arte ad oggetti dell'artigianato africano. La mescolanza di stili che caratterizza l'arredamento di tutte le camere del Saint Martin's Lane dà vita a uno stile singolare difficile da catalogare.

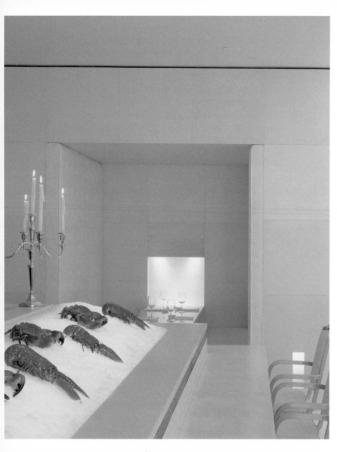

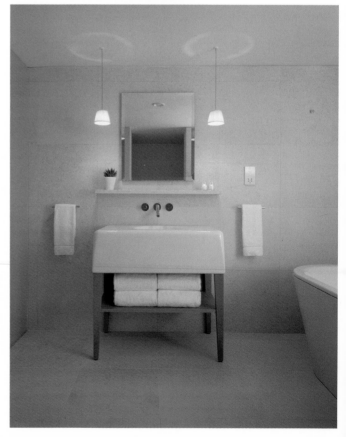

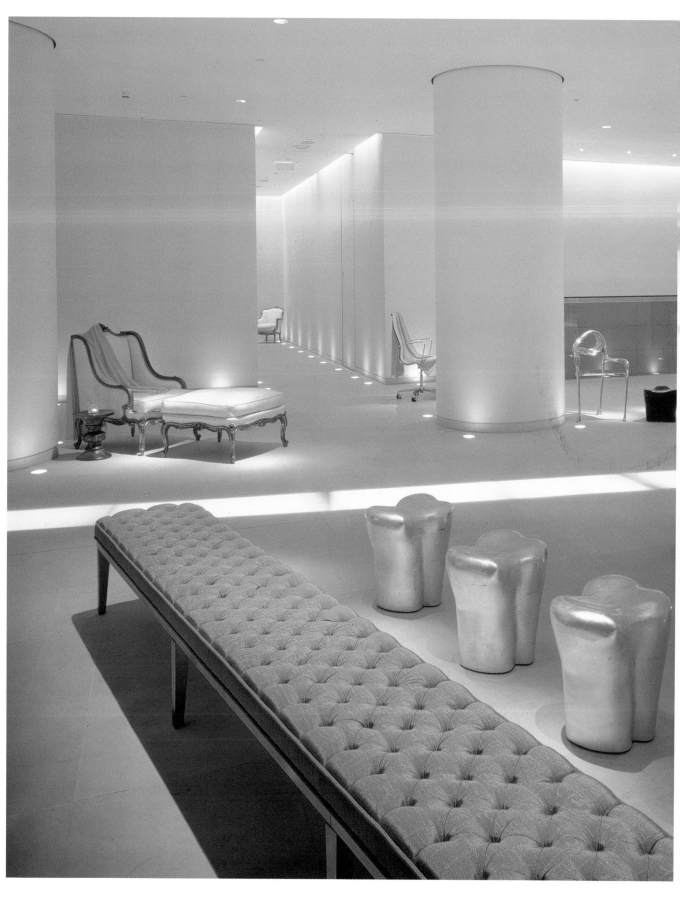

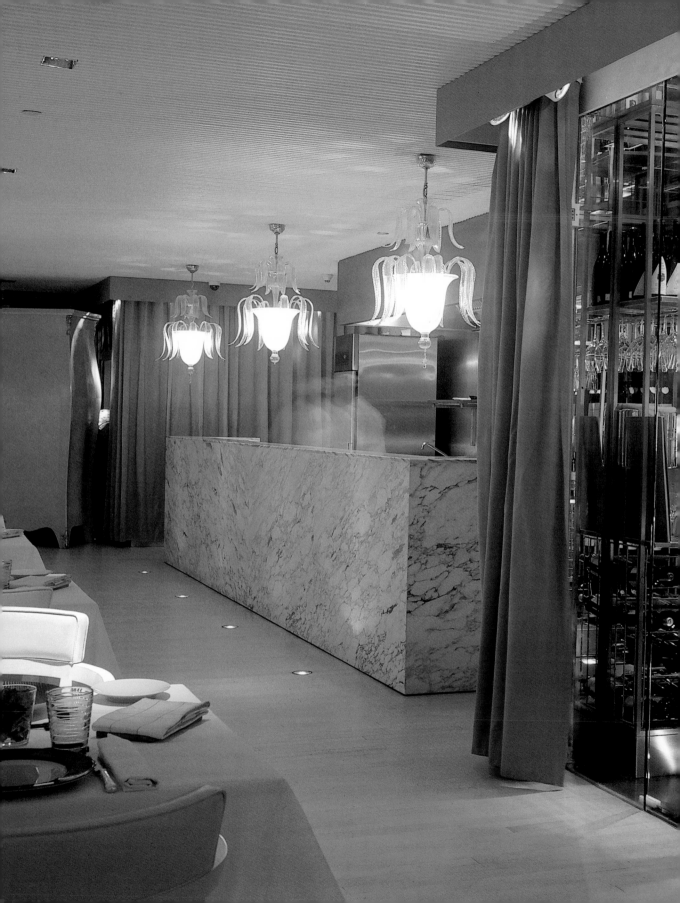

50, Berners Street, London W1P 3AD, UK Tel.: +44 207 300 1400 www.hotels-london.co.uk

Sanderson Hotel

Designer: Philippe Starck **Photographers:** © Mihail Moldoveanu and Todd Eberle **Opening date:** 2000
Rooms: 150 (including a suite, rooms with terraces, loft rooms and apartment rooms with private elevator)

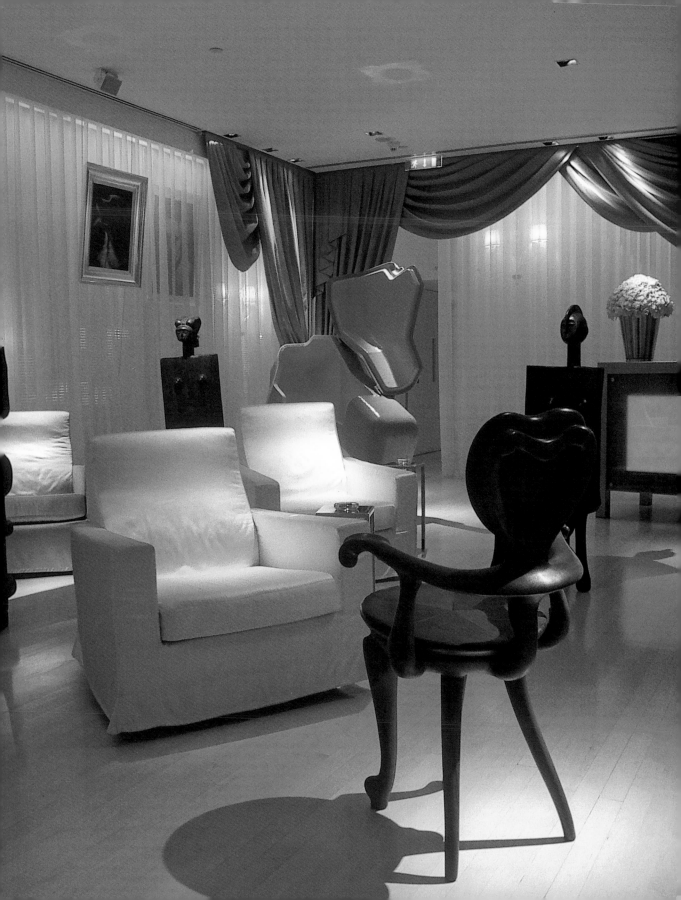

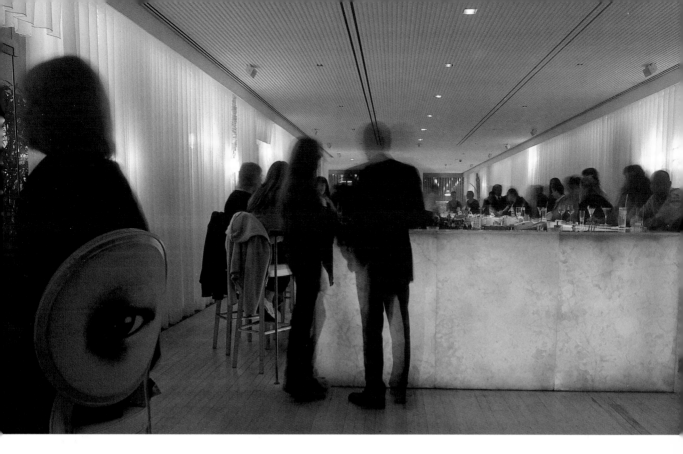

The Sanderson's restaurant, the Spoon, shows French influences not only in the food that it serves but in its style of decoration. Neutral tones and materials like marble make for a sober, relaxed ambience.

Das Restaurant des Sanderson, das Spoon, unterliegt nicht nur in der Gastronomie, sondern auch in der Gestaltung französischem Einfluss. Neutrale Farben und edle Materialien wie Marmor ließen eine schlichte und harmonische Atmosphäre entstehen.

Le restaurant du Sanderson, le Spoon, est imprégné d'influence française non seulement sur le plan de la gastronomie mais aussi dans le style de la décoration. Teintes neutres et matériaux nobles, à l'instar du marbre, confèrent une ambiance sobre et apaisante.

El restaurante del Sanderson, el Spoon, presenta influencias francesas no sólo en cuanto a su gastronomía, sino también en el estilo decorativo. Una tonalidad neutra y materiales nobles, como el mármol, conforman un ambiente sobrio y sosegado.

Il ristorante del Sanderson, lo Spoon, presenta influenze francesi non solo per quanto riguarda la gastronomia, ma anche nello stile decorativo. Una tonalità neutra e dei materiali nobili come il marmo formano un ambiente sobrio e sereno.

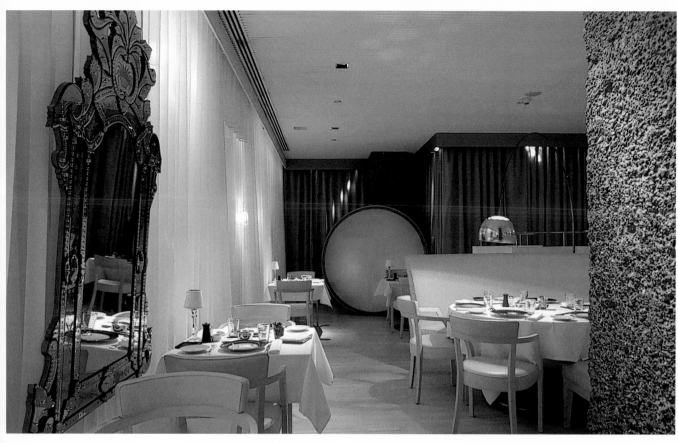

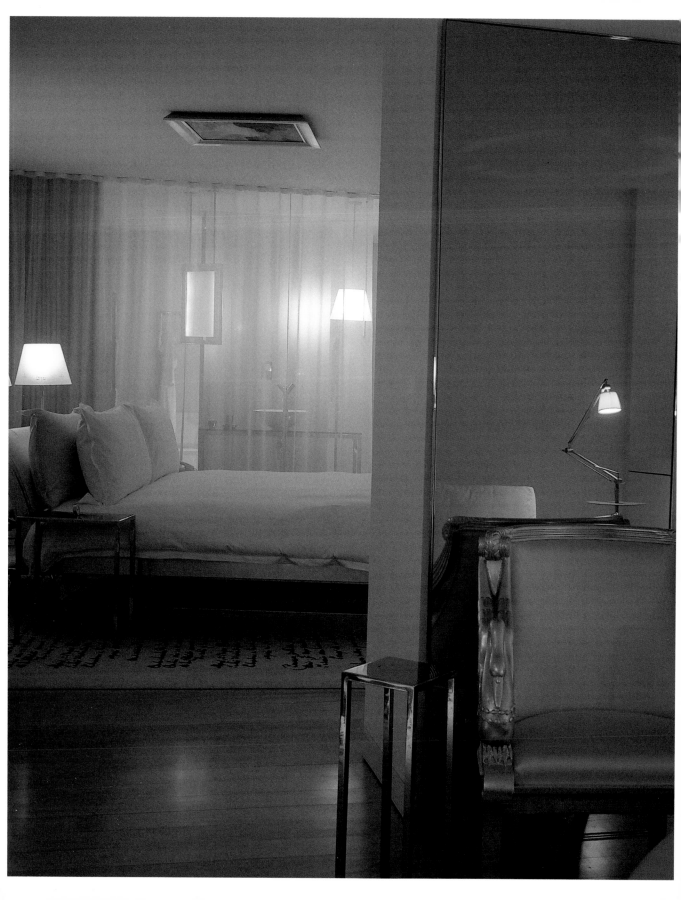

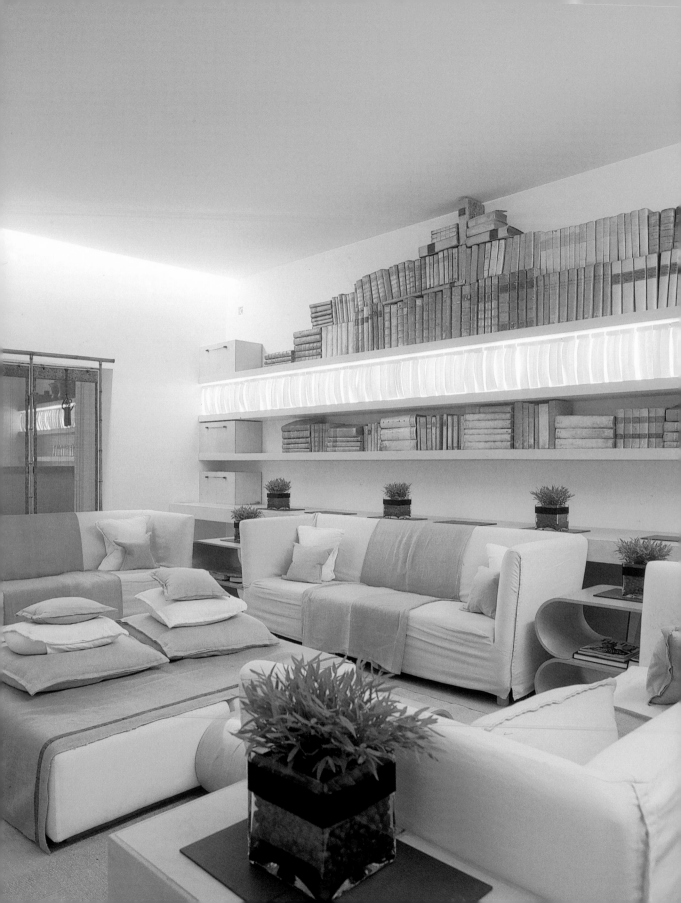

31–35 Craven Hill Gardens, London W2 3EA, UK Tel.: +44 207 298 9000 Fax: +44 207 402 4666
www.the-hempel.co.uk

The Hempel

Architect: Anouska Hempel **Photographer:** © Gunnar Knechtel **Opening date:** 1996
Rooms: 41 rooms and 3 apartment rooms

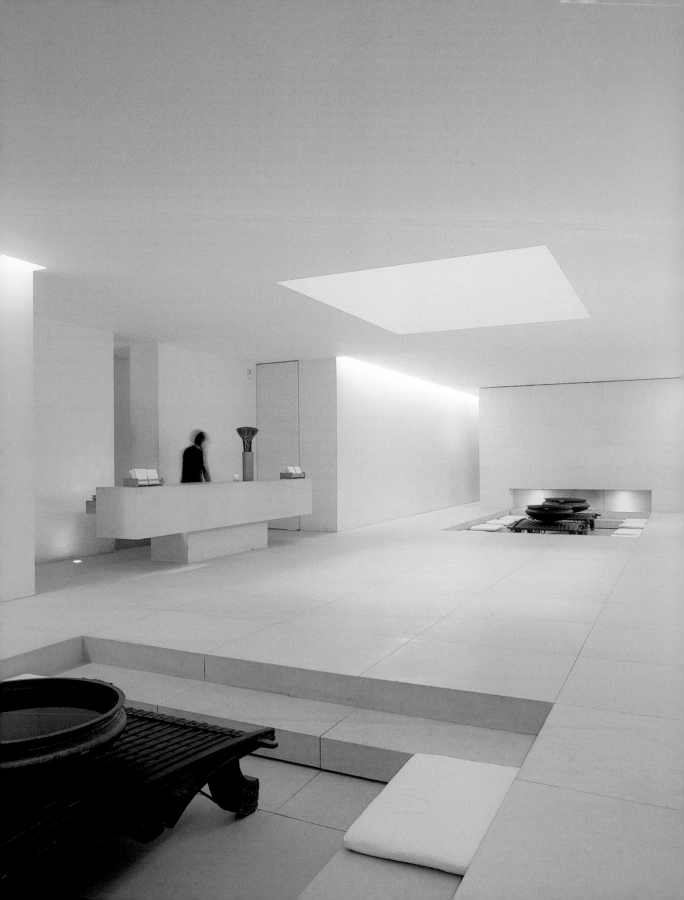

The blend of cultures is also present in the hotel library. The space is intended to be domestic, with neutral tones, and natural materials. The simple, exquisite textures configure a peaceful, meditative space.

In der Bibliothek des Hotels mischen sich Kulturen. Der Raum wirkt sehr wohnlich, durch neutrale Farben, wertvolle Materialien und natürliche Texturen entstand eine einladende und entspannende Atmosphäre.

La fusion des cultures est également présente dans la bibliothèque de l'hôtel. L'espace a été conçu comme un lieu de séjour convivial : tons neutres, matières sublimes et textures naturelles créent un havre de paix et de détente.

La fusión de culturas también está presente en la biblioteca del hotel. El espacio se ha proyectado como una estancia doméstica: tonalidades neutras, materiales exquisitos y texturas naturales consiguen crear un rincón de atmósfera relajada.

La fusione di culture è presente anche nella biblioteca dell'hotel. Lo spazio è stato progettato come una stanza ad uso domestico: tonalità neutre, materiali eccellenti e texture naturali danno vita ad un angolo dall'atmosfera rilassata.

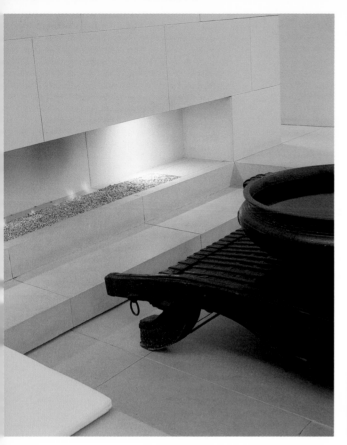

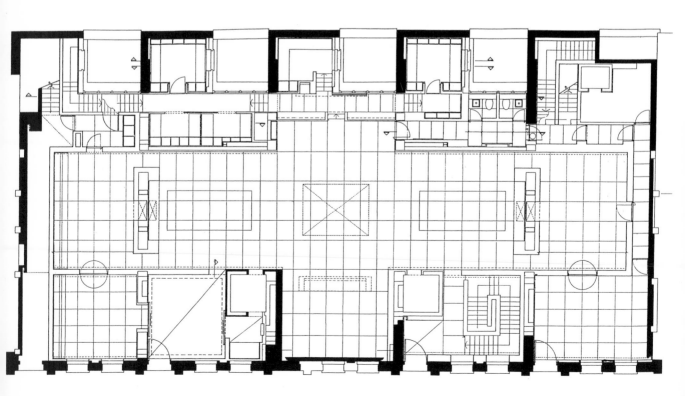

Groundfloor

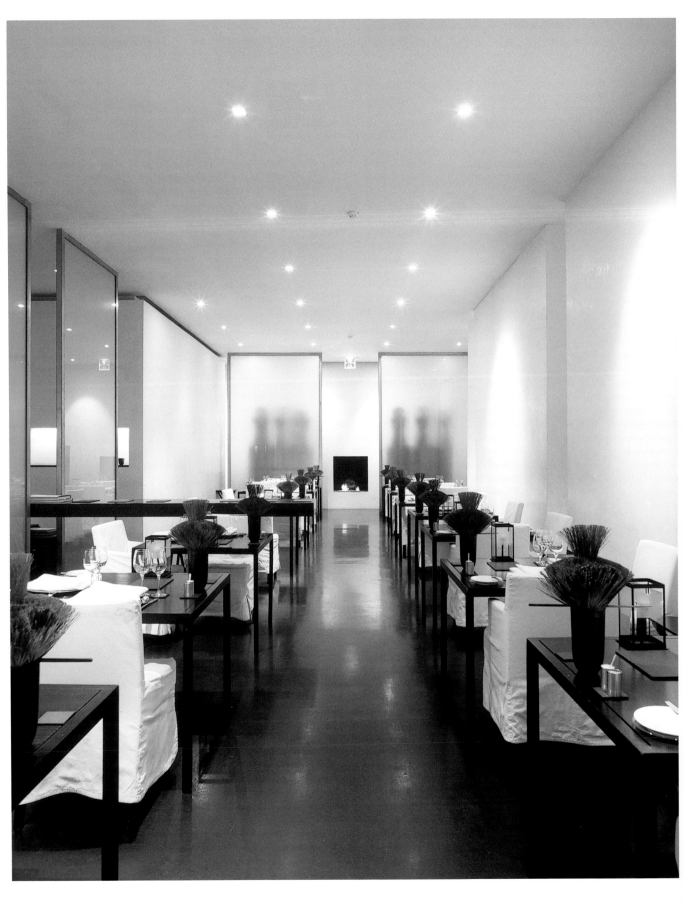

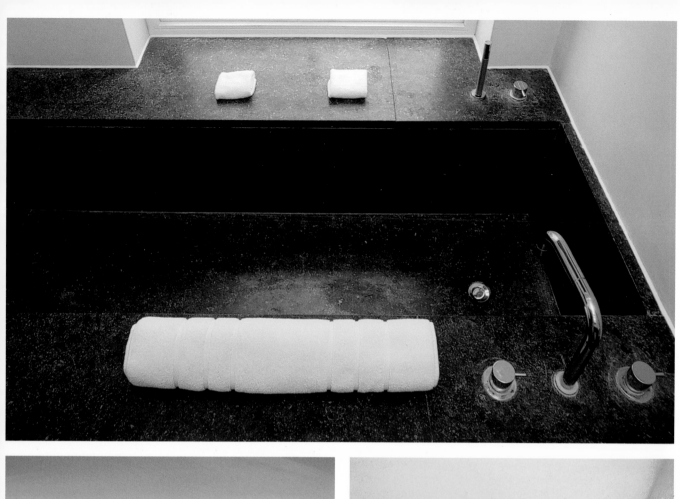
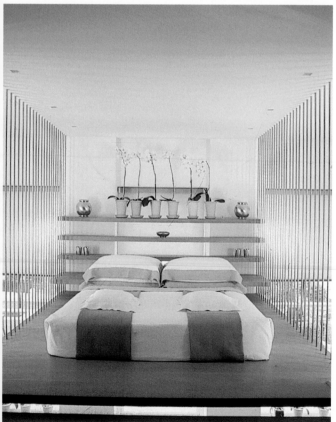
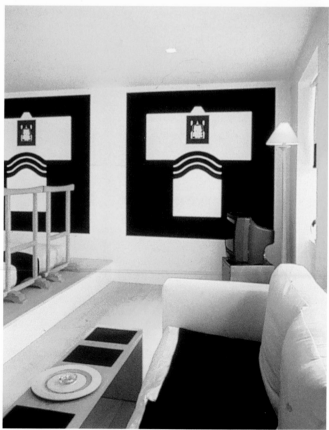

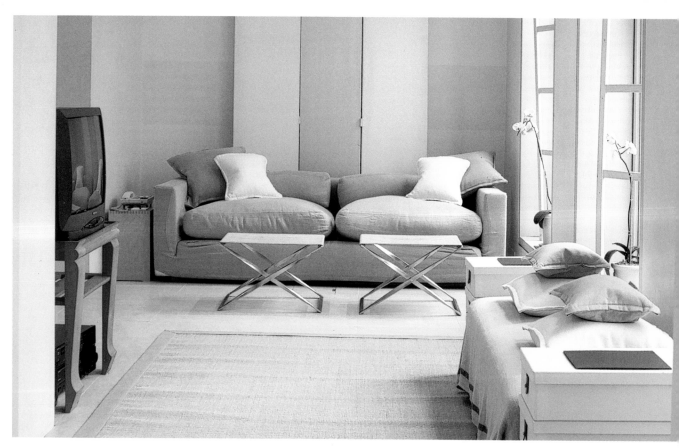
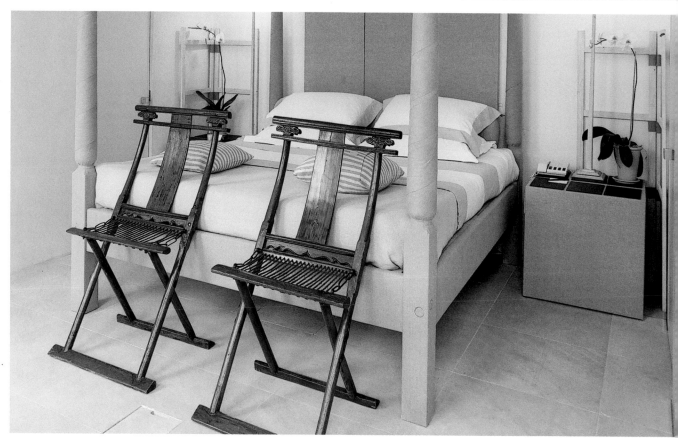

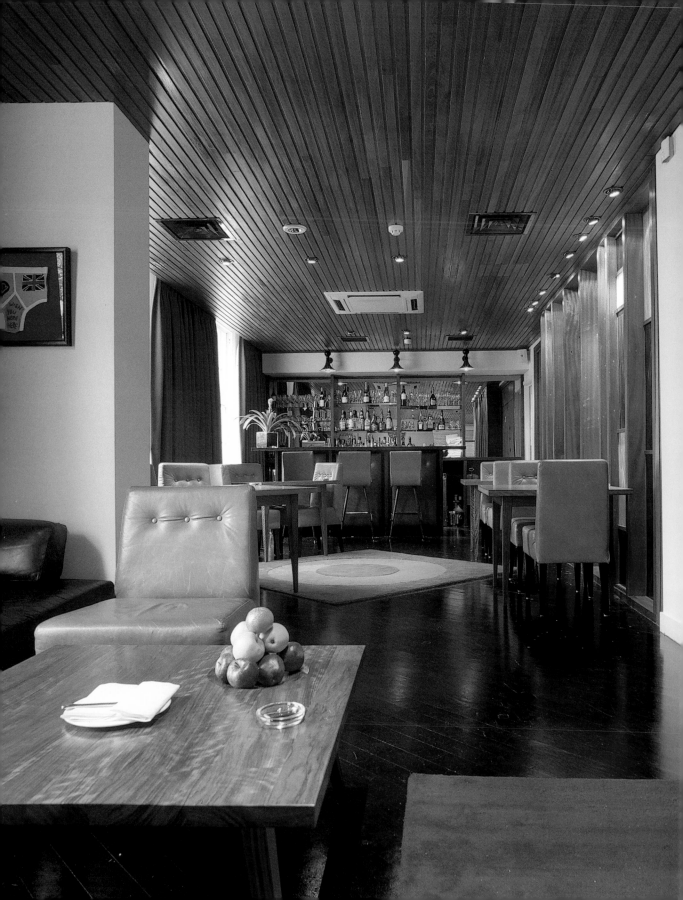

163–165 Westbourne Grove, London W112RS, UK Tel.: +44 207 243 6008 Fax: +44 207 229 7204

The Westbourne Hotel

Architect: Giles Baker Photographer: © Gunnar Knechtel Opening date: 2000 Rooms: 20

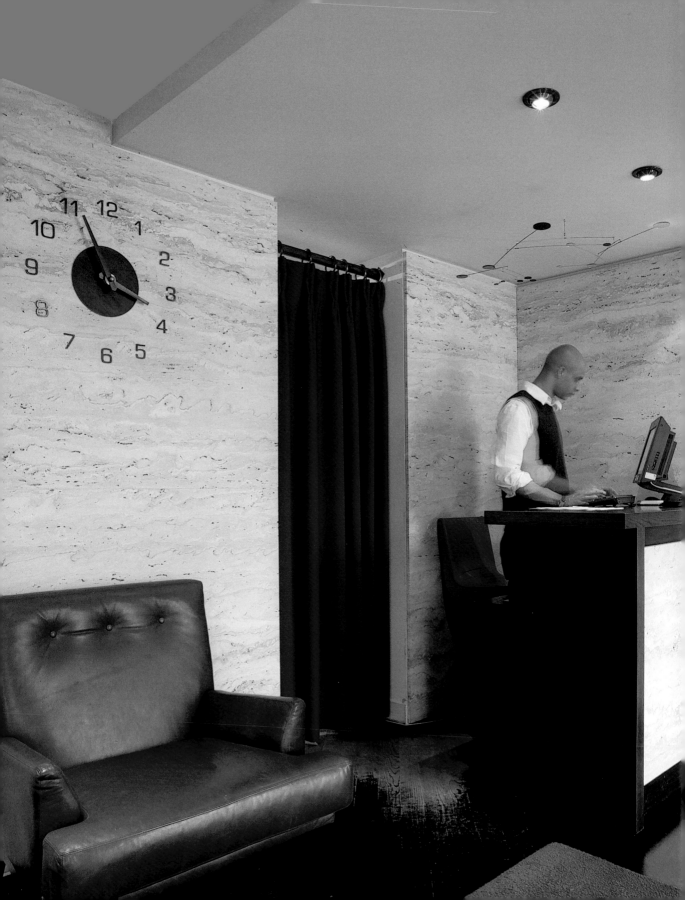

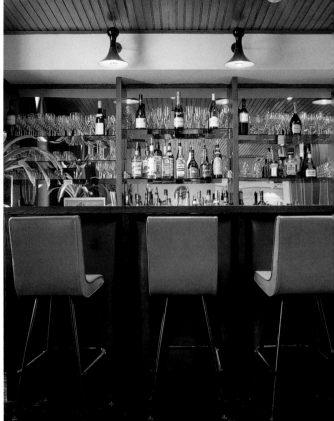

The bar and restaurant conform an intimate space accessible through Westbourne Grove and the adjacent garden. The dining area is defined by a rectangular composition that makes reference to Mondrian in green, mustard and chocolate tones.

Der Bereich der Bar und des Speisezimmers wirkt sehr einladend. Man erreicht ihn von Westbourne Grove und dem anliegenden Garten aus. Das beherrschende Element im Speisesaal ist eine rechteckige Komposition, die auf Mondrian anspielt, und in den Farben Grün, Senfgelb und Schokoladenbraun gehalten ist.

Le bar et la salle à manger forment un espace en retrait où l'on accède par Westbourne Grove ou depuis le jardin contigu. L'espace de la salle à manger, de conception rectangulaire, fait référence à Mondrian, dans des nuances de vert, moutarde et chocolat.

El bar y el salón comedor conforman un espacio recogido al que se tiene acceso desde Westbourne Grove y el jardín contiguo. El área del comedor está definida por una composición rectangular que hace referencia a Mondrian, en tonos verde, mostaza y chocolate.

Il bar e la sala da pranzo formano uno spazio raccolto al quale si accede dal Westbourne Grove e dal giardino attiguo. L'ambiente della sala da pranzo viene definito da una composizione rettangolare, che richiama lo stile di Mondrian, in toni verde, senape e cioccolata.

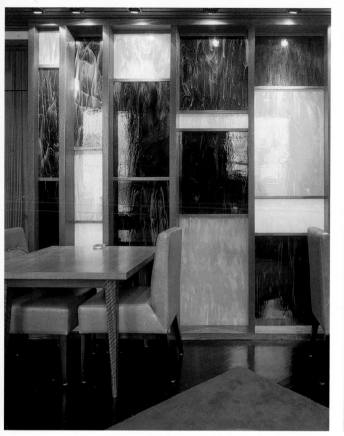

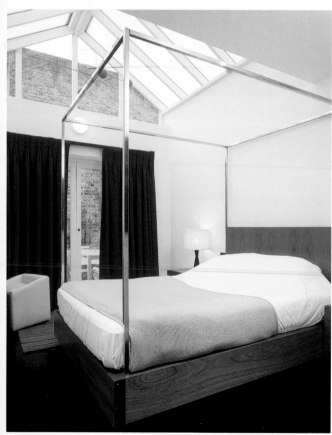
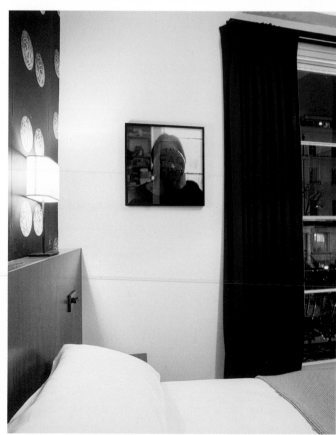

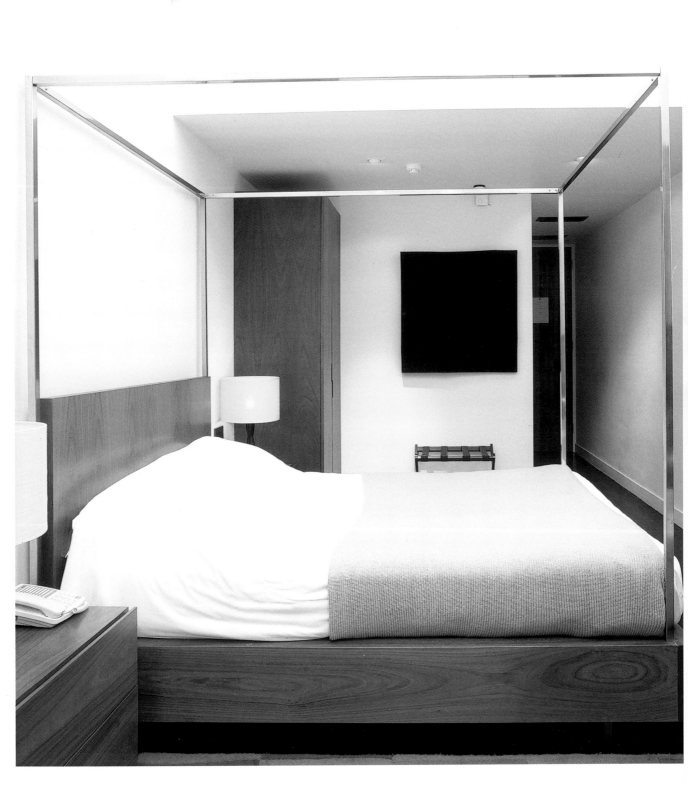